Kinesthetic Empathy in Creative and Cultural Practices

Kinesthetic Empathy in Creative and Cultural Practices

Edited by Dee Reynolds and Matthew Reason

intellect Bristol, UK / Chicago, USA

First published in the UK in 2012 by
Intellect, The Mill, Parnall Road, Fishponds, Bristol, BS16 3JG, UK

First published in the USA in 2012 by
Intellect, The University of Chicago Press, 1427 E. 60th Street,
Chicago, IL 60637, USA

A catalogue record for this book is available from the British
Library.

Cover photograph: Chris Nash. Dancers: Valentina Formenti and
Kate Jackson
Cover designer: Holly Rose
Copy-editor: MPS Ltd.
Typesetting: Mac Style, Beverley, E. Yorkshire
Production manager: Tim Mitchell

ISBN 978-1-84150-491-9

Printed and bound by Hobbs, UK

Contents

Contents

Acknowledgements

This book comes at the end of a three-year-long project titled Watching Dance: Kinesthetic Empathy. We would like to thank the other members of the project team – Shantel Ehrenberg, Marie-Hélène Grosbras, Corinne Jola, Anna Kuppuswamy, Frank Pollick, Katie Popperwell and Karen Wood – whose research and thinking around kinesthetic empathy has shaped this publication in many ways.

In April 2010 the Watching Dance project held a conference on the topic 'Kinesthetic Empathy: Concepts and Contexts'. Some of the chapters here began life as conference papers, with others being specially commissioned for this publication. We would like to thank all the authors who have contributed to this publication for helping to make the editorial process so smooth and particularly Chris Nash for engaging with the photographic research collaboration and producing such stunning images. We'd like to thank Amelia Jones for contributing a foreword.

Finally, we wish to acknowledge the financial support from the Arts and Humanities Research Council, which funded the project from 2008 to 2011 and also the support received from our respective institutions, University of Manchester and York St John University.

Foreword

Amelia Jones

Kinesthetic empathy in philosophical and art history: Thoughts on how and what art means

How does art (in the broadest sense of cultural works produced with creative intent) mean? The originality of this book is to take this question, along with the larger question of how we communicate, and insist that it can only be answered through an interdisciplinary study of embodied expression. Honouring the innovations of this book, I want to sketch, as an art historian interested in performance and the performativity of perception and interpretation, a very brief history of how and what art has come to mean in relation to theories in philosophy and the visual arts.

As the title of this book suggests, *empathy* is one way of thinking about our connection to art (or desire to see and interpret is informed by our empathetic connection with the person we imagine to be making/performing or to have made/performed the work). Art historian Wilhelm Worringer developed the idea of empathy in relation to aesthetics in a 1908 book, *Abstraktion und Einfühlung: ein Beitrag zur Stilpsychologie* (Abstraction and Empathy: Essays in the Psychology of Style), drawing on the theories of Theodor Lipps and Aloïs Riegl.[1] Aesthetic empathy, as philosopher David Morgan points out, is an extension of the German idealist concept of art as a kind of 'enchantment', art as animated by the expressiveness of the creative genius (Morgan 1996). At play in this concept is the key notion that particular kinds of human expression (here, visual art) project feelings and elicit what Lipps had called 'aesthetic sympathy' such that those engaging with the work *feel* (presumably similar feelings) in response (Lipps 1900; Morgan 1996: 321).

This is a simple idea with profound resonances across the belief systems going backward and forward in time, linked of course in European culture to eighteenth-century aesthetics and nineteenth-century romanticism as well as to twentieth-century ideas about modernist art. Art is that which expresses feeling. And art can, by expressing feeling, move viewers in

the future by changing their ideas, their emotions, their beliefs (this latter idea being the key to twentieth-century modernism in its avant-gardist forms).

Worringer, along with others developing parallel ideas, thus planted the seeds for one of the primary impulses in modernism – the extension of a nineteenth-century romantic idea of art as expression into *expressionism*. As a movement and a tendency common to twentieth-century modernism (particularly in Worringer's own Germany), expressionism expanded the belief that the forms, materials and themes of a work of art express individual feelings to be, in turn, re-experienced and interpreted by later viewers. This theory expands upon the core belief behind western aesthetics (art is an expression of an individual subject), while opening the way for what the authors of the chapters in this volume call kinesthetic empathy (art, and other modes of human being in the world, potentially engages others through eliciting empathetic responses).

Movement or kinesthesia is the term added to Worringer's theory, with aesthetics (in Euro-American thought largely focussed on still images and objects) opened to the shifting, pulsating, writhing, dancing, expressive action of bodies in space over time. More than just an idea of the expression of feeling, *kinesthetic* empathy explores what Henri Bergson, just before Worringer's investigations, argued to be the *durational* dimension of human experience, the embodied mind's capacity to give meaning to each present instant by making recourse to past embodied memories.[2]

Dance, theatre, cinema, music and performance are time-based media (what Matthew Reason usefully calls in the introduction to part three of this book 'explicit performances' that announce themselves as creative and 'to-be-looked-at' as such) and, if we stick with creative expressions, for obvious reasons thus appear to be paradigmatic sites of investigation for the project of exploring kinesthetic empathy. Here, however, from an art historical point of view, I want to push this boundary of how we conceive meaning and time in relation to embodiment by suggesting (as argued by several authors in this book) that a static artwork (in Worringer's sense) also clearly functions as a potential site of kinesthetic empathy. As Bergson's model suggests, the *durationality* of any encounter explains how humans make sense of things, people and other aspects of the world. All experience is durational and technically speaking (in terms of how human perception works) there is no moment of non-kinesthetic empathy in our apprehension of creative or even everyday objects and bodies in the world. This broader concept of durationality adds a crucial phenomenological dimension to the understanding of human intersubjectivity as kinesthetic and empathetic.[3]

In fact, Bergson is careful to note that all experience is durational. The moving body in space 'has no reality except for a conscious spectator ... and motion ... is a mental synthesis, a psychic ... process' (1889: 111). Motion, insofar as we can 'know' what it is and means, does not 'exist' except in perception. This observation, made in his 1889 book *Time and Free Will*, revolves in fact around a discussion of the expressive (what Worringer or the authors here might call *empathetic*) capacity of art as a special domain of human production. I cite Bergson on this point at length because of the very interesting implications of what

he is saying in relation to what is innovative about this book on kinesthetic empathy (the emphases are mine):

> [A]rt aims at impressing feelings on us rather than expressing them: it suggests them to us, and willingly dispenses with the imitation of nature when it finds some more efficacious means.… [W]e should have to relive the life of the subject who experiences it [the emotion] if we wished to grasp it in its original complexity. Yet the artist aims at giving us a share in this emotion, so rich, so personal, so novel, and at enabling us to experience what he cannot make us understand. *This he will bring about by choosing, among the outward signs of his emotions, those which our body is likely to imitate mechanically, though slightly, as soon as it perceives them, so as not to transport us all at once into the indefinable psychological state which called them forth.* Thus will be broken down the barrier interposed by time and space between his consciousness and ours: and the richer in ideas and the more pregnant with sensations and emotions is the feeling within whose limits the artist has brought us, the deeper and the higher shall we find the beauty thus expressed. *The successive intensities of the aesthetic feeling thus correspond to changes of state occurring in us,* and the degrees of depth to the larger or smaller number of elementary psychic phenomena which we simply discern in the fundamental emotion.
> (1889: 16, 18)

For Bergson, art *impresses* rather than *expresses* feelings – this is to say that art's primary intention in a phenomenological sense of purposeful action is to *convey emotions* to future viewers. And, presciently suggesting the body's 'mechanical imitation' of the emotions that have been expressed in the work, Bergson opens the door for later discussions of 'mirroring' – in turn, structures that 'call forth' the psychological states originally motivating the artist's creative actions. Most importantly, this interrelation (which is of course paradigmatically intersubjective) leads to a potential 'change of state' for the viewer, who can in fact become (as it were) a different person in relation to the work. Interestingly, in the case of static visual artworks, the intersubjectivity rarely involves the simultaneous presence of the two subjects in question in the same space.[4] With 'live' performances the potential is for both performer and viewer to be *changed* through this empathetic relation as they are, presumably, in the same space at the same time.

All of the elements are in place in Bergson, to some degree, for a theory of kinesthetic empathy. What is new to the recent scholarship, however, so usefully brought together here, is the more elaborated awareness (due in part to a century's developments in philosophy and neuroscience, not to mention huge demographic shifts internationally and transformations in technology) of how this interchange works, and what it means that we are never whole and final as subjects but always porous, through kinesthetic empathy perhaps, to the impact and impression of other subjective expressions around us. Also new is the explicit political recognition in work by Rose Parekh-Gaihede's chapter and in work by others elsewhere of the *ethical dimensions* of exploring how the intersubjectivity of kinesthetic empathy works

in specific situations.[5] Key to the ethics of such an exploration is, as many of the chapters in this book point out, to acknowledge the contextual and embodied specificity of how these exchanges occur. In every case, we must now – being part of an expanded globalized cultural context – be extremely sensitive to the nuances of how particular bodies (including our own) are positioned, presented, experienced, understood geographically, technologically, spatially, temporally and otherwise. And to keep the determination of meaning open as a process rather than finalising it in a particular moment of identity or signification.

How do bodies, particularly those creatively motivated to move intentionally towards the ends of communicating artistic meaning (however this might be defined), come to mean to others who encounter them? This is a question with profound implications – in fact, all of history and contemporary life (including politics, pedagogy, therapies of various kinds, and other intersubjective arenas, as the chapters here suggest) could be explored using the model of kinesthetic empathy. Drawing together the insights from aesthetic theory, phenomenology, neuroscience and other domains, Dee Reynolds and Matthew Reason propose a new framework for imagining how embodied subjects engage with the world, how we come to *mean* for one another.

More than anything, this array of chapters proposes to provide new ways of understanding intersubjective relationships in general. Between Bergson and today, nothing could be more important than trying to come to grips with how we signify to one another and (as an extension) ways of potentially enhancing or changing these processes of intersubjective meaning. To keep them, in fact, in motion (kinesthetic) rather than allowing the kind of freezing to take place that enables fascism, certain modes of neo-liberalism, fundamentalism and totalitarianism.

Honouring the durationality of subjects (and meaning), while attempting to understand their significance, their impact and influences on us now, is the single most urgent task we face as the world becomes more and more globalised and more and more obviously interconnected and, at the same time, increasingly confusing and complex. Kinesthetic empathy can, as the authors here suggest, result in both positive and negative (oppressive) effects. It is the fruit of such nuanced studies as these chapters offer here to insist that we be aware of these effects as they come into formation.

Notes

1. Particularly interesting in this regard are Riegl's theory of the '*Kunstwollen*', the collective artistic will that 'makes its way forward in the struggle with function, raw material, and technique', giving the work meaning; and his concept of the 'haptic' qualities of works of art – the potential of visual art to elicit a sense of tangibility (beyond vision or 'optic' qualities) and, by extension, a visceral and embodied response. On the *Kunstwollen*, see Riegl (1985: 5–17).
2. See Bergson (1889, 1908).
3. This is not to say that all experiences are ontologically equivalent at all. Clearly the experience of dance or of a film will be processed and understood differently from that of a painting on the wall.

4. This tendency has changed with the recent turn to performative, live interactions on the part of visual artists. These have been theorised since the 1970s in terms of an opening to 'situation', 'intersubjectivity' or 'interrelationality'.
5. I make this point, for example, using the more Merleau-Pontian rhetoric of chiasm and reciprocity, in my books *Body Art/Performing the Subject* (Jones 1998) and *Self/Image: Technology, Representation, and the Contemporary Subject* (Jones 2006). See also the work of cultural studies and performance studies scholars, for example Noland (2009) and Muñoz (2009).

References

Bergson, H. (1896). *Matter and Memory*, trans. N. M. Paul and W. Scott Palmer. New York: Zone Books, 2002; from fifth edition of 1908.

Bergson, H. (1889). *Time and Free Will: An Essay on the Immediate Data of Consciousness*, trans. F. L. Pogson. London: George Allen and Co., 1913, facsimile reprinted Adamant Media Corporation, 2005.

Jones, A. (1998). *Body Art/Performing the Subject*. Minneapolis: University of Minnesota Press.

Jones, A. (2006). *Self/Image: Technology, Representation, and the Contemporary Subject*. New York & London: Routledge.

Lipps, T. (1900). 'Aesthetische Einfühlung'. *Zeitschrift für Psychologie und Physiologie der Sinnesorgane*, 22: 432–433.

Morgan, D. (1996). 'The Enchantment of Art: Abstraction and Empathy from German Romanticism to Expressionism'. *Journal of the History of Ideas*, 57 (2): 317–341.

Muñoz, J. E. (2009). *Cruising Utopia: The Then and There of Queer Futurity*. New York: New York University Press.

Noland, C. (2009). *Agency and Embodiment: Performing Gestures, Producing Culture*. Cambridge, MA: Harvard University Press.

Riegl, A. (1985). *Late Roman Art Industry* (1901), trans. Rolf Winkes. Rome: Giorgio Bretschneider.

Introduction

Dee Reynolds and Matthew Reason

W e embarked on the process of devising and editing this book having spent the previous three years engaged with the question of kinesthetic empathy. The immediate context for this was a research project, titled 'Watching Dance: Kinesthetic Empathy', funded in the UK by the Arts and Humanities Research Council between 2008 and 2011. As is natural with such projects both it and we changed and grew during the course of the research. One area where this occurred was in the increasing realisation that debates about kinesthetic empathy were taking place in different parts of the world, in many disciplines and in contexts far beyond our immediate focus on dance.

Kinesthetic empathy is clearly a concept that many people (scholars, artists, educationalists and others) are finding useful, a moment of conceptual coming together that we believe is both produced by and representative of a particular cultural and scientific moment. The cultural moment is what has been described as a 'corporeal turn' (Sheets-Johnstone 2009; Tamborino 2002) or growing focus on 'embodied knowledge' (Nelson 2009: 115) in the arts, humanities and sciences. The scientific moment is marked by research into the evocatively named 'mirror neuron' system, which has extended into characterising empathic reaction in relation to the sense of movement (Grosbras 2011). Mirror neuron research has reignited interest in the concept of kinesthetic empathy that was originally developed through aesthetics. Both of these are discussed further here and are recurring issues in the chapters contained within this book.

This book contains chapters engaging with kinesthetic empathy in diverse contexts: dance, film, theatre, music, sport, photography, therapy, applied and participatory performance and interactive environments. The disciplinary perspectives are varied, as are the methodological approaches, with many of the authors very consciously engaging with innovative interdisciplinary and cross-methodological research. And, moreover, the material in this book is only a sample of what could be presented as current research into kinesthetic empathy, in what appears to be an expanding field. We feel comfortable, therefore, in stating

that kinesthetic empathy is a key interdisciplinary concept in our understanding of social interaction and communication in creative and cultural practices ranging from art through entertainment and sport to physical therapies. In presenting work carried out by scholars from different disciplines and with contrasting methodological approaches, we are inviting the reader to venture across disciplinary boundaries and to develop new understandings and insights into the cultural and embodied phenomenon of kinesthetic empathy in its diverse manifestations. We have divided the book into five parts, each introduced by an editorial commentary that discusses and makes connections between the different methodologies and perspectives presented. This general introduction to the book as a whole will place kinesthetic empathy in context and explore some of the reasons for its current significance.

Kinesthetic empathy in context

For all its currency, the concept of kinesthetic empathy remains elusive, and its definitions problematic. Or perhaps more accurately it is not the definitions themselves that are problematic, but rather agreement on the implications of those definitions for the concept itself. Indeed, for us as researchers and editors many questions have recurred as we have grappled with the term over the last few years, including: how far might kinesthetic empathy be stretched as a concept; how to recognise it when you see it; what are the relationships between arts-based and neurological definitions; and what is the relationship between cognitive and affective understandings or experiences of kinesthetic empathy.

In terms of definitions it is worth first briefly isolating the two terms within kinesthetic empathy. Broadly speaking 'kinesthesia' can be understood to refer to sensations of movement and position. It has a complex relationship with proprioception, in that these concepts are described and worked with differently by scholars from different disciplinary and epistemological standpoints. (See, for instance, Gallagher 2005; Gallagher and Zahavi 2008; Noland 2009; Sheets-Johnstone 2011.) Sometimes kinesthesia and proprioception are used interchangeably, or one is subsumed into the other. For some, proprioception is defined as the sensing of one's own position and movement stimuli from within the body, through sense receptors in the muscles, joints, tendons and inner ear, as distinct from exteroception, the detection of environmental events through receptors in the eyes, ears and skin. However as Jeffrey Longstaff has pointed out, the inner/outer distinction is not always clear cut. For instance, receptors in the skin fulfil both functions (Longstaff 1996).

Kinesthesia is informed by senses such as vision and hearing as well as internal sensations of muscle tension and body position (Reynolds 2007: 185). It is embedded in a network of sensory modalities including hearing and touch, which have also been implicated in the mirror neuron system (Keysers et al. 2004; Gazzola et al. 2006). As well as mirror neuron research, this connects with current interest in perception as active and involving interrelation between different senses. Influences here are interdisciplinary, embracing discourses drawn from Maurice Merleau-Ponty's phenomenology of perception (Merleau-Ponty 1962), James

Gibson's ecological approach to visual perception (Gibson 1966), neuroscience (Berthoz 2000; Noë 2004) and affect (Massumi 2002).

The term *Einfühlung*, translated into English as 'empathy' by Edward Titchener in 1909, was first used in its modern sense of projecting oneself into the object of contemplation by Robert Vischer (1872) and was later promoted by Theodor Lipps in his writings on aesthetic experience (Lipps 1920, 1923). As discussed by several authors in this book, empathy can also concern relationship to objects rather than exclusively intersubjective relationships with other people. In Vischer's and Lipps' writings on aesthetics, kinesthetic sensation was considered an intrinsic part of empathy.

Although kinesthetic empathy was discussed in relation to aesthetic experience generally, including the visual arts (Worringer 1908), the concept took on particular prominence in relation to dance and the aesthetics of movement. Indeed, with John Martin, the dance critic who had a formative influence in defining the parameters of American modern dance in the 1930s, it became the cornerstone of a new dance genre, defining the relationship between dancer and spectator. Martin cited Lipps and used the terms 'inner mimicry' and 'kinesthetic sympathy' to refer to spectators' muscular and emotional responses to watching dancers (1939: 49; 1936: 117). He argued that inner mimicry of dance movement had a physiological dimension, involving movement memory, anticipation and associated changes in physiological states. Controversially, he also proposed that inner mimicry of a dancer's movement allowed spectators direct access to dancers' feelings: 'It is the dancer's whole function to lead us into imitating his actions with our faculty for inner mimicry in order that we may experience his feelings' (Martin 1939: 53).

There are some parallels here with the idea that mirror neuron activity enables us to experience others' thoughts and feelings through simulation. First discovered in macaque monkeys, the so-called mirror neurons are activated during performance of actions and also during observation of actions performed by another (Di Pellegrino et al. 1992; Gallese et al. 1996). Mirror neurons are special cells in the monkey brain that present the same pattern of activity when the monkey performs a specific action (e.g. grasping a peanut) and when it merely sees another animal performing the same action. Subsequent studies aimed to show the existence of a similar mirror system for gesture recognition in humans (e.g. Rizzolatti and Arbib 1998). A range of evidence indicates that such neurons also exist in the human brain and that 'the mirror mechanism . . . unifies action production and action observation, allowing the understanding of the actions of others from the inside' (Rizzolatti and Sinigaglia 2010). It has been posited that mirror neuron mechanisms are involved in the capacity to share emotions and sensations with others by 'activating the observer's own neural substrates for the corresponding state' or providing 'shared affective neuronal networks' (Preston et al. 2007; de Vignemont and Singer 2006). Neuroscientist Vittorio Gallese describes embodied simulation as 'the functional mechanism underpinning *Einfühlung*' (Gallese 2008: 776), and argues that it can lead to a sharing of affective states. The observer's 'embodied simulation' produces a 'body state shared by observer and observed' (Gallese 2008: 771).

Although this argument could be interpreted in a reductive and universalist manner, Gallese also points out that embodied simulation is 'modulated by our own personal history, by the quality of our attachment relations and by our sociocultural background' (Gallese 2008: 775). The brain itself is plastic and neural pathways are constantly being reorganised through new experiences; learning and enculturation are central to embodied cognition. Similarly, although Martin's view of kinesthetic empathy can be critiqued for its universalism (Foster 2008, 2011), the discourse of kinesthetic empathy is constantly being (re)constructed in different contexts and also involves negotiation across differences, respecting otherness, rather than eliding the other in the self-same. This ethical aspect of kinesthetic empathy is discussed particularly by Meekums, Parekh-Gaihede and Shaughnessy in this book. All the contributions are concerned with the various ways in which kinesthetic empathy can intervene in and impact on experience in encounters with others and the environment, whether through artistic and embodied practices, everyday or sporting actions. In a recent paper exploring qualitative research with dance audiences, we expand the range of kinesthetic pleasures and responses that spectators describe beyond that of mimicry, to embrace other sensorial, emotional and imaginative responses (Reason and Reynolds 2010).

Kinesthetic empathy now

The wider context for this topic is a moment of synergy, possibly of historical importance, between research in the arts/humanities and the sciences, that accompanies a paradigmatic shift towards embodied cognition. In his chapter in this book, Brian Knoth describes embodied cognition in terms of the view that 'what is going on inside the brain integrally depends on what is happening with the body and how it is interacting with its environment'. Or, as neuroscientist Antonio Damasio writes, 'brain changes reflect physiological changes in the body' (Damasio 2008: 17).

This seemingly straightforward tenet has far-reaching consequences, not least as a catalyst for both new research and creative practice. To conceptualise perception, emotion and cognition as embodied has significant implications for how we frame thought, how we engage in communication, and how we make and receive artworks. Something of this creative excitement is captured by Siân Ede, Deputy Director of the Calouste Gulbenkian Foundation, reporting on the Embodied Mind Symposium held in 2008.

I have worked in the arts all my professional life with a background in theatre, and had a hunch that some of the recent ideas emerging from neuroscience would be recognised by theatre and dance practitioners and teachers who are daily thinking *through* their bodies, investigating ways of communicating that might have been influenced by the great theorists/ practitioners in their fields … Clinicians are sometimes amazed by the brain's/body's determination to cope with injury or illness, its flexibility and plasticity,

and an insight into this could inspire dance and theatre artists not just to understand and challenge their own practice but to create new artworks that communicate differently.

(Ede 2008: 3)

At the forefront of scientific developments in this area has been the exploration of the 'mirror neuron' system. The significance of such a system is its role in intersubjective communication through 'motor-based understanding' (Rizzolatti and Sinigaglia 2010). When we observe someone performing an action, such as waving their hand in greeting, 'we covertly and unconsciously simulate ourselves performing the movement, access our own associated intentions and goals for that particular movement, and assign them to the person we are observing' (Dinstein 2008). The question of whether it is possible to identify mirror neuron activity in humans remains controversial (Dinstein 2008; Lignau et al. 2009), not to mention the claim that we can assign motives to others on the basis of our own experience, which parallels Martin's universalist claims for kinesthetic empathy. Whatever the future holds for mirror neuron research, the discourses and widespread debates it has produced have already provided significant impetus for research and practice in the arts and humanities, as is exemplified by several contributions to this book.

Engagement with mirror neurons, however, marks only one element of what some scholars have termed a corporeal turn, that can also be considered as another development in challenging the centuries-long division, within western thought in particular, between conceptualisation of the mind and body. For John Tamborino (2002), the corporeal turn demands that we face the challenge of considering practices and experiences (such as, with this book, kinesthetic empathy) that typically sit outside of reflective consciousness. Within the arts this is most explicitly manifest in the development of practice-based research. Also referred to as practice-led research or practice-as-research, practice-based research is varied and far from homogeneous in its methodology or subject matter, but broadly speaking it describes the recognition that arts-making, across disciplines, can represent a form of research that generates and communicates knowledge. This is a field that has as its defining core the ideas of embodied knowledge and the dissemination of knowledge through the body and through experience itself (Nelson 2009; George 1996). It is no surprise, therefore, that arts practice forms a central methodological structure (rather than merely thematic content) for several chapters in this collection, and it is the explicit focus of Part IV.

At the same time, we would argue that the turn to embodied cognition should be informed by the previous so-called 'cultural turn', which came to prominence in the late 1970s in several disciplines, notably sociology and history, and where culture is regarded as constitutive of the topic under study. The cultural turn saw both a greater emphasis on individuals' everyday cultural behaviours and upon the importance of culture and the lived experience in shaping meaning. As David Chaney writes, 'it is through culture that everyday life is given meaning and significance' (1994: 7). Importantly, Tamborino argues that we must 'foreground the body without relegating language, culture, consciousness to the background. Indeed, the greatest challenge is to explore the intersections between the

body, language, culture and consciousness' (2002: 3). It is this intersection that marks our engagement with kinesthetic empathy, as we present chapters that engage with it as a bodily, linguistic and cultural phenomenon and experience.

The structure of this book

We have divided this book into five parts, each of which has its own short editorial introduction. The divisions we have made are inevitably slightly artificial, as there are correspondences between chapters in different parts as well as within parts. For example chapters in different parts engage with ideas of affect (Donaldson, Reynolds), communication (Bolens, Gray), epistemology (Reason, Shaughnessy), motor systems and skills (Hayes, Fogtmann), participation (McKinney, Shaughnessy, Whatley) and with many other themes under which we could have grouped chapters. We also decided not to emphasise boundaries by grouping chapters by methodology (practice-based, qualitative, cognitive psychology) or by context (dance, theatre, sport, film). Instead the connections we have made are consciously cross-disciplinary and cross-methodology, and are thematically designed. The part introductions serve to provide our editorial perspective on the chapters, therefore here we will restrict ourselves to mapping out the book as a whole.

Part I is titled 'Mirroring Movements: Empathy and Social Interactions' and examines how kinesthetic empathy/mirroring operates in social situations ranging from applied theatre (Shaughnessy) and dance as therapeutic intervention (Meekums) to everyday actions (Hayes and Tipper). Across these diverse contexts and methodologies, the affective impact of kinesthetic empathy in the form of embodied responses emerges as a key concern. Another theme that emerges from this research is the role of objects and the material environment in the construction of empathy, an issue that is also taken up by authors in later chapters.

Part II takes its main focus from aspects of intersubjectivity, a key philosophical concept related to kinesthetic empathy. Whereas empathy in the context of social interactions includes relations to objects and the environment, the concept of intersubjectivity concerns relations between human subjects. Our contributors are less concerned with intersubjectivity as an epistemological dilemma ('the problem of how we know others': Gallagher 2005) than with how situations involving embodied interactions with others can impact on and intensify experience. Under the title 'Kinesthetic Engagement: Embodied Responses and Inter/Subjectivity' this part presents discussions of spectators' and performers' experiences of film (D'Aloia), music (Rabinowitch, Cross and Burnard) and dance (Reynolds) in terms of empathy and embodied, kinesthetic response, and considers aesthetic and social aspects of kinesthetic empathy.

In each of the previous parts performance (both the everyday and the artistic) is a strong contextual thread. Attention to performance then becomes the core theme in Part III, 'Kinesthetic Impact: Performance and Embodied Engagement', which presents three

considerations of how active kinesthetic engagement with film (Bolens, Donaldson) and theatre (Parekh-Gaihede) can alter spectators' emotional and/or cognitive states.

Part IV, 'Artistic Enquiries: Kinesthetic Empathy and Practice-Based Research', explores kinesthetic empathy in relation to examples of performance (Gray), scenography (McKinney) and photography (Reason) that utilise practice-based approaches to knowledge. Each chapter engages in research that is conducted through and embodied within experimental and reflective processes.

The chapters in Part V, 'Technological Practices: Kinesthetic Empathy in Virtual and Interactive Environments', discuss spectators' embodied experiences of digitally produced bodies and environments (Whatley), multimedia performance spaces (Knoth) and interactive sports training equipment (Fogtmann).

The way the material is organised through the book is non-linear. In any edited collection, but particularly one as multidisciplinary as this, the index allows you to trace themes across chapters and to construct your own trajectories of interest. Alternatively the introductory texts to each parts can function as useful reference points, so you might read these first as they are designed to highlight the disciplinary specificity of individual contributions as well as to provide an overview of each part.

We are also very appreciative of the inherent tension in producing a book – and a predominately textual and discursive book at that – which engages with a concept that as an experiential phenomenon is often described as resistant to textual and reflective knowledge. Of course we do not want to maintain absolute binaries between what is knowable through discourse and through the body, and would celebrate many of our authors here for producing writing that is at times extremely evocative in ways that are no less corporeal than cerebral. Of course writing has the potential to touch us in an embodied fashion when we read with our eyes but respond with our bodies. Nonetheless when reading and dipping in and out of this book, we would encourage you to take your thinking off the page as you reflect upon your own kinesthetic empathy interactions with the world and people and objects around you.

References

Berthoz, A. (2000). *The Brain's Sense of Movement*. London: Harvard University Press.

Chaney, D. (1994). *The Cultural Turn: Scene-Setting Essays on Contemporary Cultural History*. London: Routledge.

Damasio, A. (2008). 'Brain, Body and Emotion', The Embodied Mind: Report of a symposium held at the Squire Bancroft Studio, Royal Academy of Dramatic Art, London, 12 December 2008, 16–17. http://www.gulbenkian.org.uk/pdffiles/--item-1638-339-The-Embodied-Mind.pdf. Accessed 17 April 2011.

De Vignemont, F. and Singer, T. (2006). 'The Empathic Brain: How, When and Why'. *Trends in Cognitive Science*, 10 (10): 435–441.

Dinstein, I. (2008). 'Human Cortex: Reflections of Mirror Neurons'. *Current Biology*, 18 (20): R956–R959.

Di Pellegrino, G., Fadiga, L., Fogassi, L., Gallese, V. and Rizzolatti, G. (1992). 'Understanding Motor Events: A Neurophysiological Study'. *Experimental Brain Research*, 91: 176–180.

Ede, S. (2008). 'Introduction', The Embodied Mind: Report of a symposium held at the Squire Bancroft Studio, Royal Academy of Dramatic Art, London, 12 December 2008, 2–4. http://www.gulbenkian.org.uk/pdffiles/--item-1638-339-The-Embodied-Mind.pdf. Accessed 17 April 2011

Foster, S. (2008). 'Movement's Contagion: The Kinesthetic Impact of Performance'. In T. C. Davis (ed.) *The Cambridge Companion to Performance Studies*. Cambridge: Cambridge University Press, 46–59.

Foster. S. (2011). *Choreographing Empathy: Kinesthesia in Performance*. New York: Routledge.

Gallagher, S. (2005). *How the Body Shapes the Mind*. Oxford: Oxford University Press.

Gallagher, S. and Zahavi, D. (2008). *The Phenomenological Mind: An Introduction to Philosophy of Mind and Cognitive Science*. London: Routledge.

Gallese, V., Fadiga, L., Fogassi, L. and Rizzolatti, G. (1996). 'Action Recognition in the Premotor Cortex'. *Brain*, 119: 593–609.

Gallese, V. (2008). 'Empathy, Embodied Simulation, and the Brain: Commentary on Aragno and Zepf/Hartmann'. *Journal of the American Psychoanalytic Association*, 56: 769–781.

Gazzola, V., Aziz-Zadeh, L., Keysers, C. (2006). 'Empathy and the Somatotopic Auditory Mirror System in Humans'. *Current Biology*, 16 (18): 1824–1829.

George, D. E. R. (1996). 'Performance Epistemology'. *Performance Research*, 1 (1): 16–25.

Gibson, J. (1966). *The Senses Considered as Perceptual Systems*. Boston: Houghton.

Grosbras, M.-H (2011). 'Kinesthetic Empathy', communication at 'Kinesthetic Empathy in Action', Round Table discussion organised by the Watching Dance project, Laban, 25 March 2011. http://watchingdance.ning.com/forum/topics/watching-dance-round-table-discussion-laban-25th-march-2011. Accessed 20 January 2012.

Keysers C., Wicker, B., Gazzola, V., Fogassi, L. and Gallese, V. (2004). 'A Touching Sight: SII/PV Activation during the Observation and Experience of Touch'. *Neuron*, 42: 335–346.

Lignau, A., Gesierich, B. and Caramazza, A. (2009). 'Asymmetric fMRI Adaptation Reveals No Evidence for Mirror Neurons in Humans'. *Proceedings of the National Academy of Sciences of the United States of America*, 106: 9925–9930.

Lipps, T. (1920). *Ästhetik: Psychologie des Schönen und der Kunst. Zweiter Teil: Die ästhetische Betrachtung und die bildende Kunst*, Vol. 2. Leipzig: Leopold Voss. First published 1906.

Lipps, T. (1923). *Ästhetik: Psychologie des Schönen und der Kunst. Erster Teil: Grundlegung der Ästhetik*, Vol. 1. Leipzig: Leopold Voss. First published 1903.

Longstaff, J. (1996). 'Cognitive Structure of Kinesthetic Space: Reevaluating Rudolf Laban's Choreutics in the Context of Spatial Cognition and Motor Control'. D. Phil. City University and Laban Centre London.

Martin, J. (1965). *Introduction to the Dance*. New York: Dance Horizons. First published 1939.

Martin, J. (1968). *America Dancing: The Background and Personalities of the Modern Dance* New York: Dance Horizons. First published 1936.

Massumi, B. (2002). *Parables for the Virtual: Movement, Affect, Sensation*. London: Duke University Press.

Merleau-Ponty, M. (1962). *Phenomenology of Perception*. London: Routledge.

Nelson, R. (2009). 'Practice-as-Research Knowledge and Their Place in the Academy'. In A. Jones, B. Kershaw and A. Piccini (eds), *Practice-as-Research in Performance and Screen*. Basingstoke: Palgrave Macmillan, 112–130.

Noë, A. (2004). *Action in Perception*. Cambridge, MA: MIT Press.

Noland, C. (2009). *Agency and Embodiment: Performing Gestures/Producing Culture*. Cambridge, MA: Harvard University Press.

Preston, S. D., Bechara, A., Damasio, H., Grabowski, T. J., Stansfield, R. B., Mehta, S. and Damasio, A. R. (2007). 'The Neural Substrates of Cognitive Empathy'. *Social Neuroscience*, 2(3 and 4): 254–275.

Reason, M. and Reynolds, D. (2010). 'Kinesthesia, Empathy, and Related Pleasures: An Inquiry in Audience Experiences of Watching Dance'. *Dance Research Journal*, 42: 2: 49–75.

Reynolds, D. (2007). *Rhythmic Subjects: Uses of Energy in the Dances of Mary Wigman, Martha Graham and Merce Cunningham*. Alton: Dance Books.

Rizzolatti, G. and Arbib, M. A. (1998). 'Language within Our Grasp'. *Trends in Neurosciences*, 21 (5): 188–194.

Rizzolatti, G. and Sinigaglia, C. (2010). 'The Functional Role of the Parieto-Frontal Mirror Circuit: Interpretations and Misinterpretations'. *Nature Reviews Neuroscience*, 11: 264–274.

Sheets-Johnstone, M. (2009). *The Corporeal Turn: An Interdisciplinary Reader*. Exeter: Imprint Academic.

Sheets-Johnstone, M. (2011). *The Primacy of Movement*, expanded 2nd edn. Amsterdam: John Benjamins. First published 1999.

Stern, D. (2004). *The Present Moment in Psychotherapy and Everyday Life*. New York: W.W. Norton and Company.

Tamborino, J. (2002). *The Corporeal Turn: Passion, Necessity, Politics*. Lanham: Rowman and Littlefield.

Vischer, R. (1872). *Über das optische Formgefühl – ein Beitrag zur Ästhetik* (On the Optical Sense of Form: A Contribution to Aesthetics). Diss., Tübingen 1872.

Worringer, W. (1908). *Abstraktion und Einfühlung: Ein Beitrag zur Stilpsychologie* (Abstraction and Empathy: Essays in the Psychology of Style). Munich: Piper and Co.

Part I

Mirroring Movements: Empathy and Social Interactions

Introduction

Dee Reynolds

This part explores the uses and effects of kinesthetic empathy in very different environments and disciplinary contexts – applied theatre, dance movement psychotherapy, and cognitive psychology – looking at a range of ways in which kinesthetic empathy impacts on social interactions. A shared concern is the affective implications of kinesthetic empathy. For Shaughnessy and Meekums, this is central to their practices, which aim to influence participants and effect positive change. Hayes and Tipper highlight the impact on everyday actions of motor affect, which generally goes unnoticed.

Nicola Shaughnessy's chapter, 'Knowing Me, Knowing You: Autism, Kinesthetic Empathy and Applied Performance', discusses a project that drew upon scientific and physiological understandings of empathy (related to the context of mirror neuron research) to shape and focus the practice of participatory theatre. She recounts her work with drama practitioners and a cognitive psychologist to devise a theatrical experience that could facilitate autistic children in overcoming their difficulties in engaging with others. In the performance this engagement was mediated by a specially constructed theatrical environment, which was multisensory and immersive and which connected the real with the make-believe and facilitated individuals on the autistic spectrum to enter into imaginative play. For example, the performance used puppets – which are solid and real, and which have the appearance of life, but are less threatening than dealing with the full otherness of other people – to give participants the opportunity to act out social relations in a predictable, non-threatening way. At times the children were invited to help operate the puppets, and this along with other techniques (such as interaction between participant and performer, and the use of a live video feed) invited a kind of play that was spontaneous but also self-reflexive and always conscious of its own pretence.

The interactive environment, then, enabled the children to develop their abilities to play spontaneously and consequently also their skills of communication, social interaction and imagination. Alongside the children's development and discovery through the performance,

the researchers themselves were involved in a process of engaging imaginatively with autism by interacting empathically with the participants in the multisensory space. Rather than assimilation (as critiqued by Bertolt Brecht), this was an 'encounter' that recognised and valued the difference of a 'neuro divergent imagination', which privileges visual and imagistic modes of thinking. The performances therefore provided the researchers with a liminal space where they could experience the autistic imagination at work. Through embodied, multisensory engagement both with the environment and with each other, participants and researchers alike learned new ways of behaving and new ways of knowing. As well as mobilising kinesthetic empathy to 'intervene' in autistic consciousness, this experience points to a model for scholarship based on empathy and dialogue with difference.

In her chapter, 'Kinesthetic Empathy and Movement Metaphor in Dance Movement Psychotherapy', Bonnie Meekums in turn explores kinesthetic communication, this time in the context of dance movement psychotherapy, where therapist and client (or group of clients) use movement as a mode of exploration and transformation. The embodied experience of moving constructs 'dialogues'. between individuals where cognition and understanding are brought into play. This encounter is mediated by the 'movement metaphor', where movements suggest meanings and allow creative interaction between what is unconscious and unsymbolised, and what is consciously known and accessible to verbalisation. The therapist's 'mirroring' of the client's movement and postural shifts is different from mimicry, as the process of reflecting back also subtly alters and inflects the other's movement. (Meekums' argument here resonates with aspects of kinesthetic mirroring explored in Chris Nash's photos and discussed by Matthew Reason later in this book.) The therapist also becomes subjectively involved in this process and brings their own experience into play, to create a kinesthetic dialogue predicated both on empathic engagement and cognitive awareness.

The mediating space of the movement metaphor provides a degree of emotional distance, which is significant particularly where the therapist or group has the role of 'witnessing' another's (potentially traumatic) experience. This involves an empathic relation to the person being witnessed, in an attitude of 'not knowing', where embodied connection is intertwined with conscious intention and awareness that one can only approximate the truth of another. Moreover, in order for insights for both client and therapist to emerge from mirroring and/ or witnessing, the creative process needs to lead to evaluation and ultimately to releasing and separation, initiated by the therapist and enacted through metaphors of grounding and containment.

While Shaughnessy's theatre practice and Meekums' therapeutic practice are designed to lead to kinesthetic learning and insights, Amy Hayes and Steven Tipper, coming from cognitive psychology, explore through experimentation how performing or observing motor actions in everyday life can influence our affective states, even without any conscious awareness or evaluation. As they point out in their chapter, 'Affective Responses to Everyday Actions', whereas considerable attention has been paid to how emotions influence motor responses (e.g. fear leading to running away), their own focus is on how motor processes

can evoke emotions. Hayes and Tipper hold in common with Shaughnessy and Meekums a concern with how the body, and particularly the body in movement, can evoke affect, and with how empathic understanding is linked with simulation on the part of the observer. Following James Gibson's ecological model of perception, they consider the role of vision in observing an action, where the body acts in and interacts with the environment. For instance, fluent actions, which appear not to involve much effort, are easier to process and are more readily perceived as opportunities for action on the part of the observer.

Through a series of experiments, Hayes and Tipper and their colleagues tested their hypothesis that fluent actions lead to positive affect for both performer and observer. The actions included moving objects in either an obstructed or a non-obstructed trajectory; performing fluent or non-fluent actions; or observing others interacting with objects in a more or less fluent way. This approach was unusual in that it was the first time that the affective impact of watching emotionally neutral actions had been tested in relation to the qualities of the movement itself. Their results indicated that participants had a preference for fluent over non-fluent actions.

Hayes and Tipper's experimental approach is of course very different to the practice-based research of Shaughnessy and Meekums, and of several other contributors to this book. This is reflected, for instance, in the greater distance between researchers and 'participants' where there is no question of empathic relationships; rather, the researchers dispassionately observe the participants' behaviour. Also, as is quite common in cognitive psychology, they enquire into the possible (evolutionary) reasons for the behaviour patterns they observe. What potential benefits might there be in connecting motor fluency with positive affect? The authors surmise that pleasure in perceptual fluency may be linked with familiarity, indicating that an object is safe to approach, while motor fluency might act as a reward for well executed actions, hence motivating skill learning. For motor events, goal-related evaluations, which may be unconscious, are a particularly important source of affect. Also, more unusually in the context of their discipline, Hayes and Tipper reflect on the implications of differences between the laboratory environment and everyday life, where goals can be multiple and complex, requiring appraisal on many levels at once and being influenced by contextual factors, which can be cultural and social. Although the context within which these experiments were conducted was restricted, the implications for the affective impact of performing and watching fluent actions are very broad, ranging from influence on consumer preferences (e.g. in advertising) to impact on skills learning.

All three chapters treat empathy and affect as embodied, as involving movement, and also as mediated by interactions with objects as well as direct interactions between people. The role of objects in kinesthetic and empathic interactions is particularly interesting, as it links up with the history of kinesthetic empathy (see introduction to this book) and also points to the importance in kinesthetic empathy of interactions with the material environment as well as direct intersubjective relations. Related issues emerge in the chapters by McKinney and Whatley in their discussions of theatrical and virtual environments, and in the context of design in the chapter by Fogtmann.

Chapter 1

Knowing Me, Knowing You: Autism, Kinesthetic Empathy and Applied Performance

Nicola Shaughnessy

Knowing refers to those embodied, sensuous experiences that create the conditions for understanding ... performed experiences are the sites where felt emotion, memory, desire and understanding come together.

(Denzin 2003: 13)

In his discussion of performance ethnography, from which the title of this chapter draws its inspiration, Denzin succinctly summarises what drama practitioners refer to variously as embodied knowledge, kinesthetic learning and empathetic understanding. Recent research in the fields of cognitive neuroscience, phenomenology, philosophy and psychology shows how embodied activities shape human cognition and perception. According to Raymond Gibbs:

Our bodies, and our felt experiences of our bodies in action, finally take center stage in the empirical study of perception, cognition and language and in cognitive science's theoretical accounts of human behaviour.

(Gibbs 2006: 13)

This chapter explores the dialogue between cognitive neuroscience and 'applied theatre', a term used to refer to participatory theatre activities in educational, social or community contexts. In particular it discusses a pilot project involving autistic children in participatory performance, where drama, performance and digital media are used as interventions for autistic spectrum conditions. The project was directed and designed by myself and Melissa Trimingham in collaboration with four drama practitioners and a psychologist specialising in autism and learning disability.[1] The work is part of ongoing research at Kent University's Research Centre for Cognition, Kinesthetics and Performance.

My account is informed by recent research in cognitive neuroscience, particularly mirror neuron theory as this has significant implications for both applied theatre and autism. Mirror neurons are brain cells that are activated not only in the individual performing an action, but also in the brain of the observer witnessing the action and are thought to be the neural mechanism underpinning our ability to perceive emotions, intentions and gestures.[2] Discussion of mirror neurons is now pervasive as a cross-disciplinary dialogue between the arts, humanities and sciences, proposing a physiological basis for empathy, language, culture and morality.[3]

The mirror neuron system is also discussed in the context of autism, a condition in which language, communication, social interaction, imagination and empathy with others are problematised:[4]

> How is it possible to imagine that children can coherently evaluate the people they see if they cannot evaluate relationships between their own bodies and the environment? … How can beings whose brains are the center of multiple incongruities have even the slightest desire to communicate with a world with which they cannot identify?
>
> (Berthoz 2002: 96)

This account examines how drama can be used as a means of engaging with autism through interactive encounters in sensory environments, promoting empathic responses between performers and participants. The methods used, drawing upon contemporary performance strategies, facilitate embodied understanding and the *felt* emotion, desire, pleasure and memory to which Denzin refers. In this liminal space, we were able to engage imaginatively in the experience of autism and a mutual process of 'knowing' was begun. As our work developed, we became increasingly aware of the differences involved in the autistic individual's engagement with and perception of their environment. Writing on autism increasingly explores 'difference' and suggests that the autistic brain processes the world in a particular way (Mills 2008; Baron-Cohen 2009).

> With the increased incidence of autism and the insights arising from autists' self-reporting and artistic work … we might begin to re-think past paradigms that oppose typical/normal with atypical/abnormal creative processes. In the continuum that marks the different cognitive processes that produce 'art', we might begin to refine an understanding of the imagination in relation to autism.
>
> (Mills 2008: 118)

I begin with an exercise in empathy to offer an account of the experience of autism.

The neuro diversion

Imagine a situation in which parents are told that their two-year-old son has autism. The child (let us call him Finn) had very little language: 'He knows his alphabet and can count to 100' his mother explained to a health visitor, 'but he doesn't speak in sentences and he doesn't respond to his name'. He could identify colours, animals, objects on picture cards, but did not initiate communication. His mother felt he was becoming increasingly withdrawn and isolated. She had noticed him tracking and stroking lines in a fence when she took him to an animal park; she was concerned that he did not point like other toddlers and did not appear to be interested in playing with his siblings. The diagnosis was swift and bleak; he

was autistic and was unlikely to talk, would never achieve independence and would need constant support.

Finn's parents embarked on the journey described by Emily Perl Kingsley (1987) in her oft-cited account of the experience of parenting a disabled child. There is frustration and disappointment that you are denied the pleasures and experiences you had anticipated, but there are alternative surprises, challenges and fulfillment. Finn's parents became aware of their son's alternative reality through his pictures and writing depicting a visual, sensual world. While 'typically' developing children learn through imitation and role play, Finn copied only in a literal sense, struggling to conceptualise and engage with the confusing social world he inhabited. He copied his siblings dressing up but had no idea how to interact 'in role' and his idiosyncratic combination of costume items appeared to be chosen on the basis of colour and texture rather than through any understanding of representation.

Finn communicated through a script of 'learned' phrases, mostly requests for food, in appropriate contexts. One day, his mother observed a therapist telling Finn to 'copy me' and sadly noted the accuracy and emptiness of his imitation; like an automaton he learned his social scripts, reciting his name, address and set responses to questions about days of the week, the weather, his family etc. The drills were repeated and delivered in a voice devoid of emotional expression or spontaneous engagement. Finn the robot, his mother sadly reflected. Until one day she observed him acting out his therapy sessions with a puppet: 'What is your name?' Finn was saying to the puppet and the puppet answered 'my name is Finn'. Although Finn was 'generalising' by transferring the dialogue he had learned with his therapist to a play situation, so it could be argued that Finn was 'pretending to pretend'; this was the first indication of a potential to play spontaneously and imaginatively. Joining him on the floor, Finn's mother began her first conversation with her son via the puppet; looking at her in some surprise, and engaging in unprompted eye contact, Finn started to play.[5]

Puppetry and the performance of pretence

The usefulness of puppets in autism has been documented anecdotally; there is a general consensus that puppets can be an effective tool as a means of mediating between the child, the carer and the external world (Trimingham 2010). However, there is very little research, either qualitative or quantitative, in this area. Likewise, there is a lack of research into many interventions that claim to be effective in autism, including drama, which has a long history as a therapeutic medium (Trimingham 2010: 251). The fictional world in which participants can perform roles as 'other' offers a safe space to explore, rehearse and to play with identities and experiences. Difficulty in understanding the concept of otherness is one of the defining characteristics of autism (Baron-Cohen 1995). The puppet's role, as evident in Trimingham's account, is to facilitate engagement with a material and object other. She suggests that puppets may work in similar ways to Winnicott's 'transitional objects', operating in a 'transitional space'.

Uniquely, because they are objects, the child can focus upon them as solid and real, but imbue them with 'mind'. They act as a safe bridge to the less predictable world of other objects and people, helping them to deal with that 'otherness' and learn (and embody crucial aspects of it).

(Trimingham 2010: 262)

This bridge, in between realities, is the space in which our practice-based research was situated and we began to engage with the experience of autism. Puppets were used in conjunction with other media as part of a series of immersive, multisensory environments (e.g. under the sea, space, winter etc.) in which autistic children could participate in imaginative play. The fictional environments, however, through their use of self-reflexive contemporary performance strategies (live feed, interaction between performers and participants, involvement of participants in creating the staging, operating puppets, etc) enabled the participants to remain conscious of themselves pretending. In this form of participatory theatre, which can be allied to the work of companies such as Oily Cart and Horse and Bamboo, pretending to pretend is fundamental to its ethics and methodology:

[T]he collaboration between the performer/animateur and the spect/actor or client is negotiated in a space between the 'real' and the 'not real' so that the participants are conscious that the situations played out, although 'live' are both real and not real while the performers are more explicit about their roles than in more conventional theatre frameworks. This space between performance and ordinary life … is a space for intervention and change.

(Shaughnessy 2005: 201)

Rehabilitating empathy

Kinesthetic knowledge and understanding are at the heart of applied theatre practice where participatory performance is used to 'effect' change (defined variously as 'transformation' or 'transportation') through 'affecting' participants (Nicholson 2005; Thompson 2009). Drama activities in educational, social and community contexts are generally designed to involve practitioners and participants as 'active producers', rather than passive consumers, who 'are enabled to move … through creative activity, towards a valuable goal of applied theatre praxis: social transformation' (Sutton 2007: 32–33).

Our initial aim was to explore how far drama activities could 'compensate' for the 'triad of impairments', which are the diagnostic criteria for autism,[6] by facilitating social communication, imagination and interaction. We were not proposing to 'cure' autism but our objective was to try to effect change through what we defined as an 'intervention' – a term used in autism and in applied theatre to refer to practices designed to benefit participants. This had ethical and ideological implications. Although we used the terms 'neuro typical' and

'neuro divergent' as our work developed to refer to our awareness of 'difference' in autistic consciousness and perception, we were aware of some difficulties posed by this terminology. Emerging from opposition to the 'deficit' model of disability, new approaches are predicated on a 'social' model, advocating that autism should be respected and acknowledged as 'divergence' rather than medicalised as treatable through normalising interventions.[7] The fact remains, however, that autism can be a distressing condition, particularly for those at the lower end of the spectrum where it presents considerable challenges.

As our work progressed we became increasingly aware of each individual as a spectrum of difficulties *and* abilities and this understanding informed the development of our practices. What was demanded from us as researchers and practitioners was an empathic engagement with the group we worked with. We needed to be fully aware of the experience of autism and the lived experience of the researchers who had family members with autism was extremely important to the body of knowledge the research team drew upon.

For the applied theatre practitioner, empathy might be considered to be an important feature of practical and ethical engagement with the 'client group'. Empathy, however, has a somewhat mixed history with the term used pejoratively by some contemporary performance scholars and practitioners. This is due largely to the legacy of Bertolt Brecht, a seminal influence in the field of applied theatre, whose references to 'crude empathy' and mimesis have a tendency to be misunderstood and simplified in the critique of 'identification' (Brecht 1949). As Jill Bennett observes in *Empathic Vision: Affect, Trauma and Contemporary Art*:

> What is wrong with [crude empathy] is, of course, that another's experience … is assimilated to the self in the most simplistic and sentimental way; anything beyond the audience's immediate experience remains beyond comprehension … we fail to 'respect' the difference between their suffering and our own.
>
> (Bennett 2005: 111)

Drawing upon Brecht's insights, Bennett suggests it is possible for the empathic connections provoked through, for example, representations of trauma, to combine affect with critical inquiry, so that the space between self and other is not eradicated but 'inhabited':

> This conjunction of affect and critical awareness may be understood to constitute the basis of an empathy grounded not in affinity (*feeling for* another insofar as we can imagine *being* that other) but on a *feeling for* another that entails an encounter with something irreducible and different, often inaccessible.
>
> (Bennett 2005: 10)

This notion of an empathetic 'encounter' with something enigmatic and generally regarded as 'inaccessible' is particularly appropriate to the exploratory nature of the autism project, as we sought to investigate autism and the imagination and we were engaging our imaginations and creativity in doing so. Our role as researchers involved us in an 'encounter'. Access

to the world of autism was facilitated through the 'provocation of the senses' which, as Stephen Di Benedetto demonstrates, is the primary means through which contemporary performance functions. His central premise is that sensorial perception is fundamental to the transformational potential of theatre:

> Recent neuroscientific discoveries have proved that the brain is plastic and all sensations it experiences continually modify how it perceives the world. Theatrical performance has the potential to change our experience of the world and therefore, the potential to change our ability to perceive the world in a new way.
>
> (Di Benedetto 2010: X)

It was my research on autism that led to my first encounter with cognitive neuroscience and the realisation that an understanding of the scientific and physiological basis for empathy has important implications for the theory and practice of applied theatre and its discourse of intervention, transportation, affect and change.

Empathy, autism and contemporary performance

Enhanced awareness of the neural underpinnings of empathy have transformed our understanding of intersubjectivity; as Evan Thompson concludes in the final chapter of *Mind in Life*, this is now 'a central concern' for developmental, social and clinical psychology, as well as psychoanalysis and affective and cognitive neuroscience (Thompson 2007: 382). Difficulties in understanding the relations between self and other are generally acknowledged as being fundamental to autism and are discussed in relation to the concept of empathy. Edith Stein's phenomenological study underpins Thompson's explanation of the relations between perception and empathy and, by extension, the connections between empathy, memory and imagination. These have crucial implications both for understanding the processes involved in theatre and performance and the perceptual issues for the autistic individual whose memory and imagination function differently – a difference that is generally considered 'dysfunctional'.

Whilst cognitive neuroscientists refer to the colloquialism 'I feel your pain', there is an autistic irony in reading this too literally; the experience of pain is, of course, felt differently by the person suffering the injury than it is by the observer. As Stein puts it, 'I can consider the expression of pain, more accurately, the change of face I empathetically grasp as an expression of pain, from as many sides as I desire. Yet, in principle, I can never get an "orientation" where the pain itself is primordially given' (Stein 1989: 7). This has important implications for theatre and indeed any artistic representation of experience; empathy in theatre as in life involves a form of perceptual presence, which Thompson refers to as 'a perceptual presence-in-absence':

This 'nonprimordiality' of empathy – the fact that an experience cannot be disclosed in its original first-person subjectivity from the second-person perspective of empathy – means there is also a parallel or an analogy between empathy and memory and imagination. When one remembers a joy ... The joy is absent, but it is not simply absent, for it has a kind of presence-in-absence for the remembering experience. It is ... phenomenally absent.

(Thompson 2007: 387)

Thompson's outline of a 'neurophenomenological framework for the scientific study of empathy' offers a paradigm for approaching and understanding both the autistic consciousness and the 'interventions' we developed using contemporary performance methodologies as a means of facilitating both cognitive and emotional empathic understanding.

Thompson's typology identifies four types of empathy: 'affective and sensorimotor'; 'active and cognitive'; 'mutual self and other understanding' and 'moral perception'. The first type, 'affective and sensorimotor coupling', is considered as passive, operating spontaneously at an unconscious level. Thompson refers to newborn babies crying in response to the cries of others as an example of 'affect response'. Current research suggests that mirror neurons play an important role in the development of the infant's initial awareness of the relations between self and other:

[T]here is growing consensus that mirror neurons and the related brain areas that are activated for self-movement and perception of another person's body movement play an important role in neonate imitation and the infant's ability to perceive intentions ... To imitate a facial gesture that it sees, however, the infant has no need to simulate the gesture internally. It is already simulating it on its own face. Its own body is already in communication with the other's body at prenoetic and perceptual levels that are sufficient for intersubjective interaction.

(Gallagher 2005: 223)

As Gallagher acknowledges, sensory motor problems in childhood can be present in individuals who do not develop autism, whilst there are numerous accounts of children with 'normal' motor development who go on to develop autism. What is clear, however, is that autistic individuals, to varying degrees, have difficulty engaging with and understanding others and this is intimately connected to their experience of engaging with the environment they inhabit.

The second type of empathy identified by Thompson is 'active and cognitive' and is termed 'imaginative transposition'. Although Thompson indicates that various 'intermediate' forms of empathy are evident in other species, he argues that cognitive empathy 'at its fullest' is most clearly evident in humans. This, however, requires 'theory of mind' in order to be able to 'mentally adopt the other's perspective by exchanging places with the other in imagination' (Thompson 2007: 397). This form of empathy appears to broadly correspond

to Brecht's notion of 'crude empathy'. In child development theory, the development of the ability to engage in 'imaginative transposition' (as described by Thompson) can be associated with 'joint attention', which emerges around 9–12 months of age where the child engages through eye contact, gesture and initial verbalisation in a three-part interaction between themselves, the objects/events they are observing, and the adult caretakers with whom they communicate.

A triadic structure of shared communication is also fundamental to theatre and the interaction between actor, the staged event and the spectator (Elam 2002). Whilst this might lead us to conclude that the autistic child cannot easily participate in an experience that is predicated on the ability to engage in 'imaginary transposition', autistic children have proven to be adept at imitation with enhanced facilities for copying speech, facial expressions, mannerisms and line learning. Although the autistic individual may not have 'cognitive empathy', role play is used in a range of interventions to facilitate communication and social interaction. The Applied Theatre Research and Autism Network identifies how theatre practices address the 'deficits' associated with autism: 'using theatre … to teach emotion recognition, emotion expression, behaviours and gestures, listening skills, eye contact, conversation skills and several other critical social skills.'[8]This builds on a high-functioning autistic child's ability to imitate, enabling them to function through the scripts they have learnt and, it is hoped that by learning various forms of interaction, the autistic child will begin to generalise, becoming more spontaneous and creative. However, this can lead to an artificial and stilted way of speaking and behaving. The autistic child's 'performance' here is not embodied as s/he is copying responses that are not 'felt'.

One could argue that this approach, rooted in naturalism, might enable the autistic individual to begin to develop 'imaginary transposition' by repeatedly playing out situations in which s/he is acting in role as a participant in social interaction, but it is unlikely to lead to the achievement of Thompson's third type of empathy: the more conceptually sophisticated 'mutual self and other understanding'. This is social imagination and 'involves not simply imagining myself in your place but understanding you as an other who accordingly sees me as an other to you' (2007: 398).

Autism has been described as a 'disorder of imagination' (Currie and Ravenscroft 2002) whereby 'impaired pretend play' and difficulties in 'metarepresentation' are considered to be key features in diagnosing the condition. 'Autistic difficulty with pretending is due to difficulty with recreative imaginations … the imaginative defect also explains other important aspects of the condition' (2002: 145). Nevertheless, what Currie and Ravenscroft identify is important to recognising autism in terms of difference: 'the primary mode of thinking among autists is visual and imagistic' (155). These are features of what we might refer to as a 'neuro divergent imagination' and this, I will argue below, can be explored and extended through the sensorial environment of contemporary theatre.

Before discussing this in further detail, however, I want to briefly consider the importance of the fourth type of empathy identified by Thompson as 'moral perception' as this is a defining feature of the research discussed below. This type of empathy involves

'the perception of the other as a being who deserves concern and respect' (401). It can be paralleled with Norman Denzin's discussion of performance ethnography and the ethics of conducting research with human subjects: Denzin calls for 'a moral ethnography that presumes a researcher who builds collaborative, reciprocal, trusting and friendly relations with the person he or she studies' (Denzin 2003:13). What is advocated here is an ethical and critical pedagogy: a way of approaching research involving human subjects, which draws upon the human capacity for empathy.

As Olga Bogdashina urges in her study of autism:

> Do understand the underlying causes of the behaviours and try to develop an approach not based on symptoms but on prevention. Challenging behaviours are caused by problems of communication, social understanding, by different imagination, by sensory problems ... Therefore try to understand autism 'from within'. It is easier said than done because it requires an enormous effort of imagination.
>
> (Bogdashina 2003: 15)

The empathic understanding required in this research, I suggest, is critical empathy, drawing upon the 'moral perception' Thompson identifies. The researcher needs to engage imaginatively with the subject(s) of their enquiry through participatory practices and exploratory, open structures, facilitating knowledge exchange. The project discussed below responds to Bogdashina's challenge. It uses contemporary performance techniques to explore how autistic children experience and respond to sensory stimuli. Through contemporary performance practices we are investigating the 'different sensory experiences' and the 'different perceptual worlds' Bogdashina refers to as well as responding to a question she raises in her conclusion: 'How could we enter their perceptual world and bring them into ours?' (2003: 183).

Imagining autism: In between realities

The broad objectives of this pilot project were to help autistic children compensate for the triad of impairments through participation in interactive drama-based activities. These structures create mediated realities designed to encourage *emotional* and *cognitive* engagement. The *devising* methodologies used in these programmes offer a visual and physical vocabulary to work with, enabling the participants to engage spontaneously, flexibly and creatively. The media used in the project create a series of landscapes, acting as environments of otherness, in which the autistic child can engage in improvisatory imaginative play: this is a three dimensional and interactive physical environment. Various media are used within immersive, fantasy structures (e.g. outer space, underwater, under the city) and include puppetry (e.g. glove/rod/cut outs), masks, digital media (e.g. live feed) and object-based imagery (e.g. using UV light). Immersed in the environment,

children can engage in an iterative cycle that might include entering, leaving and rejoining the environment several times; watching, handling and then working the puppets themselves, experiencing, taking part in and repeating the same action several times over and repeated interactions with facilitators 'in role'. This experience gives opportunities for communication, social interaction and imagination to take place within a reasonably predictable but infinitely flexible loose narrative structure (giving the child space to develop these skills).

During the project (undertaken in a Special School over a 12-week period, working with 10 children aged 5–10), autistic children were observed responding spontaneously to the practitioners and stimuli. Self-stimulating and repetitive behaviours were significantly reduced, and in one case eliminated while the child was in the environment. Teachers observing the children noted increased eye contact and shared attention as participants interacted with puppets, objects and practitioners.[9] In a snow scene, for example, one child responded to the shivering snowman by giving him a scarf, thereby responding empathetically to the practitioner in costume, moving towards Thompson's 'imaginative transposition'. Live feed was particularly successful as the children delighted in seeing their images and activities mirrored on the screen. In an underwater environment, a plastic sheet was waved above the playing space to represent waves. One child lay back, raising his hands to copy the wave movement and gestured for more, beckoning for the sheet to waft over him. This child rarely engaged in spontaneous play, yet his participation within the context of this interactive installation engaged him physically and imaginatively. Another child, who is non-verbal with behavioural difficulties, spent an hour in the environment, 'catching' the puppet fish.

Whilst the activities we devised were designed to facilitate communication, social interaction and imagination, our research questions were redefined as the project developed. The installations were designed to engage participants in a series of controlled conditions, which could be adapted to the responses, needs and abilities of the individual child. A question arising during a debrief became central to our investigation: what happens when we follow their cues, rather than requiring them to follow ours? Indeed, we considered ourselves to be 'transported' by our discoveries as we experienced the autistic imagination at work in an interactive, intermedial playground. Intermediality, 'leads us into an arena and mental space that may best be described as in between realities' (Chapple and Kattenbalt 2006: 1). In our experience, this liminal space offers an opening into the autistic imagination and perception. In the course of our work we discovered a synergy between the autistic consciousness and contemporary performance paradigms: the highly visual, kinesthetic and aural qualities of the autistic imagination shifts perception from sense to sensuality.

As the project developed I found myself on familiar territory through my previous research on the theatre of Gertrude Stein and Robert Wilson's productions of her work. Wilson's work with the autist Christopher Knowles is generally considered to be an important influence on the development of his aesthetic. Wilson's productions use a distinctive performance vocabulary:

The Wilson stage is typically an entire world, encompassing humans, animals, buildings, trains, space ships, as well as the many phenomena of the natural world. *His theater, whether set in nature or not, requires from the audience the 'landscape-response' appropriate to a diffused perceptual field,* a response enforced by the slow moving gradualism of his staging (my emphasis).

(Fuchs 1996: 98)

This 'landscape response' has interesting affinities with the 'Gestalt perception' associated with autism whereby autistic individuals are unable to distinguish between foreground and background information: 'the bits and pieces set inside a particular context are seen as what they are – the same – even if they look quite different in another context' (Frith 2003: 90). During a snow scene, created by shredded paper being poured over the side of our 'tent', one of the children exclaimed excitedly 'my letters, my letters'. Recognising that the 'snow' was created through recycled paper, she accepted the representation but indicated simultaneously her awareness of how this effect was manufactured; this literal eye for detail is one of the features we might identify as being distinctive where 'bits and pieces' are seen as they are even though they are in a different context.

This detail-focused processing style not only applies to vision. It also applies to hearing and to language. What about other senses – touch, for example? Here, an intriguing phenomenon is that many people with autism are reported to be hypersensitive to touch. Possibly, having hyper-acute touch might be like having absolute pitch.

(Frith 2008: 93)

Several of the children we worked with appeared to have a heightened attendance to touch, exploring the tactile qualities of objects and aspects of the environment and seeking further stimulus through rubbing and stroking. For anyone unfamiliar with autism, this appears unusual as it involves fingering and touching objects in ways we associate with infants – often extending to 'mouthing' as the object is licked. One of the most striking examples of this involved the child who lay on his back to experience the sensation of the plastic sheet waving over him. He smiled and gestured for more repeatedly but in raising his hands it is clear from the documentation that he is seeking to touch the plastic as it brushes over him and he smiles and laughs as the air generated by this action wafts over his face. Also striking was the desire of several children to physically hug the snowman and indeed any performer in a distinctive costume. Teachers commented on this as some of the children initiating this contact were not physically demonstrative and rarely manifest affection in this way. We speculated that the costume transforms the performer into an object, enhancing its 'otherness' so that it works in similar ways to the puppet, acting as an intermediary between the child and the adult. As Cynthia Berrol observes, the 'mirror making mechanism is activated in relation to a stimulus outside the self i.e. in relation to another' (Berrol 2006: 307) and this is a trigger for empathy. In one of our earliest

sessions we experimented with mask and costume, introducing the children to 'Jimmy', a guitar-playing, singing bird with a huge beak and brightly coloured cloak. The children responded to Jimmy compassionately, stroking his beak, hair and cloak and guided him around the space as if he were old and frail, in need of their care. We had not characterised Jimmy in this way and were surprised that his presence provoked such a strong and shared response. Some of the children appeared to respond to each other's cues; there was very little verbalisation but through a series of interactions several of them began to work as a group in what appeared to be a collective empathic response. This might be seen as evidence of Thompson's third and fourth kinds of empathy with care and concern for another evident in the childrens' relationship to Jimmy.

The responses to the environments we created were largely based on sense reception. It became evident that some participants were more responsive to auditory stimuli while for others, the visual aspects elicited a higher level of engagement, which was evident in increased eye contact, interactions with others and shared attention through pointing or verbal observations. Participants made the familiar strange through their interactions with objects and engagement with the stimuli and meaning was constructed playfully and intuitively. The play of light on a fish puppet's tail provoked a child to seize the rod and replicate it in a slow motion sequence, which she repeated again and again, creating a magical transformative effect that worked like Wilson, 'using light and shadow' to create 'rhythm and tempo' (Di Benedetto 2010: 41). Here, our experience of working creatively with autistic children was enabling us to perceive objects and colour differently.

The performance vocabulary we were using involved UV light, recorded and live sound (e.g. whale recordings in the underwater installation and a 'diver'/saxophonist accompanying our killer shark puppet) rhythm, tempo and repetition to create environments, moods and meaning. In Wilson's work, the dynamic relationship between form and content has been linked to the Californian Light and Space artists where the experience of the participant is described in terms that suggest a close correspondence with the immersive environments we created in the project:

> The participant in a work of Light and Space slowly lets go of rational, structured reality and slips into an altogether different perceptual state. In this [state] … the *presence* of light, the *sense* of color, and the *feel* of space merge, becoming far more real than any representation of them could be.
>
> (Butterfield 1996: 10)

Using the resources of sensory, immersive performance, we were able to stimulate embodied experiences as the participants physically and creatively engaged with the environments. This is 'action in perception', to use Alva Noë's terms. The participants, both ourselves and the children, were mediating the environment in a process of perceptual discovery: 'It is not pictures *as* objects of perception, that can teach us about perceiving; rather it is *making pictures*' (Noë 2004: 179).

Kinesthetic learning was at the heart of our work. The relations between affect and effect were also central to our research investigations and methodologies. In *Autism and Representation*, Mark Osteen calls for an 'empathetic scholarship: a blend of experience and scholarly rigor, of intelligence and emotion [which] can engage scholarship in a true dialogue with disability and difference' (2008: 300).

Our ongoing research seeks to respond to Osteen's call for scholarship that explores 'the similarities and differences between autistic and neurotypical brands of creativity' (2008: 301).[10] The work is informed by what Noë refers to as 'enactive neuroscience – that is, a neuroscience of *embodied* activity, rather than a neuroscience of brain activity' (2004: 227). The research aims to achieve benefits in understanding the experience of autism (offering insights into the autistic consciousness) *as well as* providing a means of facilitating communication, social interaction and the imagination through 'embodied activity'. Moreover, Noë concludes: 'neural rewiring leads to experiential plasticity (changes in the character of experience) only when the rewiring plays a role in a process of sensorimotor reintegration' (2004: 226).

Research in cognitive neuroscience endorses this view with evidence that the mirror neuron system can be retrained through sensory motor experience. As Caroline Catmur's pioneering research indicates:

> the mirror properties of the mirror system are neither wholly innate nor fixed once acquired; instead they develop through sensorimotor learning. Our findings indicate that the human mirror system is, to some extent, both a product and a process of social interaction.
>
> (Catmur et al. 2007: 1527)

This might mean that our work could function positively as an 'intervention' in the autistic consciousness, as a form of sensorimotor experience and training, enabling participants to develop kinesthetic empathy through their participation in and learning through the sensory environment of contemporary performance.

Notes

1. The project investigators were Nicola Shaughnessy (Drama), Melissa Trimingham (Drama), Julie Beadle-Brown (Tizard Centre) and David Wilkinson (Psychology). The pilot project was funded through Kent University's Innovation and Enterprise 'Ideas Factory' scheme.
2. The discovery of mirror neurons is generally credited to Giacomo Rizzolatti in 1995; whilst recording the brains of monkeys performing actions, Rizzolatti observed that a neuron would fire not only when the monkey reached for a peanut but also when it watched another monkey reach for a peanut (see Rizzolatti and Craighero 2004, Gallese et al. 1996). Mirror neurons are now accepted as existing in the brains of primates and in some birds. Further research on the human brain using fMRI (Functional Magnetic Resonance Imaging) suggested that mirror neurons in

humans communicate spontaneously with our emotional system so that, for example, when we hear a child scream the same brain circuits are instantaneously activated: 'to feel distress stirs an urge to help' (Goleman 2006: 60). This means, as Marco Iacoboni puts it, that humans are 'wired for empathy' (2008: 4). Researchers at UCLA in April 2010 found substantial evidence of mirror neurons in humans and suggested this might have implications for autism (see Mukamel et al. 2010).

3. For an accessible discussion of mirror neuron theory, see Marco Iacoboni (2008) *Mirroring People*. For critics of the research, see Alison Gopnik's objections in *Slate* (Gopnik 2007). She argues that there is insufficient evidence of mirror neurons in humans and suggests that they are a metaphor, simplifying the workings of the brain.

4. Neurological research on autism points towards deficits in areas of the brain associated with empathy and the imagination (Frith 2003). For discussion of mirror neuron dysfunction and autism, see Williams et al. (2006); Dapretto et al. (2006); Catmur et al. (2007).

5. This account is based on my own experience with my autistic son. The name has been changed.

6. The triad of impairments are broadly defined as social imagination, social communication and social interaction. See Wing (1996).

7. Neurodivergence emerged as a term in the 1990s, challenging the pathologisation that seeks to cure the condition. See Blume (1998).

8. See http://www.autismtheatre.org.

9. Evaluation of the pilot project used qualitative methodologies via questionnaires and discussion with teachers and parents. A psychologist observed the process and also provided feedback. A further project uses quantitative and qualitative methods to assess the efficacy of the programme.

10. The pilot project led to the AHRC funded 'Imagining Autism' project at the University of Kent, 2011–2014 (see www.imaginingautism.org).

References

Baron-Cohen, S. (1995). *Mindblindness: An Essay on Autism and Theory of Mind*. Cambridge, MA: MIT Press/Bradford Books.

Baron-Cohen, S. (2009). 'The Systemizing Empathizing Theory of Autism: Implications for Education'. *Tizard Learning Disability Review*, Pier Professional, 14 (3): 4–11.

Bennett, J. (2005). *Empathic Vision: Affect, Trauma and Contemporary Art*. Chicago: Stanford UP.

Berrol, C. (2006). 'Neuroscience Meets Dance/Movement Therapy: Mirror Neurons, the Therapeutic Process and Empathy'. *The Arts in Psychotherapy*, 33: 302–315.

Berthoz, A. (2002). *Mind and Motion: The Brain's Sense of Movement*. Cambridge, MA: Harvard University Press.

Blume, H. (1998). 'Neurodiversity'. *The Atlantic*, 30/09/90. http://www.theatlantic.com/magazine/archive/1998/09/neurodiversity/5909/. Accessed 12 December 2010.

Bogdashina, O. (2003). *Sensory, Perceptual Issues in Autism and Asperger Syndrome: Different Sensory experiences, Different Perceptual Worlds*. London and Philadelphia: Jessica Kingsley.

Butterfield, J. (1996). *The Art of Light and Space*. New York: Abbeville Press.

Brecht, B. (1949). 'A Short Organum for the Theatre'. In *Brecht on Theatre: The Development of an Aesthetic* (1978), trans. John Willett. London and New York: Methuen, 179–209.

Catmur, C. and Heyes, C. (2007). 'Sensorimotor Learning Configures the Human Mirror System'. *Current Biology*, 17: 1527–1531.

Chapple, F. and Kattenbelt, C. (eds) (2006). *Intermediality in Theatre and Performance*. Amsterdam/ New York: Rodopi.

Currie, G. and Ravenscroft, I. (2002). *Recreative Minds: Imagination in Philosophy and Psychology*. Oxford: Clarendon Press.

Dapretto, M., Davies, M., Pfeifer, J., Scott, A., Sigman, M., Bookheimer, S. and Iacoboni, M. (2006). 'Understanding Emotions in Others: Mirror Neuron Dysfunction in Children with Autism Spectrum Disorders'. *Nature Neuroscience*, 9 (1): 28–30.

Denzin, N. (2003). *Performance Ethnography: Critical Pedagogy and the Politics of Culture*. London: Sage.

Di Benedetto, S. (2010). *The Provocation of the Senses in Contemporary Theatre*. London and New York: Routledge.

Elam, K. (2002). *The Semiotics of Theatre and Drama*. London and New York: Methuen.

Frith, U. (2003). *Autism, Explaining the Enigma*, 2nd edn. Oxford: Blackwell.

—— (2008) *Autism: A Very Short Introduction,* Oxford: Oxford University Press

Fuchs, E. (1996). *The Death of Character: Perspectives on Theater After Modernism*. Bloomington: Indiana University Press.

Gallagher, S. (2005). *How the Body Shapes the Mind*. Oxford: Clarendon Press.

Gallese, V., Fadiga, L., Fogassi, L. and Rizzolatti, G. (1996). 'Action Recognition in the Premotor Cortex'. *Brain*, 1192: 593–609.

Gibbs, R. (2006). *Embodiment and Cognitive Science*. Cambridge: Cambridge University Press.

Goleman, D. (2006). *Social Intelligence: The New Science of Human Relationships*. New York: Bantam Books.

Gopnik, A. (2007).'Cells that Read Minds? What the Myth of Mirror Neurons Gets Wrong about the Human Brain'. http://www.slate.com/id/2165123/26/04/2007. Accessed 17 December 2010.

Iacoboni, M. (2008). *Mirroring People*. New York: Farar, Straus & Giroux.

Kingsley, E. P. (1987). 'Welcome to Holland'. http://www.our-kids.org/Archives/Holland.html. Accessed 12 December 2010.

Mills, B. (2008). 'Autism and the Imagination'. In Mark Osteen (ed.), *Autism and Representation*. London & New York: Routledge, 118–132.

Mukamel, R., Ekstrom, A. D., Kaplan, J., Iacoboni, M. and Fried, I. (2010). 'Single-Neuron Responses in Humans during Execution and Observation of Actions'. *Current Biology*, 20 (8): 750–756.

Nicholson, H. (2005). *Applied Drama: The Gift of Theatre*. Basingstoke: Palgrave Macmillan.

Noë, A. (2004). *Action in Perception*. Cambridge MA: Massachusetts Institute of Technology.

Osteen, M. (ed.) (2008). *Autism and Representation*. London and New York: Routledge.

Rizzolatti, G. and Craighero, L. (2004). 'The Mirror Neuron System'. *Annual Review of Neuroscience*, 27: 169–192.

Shaughnessy, N. (2005). 'Truth and Lies: Exploring the Ethics of Performance Applications'. *RIDE: Research In Drama Education*, 10 (2): 201–212.

Stein, E. (1989). *On the Problem of Empathy*. Washington, DC: ICS Publications.

Sutton, P. (2007). 'The Dramatic Property: A New Paradigm of Applied Theatre Practice for a Globalised Media Culture'. Unpublished thesis, University of Kent.

Thompson, E. (2007). *Mind in Life: Biology, Phenomenology and the Sciences of Mind*. Cambridge, MA: Harvard UP.

Thompson, J. (2009). *Performance Affects: Applied Theatre and the End of Effect*. Basingstoke: Palgrave Macmillan.

Trimingham, M. (2010) 'Objects in Transition: The Puppet and the Autistic Child'. *Journal of Applied Arts and Health*, 1: 3, 251–265.

Williams, J., Waiter, G., Gilchrist, A., Perrett, D., Murray, A. and Whiten, A. (2006). 'Neural Mechanisms of Imitation and "Mirror Neuron" Functioning in Autistic Spectrum Disorder'. *Neuropsychologia*, 44: 610–621.

Wing, L. (1996). *The Autistic Spectrum: A Guide for Parents and Professionals*. London: Robinson.

Chapter 2

Kinesthetic Empathy and Movement Metaphor in Dance Movement Psychotherapy

Bonnie Meekums

All forms of psychotherapy rely on the presence of a therapist, and the quality of the relationship between therapist and client has been shown to be crucial to the outcome of psychotherapy, as first identified by Rogers (1957). Despite the wealth of research and theory concerning the therapeutic relationship, remarkably little of this has, until relatively recently, addressed non-verbal aspects. Some writers continue to emphasise cognitive and linguistic aspects of empathic engagement, which could be said to derive from a Cartesian privileging of mind over body. This is particularly odd given that patterns of relating are initially learnt through early (including pre-verbal) experience. In fact, a close examination of psychotherapy theories reveals some interesting emphases on early non-verbal interactions. Winnicott (an object relations theorist), for example, uses the metaphor of the 'holding environment' (1960), in which the caregiver's literal holding of the infant is also symbolic of psychological containment. More recently, some analysts have begun to acknowledge 'implicit relational knowing' (Lyons-Ruth et al. 1998: 284), which is evident in the way we have learnt to interact with each other non-verbally and without having to think about what we are doing (for example making space for someone to sit down). Such implicit relational knowing is arguably determined by social (including cultural and gender defined) norms.

Despite these examples, most of the psychotherapeutic approaches that emphasise and work directly with the embodied relationship lie outside of the mainstream. These include Relational Body Psychotherapy[1] (Soth 2005), and Dance Movement Psychotherapy (DMP). This chapter focuses on DMP, and in particular the role of kinesthetic empathy. However, before we can consider kinesthetic empathy in DMP, it is necessary to take a small detour to understand another key concept in DMP practice: the movement metaphor.

The movement metaphor

The 'movement metaphor' is central to DMP practice (Meekums 2002). Metaphor is, according to the Oxford dictionary (2003): 'a thing regarded as representative or symbolic of something else'. Lakoff and Johnson (1980) move beyond seeing metaphors either as linguistic devices or as 'things', and suggest that they are evident also in thought and action. They propose that our conceptual systems are fundamentally metaphorical and embodied, and linked with cultural values. For example, more is better, more is up (as in a higher pile of coins), so up is good (and down is bad). This embodied and cultural coding has recently

been demonstrated experimentally by Casasanto and Dijkstra (2010), who asked a group of volunteers to recall autobiographical memories with either positive or negative valence, whilst moving marbles upwards or downwards. They found that recall was quicker when the direction of movement was consistent with the culturally encoded valence (i.e. up for positive memories) than when instructed to move in the opposite direction.

Dance uses much more complex metaphors than a simple bidirectional valency, and choreographers sometimes turn cultural norms on their heads in order to challenge the audience. However, the fact that audiences actively seek out and engage with dance suggests that there is some communicative power inherent in it that must link with the audience's prior experience. Conversely, not everyone does seek out dance, and so one interesting question (outside the scope of this chapter) might be why some do, and others do not engage actively with dance, as adults. However, all small children dance to music they like, and so dance lies in all of our embodied memories. In this sense, we are all potential dancers, who, when given the right conditions, can move in ways that make use of movement metaphor. Recent advances in cognitive psychology emphasise the participatory sense-making that is associated with what Fuchs and De Jaegher (2009) call 'mutual incorporation', which they define as 'a process in which the lived bodies of both participants extend and form a common intercorporality' (465). Extending these ideas, I suggest that, in the context of DMP, meanings are co-created by the therapist and individual or group, through the movement metaphor.

For example, a group DMP session[2] may include what is sometimes referred to as 'shared movement'. This makes use of a circle formation for the group, each person taking turns to lead the group in movement. Sometimes, the group works with a 'prop' as the focus for movement, for example a large piece of stretch cloth. As far as possible, transitions between leaders are smooth so that the movement flows as a whole piece; group members are encouraged not to spend time thinking about what they might do or trying to come up with 'impressive' movement, but to continue doing what the person before them was doing and just 'make it their own' in some way. So, if the previous movement was an arm swing with a corresponding shift of weight through the feet, the leader might feel that she or he wants to drop the arms and concentrate on raising one foot off the floor at a time. As the movement progresses around the circle, the group may be encouraged to verbalise any associations they have with the movement. An example might be 'this reminds me of being on a swing as a child', to which the therapist might respond by asking what that feels like, and the person might respond that it feels 'free' or 'scary'. Such experiences often have resonance with current life situations; the individual might feel that life is too constrained right now, or that to let go into a state of abandon would be too scary.

The process described above is essentially one of noticing how the movement feels in one's own body, and recalling this within a bank of prior and complex experience, symbolically encoded. What is being tapped into here may be a pre-reflective implicit (embodied) memory. Some of these will be linked to what Lyons-Ruth et al. (1998) call 'implicit relational knowing', in other words memories of how we interact with others, encoded in relational

movement procedures. The DMP process allows for such memories to become available for conscious reflection and potential verbalisation, leading to greater understanding and often new (co-constructed) insights. The process of recall and exploration may be repeated several times in relation to any one metaphor, as metaphors contain complex and multi-layered co-constructed meanings; each exploration of the movement metaphor can thus reveal new insights. Verbalisation, like movement metaphor, is also an attempt to symbolise experience, and as such words may remain an inadequate representation of the kinds of knowledge that arise through the moving body.

The understanding of another's spontaneous dance is always only partial and is filtered through the experience of the person who is attuning to this. Indeed, it is possible to entirely misunderstand the intention in another's communication, and mismatching of affect is routine even in infant–caregiver interactions (Tronick and Cohn 1989, cited in Fuchs and De Jaegher 2009: 479). Fuchs and De Jaegher suggest that such misunderstandings and mismatches when followed by repair may be important in developing a sense of agency and a trust that miscommunications can lead ultimately to understanding. Individual and group metaphors arising in DMP may also be open to more than one interpretation, some of which may be culturally determined.

In the context of DMP, the movement metaphor exists in the creative space between therapist and client (or between group members), which Winnicott (1971) called the 'potential space'. This creative space mediates between what is consciously known and accessible to verbalisation, and what is symbolically encoded and part of implicit knowledge (Ellis 2001). When such implicit knowledge is accessed, it can provide valuable insights. Movement metaphors, like all metaphors, carry with them the potential for transformation (Lakoff and Johnson 1980). In individual DMP the movement metaphor may emerge out of initial discussion, for instance of feeling 'trapped'; in group DMP this could emerge as a core theme from an initial 'check-in' during which each group member states briefly how they are feeling. The therapist then encourages the client(s) to explore this theme, either by offering an image (e.g. being a chrysalis) or by allowing the client(s) to find their own movement metaphors through an improvisation (e.g. moving as if in an enclosed space). This allows the therapist to ask pertinent questions like: How much do you really want to emerge from this space? What might be keeping you there? What might be scary about emerging/flying? Each of these possibilities can be explored physically through dance movement improvisation, with the therapist gently guiding. The experience of the client is then discussed.

One of the interesting aspects of working metaphorically in therapeutic contexts is the fact that it offers an increased distance from emotional material (thus enhancing the client's sense of safety), and at the same time reduces the sense of distance (itself an embodied metaphor, of course) between client and therapist (Angus and Rennie 1989; Cox and Theilgaard 1987, 1997) because the metaphor may be shared without the need to make meanings verbally explicit. However, it should be borne in mind that some people do find it difficult to symbolise in this way. For example, some adults who have been abused as children or brought up in very strict households have learnt not to trust their own impulse

to move, or to create. Individuals who have an autistic spectrum disorder may also have difficulty in working through metaphor. In this case, mirroring by the therapist of the client's movement can form the basis of a therapeutic relationship, and it is to this function that we now turn.

Mirroring and witnessing

Mirroring in DMP

Marian Chace is usually credited with being the 'grandmother' of DMP, having developed her methods in the US during the 1940s and 1950s. Her methods are described by Chaiklin and Schmais (1986). Mirroring of movement was key to Chace's method, but Chaiklin and Schmais clearly distinguish this from mere mimicry:

> Mimicry involves duplicating the external shape of the movement without the emotional content that exists in the dynamics and in the subtle organization of the movement ... Chace was aware that answering movement in similar forms dissipates the feeling of apartness ... Empathy meant sharing the essence of all non-verbal expression resulting in what she called 'direct communication'.
>
> (26–27)

From this excerpt we can see that Chace used mirroring of emotional expression in order to establish what Rogers (1957) called 'psychological contact'. The communication of empathic engagement described here also implies what Yalom (1975) referred to as 'universality', or the sense that one is not alone because some experiences are shared and may feel universal (even if they are not).

I would suggest that the mirroring process in DMP practice is in fact one of mirroring the movement metaphor, and that this can take any of the three forms that are analogous to the vocal forms of call and response, Greek chorus or echo. The therapist's understanding of the symbolic meaning of the client's movement expression is inevitably filtered through his or her own store of experiences. This calls into question to what extent it is ever possible for one human being to accurately attune to another. However, there seems to be some value for clients when the therapist approximates to their own experience. This allows clients the possibility of 'trying on for size' this fresh but not wholly alien (metaphorical) position and perspective, before finding their own. The following vignette from my own practice illustrates my own understanding of the client's metaphor, which was never shared directly but had the effect of deepening my empathic connection to him.

> I was moving with a very familiar prop, together with a client.[3] We were holding a piece of stretch cloth between us, and allowing it to float up and down, side to side and so

on. I allowed him to play with direction, strength, speed and rhythm, and did my best to move with him, mirroring the affective quality in his movement expressed through these dynamics. At the same time, I encouraged him to expand his range and use of space by, for example, gently and subtly bending my own knees when I saw that his were held rigidly. My client was suffering from bipolar disorder (previously known as manic depression), and so I knew that he had times when he would go 'high', but also times when he could sink into terrible depression. As the cloth moved, I asked him what it reminded him of. He replied that it felt like clouds. I immediately became aware of the potential dual meaning of this: 'head in the clouds', as in 'going high' (becoming manic), and being 'under a cloud' as in depression. We continued to work with these ideas in movement, until finally we brought the movement to a close by 'grounding' the cloth carefully on the floor, then folding it up and 'containing' it.

Mirroring can thus be seen as one form of kinesthetic empathy, though it is by no means the only way in which dance movement psychotherapists use kinesthetic empathy in contemporary practice. The therapist also needs to sense and find ways to make the process safe for the client, to ask questions in order to assist insight, and to find ways to draw the movement to a close that will help the client's overall therapeutic goals. All of this requires a subtle awareness of the client's needs, facilitated both through intellectual knowledge (e.g. about the nature of serious mental illness) and kinesthetic empathic engagement.

Mirroring and psychological research

Evidence for the importance of mirroring in empathic engagement is to be found in the psychological literature dating back half a century. Scheflen (1964), observing a psychotherapy session using frame-by-frame analysis, demonstrated that at moments of apparent empathic engagement the pair mirrored each other's postural shifts. Later, Condon and Sander (1974) demonstrated that newborn babies synchronise their movements with the mother's speech, suggesting that we are hardwired from birth or before to respond in this way. Thus, the analogy of mirroring and a conversation has some basis in scientific study. Condon and Sander suggest that it is the *rhythm* of speech that assists the infant in acquiring the structure of language, long before she or he learns to speak it.

In adults, echoing may be more significant than synchrony[4] for the experience of feeling understood. Fraenkel (1983) observed echoing and synchrony in eight women (using the naked eye rather than filmed data) and found movement echoing to be significantly related to empathy, whereas synchrony was not. This finding has been confirmed by more recent psychological research, using contemporary motion capture technology by Ramseyer (2006), who found that whilst a degree of synchronised behaviour occurs independently of rapport, there was a curvilinear relationship between the two, such that increased rapport was associated with what he describes as synchronised non-verbal behaviour. However, this

was not complete synchrony; the optimum was somewhere between complete mimicry and uncoordinated movement, in other words echoing within an optimum time lag.

More recently, advanced technology combining dual video recording and dual electro-encephalogram (EEG) readings has shown that interactional synchrony in the mirroring of hand movements (the mirrored movements beginning and ending simultaneously) is associated with interbrain synchronising of the alpha-mu band between the right centroparietal regions (Dumas et al. 2010). Unfortunately, the measurements were not linked to any assessment of how the experimental subjects experienced the phenomenon of mirroring; however, such interactional synchrony is often present in leaderless dance movement, which anecdotally can be experienced as deeply satisfying, associated with a feeling of connectedness and even transcendence beyond the boundaries of the self. Such moments may be understood as 'moments of meeting' (Lyons-Ruth et al. 1998) or of 'mutual recognition' (Benjamin 1990).

Support for this proposition can be found in Stern (1977), researching mother–infant interactions. He demonstrated that whilst some dyadic movements appear to fit a stimulus–response model, others occur within an interval that is less than the known reaction time and therefore appear to take place within a shared movement sequence. Interestingly, Stern uses the metaphor of dance to describe these shared programmed sequences of caregiver–infant interaction: 'The more they have danced together, the longer sequences of programmed patterns they can string together without requiring a lead stimulus and a following response' (Stern 1977: 100).

Witnessing

In DMP, witnessing involves the therapist or group empathically attending to the client's expressive movement or other communication. This does not usually involve moving with the client. More broadly in psychotherapeutic contexts, witnessing involves an empathic attention to what is being communicated. In some cases, this may have a similar quality to the witness of another's testimony. For example, witnessing has been identified by survivors of child sexual abuse as one of the curative factors in an integrative arts therapies programme (Meekums 1999). The arts activity (for example visual image, dance, poem) operated as a medium through which they, as individuals, and their engagement with the art form could be witnessed. In this sense, the art form *spoke for them*. In the DMP context, the therapist (and group in the case of group DMP) bears witness by being with the person who is using dance movement to communicate something of her or his own (potentially traumatic) experience.

Some theatre practitioners have used the performance medium to bear witness to another's trauma story. For example Fisher (2009: 109) writes of trauma as 'that which it is impossible to *know*' (original emphasis), not least because testimony by trauma survivors is necessarily fragmented, thus bringing into question the feasibility of representation. Yet,

such stories demand to be told and heard. Bundy (2009) has used theatre as a vehicle for young people to tell their own stories, and in this sense her work is closer to the work of the dance movement psychotherapist than those practitioners who create theatre from the stories of others, though performance in a theatre is rarely a goal in DMP. Both Bundy and Fisher recognise the importance of emotional distance for the storyteller, which may be achieved either through translation into a foreign language (Fisher) or taking on the role of director (Bundy). In DMP, the movement metaphor aids emotional distance, and emotional safety is central to the work through procedures such as confidentiality, a private space and time boundaries. Forming the movement into a repeatable movement motif may also help to gain some sense of mastery over the emotional content that generated the initial exploration. Bundy makes the point that those who witness in the role of audience may be less well prepared and may suffer as a result. In the DMP context, there is no such clear distinction between audience and performer, as all are members of the therapeutic milieu, though this does not mean that they are immune from being affected in their role as witness. The client's sense of safety is therefore key to therapeutic progress (Meekums 1999).

In some DMP practices, the term 'witnessing' is taken to mean a conscious and specific activity, associated with one particular form called Authentic Movement. The form was developed by the American Janet Adler from earlier work by Mary Whitehouse. Adler (1999) likens witnessing to the attention that a parent offers to the infant, and a kind of loving. Through the experience of being witnessed the mover also learns to witness her- or him- self, and ultimately begins to learn to be able to witness others. One of the most intriguing propositions made by Adler is that the witness is also transformed: 'For no matter how well and objectively one can witness oneself, that self-witnessing is transformed after truly seeing another as she is … seeing another as she is – loving her – enables me to see myself as I am' (Adler 1999: 154). For many, this is a deeply spiritual experience, though it does not rely on any set of beliefs or faith.

In my own DMP practice I use the term 'witnessing' to include any conscious witnessing of another's movement. The attitude of 'not knowingness' is essential to the art of witnessing. This is a time when the therapist (or witness) attempts to let go of all preconceptions, theories and judgements, and allows herself or himself to simply *be with* the other, the mover, in a state of quiet receptivity. The following vignette from my DMP supervision practice articulates a possible link to kinesthetic empathy.

My supervisee was moving spontaneously, in order to allow symbolism to emerge through her movement that might throw light on her work, and I suddenly became aware of a sensation in my genitals, at the point at which she made a particular movement with her arms, crossing and uncrossing her wrists over each other. I did not understand the sensation at all, but decided to share this with her during our discussion (we had developed a very trusting relationship over several years). At this point, she told me that she had been aware of the play Titus Andronicus, in which Lavinia is raped and her hands cut off. This enabled my supervisee to make a profound connection to her feelings that an

agency for which she has been working had been 'raped', having been used for some time and then had its funding cut so that it could no longer continue its work (the hands being strongly associated with work, as in the expression 'hired hands').

This vignette raises some important questions: Did my body 'know' that my supervisee was herself tuning into themes like rape, as metaphor for her professional experience? Was my own corporeality significant in being able to tune into my supervisee's experience? How might this have been different if I was a man? What implications does this have for working with clients whose embodied gender stories are different from my own?

Whether as audience in a theatre, as actor or director attempting to offer witness to another's story, or as psychotherapy group member or therapist, the process appears to be one of embodied and imaginative empathic connection to the other. It is this imaginative component that perhaps is overlooked in the current emphasis on the role of mirror neurons. Once we have a physical reaction (which may be mediated by the involuntary workings of our mirror neurons) we then do something with this; we imbue it with meanings. The meanings we add to our experience are determined in part by our own lived stories, both individual and culturally shared/determined. Until we analyse these, they remain largely unconscious and seemingly automatic. However, there is always a part of our meaning making that is accessible to our own creative elaborations. These are our intentional attempts at empathy, which can only ever be (and perhaps should only ever be) somewhere near to the truth of the person we are witnessing. In fact, if we even inadvertently offer a different view of reality, we may open up possibilities for the other.

Recent developments in cognitive psychology suggest that meanings are not the domain of the individual, but co-created. Fuchs and De Jaegher (2009), for example, argue that 'our primary and everyday encounters with others are not solitary observations but interactions in the second-person perspective' (468). At first glance, their emphasis on shared meanings and intercorporality would seem to negate the idea of 'witnessing'. However, witnessing does not imply a one-way process; in the vignette above, my own body was affected and participating in the construction of meaning. But, I would argue, in the therapeutic relationship the roles are not equal; there is a directionality and a very important privileging of focus on the client's (or supervisee's) meaning-making. This meaning-making does not arise simply from some internal process, but rather from a bank of embodied memories, which are interactional, even if only with things. The therapist, in bearing witness, engages with such meaning-making in an (inter)active, embodied way. Fuchs and De Jaegher criticise the emphasis on mirror neurons in recent times as assuming a unidirectionality, but this may be based in a limited understanding of their function. Until very recently, technological limitations dictated a unidirectional analysis, but Dumas et al. (2010) have now moved beyond this and demonstrate that, even at a brain level, social processes are bidirectional. At the same time, it is important, even in this relational turn of neuroscience, not to ignore the individual agent. Intersubjectivity implies a subject. As Fuchs and De Jaegher (2009) comment, in order to avoid the loss

of subjectivity and agency, it is sometimes necessary to move out of attunement, and this also reinforces the possibility of recovery and re-connection.

The move to intersubjectivity in psychotherapy

DMP has borrowed much of its theory over the years from psychoanalytic psychotherapy. Some psychoanalysts have focussed on what they call mirroring, although this has a more expanded meaning in the analytic literature than in DMP. For example, in group analysis it is assumed that group members see aspects of themselves in others. Schermer (2010) discusses the usefulness of using the metaphor of a mirror when describing psychodynamic processes, and his deliberations pose some interesting questions for dance movement psychotherapists. For example, he points out that a real mirror has no identity of its own, 'merely reflecting the light that impinges on it' (216), which does not accurately reflect the contemporary understanding of the intersubjective therapeutic relationship. However, he does point out that the mirror is a useful metaphor when contemplating the immediacy with which we all react to each other's non-verbal communication. He also notes the embodied nature of empathic engagement and suggests that 'Like the mirror's reflection, the social brain-mind is in a constant "dance" with other brains' (220). In his discussion of the discovery of mirror neurons, he observes that 'There is a "motoric" dimension to empathy, attunement, and attachment. That we are "moved" by another has a literal connotation' (222).

The neuroscientists Gallese et al. (2007) have described an intersubjective model of psychotherapeutic change, with reference to the mirror neuron system. They prefer the term 'intentional attunement' to 'mirroring'. Their model of the psychotherapeutic encounter can be summarised as follows:

1. The client experiences an embodied emotion.
2. The therapist experiences feelings that are similar but are not an exact replica.
3. The therapist offers a modified embodied and possibly vocal expression of the client's emotional state, which has a regulatory function for the client.
4. The client perceives this: if the therapist is attuned, the client experiences the therapist's expression as congruent with her or his initial feeling state.
5. The client feels 'connected' to the therapist and experiences an enhanced sense of self.

In DMP, we see this very clearly in the act of mirroring, in which as we have already seen the therapist does not precisely mirror what she or he sees, but offers a modified response with the function of emotional regulation. For example, the client who is striking the air in a seemingly random way may be helped to focus his or her anger using a martial art movement, which is both controlled and targeted; vocalisation may also be added.

The move towards intersubjectivity within psychotherapy assumes a different and more socially progressive reality, in which I acknowledge that you, like me, have thoughts, feelings, experiences and cultural practices of your own that may be very different from but have equal validity to my own. This is a profoundly political move, articulated for example by the analyst Jessica Benjamin (1990). The theory potentially assumes the interconnectedness and equality of all humanity without imposing an artificial sameness. The rewards of adopting this intersubjective approach include, according to Benjamin (1990), increased awareness of our own subjective experiencing, a pleasurable sense of 'mutual recognition' (35) and 'love, the sense of discovering the other' (41). This description of mutual recognition appears to resonate with the experience of movement improvisation in which there is no leader, as for example in contact improvisation (Paxton 1982).

Despite its progressive nature, the current focus on intersubjectivity in relational psychoanalysis is problematic. The Jungian analyst Andrew Samuels has suggested that there is a 'shadow' component; therapists may give subtle messages to their clients that they must be in relating mode (Samuels 2010). Moreover, if we spend all of our time trying to attune to others, this can be very wearing and does not offer the opportunity for renewal through inner stillness. Infants know this instinctively; when they are being cooed by doting adults, they sometimes simply shut their eyes and go to sleep. Creativity demands both engagement with and disengagement from the environment, in rhythmic interchange.

Discussion and conclusions

Dance movement psychotherapists are now, more than ever, engaging with scientific discourse. The discovery of mirror neurons has been seen by some as justification for DMP practice. However, it may be that the embodied attunement to another individual described in the above examples of mirroring, witnessing and the leaderless dance improvisation go beyond that which can be neatly explained through the current excitement over mirror neurons, even given recent discoveries of bidirectional brain attunement during mirroring of movements.

Many writers, including the choreographer Mary Fulkerson (1987), have suggested that it is at the interface between activity and an attitude of stillness (or quiet receptivity) that insights occur. I would suggest that the development of insights is also assisted by the empathic mirroring and witnessing by another, which is a form of kinaesthetic empathy linked to the movement metaphor. Such metaphors do not appear to require conscious processing in order to be deeply moving and promote empathic connection. Kinesthetic empathy, as mutual incorporation (Fuchs and De Jaegher 2009) linked to movement metaphor, may also help to explain why some creative processes seem so much easier when they are collaborative.

I have suggested in this chapter that creative elaboration may play a crucial role in kinesthetic empathy, in that mirror neuron activity alone is not enough; however, neither is

intellectual reasoning. In fact, embodied (affective) empathy appears to be strongest when intellectual reasoning is relinquished and the individual enters a state of quiet receptivity.

The leaderless duet (as in contact improvisation for example) can be experienced as transcending the boundaries of self and invoking feelings of oneness. This may offer fertile ground for research linked to recent advances in cognitive science that emphasise mutual incorporation. It may be that this leads to a kind of mutual witnessing linked to participatory sense-making, but the proposition remains untested. This leaves the question of the extent to which the movement metaphor is at play during the leaderless dance. In contact improvisation, for example, both bodies appear to be 'in synch', suggesting some underlying movement metaphor for the experience of oneness, implicitly known rather than verbalised.

My necessarily tentative conclusion is that the movement metaphor in DMP is fundamental to therapeutic change and that kinesthetic empathy is inextricably linked to perception of and transformation through such movement metaphors. In this process, mirroring, witnessing and the leaderless dance can all be used as manifestations of kinesthetic empathy, to catalyse positive change. Further research is needed, particularly with respect to the role of creative elaboration within kinesthetic empathy, and its relevance to therapeutic change in DMP.

Notes

1. Earlier versions of body psychotherapy focused on the client as recipient of an intervention. Relationship Body Psychotherapy, in contrast, focuses more on the therapeutic relationship and interpersonal dynamics within this.
2. Dance Movement Psychotherapy may be provided either in group or individual format. In group DMP, the group acts as an adjunct to the therapeutic relationship, offering another source of kinesthetic empathy to the individual within it. The group can provide a powerful source of both movement response and on occasions verbal feedback.
3. Where I refer to specific client work, clients have either given informed consent for their work to be referred to in this way and/or I make use of composite pictures in ways that reflect my general practice but do not allow identification of any one client with whom I have worked over the years.
4. Echoing is the repetition of another's movement, soon after seeing or feeling it. Synchrony is evident when two people move at the same time and in the same way, as with parents who say 'take your shoes off' to their child at the same time and with the same intonation, or two people synchronising their breathing.

References

Adler, J. (1999). 'Who is the Witness?'. In P. Pallaro (ed.), *Authentic Movement: A Collection of Essays by Mary Starks Whitehouse, Janet Adler and Joan Chodorow.* London: Jessica Kingsley Publishers, 141–159.

Angus, L. E. and Rennie, D. (1989). 'Envisioning the Representational World: The Client's Experience of Metaphoric Expression in Psychotherapy'. *Psychotherapy*, 6: 372–379.

Benjamin, J. (1990). 'An Outline of Intersubjectivity: The Development of Recognition'. *Psychoanalytic Psychology*, 7 (Suppl): 33–46.

Bundy, P. (2009). 'The Performance of Trauma'. In T. Prentki and S. Preston (eds), *The Applied Theatre Reader*. London: Routledge, 233–240.

Casasanto, D. and Dijkstra, K. (2010). 'Motor Action and Emotional Memory'. *Cognition*, 115: 179–185.

Chaiklin, S. and Schmais, C. (1986). 'The Chace Approach to Dance Therapy'. In P. Lewis (ed.), *Theoretical Approaches in Dance-Movement Therapy*, Volume 1, 2nd edn. Iowa: Kendall/Hunt, 17–36.

Condon, W. and Sander, L. (1974). 'Synchrony Demonstrated between Movements of the Neonate and Adult Speech'. *Child Development*, 45: 456–462.

Cox, M. and Theilgaard, A. (1987, 1997). *Mutative Metaphors in Psychotherapy – the Aeolian Mode*, 1st and revised edns. London: Tavistock.

Dumas, G., Nadel, J., Soussignan, R., Martinerie, J. and Garnero, L. (2010). 'Inter-Brain Synchronization during Social Interaction'. *PLoS ONE*, 5 (8): e 12166.

Ellis, R. (2001). 'Movement Metaphor as Mediator: A Model of Dance/Movement Therapy Process'. *The Arts in Psychotherapy*, 28 (3): 181–190.

Fisher, A. S. (2009). 'Bearing Witness: The Position of Theatre Makers in the Telling of Trauma'. In T. Prentki and S. Preston (eds), *The Applied Theatre Reader*. London: Routledge, 108–115.

Fraenkel, D. (1983). 'The Relationship of Empathy in Movement to Synchrony, Echoing and Empathy in Verbal Interactions'. *American Journal of Dance Therapy*, 6: 31–48.

Fuchs, T. and De Jaegher, H. (2009). 'Enactive Intersubjectivity: Participatory Sense-Making and Mutual Incorporation'. *Phenomonology and the Cognitive Sciences*, 8: 465–486.

Fulkerson, M. (1987). 'Interview with Peter Huylton and Richard Allsopp'. *New Dance*, 40: 20–21.

Gallese, V., Eagle, M. N. and Migone, P. (2007). 'Intentional Attunement: Mirror Neurons and the Neural Underpinnings of Interpersonal Relations'. *Journal of the American Psychoanalytic Association*, 55: 131–175.

Lakoff, G. and Johnson, M. (1980). *Metaphors We Live By*. London: University of Chicago Press.

Lyons-Ruth, K., Bruschweiler-Stern, N., Harrison, A., Morgan, A. C., Nahum, J. P., Sander, L., Stern, D. N. and Tronick, E. Z. (1998). 'Implicit Relational Knowing: Its Role in Development and Psychoanalytic Treatment'. *Infant Mental Health Journal*, 19 (3): 282–289.

Meekums, B. (1999). 'A Creative Model for Recovery from Child Sexual Abuse Trauma'. *The Arts in Psychotherapy*, 26 (4): 247–259.

Meekums, B. (2002). *Dance Movement Therapy*. London: Sage.

Oxford Dictionary of English (2003), 2nd edn. Available online: http://oxforddictionaries.com/view/entry/m_en_gb0514520#m_en_gb0514520. Accessed 1 November 2010.

Paxton, S. (1982). 'Contact Improvisation'. *Dartington Theatre Papers*, 4th series. Dartington: Dartington College of Arts.

Ramseyer, F. (2006). 'Co-Ordination of Non-Verbal Behavior in Psychotherapy: Synchrony as a Marker of Rapport?' Presentation to the 37th International Meeting of the Society for Psychotherapy Research, Edinburgh, Scotland, 21–24 June.

Rogers, C. (1957). 'The Necessary and Sufficient Conditions of Therapeutic Personality Change'. *Journal of Consulting Psychology*, 21 (2): 95–103.

Samuels, A. (2010). Personal communication.

Scheflen, A. (1964). 'The Significance of Posture in Communication Systems'. *Psychiatry*, 27: 316–331.

Schermer, V. L. (2010). 'Reflections on Mirroring'. *Group Analysis*, 43 (3): 214–227.

Soth, M. (2005). 'Body Psychotherapy Today: An Integral-Relational Approach'. *Therapy Today*, 16 (9): 8–12.

Stern, D. (1977). *The First Relationship: Infant and Mother.* London: Open Books.

Trevarthen, Colwyn and Aitken, K. (2001). 'Infant Intersubjectivity: Research, Theory, and Clinical Applications'. *Journal of Child Psychiatry*, 42 (1): 3–48.

Wampold, B. E., Mondin, G. W., Mody, M., Stich, F., Benson, K. and Ahn, H-N. (1997). 'A Meta-Analysis of Outcome Studies Comparing Bona Fide Psychotherapies: Empirically, "All Must Have Prizes"'. *Psychological Bulletin*, 122 (3): 203–215.

Winnicott, D. W. (1960). 'The Theory of the Parent–Infant Relationship'. In D. W. Winnicott, *The Maturational Processes and the Facilitating Environment.* London: Hogarth Press, 37–55.

Winnicott, D. W. (1971). *Playing and Reality.* London: Routledge.

Yalom, I. (1975). *The Theory and Practice of Group Psychotherapy*, 2nd edn. New York: Basic Books.

Chapter 3

Affective Responses to Everyday Actions

Amy E. Hayes and Steven P. Tipper

In our daily lives, our interactions with people and objects evoke a spectrum of positive and negative feelings. Items encountered in a shop or a restaurant may please us; a scowl from a friend or colleague may leave us feeling low. Such feelings occur automatically, even when we are not attending to the affective aspects of an object (Fazio 2001). It has been suggested that affective responses may accompany most if not all perceptions and thoughts, because individuals constantly evaluate the significance that stimuli and events have for them (e.g. Arnold 1960; Ellsworth and Scherer 2003; Izard 1979; Zajonc 1980). In this chapter we propose that the fluency of motor actions – whether our own or the observed actions of others – is of significance to individuals, and evokes evaluative feelings. To support this proposal, we will review evidence that indicates that an individual's affective state is influenced by performing and observing actions, even simple actions of everyday life.

Throughout this chapter we use the terms 'affect', 'feeling' and 'emotion' interchangeably to mean positive and negative reactions that relate to preferences, and that underlie approach/avoidance behaviour (e.g. Zajonc 1980). This is consistent with Arnold's definition of emotion as 'a felt tendency toward anything appraised as good, or away from anything appraised as bad' (Arnold 1960: 182). In modern appraisal theories of emotion, where emotional experience is assumed to be evoked by the individual's evaluation of their situation on a number of dimensions, this fundamental dimension of good versus bad might be called 'valence' or 'intrinsic pleasantness' (Ellsworth and Scherer 2003).

Influences of motor processes on affective experience

Evaluative feelings guide how we select items and people for interaction. It is not surprising, then, that researchers in fields such as social psychology and consumer science have attempted to determine which aspects of a stimulus or situation evoke positive or negative emotional responses (e.g. Ellsworth and Scherer 2003; Loken 2006; Tesser and Martin 1996). Researchers have examined how affective responses depend on perceptual and cognitive processes, such as appraising the apparent sensory features of an object and evaluating the semantic information that is associated with the object. Less consideration has been given to how motor processes, that is, the planning and execution of body movements, during an interaction with an object, might generate affective appraisals. That is not to say that motor processes have been ignored in emotion research. Motor processes are seen to play a role in

the emotional *response* to the perceptual and cognitive appraisals. For example, a frightening stimulus might evoke an emotive facial expression and a reflexive withdrawal movement. Emotions have been viewed as sensorimotor events (Leventhal and Scherer 1987), because the individual's experience of these bodily responses can be an important component of the subjective experience of the emotion (e.g. Damasio 1999). In these models, motor processes play an important role in grounding emotional experience, but their role is dependent on emotional appraisals by perceptual and cognitive processes. In contrast we argue that motor processes can evoke emotions rather than emotions simply evoking motor responses.

In recent decades there has been increasing interest in how the state of the body can itself evoke affect (for reviews see Niedenthal 2007; Ping, Dhillon and Beilock 2009). A number of studies have demonstrated that movements and postures can influence the affective state of the person performing them. For example, people find messages more persuasive when required to move their head up and down (an action associated with agreement) while hearing the message than when shaking their head side-to-side (Wells and Petty 1980). Strack, Martin and Stepper (1988) found that when participants were required to hold a pen between the teeth, producing activation of the facial muscles associated with smiling, cartoons were evaluated as funnier than when holding the pen between the lips, which inhibits smiling. Hence, body postures and actions that *express* emotion can also automatically *evoke* the associated affective states.

In our research we have investigated whether other types of motor actions – besides those actions specifically associated with emotional expression – might also evoke affective responses. Specifically, we investigated whether quite ordinary, everyday actions might have an affective quality. For example, a friend reaches around a coffee mug to pick up her car keys; does the quality of that action influence the affective impact of the event? Our affective systems certainly evaluate the reward value of the *outcome* of actions (e.g. keys successfully grasped). But the specific motor processes that led to such outcome (e.g. the trajectory and effort required to reach around the mug) are presumably also of significance to the actor as they may relate to important issues such as energy expenditure or reproducibility of an action. We hypothesised that items will be assessed more positively when they have been handled in a fluent manner (Hayes et al. 2008). We will discuss the nature of fluency in greater detail later, but by fluency we mean actions that are in some way facilitated, or perceived to be facilitated. This could include actions that are faster, less variable, or perceived to be less effortful.

In certain situations the link between action fluency and affect seems salient. Tennis enthusiasts would probably agree that performing or watching a well-executed service return feels good. Some observers of dance performances report that observing fluent, graceful dance movements is pleasurable (Reason and Reynolds 2010). We expect that positive affective responses to highly skilled actions should not be limited to sporting or artistic performances, but should accompany all fluently executed skills. Indeed, this has been demonstrated in research experiments investigating the skill of typing. Van den Bergh, Vrana and Eelen (1990) asked expert typists to evaluate their preference for pairs of letters. Some letter pairs required the same finger to type, which creates conflict in planning the

finger action, whereas other letter pairs required different fingers to type and hence could be executed more fluently. The expert typists were not aware of this manipulation and no motor responses were executed. Nevertheless, those letter pairs that would be more fluent to type were preferred to letter pairs that would be less fluent to type; these effects were not observed in non-typists (see also Beilock and Holt 2007). Hence, even for skills that do not seem inherently emotional – like typing – fluency of action (or in this case, a representation of action evoked by viewing the letters) elicits positive affect. In our studies reviewed below, we assess whether affective responses are also evoked by simple, everyday actions that are familiar and competently executed but that do not require specialised skills.

Perceptual fluency and affect

Our fluency hypothesis is supported by research that has demonstrated a link between affect and *perceptual* fluency. Researchers have found that when images of items are perceived more easily (because the presentation time of the image is slightly longer, the figure-ground contrast is greater, or the image is preceded by a subliminal priming image) the items are evaluated more favourably (Reber, Winkielman and Schwarz 1998). Thus our affective response to an encounter with an item can be influenced by the quality of our own cognitive and perceptual processing of the event; fluent processing evokes positive affect.

It is natural to extend the notion of processing fluency to include motor processes. It has been argued that a core function of the brain is to represent the world in terms of the actions an organism must produce to survive. As Gibson (1979) noted, sensory systems evolved to facilitate successful action. Therefore a major role of vision is to assess how the body can interact with the environment. A hand-sized apple affords grasping; steps afford climbing. Evidence from research experiments indicates that when people view objects that can be acted upon, the appropriate motor responses are automatically activated. For example, Tucker and Ellis (1998) showed participants images of graspable objects, such as a coffee mug with the handle oriented to the right side that would afford a right hand grasp. Although participants had no intention of acting on the object in the image, key press responses to report whether the image was upright or inverted were faster when the hand of the key press matched the hand afforded by the object in the image. Hence, simply viewing the graspable object automatically facilitated a hand response. Evidently we represent our surroundings largely as opportunities for action; we expect that these action representations are of significance to individuals and generate affective evaluations.

Action fluency evokes positive affect in the actor

To test the influence of motor fluency on affect, participants in our study interacted with ordinary household items in either a fluent or non-fluent manner. The participant was

seated at a table, and at the start of each trial a household item, such as a jar of coffee or a box of washing powder, was placed on a mat before her. The participant's task was simply to pick up the item and quickly move it to a destination mat several inches away from the item's starting location. In the non-fluent condition (Figure 3.1, Panel B) the action was made difficult by the presence of an obstacle in the path between the item's starting position and the destination mat. The obstacle was a thin glass vase filled with water, so an accurate trajectory was required in order to prevent a messy collision. In the fluent condition, the action was easier because the vase stood to the side of the destination mat and did not act as an obstacle (Figure 3.1, Panel A). We chose this particular manipulation of fluency simply because we felt it would likely disrupt action on a number of dimensions: the non-fluent actions were executed more slowly, required a longer and more complex trajectory, and were more effortful to execute. Immediately after placing the item on the destination mat, participants rated how much they liked the item, using a nine-point scale. We found that participants rated items as more liked when the interaction with the object was fluent; when the interaction required avoiding an obstacle, the items were less liked (Hayes et al. 2008; Figure 3.2 left bars). These results support our hypothesis that fluent motor actions evoke positive affect (see also Ping, Dhillon and Beilock 2009).

We would like to generalise the result from our study to our everyday encounters with objects, and suggest that the fluency of our actions influences our feelings about our surroundings. Of course, a notable difference between our experimental situation and our ordinary actions in the world is that we are not typically required to make explicit assessments of our feelings about the objects we interact with. Rather, our feelings may arise and guide our interactions with our surroundings in a more implicit way, often outside our awareness.

We wished therefore to test whether affect associated with motor fluency arises spontaneously, when feelings about the objects of the interactions are not consciously attended to (Cannon, Hayes and Tipper 2010). We did this by measuring the affective response to motor events implicitly, that is, without requiring participants to explicitly attend to and report their affective states. Participants performed fluent or non-fluent actions, and as they performed the actions we measured facial muscle activity using electromyography (EMG). Surface electrodes placed on the face detected the electrical activity associated with the muscle response. Many studies have demonstrated that facial muscle activity reflects emotional responses to stimuli. Stimuli that evoke positive emotional responses have been shown to evoke subtle activity in the zygomaticus muscles, which control smiling; stimuli that evoke negative emotions activate the corrugator muscles, which control frowning. Facial EMG has demonstrated emotional responses to viewing emotionally expressive faces (Dimberg 1982), pleasant and unpleasant stimuli (Dimberg 1986), and images that are perceived more fluently (Winkielman and Cacioppo 2001).

So that overall movements could be minimised while recording facial EMG, in this study participants did not interact with actual objects, but rather responded to images on a computer screen by pressing keys on the computer keyboard. Participants viewed images

A Fluent Action

B Non-Fluent Action

Figure 3.1: These frames illustrate fluent actions (a) and non-fluent actions (b) performed by participants. These are also sample frames from a movie clip used in the study that tests the effect of *observing* actions. The first and last frames, and one representative middle frame, are shown. Reproduced from Hayes et al. (2008), copyright Springer-Verlag 2007, with kind permission of Springer Science+Business Media.

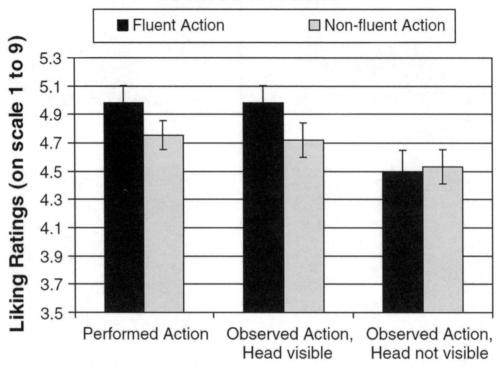

Figure 3.2: Mean liking ratings for objects that were the target of fluent and non-fluent actions. Higher ratings correspond to greater liking. Error bars indicate standard error of the mean. Reproduced from Hayes et al. (2008), copyright Springer-Verlag 2007, with kind permission of Springer Science+Business Media.

of household objects and classified each image by making a right hand key press to an item belonging in the kitchen (e.g. kettle, mug) or a left hand key press to an item belonging in the garage (e.g. power drill, jig saw; right and left key assignments were reversed for half the participants). Each stimulus was a graspable object, and in half the trials the image was oriented so that the handle would be most easily graspable by the hand that corresponded to the correct key press, thus facilitating execution of the correct response (Tucker and Ellis 1998). In these trials the image was also positioned on the side of the screen closer to the responding hand, which also facilitates pressing of the correct response key (Simon and Small 1969). In the remainder of the trials the handle was oriented to the hand that corresponded to the incorrect key press, making execution of the correct response more difficult, and in these trials the image appeared on the side of the screen opposite to the hand of the correct key press. Hence, in half the trials we facilitated motor responses by showing

objects with grasp affordances and spatial locations that automatically activated responses from the correct hand; the remaining half of the trials were more difficult because the incorrect key press was facilitated. We predicted that relative to the incompatible condition, items in the spatially and grasp compatible condition would be classified more quickly, and that this fluency of response would evoke more positive affect, as measured by facial EMG.

Our results confirmed our predictions. Responses to the compatible condition were faster, and activity in the zygomaticus muscle that controls smiling was higher, indicating that the participants experienced a positive affective response to the motor fluency. Thus, motor fluency evokes positive affect even when the actors' attention is not at any point directed to their feelings about the situation, as is often the case during our ordinary encounters with our environment.

Action fluency evokes positive affect in observers

We next considered whether fluently executed actions influence the affective state of observers watching the actions. We created video clips depicting the fluent and non-fluent actions from our previous experiment. That is, an actor was filmed picking up items from a table, and moving them to a destination mat, either directly (fluent condition) or by avoiding a glass vase that acted as an obstacle (non-fluent condition; Figure 3.1). Participants simply sat passively observing the video clip and then gave a liking rating for the item they had just seen in the video clip. We found that just as when actually executing fluent interactions, people also like items more when *others* have had fluent interactions with them (Hayes et al. 2008; Figure 3.2 middle bars).

We propose that the mechanism by which an observed action can evoke an affective response in the non-acting observer is through motor simulations. That is, it has been proposed that when actions are perceived, the corresponding action representations are activated in the observer's own motor system via the so-called mirror system (Di Pellegrino et al. 1992). By simulating an observed action, representations relevant to the action are also activated, which provides a means of understanding another person's current behaviour and future intentions (e.g. Blakemore and Decety 2001). We propose that simulation of an action also evokes affect. The affective response that would be experienced if the action were actually executed may be evoked; additionally, the ease of motor simulation could be pleasurable in and of itself. Research has shown that people automatically simulate emotional expressions of others, such as facial expressions (Dimberg 1982). Such simulations are thought to underlie empathic understanding of others' emotions (for a review see Bastiaansen, Thioux and Keysers 2009). Our research makes a novel contribution to empathy research by demonstrating that even observation of non-emotive actions, such as interactions with everyday objects, may facilitate access to another person's emotional state.

The role of eye gaze in fluency-related affect

We have so far demonstrated that the fluency of ordinary actions modulates our affective responses. Furthermore, simply observing another person's action also evokes affect. While these effects can be demonstrated in the lab, is it really the case that *all* the varied actions we perform and that occur around us influence our emotional state? Would that be desirable, even if it were possible?

In a final experiment (Hayes et al. 2008) we demonstrated an important constraint regarding the simulation of motor-induced affect. As in the previous experiment, participants rated household items seen in video clips depicting actors interacting with the items using fluent or non-fluent actions. In this experiment, however, the actor's head was occluded in the video clips (Figure 3.3). We found that when the actor's gaze was not visible, participants no longer demonstrated any preference for objects of fluent actions (Figure 3.2 right bars).

This finding is in line with evidence that actions are only simulated by an observer if the actor is seen to be attending to the action. Castiello (2003) demonstrated that only when the actor's eye gaze is visible to the observer do reaching actions automatically activate action in the observer. Similarly, in our study, simply viewing fluent and non-fluent actions was not sufficient to evoke affect, suggesting that the action was not simulated by the observer. Emotion is evidently only elicited by actions that the actor is attending to, that is to say goal-directed, meaningful actions. Incidental actions that are not attended by the actor will be simulated to a lesser degree if at all; consequently the influence of incidental actions on the observer's affect will be attenuated. A similar mechanism may operate for self-performed actions. That is, perhaps only attended, goal-directed actions will evoke an affective response in the actor; incidental actions may have no entry to the affective system. This is a question that remains to be tested.

The nature of motor fluency

We have so far defined motor fluency simply as facilitated action. When our participants interacted with household objects, fluent actions were those that required a shorter and simpler hand trajectory, and that required less effort (as reported by participants in similar, subsequent experiments). We assume that these two aspects of an action, the level of effort required and the nature of the movement forces and kinematics (i.e. the change in body position over time), are important contributing factors to the assessment of fluency and its influence on affect. But we do not yet know how forces and kinematics specify fluency, nor the role that sensations such as perceived effort play in the assessment of fluency. A more thorough understanding of how actions evoke affect will depend on being able to systematically describe the quality of motor actions in these (or other) terms.

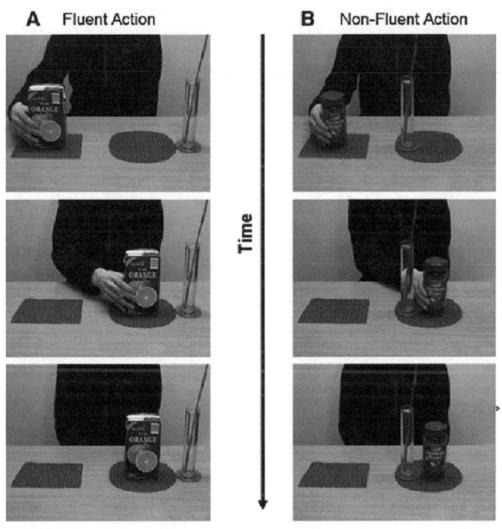

Figure 3.3: Sample frames from a movie clip used in the study testing the effect of observing actions when the actor's head was occluded. The first and last frames, and one representative middle frame, are shown. Reproduced from Hayes et al. (2008), copyright Springer-Verlag 2007, with kind permission of Springer Science+Business Media.

The challenge of describing and analysing the quality of body movements has been tackled in the past. For example, Rudolf Laban developed a system for evaluating the quality of an action using dimensions of force, space, time and flow (Laban and Lawrence 1947; for a review see Reynolds 2007). Laban was motivated by a thesis that actions are linked with mental and affective states through 'Antrieb', a concept that has become known in English as 'effort' but is in fact closer to the meaning of 'impulse' (Reynolds 2007). Laban's system has been extensively used, and further developed, by dance professionals and other movement professionals to describe and theorise movements. Our attempt to link motor fluency (in Laban's terms, 'flow') to affect can build on the success of this approach, and perhaps can further inform these investigations.

Recent research in motor control related to action fluency may suggest useful methods for relating affect to movement characteristics. Researchers have investigated the relationship between movement and perceived effort by systematically varying aspects of actions such as magnitude and duration of force, or trajectory length and direction, and asking participants to indicate which combinations of actions were perceived to be easier (Körding et al. 2004; Rosenbaum and Gaydos 2008). By including measures of affective response as well, these studies could be extended to examine how affect relates to both perceived effort and to action characteristics. Another approach would be to adopt models of motor control that propose characteristic geometries underlying actions (Bennequin et al. 2009), or that propose optimal sensorimotor control strategies (e.g. Todorov 2004), and assess how deviations from predicted actions relate to changes in affect and effort. Whichever methods are adopted, it will be a challenging task to understand how affect, perceived effort, and action forces and kinematics interrelate.

Finally, we should note that we have primarily discussed fluency as a motor process. However, motor actions are accompanied by perceptions, including perceptions of effort, as mentioned, but also visual and kinesthetic perceptions that sense body position and movement. Both motor processes and sensory processes could influence affect, and the contributions of both have yet to be disentangled. Moreover, the critical signals to the affect system could presumably occur both while anticipating the motor and sensory signals during the planning of the action, as well as while actually executing the action. Clearly, much remains to be determined regarding the underlying mechanisms that link action fluency to affect.

Functions of fluency-related affect

Winkielman and Cacioppo (2001) discussed the affective consequences of perceptual fluency in terms of a 'hedonic fluency' model. They suggested that the positive affect associated with processing ease serves at least two functions. First, it provides information both about the state of internal processing and about the environment, which can be important for approach/avoidance decisions. For example, ease of perceptual processing can indicate that

a stimulus is familiar, and thus more likely to be safe to approach. Secondly, the positive affect associated with processing fluency may act as a reward that can facilitate continued processing.

Affect evoked by motor fluency may serve similar functions. First, the affective signal may direct attention to items that are most suitable for efficient interactions. When considering an object, an anticipation of fluent action might be based on shape and apparent action affordances (Ping, Dhillon and Beilock 2009) or based on memories of previous interactions, although it remains to be tested whether the affect associated with a fluently handled object endures in memory. Secondly, affect associated with motor fluency might signal the motor capability of the actor, whether oneself or an observed actor, and hence provide cues regarding the actor's skill competency or health. A further function of motor-related affect, and perhaps a very important one, may be to act as a reward for well executed actions, which may be a key mechanism for facilitating skill learning and for maintaining proficiency of skills.

The experiments we have reviewed indicate that motor actions drive the affective system. We speculate that motor actions may therefore play an important role in affect regulation. Some pastimes that people find particularly relaxing, such as knitting or walking at a leisurely pace, consist of repeatedly executing fluent movements. Performing fluent movements may be a particularly straightforward way to evoke positive affect and may provide a simple way to promote self-regulation of the emotion system. Motor fluency may play a part in the positive affect that is associated with moderate levels of physical activity (Ekkekakis, Hall and Petruzzello 2005), and may be related to some of the difficulties that emerge from sedentary lifestyles where sustained periods of fluent action are infrequent. By the same reasoning, the affect evoked by motor fluency may play a role in the efficacy of movement-based therapies such as dance therapies (Jeong et al. 2005) for treating affective disorders and promoting wellbeing.

The role of context in emotional responses to action fluency

We have argued that fluently executed actions evoke positive affect. However, experience suggests that it can sometimes be more enjoyable to perform difficult actions than easy ones, even at the expense of fluent performance. Instead of simply dropping a crumpled sheet of paper in the wastepaper basket, a person might try throwing it around his back – an effortful and awkward manoeuvre that has a lower chance of success. Why is it appealing to act non-fluently? Similarly, viewing the non-fluent actions of others can also be pleasurable. When observing dance performances, some people experience pleasure from viewing actions where the effort expended by the actor is particularly evident (Reason and Reynolds 2010). How can our account of fluency-related affect accommodate these experiences?

It is possible that fluently executed actions evoke positive affect only in certain contexts. Alternatively, fluent actions may elicit positive affect in all situations, but in some contexts

other sources of affect come to dominate the overall affective experience. This latter possibility is in keeping with appraisal theories of emotion (for a review see Ellsworth and Scherer 2003). Emotions evoked by a stimulus are thought to consist of processes of appraising and reappraising the stimulus for its relevance to the individual. These appraisals can involve complex cognitive evaluations, but appraisals can also consist of very rapid perceptions. The most basic appraisal is thought to be an assessment of novelty, which causes the individual to orient (or not) to the stimulus. The next most basic assessment is, arguably, an evaluation of the valence or pleasantness of the stimulus; this is the fundamental assessment that the item is good or bad, and it is thought to occur rapidly and automatically (Zajonc 1980). This evaluation may occur outside conscious awareness. We assume that the affect related to motor fluency occurs at this basic level. After these basic evaluations, the stimulus might be assessed on a number of additional relevant dimensions such as an evaluation of how the stimulus relates to the individual's current needs and goals. Satisfaction of a goal will evoke positive affect, but also the rate of progress towards a goal is thought to be an important source of affect (Carver and Scheier 1990). These goal-related evaluations are likely to be highly relevant for motor events. Further evaluations include how the stimulus or event complies with personal and societal norms and values. Additionally, Lazarus (1966) proposed that experiencing emotion involves not only an appraisal of the stimulus or external situation, but also an appraisal of the individual's own ability to handle the situation, which may be another particularly relevant dimension when appraising motor actions.

We assume that when actions are performed or observed, the fluency of the action is evaluated rapidly and automatically. This affective signal may provide information about the situation, such as an assessment of the actor's competency, and may reinforce well-executed actions, as previously mentioned. The conscious emotional experience of the action, however, will additionally be influenced by the types of appraisals listed above. In our experiments, the motor actions were executed in a rather impoverished laboratory context that was designed to minimise extraneous stimulus features and goals, hence the positive affect evoked by fluent actions was particularly salient. In real life, however, actions are performed in the context of multiple goals and the situation and the self are evaluated on a variety of dimensions besides fluency of action. A routine task like putting an item in the wastepaper basket might be performed in an uncomfortable and non-fluent way (throwing behind the back) in order to achieve the goal of increasing alertness and feelings of interest, or it may represent progress towards the goal of achieving a new skill that, once fluent, will be pleasurable to execute, will increase feelings of competency, and will impress co-workers. Hence this non-fluent action may be experienced positively as it satisfies the pursuit of these goals.

The situation of watching a dance performance is a particularly good example of how many appraisals might be occurring when observing actions. Reason and Reynolds (2010) have explored audience responses to dance and have argued that individuals' emotional responses are dependent on a number of factors including, for example, their expectations about what they will experience, their knowledge of the dance form and their levels of

experience in performing the observed movements, their degree of kinesthetic involvement with the observed actions, and the self-perceptions that are evoked by the observed performance. The automatic assessment of fluency may play a role in the appraisal of some of these contextual factors. For example, self-perceptions that arise from comparing the self to a viewed performer may be highly dependent on an evaluation of the performer's fluency of action. Other appraisals may be rather independent of the evaluation of fluency. Therefore, the role of fluency in the conscious emotional response to an action is not straightforward. Fluency evokes affect, but fluency can also contribute to appraisals that are more complicated than simply experiencing positive affect with increased fluency. Furthermore, the overall affective experience could be dominated by appraisals unrelated to fluency.

A further complicating factor in linking affect to fluency is that not only does fluency influence other appraisals of the action, but contextual factors can also modulate the basic, automatic evaluations of fluency. For example, assessments of fluency will change as an individual gains more experience with an action. As another example, we have seen that emotion evoked by observed fluency can change depending on the actor's attention to the action. Assessment of fluency might also change as goals or external rewards change; different fluency criteria may be activated, for example. And even cultural values can influence the evaluation of fluency. We may tend to think of optimal motor fluency as being solely specified by the biomechanical demands of the action. However, it has been argued that societal norms specify appropriate ways of using energy; these norms are reflected in cultural practices such as dance, which can enforce the norms or challenge them (Reynolds 2007). Even highly prescribed actions such as traditional postures in classical ballet are not entirely fixed but rather are governed by cultural norms and have been shown to change over time (Daprati, Iosa and Haggard 2009). Presumably our everyday actions are subject to such societal norms as well.

To summarise the role of context in affective responses to actions, we assume that motor fluency evokes affect rapidly and automatically, and that the functions it serves, such as eliciting a reward signal for fluently executed actions, can operate outside of awareness. The conscious emotional response to an action will be influenced by fluency but also by other appraisals, some of which may be dependent on evaluations of fluency, and others which may be independent. Moreover, the evaluation of fluency can itself change with context. Thus the various sources of affect associated with actions are highly interdependent. We hope that an increased understanding of how action fluency evokes affect in controlled conditions will contribute a building block in our understanding of emotional responses to naturally occurring actions.

Summary

Individuals constantly evaluate how stimuli and events are relevant to themselves. Consequently, most – if not all – perceptions and thoughts evoke affective responses. We

assume that many motor actions evoke affect as well. We have demonstrated that action fluency evokes positive affect in the performer as well as in those who merely observe the action. We have found this to be true for the ordinary actions of reaching for and moving objects, and for simple key press responses – actions that are familiar but not highly skilled, and that are not inherently expressive of emotion. Regarding affective responses to *observed* actions, an important constraint is that motor fluency does not evoke affect for *all* viewed actions, but rather, affect is activated only by those actions to which the actor is attending; incidental actions are effectively attenuated from influencing the affect system. More research is needed to determine what aspects of motor actions are critical for triggering affective responses.

We believe that fluency-related affect serves a number of functions. Affect can provide information about the environment regarding which objects are efficient to interact with; it can also provide information about the skill competency and health of the actor (whether oneself or an observed actor). Fluency-related affect also likely acts to reward fluent actions and thus facilitate skill learning and skill maintenance. We speculated that fluent motor actions may play a role in affect regulation. We believe that motor-induced affect is an important contributor to our affective state and appraisals, but work remains to be done to determine how motor fluency interacts with other appraisals of internal motivational states and external contexts. This ongoing research programme concerning motor-related affect has implications for wide ranging issues including how consumer preferences and social interaction are influenced by motor actions, how performing and watching movements develop into skill learning, and how performed and viewed actions influence aesthetic pleasure and emotional well-being.

References

Arnold, M. B. (1960). *Emotion and Personality: Vol. 1. Psychological Aspects.* New York: Columbia University Press.

Bastiaansen, J. A. C. J., Thioux, M. and Keysers, C. (2009). 'Evidence for Mirror Systems in Emotions'. *Philosophical Transactions of the Royal Society: B-Biological Sciences*, 364: 2391–2404.

Beilock, S. L. and Holt, L. E. (2007). 'Embodied Preference Judgments – Can Likeability be Driven by the Motor System?'. *Psychological Science*, 18 (1): 51–57.

Bennequin, D., Fuchs, R., Berthoz, A. and Flash, T. (2009). 'Movement Timing and Invariance Arise from Several Geometries'. *PLoS Computational Biology*, 5 (7): e1000426.

Blakemore, S. J. and Decety, J. (2001). 'From the Perception of Action to the Understanding of Intention'. *Nature Reviews Neuroscience*, 2: 561–567.

Cannon, P., Hayes, A. E. and Tipper, S. P. (2010). 'Sensorimotor Fluency Influences Affect: Evidence from Electromyography'. *Cognition & Emotion*, 24 (4): 681–691.

Carver, C. S. and Scheier, M. F. (1990). 'Origins and Functions of Positive and Negative Affect – A Control-Process View'. *Psychological Review*, 97 (1): 19–35.

Castiello, U. (2003). 'Understanding Other People's Actions: Intention and Attention'. *Journal of Experimental Psychology: Human Perception and Performance*, 29 (2): 416–430.

Damasio, A. (1999). *The Feeling of What Happens: Body and Emotion in the Making of Consciousness*. New York: Harcourt Brace.

Daprati, E., Iosa, M. and Haggard, P. (2009). 'A Dance to the Music of Time: Aesthetically-Relevant Changes in Body Posture in Performing Art'. *PLoS ONE*, 4 (3): e5023.

Dimberg, U. (1982). 'Facial Reactions to Facial Expressions'. *Psychophysiology*, 19 (6): 643–647.

Dimberg, U. (1986). 'Facial Reactions to Fear-Relevant and Fear-Irrevelant Stimuli'. *Biological Psychology*, 23 (2): 153–161.

Di Pellegrino, G., Fadiga, L., Fogassi, L., Gallese, V. and Rizzolatti, G. (1992). 'Understanding Motor Events: A Neurophysiological Study'. *Experimental Brain Research*, 91: 176–180.

Ekkekakis, P., Hall, E. E. and Petruzzello, S. J. (2005). 'Variation and Homogeneity in Affective Responses to Physical Activity of Varying Intensities: An Alternative Perspective on Dose-Response based on Evolutionary Considerations'. *Journal of Sport Sciences*, 23 (5): 477–500.

Ellsworth, P. C. and Scherer, K. R. (2003). 'Appraisal Processes in Emotion'. In R. J. Davidson, K. R. Scherer and H. H. Goldsmith (eds), *Handbook of Affective Sciences*. New York: Oxford University Press, 572–595.

Fazio, R. H. (2001). 'On the Automatic Activation of Associated Evaluations: An Overview'. *Cognition & Emotion*, 15 (2): 115–141.

Gibson, J. J. (1979). *The Ecological Approach to Visual Perception*. Hillsdale, NJ: Lawrence Erlbaum Associates.

Hayes, A. E., Paul, M. A., Beuger, B. and Tipper, S. P. (2008). 'Self Produced and Observed Actions Influence Emotion: The Roles of Action Fluency and Eye Gaze'. *Psychological Research*, 72: 461–472.

Izard, C. E. (1979). 'Emotions as Motivations: An Evolutionary-Developmental Perspective'. In R. Dienstbier (ed.), *Nebraska Symposium on Motivation*, Vol. 27. Lincoln: University of Nebraska Press, 163–200.

Jeong, Y. J., Hong, S. C., Lee, M. S., Park, M. C., Kim, Y. K. and Suh, C. M. (2005). 'Dance Movement Therapy Improves Emotional Responses and Modulates Neurohormones in Adolescents with Mild Depression'. *International Journal of Neuroscience*, 115 (12): 1711–1720.

Körding, K. P., Fukunaga, I., Howard, I. S., Ingaram, J. N. and Wolpert, D. M. (2004). 'A Neuroeconomics Approach to Inferring Utility Functions in Sensorimotor Control'. *PLoS Biology*, 2 (10): 1652–1656.

Laban, R. and Lawrence, F. C. (1947). *Effort*. London: Macdonald & Evans.

Lazarus, R. S. (1966). *Psychological Stress and the Coping Process*. New York: McGraw-Hill.

Leventhal, H. and Scherer, K. (1987). 'The Relationship of Emotion to Cognition: A Functional Approach to a Semantic Controversy'. *Cognition & Emotion*, 1 (1): 3–28.

Loken, B. (2006). 'Consumer Psychology: Categorization, Inferences, Affect, and Persuasion'. *Annual Review of Psychology*, 57: 453–485.

Niedenthal, P. M. (2007). 'Embodying Emotion'. *Science*, 316 (5827): 1002–1005.

Ping, R. M., Dhillon, S. and Beilock, S. L. (2009). 'Reach for What You Like: The Body's Role in Shaping Preferences'. *Emotion Review*, 1 (2): 140–150.

Reason, M. and Reynolds, D. (2010). 'Kinesthesia, Empathy, and Related Pleasures: An Inquiry into Audience Experiences of Watching Dance'. *Dance Research Journal*, 42 (2): 49–74.

Reber, R., Winkielman, P. and Schwarz, N. (1998). 'Effects of Perceptual Fluency on Affective Judgements'. *Psychological Science*, 9 (1): 45–48.

Reynolds, Dee (2007). *Rhythmic Subjects: Uses of Energy in the Dances of Mary Wigman, Martha Graham and Merce Cunningham*. Alton: Dance Books.

Rosenbaum, D. A. and Gaydos, M. J. (2008). 'A Method for Obtaining Psychophysical Estimates of Movement Costs'. *Journal of Motor Behavior*, 40 (1): 11–17.

Simon, J. R. and Small, A. M., Jr. (1969). 'Processing Auditory Information: Interference from an Irrelevant Cue'. *Journal of Applied Psychology*, 53 (5): 433–435.

Strack, F., Martin, L. L. and Stepper, S. (1988). 'Inhibiting and Facilitating Conditions of the Human Smile: A Nonobtrusive Test of the Facial Feedback Hypothesis'. *Journal of Personality and Social Psychology*, 54: 768–777.

Tesser, A. and Martin, L. (1996). 'The Psychology of Evaluation'. In E. T. Higgins and A. W. Kruglanski (eds), *Social Psychology: Handbook of Basic Principles*. New York: Guilford Press, 400–432.

Todorov, E. (2004). 'Optimality Principles in Sensorimotor Control'. *Nature Neuroscience*, 7 (9): 907–915.

Tucker, M. and Ellis, R. (1998). 'On the Relations between Seen Objects and Components of Potential Actions'. *Journal of Experimental Psychology: Human Perception and Performance*, 24 (3): 830–846.

Van den Bergh, O., Vrana, S. and Eelen, P. (1990). 'Letters from the Heart: Affective Categorization of Letter Combinations in Typists and Nontypists'. *Journal of Experimental Psychology: Learning, Memory, and Cognition*, 16: 1153–1161.

Wells, G. L. and Petty, R. E. (1980). 'The Effects of Overt Head Movements on Persuasion: Compatibility and Incompatibility of Responses'. *Basic and Applied Social Psychology*, 1 (3): 219–230.

Winkielman, P. and Cacioppo, J. T. (2001). 'Mind at Ease Puts a Smile on the Face: Psychophysiological Evidence that Processing Facilitation Elicits Positive Affect'. *Journal of Personality and Social Psychology*, 81 (6): 989–1000.

Zajonc, R. B. (1980). 'Feeling and Thinking; Preferences Need No Inferences'. *American Psychologist*, 35 (2): 151–175.

Part II

Kinesthetic Engagement: Embodied Responses and Intersubjectivity

Introduction

Dee Reynolds

Crucial to all the contributions in this part is the idea that subjectivity is embodied and that this embodiment grounds our experience of the world and each other. It follows, therefore, that changes in embodied experience have the capacity to transform both subjective consciousness and relationships between subjects. The authors explore implications of embodiment for empathic and intersubjective experience, in different contexts – cinema, music, dance – and from different disciplinary and methodological angles, drawing on phenomenology, cognitive psychology, neuroscience and affect theory.

In his chapter, 'Cinematic Empathy: Spectator Involvement in the Film Experience', Adriano D'Aloia discusses the role of empathy in spectators' involvement in narrative fiction film. He highlights the importance of the 'quasi' or 'as if' aspect of empathy: when we experience the fictive world of the film 'as if' it was real, while also knowing that it is not and we relate to the other 'as if' they were us, while knowing that they are separate. This 'as if' experience is an imaginary act that activates the spectator's kinesthetic sensations in a motor imitation of movement perceived in the film, which can be that of a character or of the film itself, as in the movement of the camera. D'Aloia exemplifies graphically the 'as if' experience in film spectatorship by contrasting the reaction of spectators within a film who witness an acrobat falling with the reaction of spectators in the cinema; whereas the former jump up in horror, the latter remain seated – perhaps also horrified, but viewing the event 'as if' real, while not actually happening in front of them.

Whereas D'Aloia is concerned with the relation between the spectator and the film, in their chapter 'Musical Group Interaction, Intersubjectivity and Merged Subjectivity', Tal-Chen Rabinowitch, Ian Cross and Pamela Burnard consider the experience of joint music-making and listening as a situation involving social interaction. They discuss intersubjectivity in the context of embodied interactions among musicians and among listeners. They argue that by synchronising rhythms, where people mutually adjust to one another's pace, it is possible also to align affective states and promote social interactions. Closely related to

synchronisation is the phenomenon of entrainment, which involves the coming together of two or more rhythmic patterns and which impacts on the relationship among players and also among listeners.

Rabinowitch et al. are particularly interested in the emotional charge of intersubjective communication as experienced through joint music-making and its capacity to influence intersubjective alignment of intentions and emotions. This clearly has significant social implications, for instance in the case of people who have difficulties with empathy, such as autists (see chapter by Shaughnessy in Part 1). Moreover, our body schema, or map, is itself fluid; we can 'incorporate' objects and treat them as extensions of our body, and it seems that this may also extend to intersubjective relations where players can experience the actions of their fellow players, at least in part, as their own. Synchronised sensorial experience (such as occurs in joint music-making) can lead to a blurring of self–other boundaries and confusion of agency, which Rabinowitch et al. dub 'merged subjectivity'.

D'Aloia also explores connections between motor and emotional experience in spectators' responses to films. However, he regards imitation in the form of synchronisation (e.g. foot tapping) as a relatively basic and undeveloped form of activation, which 'must not be confused with empathy as such'. D'Aloia emphasises the potential of film to *intensify* the spectator's experience, and rather than temporal alignment as in the musical context, he is interested in how, for the cinema spectator, motor imitation carries an affective charge that intensifies emotional response. The camera can include its own movement – that of the 'film's body', which is specific to the film medium – thereby intensifying the spectator's own kinesthetic sensations as they internally 'imitate' the movement of the camera as well as the character. Spectators' involvement can be enhanced by skilful acting (note connections with issues discussed by Bolens and Donaldson in their chapters in Part III), by narrative, or by the dramatic quality of the movement itself, such as an acrobat swaying on a tightrope, in danger of falling. (The affective implications of movement qualities in everyday situations rather than artistic contexts are discussed by Hayes and Tipper in this book.)

D'Aloia relates spectators' intensified experience to the cinematic space in which they can be 'immersed', and he also discusses writings on cinema from the 1920s and 1930s. It would be interesting to compare historical responses to cinema as a relatively young medium with present-day responses to recent technologies, such as 3D film, or to digitally constructed immersive environments, as discussed by Whatley in her chapter.

The intensification that D'Aloia discusses as central to the film spectator's experience of empathy is also central to my own approach to kinesthetic empathy in the last chapter in this part, 'Kinesthetic Empathy and the Dance's Body: From Emotion to Affect'. However, I suggest that conceptualisations of empathy can be too restrictively tied to the category of emotion and propose instead to treat it in terms of the more fluid notion of 'affect', which is embodied and not defined by emotional categories. I explore kinesthetic empathy as a movement across and between bodies, which, in an artistic situation, can have affective impact with potential to change modes of perception and ways of knowing. For different purposes, both D'Aloia and I draw on Vivian Sobchack's idea of the 'film's body' – for me,

this becomes the 'dance's body', which involves movement among dancers and between dancer(s) and spectator, rather than any specific, individual dancer. The affective impact of dance consists in an embodied response (sometime automatic and unnoticed, and sometimes even against our volition), which resists classification in terms of particular emotions. The affect is transmitted body-to-body (where the body is understood as existing in and informed by cultural contexts) and if sufficiently intense, can produce a – sometimes uncomfortable – shock, which induces reflexivity and catalyses reflection. Through these processes, dance can impact on how and what we think. While there are many ways of producing reflexivity, I am particularly interested in work where it is provoked directly by and through the body, and where the impact of the senses on each other shifts our modes of perception and induces reflection. For me, this is the affective force of kinesthetic empathy as constructed through what I call 'affective choreography'.

This part, then, invites the reader to reflect on how kinesthetic engagement impacts on intersubjectivity, empathy and affect. While these arguments are constructed in the contexts of cinema, music and dance, their implications concern wider issues of connections between empathy and intersubjectivity, emotion and affect, and the social and epistemological resonance of these cultural activities.

Chapter 4

Cinematic Empathy: Spectator Involvement in the Film Experience

Adriano D'Aloia

The aim of this chapter is to bring to light the central role of kinesthetic empathy in spectators' experience of narrative fiction film. The fundamental argument is that, in the particular spatial and psychological situation of the cinema auditorium, and especially in respect of the main characters, the viewer's involvement entails both motor and emotional participation despite his/her consciousness of the fictional nature of the filmic events. This participation is mostly realised via the activation of empathy, a factor that reduces the psychological separation between the spectator and the characters.

It is therefore significant that there are strong parallels between philosopher Edith Stein's description of empathy, which critiques earlier accounts of *Einfühlung* (notably Theodor Lipps) from a phenomenological position, and the film theory of Belgian psychologist Albert Michotte, which explores motor and emotional empathy in the experience of watching film. Comparing these accounts highlights the *structural* analogy between the mediated nature of the empathic experience, as they describe it, and the mediated nature of the film experience; and also the *processual* analogy between the two experiences in their perceptual, emotional and cognitive stratification. I then bring into the discussion some of the main contributions of film theorists writing in the 1920s and 1930s, which relate to my argument about sensory intensification in cinema. I aim to demonstrate that empathy is inherent in the nature of narrative cinema itself and is pivotal to describing the variety and complexity of film spectatorship in the cinema as an *intensified* experience. In order to evaluate the heuristic potential of the theoretical accounts taken into consideration, I briefly analyse the prologue of the drama film *Trapeze* (Carol Reed 1956).

With-in the acrobat

In *Grundlegung der Äesthetik*, philosopher Theodor Lipps stated that in watching the tightrope walker balancing precariously on the suspended wire, the viewer *projects* and feels him/herself so *inside* the acrobat that his/her conscious self completely merges with that of the funambulist. This fusion is achieved on the basis of an 'inner imitation' through which the observer internally reproduces the movements of the observed person. Perceived movements are instinctively and simultaneously mirrored by kinesthetic 'strivings' and the experience of corresponding feelings in the observer (Lipps 1903: 121–126).

In order to discuss this neo-romantic, utopian account of *Einfühlung*, phenomenologist Edith Stein reinvoked the case of the acrobat in her *On the Problem of Empathy* (Stein 1917:

11–19). In her view, Lipps confuses the act of being drawn into the experience of the other (for instance the acrobat) with the transition from *non-primordial* to *primordial* experience (see Stein 1917: 12). Primordial for Stein is an experience whose content is present, bodily given, whereas there are psychological experiences (such as memory, expectation and fancy) that do not have their object bodily present before them (Stein 1917: 6–9). These are experiences that are primordially given, but non-primordial in their content. In the same way, the act of empathising consists in primordially experiencing something that is non-primordially given, since the content belongs to another: 'This other subject is primordial although I do not experience its primordiality' (Stein 1917: 10). The experience of empathy, in the end, consists in the feeling of being led by the other's primordiality, which is 'not experienced by me but still there, manifesting itself in my non-primordial experience' (Stein 1917: 10). 'And in these non-primordial movements I feel led, accompanied, by his movements which are only there for me in him' (Stein 1917: 17). In the empathic relation, 'I am not one with the acrobat but only "at" him. I do not actually go through his motions but only *quasi*' (Stein 1917: 17). In watching an acrobat, 'I put myself into the perceived body, as if I were his vital centre, and I perform an impulse "quasi" of the same type as that which could cause a movement' (Stein 1991: 173, my trans.). The 'quasi' describes the 'imperfect substitution' of the empathising subject with the empathised subject, a proximity and accompaniment that does not result in a fusion or replacement and that preserves a distance, a 'unity in distinction'. The act of 'putting myself into the perceived body' is, in fact, explained with the expression 'as if I were', that is, an imaginary act that connects the internal, apperceived side of the experience to its external, perceived side. This peculiar contact does not concern the body in its natural or objective physical meaning (the *Körper* in the Husserlian sense), but rather the vital activity of the experienced, animated, organic, sentient body (the *Leib*) (Husserl 1960: 42–62; Husserl 1989: 43–47). The activation of the acrobat's lived-body entails a corresponding activation of the kinesthetic sensations of the spectator's lived-body.

In brief, for Stein, rather than a *projection* or a fusion, empathy is an *accompaniment*, in which the spectator's subjectivity is not 'one with' the acrobat's subjectivity, but only 'with'. The empathising subject is side-by-side with the empathised subjects, and their adjacent position implies a paradoxical *proximity at a distance*. The form of accompaniment implies the structure of a *mediated* experience, where mediation consists both in an inevitable distance and an opportunity for contact. In this sense, the debate on *Einfühlung* seems to provide a phenomenological description that relates closely to the spectator's experience of watching film. In general terms, there is an analogy between the 'structure' of empathy and the 'structure' of film experience, on condition that we assume the *sui generis* nature of otherness, which is implied in a film character.

In what sense are the body of the character and the body of the spectator involved in an empathic relation? The oxymoronic 'proximity at a distance' of the film experience can be explained by recourse to the notions of *quasi* and *as if* that characterise the empathic act. In the light of the phenomenological and filmological accounts of empathy, the film experience

can be described as the relationship between the spectator and a series of *quasi*-bodies with which he or she interacts. As Rudolf Arnheim argued in 1932, 'every object that is reproduced [on screen] appears simultaneously in two different frames of reference [and] as one identical object it fulfils two different functions in the two contexts' (Arnheim 1957: 59): the 'film gives simultaneously the effect of an *actual happening* and of a *picture*' (Arnheim 1957: 27). The film images are experienced as celluloid bodies that, nonetheless, express vitality thanks to their *movements* and their *resemblance* to human bodies and movements. In this sense, the ambivalent filmic bodies have to be considered, more precisely, as *quasi*-bodies capable of expressing a vital essence that the spectator can *innerly accompany*.

The bodies of the film characters are one kind of *quasi*-bodies. The character is a paradoxical 'otherness' and it cannot be said that he/she has a subjectivity as others in real life have. Also, not only are the bodies on screen experienced as fictional bodies (those of the *characters*), but they are also inseparable from the performers' bodies (those of the *actors*).[1] Hence the film experience is a *quasi*-intersubjective relationship in which the spectator, under certain conditions, can empathise with the character. What is inwardly represented in the spectator's lived-body is the vital movement belonging to a primordial otherness that is not contiguous with the spectator's subjectivity.

Intensified cinema

The case of the acrobat at the core of the *querelle* between Lipps and Stein is particularly significant for the study of empathic involvement in film because it is centred on a movement that is a powerful generator of motor and emotional imitation. Implicit in the choice of the case made by Lipps and Stein is the fact that the spectator is not faced with an ordinary movement (walking), but rather a movement that is characterised by tension (walking on a suspended wire). Prior to delving into the account of empathy offered by the filmological approach and relating it to Stein's arguments, I want to trace a brief review of major psycho-aesthetic film theories from the 1920s and 1930s, in order to demonstrate cinema's capacity to intensify experience, and the consequently pivotal role of empathy in watching film. According to these theories, in fact, the situations with most potential for empathy are those in which a strong kinesthetic intensification is invited (for instance acrobatics, falling, sports performance, dance, etc.).

Since its origins, cinema has offered spectators the opportunity to experience strong emotions and has taken its place in the history of popular spectacles conceived to astonish the public with magic performances and phantasmagoria. The trailblazing experiments of cinema pioneers Étienne-Jules Marey and Eadweard J. Muybridge contributed to the understanding of human physiology but also gave new prominence to the moving human body and stirred voyeuristic impulses that cinema has been able to exploit. The first movie cameras focused their gaze on muscular bodies, acrobatics, sport performances, dance scenes or fights between men and animals – although they often had a comic or burlesque

purpose. Cinema displayed the visible surface of moving bodies, before developing its narrative vocation and requiring a complex interpretative effort.

The first psychological approaches to analysing the film experience focused on the intensified nature of cinematic perception. In the seminal *The Art of Photoplay Making*, Victor Freeburg pointed to the physical pleasure that the spectator feels when viewing images of the human body and its movements: 'This is an elemental and primitive emotion. For thousands of years gaping humanity has been thrilled by the juggler and the acrobat' (Freeburg 1918: 17). At the beginning of the 1920s, in his evocative *Bonjour Cinéma*, Jean Epstein wrote that, at the cinema, everyday life breaks away from the ordinary first and foremost in sensorial terms: the road runs under the car, the plane crashes, the tunnel swallows the train. Cinema allowed spectators to feel more and to see everything: it offered the giddy excitement of a merry-go-round, a dance seen from multiple perspectives (Epstein 1981).

In 1924, in his *The Visible Man*, Béla Balázs confirmed and relaunched the same idea, focusing on cinema's ability to offer the spectator enhanced forms of sensory experience: 'If it is true that film is concerned exclusively with visible, that is, bodily, human actions, then it follows that sporting and acrobatic performances can constitute extremely enhanced expressions of human physical life' (Balázs 2010: 64). Balázs provided a first implicit description of empathy, affirming the specificity of film experience in respect of reality: 'In reality we see only a moment, a fragment of movement. In film, however, *we accompany a runner and drive alongside the fastest car*' (Balázs 2010: 64). Cinema is capable of including the spectator in the totality of a particularly intense movement, experienced at first hand and through 'accompanying' the characters. In particular, the more 'genuine', 'unpolished' and 'spontaneous' the appearance of the character's physical activity portrayed by the film, the greater the intensity and effectiveness of spectator participation. As Balázs argues, in fact,

> Movement in film is not just a sporting or 'natural' fact; it can be the highest expression of an emotional or vital rhythm. ... Thus, the physical activities of the film hero must take care not to assume a *sporting character*, even if he has to perform the most difficult stunts. For sport means movement as a goal in itself and is useless as expressive movement.
>
> (Balázs 2010: 64–65)

For this reason 'the character who boxes must never become "a boxer", a running man must never become "a sprinter". For the film then acquires the insidious taint of the "professional", arousing our doubts as to the authenticity of the performance, and robbing the action of the immediacy of life' (Balázs 2010: 65). The spectator, Balázs appears to assert, is an amateur acrobat, a tightrope walker for a day, an aerialist on her first performance, a policeman on his first chase, a criminal making his first escape. The 'immediacy' of the experience depends on the apparent genuineness of the action, on its rudimentary and provisional characterisation. The expressive impact of the action is therefore undermined where the spectator's attention is focused on the prowess of the performance (as can be the case with sporting actions), rather

than the intensity of movement in sensorimotor and emotional terms. What is absolutely crucial is the perceived 'authenticity' of the action, which is not dependent on physical presence at all. According to Balázs, the tension evoked by the represented action

> can induce the *feeling of vertigo*. The greatest catastrophe depicted in a pictorial space that is separated from our own space will never have an impact comparable to the image that places us on the very edge of an *abyss* that opens up *before our very eyes*. … The momentary illusion of danger to oneself is always more effective than images of catastrophes that overwhelm others.
>
> (Balázs 2010: 66)

Through the use of specific optical solutions, cinema can reduce or even eliminate the 'distance' between the spectator and the screen. Although the film experience consists in being *in* the action, in the middle of the events, exposed to a danger that is felt as real, the pleasure that derives from this situation depends on the fact that the spectator knows he/she is quite safe: 'What we especially enjoy is the risk-free danger of the filmed sensation' (Balázs 2010: 65).

For Rudolf Arnheim, cinema elicits a sense of dizziness by virtue of an unbridgeable gap between two bodily frames of reference: the spectator's physical situation and the specific (optical–aural) condition in which the spectator's experience takes place, that is to say the cinema auditorium. Filmic movement is not merely a 'locomotion' perceived by the spectator as a 'shift' of elements in the visual field. The visual experience depends on the dynamic that transforms mere images into expressive bodies. This expressiveness or vitality depends on the tensive force that moves both the bodies on the screen and the spectator's body: 'Of course, physically all motion is caused by some kind of force. But what counts for artistic performance is the dynamics conveyed to the audience visually; for dynamics alone is responsible for expression and meaning' (Arnheim 1954: 408).

The boundary between functional movement and expressive movement is subtle and yet decisive. In the earliest stage of his work, influenced by Vsevolod Meyerhold, Sergei Eisenstein grounded a theatre actor's performance in 'expressive movement'. Like a circus performer or an athlete, the trained actor must be able to communicate emotions through his/her motor skills and to induce psychological states in spectators through their motor responses. The viewer automatically and 'reflexively repeats in weakened form the entire system of an actor's movements: as a result of the produced movements, the spectator's incipient muscular tensions are released in the desired emotion' (Eisenstein 1979: 37). Eisenstein described the ability of the spectacle to induce and manufacture the emotional effect on the viewers, to elicit emotions that they automatically reproduce internally, albeit in a weakened form, with the result that they experience the observed emotion directly, according to an empathic act. In *Nonindifferent Nature*, Eisenstein argued that the emotional effectiveness of works of art is based on the commutation of expressive registers: the observer

performs 'ecstatic' operations transferring himself/herself from one sensorial condition to another, where by *ex-stasis* is meant a state of 'being beside oneself' (Eisenstein 1964: 27).

This review demonstrates that, progressively throughout its history, cinema has engaged the spectator in a 'bodily relationship' with the characters on-screen and this kind of involvement is based on a sensory intensification that seems to be intrinsic to the cinematic medium, similar to the way in which the acrobatic performance was crucial in Lipps' and Stein's argument. The most effective cases of empathic relation in the film experience are those in which the movement of the represented body elicits tension and creates a field of energy that vitalises the space between the character's body and the spectator's body.

In the case of strong elicitation of sensory responses, movements in film (both the meta-movements of the camera and the depicted movements of objects and subjects) can generate an effective internal *kinesis* in the spectator. The spectator is a sensitive subject who experiences a relationship with lived-bodies on-screen. Although these bodies belong to a fictional world and cannot be considered as ontologically analogous to his/her lived-body, they are phenomenologically similar (in their movements, postures and gestures). In this sense, the character's body should be conceived as a *quasi*-body. Empathy is a factor that 'fills the gap' between bodily presence of the spectator and bodily absence of the character thanks to the film's *mediation* (in the double sense of keeping separate and putting in contact) between the two lived-bodies, although that of the character is only a *quasi*-body.

Cinematic empathy

Empathy was first discussed extensively in film theory in 1953 in an essay by the Belgian psychologist Albert Michotte van den Berck on the emotional participation of the film spectator (Michotte 1991). Michotte states that the psycho-physiological *distance* of the spectator from the fictional events on-screen can be reduced by empathy, which acts to compensate for the 'gap' between direct and mediated experience. Empathy is defined as a psycho-physiological process that involves an immediate form of experience, that is to say something that occurs 'when we observe what someone else is doing and we ourselves live it in some sense, rather than just understand it at an intellectual level' (Michotte 1991: 209).

Michotte distinguishes between *motor* empathy and *emotional* empathy, connecting the sensorimotor component of movement to feelings, mental attitudes, judgements, thoughts, and all those categories of events that are intimately connected to the viewer's inner-self. Motor empathy, which develops progressively, precedes and accompanies emotional empathy: a structural homology allows the viewer to identify the movement seen on the body of the actor with that which is felt and experienced from the inside of his/her own body. When witnessing motor performances, for instance dance, acrobatics or sports competitions, the spectator's reactions can extend across a range.

Case 1: There is no empathy at all, in the case where the perceived movement and the spectator's motor reaction are clearly separated, that is to say there is a gap between visual impressions and their tactile-kinesthetic correlates. At the emotional level, the spectator and the character have quite different emotions.

Case 2: At the most basic level of empathy, the movement of the spectator accords with that of the character merely in the form of synchronisation, for instance following a musical or dance rhythm by tapping one's foot. The emotions of the spectator and those of the character are connected by some accidental or casual reason, such as when the criticisms made by one protagonist about the behaviour of another also apply to the behaviour of the spectator when confronted with a similar situation in real life. The spectator is directly affected by such criticisms, albeit due to a motivation external to the film. Such a situation is evoked by expressions like 'I join in your joy', or 'I share your pain'.

Case 3: Actual motor empathy occurs when the spectator reproduces the observed movement, such as assuming a facial expression similar to that of the character. This imitation takes place at the musculo-skeletal level and is less intense than that of the body that actually performs the movement. As in the Steinian description of empathy, this mirror-effect does not result in a fusion of inner states. It is as if there is a single action presented in two different forms (visual and proprioceptive), belonging to two distinct subjectivities.

Case 4: In the extreme case, an apparent fusion of subjectivities occurs (here Michotte mentions Lipps). The spectator 'puts himself into the skin' of the character: there is not only a single motor action, but also a single 'moving I' (Michotte 1991: 210–211). In this case, there may be a deep identification between the 'person' of the spectator and that of the character, in terms not only of motor imitation but also of emotional absorption (Michotte 1991: 214–215).

This stratification requires some elucidation. Case 1 includes the possibility that not necessarily every film experience will entail a kind of involvement, whether sensorimotor or psycho-affective. In these cases there is no reduction in the segregation of spaces: the spectator's experience consists solely of witnessing a fictional world that remains clearly distant. Case 2 describes a physiological activation due to a form of *pre*-empathy (rhythmic synchronisation). However, this form of basic activation must not be confused with empathy as such. Whereas an extreme level of fusion is realised in Case 4, where the total assimilation of subjectivities refers to an identification in which the viewer loses the knowledge of him/herself and fuses his/her own ego with that of the character, Case 3 corresponds to the relationship between the spectator and the character of a narrative film. Even if there can be shifts in and out of different levels of empathy, depending on a number of interfering factors (such as spectators' tiredness, low level of attention, state of mind) in general terms, Case 3 designates a range of psycho-motor correlations between motor and mental states that nevertheless preserves the separation between the subjectivity of the spectator and that

of the character, a process of sharing that does not result in absorption or substitution, but remains a 'contact at a distance'.

Feeling the other

It is this combination of sharing and separation that makes Case 3 akin to Stein's interpretation of the case of the acrobat. Both the spectator of the acrobatic performance described by Stein and the film spectator described by Michotte are involved in a *quasi*-intersubjective relationship, that is to say a relationship between the spectator's primordial body and the non-primordial, or *quasi*, body of the acrobat/character. The film character is a *quasi*-other, empathically experienced as the other's lived-body.

In this sense, Stein's model seems to provide a philosophical account of cinematic empathy. As we have seen, in phenomenological terms, empathy consists in primordially experiencing something that is non-primordially given. It is a primordial act of a non-primordial content. Analogously, the film experience of the relationship with the character could be thought of as the primordial experience (in the spectator's lived-body) of non-primordial movements and emotions (those that are performed and felt by the character's *quasi*-body). Both empathy and the film experience are intimate or 'immediate', experiences of an at-a-distance, 'mediated' experience. The nature of the film experience of narrative cinema as a *sui generis* form of intersubjective relationship between the spectator and the character is structurally empathic.

The pertinence of Stein's account of empathy for film theory lies not only in its *structural* analogy with the filmic experience, as just described, but also on the *processual* analogy between the stage of realisation of the empathic act and the dynamic of the film spectator involvement in the character. My argument is that the dynamic of empathy proposed by Stein is complete and complex enough to explain the psychological relationship between the spectator and the filmic *quasi*-bodies. Here is Stein's description of the empathic process:

> When [empathy] arises before me all at once, it faces me as an object (such as the sadness I 'read in another's face'). But when I inquire into its implied tendencies (try to bring another's mood to clear givenness to myself), the content, having pulled me into it, is no longer really an object. I am now no longer turned to the content but to the object of it, am at the subject of the content in the original subject's place. And only after successfully executed clarification, does the content again face me as an object.
>
> (Stein 1917: 9)

For Stein, empathy is a composite process, one that has at least three grades or modalities of accomplishment: (1) *the emergence of the experience*: suddenly, I see sadness on the character's face; (2) *the fulfilling explication*: I am involved in his/her inner state, I experience the sadness s/he lives by moving 'at' him/her, 'with' him/her in front of the same object; (3)

the comprehensive objectification of the explained experience: in the end, I am aware of the character's sadness (see Stein 1917: 10). In brief, at the starting stage, I am in front of the object, and I experience it with my senses. In the middle stage, a fulfilling explication drives me to the subject and drives me back. At the final stage, I am again in front of the object, and I receive it into my experience, I internalise it.

In the phenomenological framework, therefore, empathy is not a purely physiological reaction, nor a purely cognitive act. Rather, it is a *feeling* composed of different levels, namely perceptual, emotional and cognitive, grounded in the lived-body. The three levels seem to be parallel to the levels of filmic experience involved in relating to a main character on screen: (1) a *perceptual* act: I perceptually face a filmic body that expresses an external and internal state and attracts my attention and my senses; (2) this act is lived as an *emotional* act: I move closer and place myself 'at' the character, 'on his side', in front of the origin of his emotion; (3) this experience is objectified by a *cognitive* act: I exit, I move back and detach myself to face the object again, to cognitively perform a new objectification. Distance, proximity and distance again: empathy allows this psychological 'round-trip' of approaching, fulfilling and detaching. The distance moments correspond respectively to an optical and mental stage (emergence and interiorisation of the experience), whereas the core of the process is a 'rapture' in which disbelief is temporarily suspended and the spectator is fully immersed in the fictional events and has the impression of living an intimate relational experience. The oxymoronic structure of filmic experience consists in an 'e-motional' moment embedded in an optical-cognitive frame. The act of filmic empathy consists in the fulfilling of the *quasi-intersubjective* structure of the filmic relation.

The third body

At this point, it is important to delve into the specificity of the film experience in respect to the ordinary experience (that is to say, the specificity of cinematic empathy in respect to empathy in everyday life) and to focus on the nature of the medium that makes it possible to fill the gap that separates the spectator's body and the character's body. What makes the viewing of narrative film an experience with specific and autonomous traits is, in fact, the capacity of cinema to enhance stimuli and to enhance the receptivity of the audience through the potential of its specific 'bodily language'. A new kind of peculiar though specifically filmic body takes part in the cine-empathic relationship: the *film's body*. In the wake of Merleau-Pontyan philosophy, in the early 1990s Vivian Sobchack stated that, even in the film experience, the consciousness we have of both our own and the other's body is not a mere audio-visual perceptual act, nor a thought or a knowledge act, but rather a pre-reflective and pre-linguistic – that is, empathic – act:

> Even if the intentional objects of my experience at the movies are not wholly realized by me ..., I nonetheless do have a *real* sensual experience that is not reducible either

to the satisfaction of merely two of my senses or to sensual analogies and metaphors constructed only 'after the fact' through the cognitive operations of conscious thought.

(Sobchack 2004: 76)

In her view, film has a lived-body in the sense that it 'uses *modes of embodied existence* (seeing, hearing, physical and reflective movement) as the vehicle, the "stuff," the substance of its language' (Sobchack 1992: 4). Although film uses linguistic and technical means, its mechanical movements *embody* the human spectator's modes of experiencing the world: a close-up is the focusing of the viewer's attention on the character's face, a fluid tracking shot is the sinuous body of the film, a shadow on the wall is its discreet presence, etc. All these technical and representational solutions are calculated to betray the presence of a 'transparent' body. The spectator in his/her lived-body is moved by the movements of this peculiar and 'invisible' lived-body, which differs from the former in its concrete nature, but has a similar capability of expressing vital movements in tactile, muscular, cinematic terms.

In brief, the film spectator experiences the *vitality* and the human-likeness of a complex of anthropomorphic and non-anthropomorphic, or even technical-linguistic, filmic bodies. The film experience is an encounter between the *empathic* tendency of the spectator and the *expressive* properties of the film, two bodies that *move* together. The expressive power of the observed object can be 'designed' with accuracy by the film-maker and the actor, and is embodied into the film 'bodily language' (camera movements, editing, point-of-view etc.). The empathic relationship is established thanks to this *sui generis* bodily communication. The mediated nature of the film experience simultaneously gives a subjectual appearance to objects (they seem to act as if they are endowed with intentionality) and an objectual appearance to subjects (that remain images on a two-dimensional screen and occur under a certain aspectuality). Empathy is enabled by the intensification of the bodily dimension of viewing through a specific and effective way of 'moving' objects and subjects on the screen, aimed at generating a motor and emotional activation in the spectator.

The fate of the acrobat

In the light of this framework, both in order to explore the structural and processual analogy of the film experience and the empathic act and to analyse them in practice, let us consider a cinematic example. In the prologue of *Trapeze* (a drama film by American director Carol Reed, 1956), the acrobat Mike Ribble performs a triple somersault in front of two kinds of audience. The first audience comprises the spectators-*in*-the-film: extras acting as the crowd of people around the circus ring that follows the performance with bated breath. The second audience consists of the spectators-*of*-the film: real people who have gathered in a cinema auditorium to watch the acrobatic performance (and the circus audience) represented in *Trapeze*. This film excerpt allows us to focus on the different psychological situations of the two kinds of audience.

It is useful to note that *Trapeze* is a narrative film that makes a 'fictional pact' with the spectator: whereas the action of the acrobat is 'direct' for the spectator in the circus, the on-screen events are considered as far from being *real* (as in a documentary), and nevertheless they are considered as *realistic*, since the represented bodies appear as human, the image is photographic, and actions and events obey the physical rules that the spectators use to interpret the real world (for instance the acrobat does not fly). It must be clarified that in mediated experience like live television broadcasting, spectators' involvement mostly depends on the fact that the beholder knows that the events that he/she is watching are actually happening at that moment and cannot be manipulated (so an accident might occur). Cinematic images can involve the spectator in a more engaging experience through the utilisation of a narrative perspective (for instance the re-enactment of the performance with an actor, suspense-inducing music and fast editing). Every narrative text, in fact, makes a *pact* with its spectator, depending on the interpretative route proposed (Eco 1994: 75–96). This pact can be *referential* in the case where the object of the experience is reality, or *fictional*, when the spectator is invited to suspend his/her disbelief and accept the imaginary world represented.

Now, consider the audience reactions to Ribble's acrobatic performance and its tragic outcome. As Ribble loses his grip and falls down in the middle of the circus floor, spectators-*in*-the-film jump to their feet in an icy silence; some of them approach that motionless body with astonishment and fear, incredulous that the show has had such a dramatic conclusion. Both the suspense and the sense of suspension experienced by the spectators-*in*-the-film are strictly dependent on the actual danger of the performance, that is, on the physical presence of the acrobat's body, who is up there in the flesh – no tricks – at risk of falling. By contrast, spectators-*of*-the-film do not interfere with the events represented (they do not stand up or call the ambulance), since they are voluntarily disposed to view the represented events *as if* they are actually happening, although they maintain an awareness that those events are merely fictional. Given this peculiar psychological structure of the film experience, spectators-*of*-the film (or 'spectators', for short, henceforth) can experience the character's sense of vertigo, loss of balance and impact with the ground vicariously. Their sensorimotor and affective activations are realised by varying degrees of empathy. The degree and quality of motor activation and emotional involvement depend on the effectiveness of the forces and tension created by the movement of on-screen bodies, as well as on the tension and movement inherent in the film's body itself.

Following the framework constructed by the comparison of the Steinian account of empathy and Michotte's description of the film experience, a circuit of empathies can be recognised in the relationship between the spectator's and the film's lived-body. At an initial level of the involvement process, the spectator is in front of the fictional world: he/she is positioned 'in the middle' of the events, so that he/she in a way participates in the performance, rather than only witnessing it. Through a series of techniques (for instance camera angle, shot scale, point-of-view), the spectator is brought closer to the action. In *Trapeze*, thanks to the alternation of long shots and close-ups, only spectators in front

of the screen can see the fatigue on Ribble's face and the sweat on his forehead, or watch the action from above or just under the safety net, behind the trapeze or even clinging to the trapeze artist's belt. In addition to camera shots, camera movements also have to be considered. Conceived as film's body movements, camera movements do not simply produce a motor activation, but rather are capable of generating or implicitly suggesting a relation between the movement perceived on the screen and the movement that is internally experienced by the spectator. In the prologue of *Trapeze*, Ribble's pendulum movement in mid-air is shown not only by the overall view provided by the extreme long shot; rather, the camera follows the acrobat and sways, on both the horizontal and vertical axes alternately, in order to keep him in the centre of the visual frame. This film body movement *simulates* the character's movement, but it is also different and autonomous. Through this solution, the spectator can perceive the loss of balance elicited by the movements of the camera as it follows the acrobat. In this sense, he/she has an experience that is available only through film (Figure 4.1).

Emotional participation is connected to cognitive and narrative factors (for instance, if the character is shown in close-ups and his action dominates that of the other characters, then he must be the main character – and if he is, he cannot die in the first scene – but if the stunt is shown in the prologue, something bad is going to happen). Here the series of close-ups that precede Ribble's fall and the related camera movements enrich the involvement strategy. This group of shots places the spectator in the midst of the events, 'at' the heart of the emotion. Because of the closeness to Ribble's face and to the acrobats' hands, and because of the swaying camera movement, the spectator perceives the beads of sweat on Ribble's furrowed brow, the tension in the grip of the two trapeze artists hanging in mid-air and the hands slipping away. Then the hold is lost and Ribble falls. By means of a high-angle shot, the spectator sees the body falling, bouncing off the recovery net, and plunging to the ground. The impact with the ground is not shown: it is hidden by the re-establishing shot of the reaction of the spectators-*in*-the-film: they leap up, the orchestra stops playing, the trapeze keeps see-sawing without its artist. After the fall, by means of a low-angle shot, the spectator sees the bleak image of the trapeze that swings in the air, now empty, the reverberation of a movement performed by an absent body, a dramatic failure, the futility of a fictional spectacle into which reality is tragically plunged back, an action without an actor. These deep meanings are communicated by the film's body through a very powerful symbolic image that embodies a presence that is no longer visible. As in the Steinian model, the moment of detachment and objectifying interiorisation completes the empathic process. Here a more complex stage of empathy is at work, one which has fed on all the previous stages and now stands out and culminates in a reflective interiorisation, the 'comprehensive objectification' (Stein 1917: 10) of the other's experience, which nevertheless preserves distance.

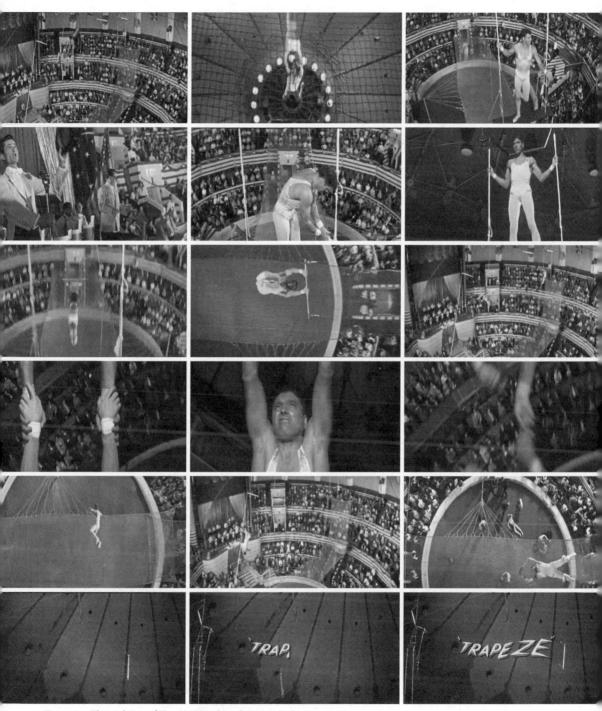

Figure 4.1: The prologue of *Trapeze* (Carol Reed, USA, 1956)

Conclusion

As the analysed example helps to clarify, cinematic empathy is a composite and developing dynamic that is rooted in kinesthetic and enteroceptive processes of the body and that is connected to the sensorial audio-visual activity of the beholder. As the brief overview of classic film theories (Freeburg, Epstein, Balázs, Arnheim, Eisenstein) I traced suggests, the extreme intensification of the senses is inherent in the nature of cinema, which since its origins offered the spectator particularly effective *motifs* of sensorimotor involvement (such as acrobatic performance). As in the filmological account of both motor and emotional empathy given by Michotte, a single movement depicted on-screen is experienced in two forms: the visual impression of the character's body in motion and the inner kinesthetic feeling experienced by the spectator *in* his/her body. The 'bridge' between visual 'external' perception and bodily 'inner' perception supports the rise of emotional empathy, that is a more complex relationship between the spectator's body and the character's *quasi*-body, both of which are to be conceived as lived-bodies in a phenomenological sense. According to Stein and Michotte (Case 3), the movements and emotions of the spectator's subjectivity remain extraneous to, or separate from, the character's *quasi*-subjectivity. Empathy implies an ontological separation that, nonetheless, represents the constitutive act of the film experience as a paradoxical 'proximity at a distance'.

Note

1. Editors' note: For a discussion of the relation between character and performer in film, see Chapter 8, Lucy Fife Donaldson, 'Effort and Affect: Engaging with Film Performance'.

References

Arnheim, R. (1954). *Art and Visual Perception: A Psychology of the Creative Eye*. Berkeley-Los Angeles: University of California Press.

Arnheim, R. (1957 [1932]). *Film as Art*. Berkeley-Los Angeles: University of California Press.

Balázs, B. (2010 [1924]). *Béla Balázs' Early Film Theory: Visible Man and The Spirit of Film*, trans. R. Livingstone. New York: Berghahn Books.

Eco, U. (1994). *Six Walks in the Fictional Woods*. Cambridge, MA: Harvard University Press.

Eisenstein, S. M. and Tretyakov, S. (1979 [1923]). 'Eisenstein's Early Work in Expressive Movement'. *Millennium Film Journal*, 3: 125–129.

Eisenstein, S. M. and Tretyakov, S. (1987 [1964]). *Nonindifferent Nature: Film and the Structure of Things*, trans. H. Marshall. Cambridge: Cambridge University Press.

Epstein, J. (1981 [1921]). *Bonjour Cinema and Other Writings*, trans. T. Milne. *Afterimage*, 10.

Freeburg, V. O. (1918). *The Art of Photoplay Making*. New York: Macmillan.

Husserl, E. (1960 [1931]). *Cartesian Meditations*, trans. D. Cairns. The Hague: Nijhoff.

Husserl, E. (1989). *Ideas Pertaining to a Pure Phenomenology and to a Phenomenological Philosophy,* Second Book: *Studies in the Phenomenology of Constitution,* trans. R. Rojcewicz and A. Schuwer. Dordrecht: Kluwer.

Lipps, Th. (1903). *Grundlegung der Ästhetik.* Voss, Hamburg-Leipzig: Voss.

Michotte, A. (1991 [1953]). 'The Emotional Involvement of the Spectator in the Action Represented in a Film: Toward a Theory'. In G. Thinès, A. Costall and G. Butterworth (eds), *Michotte's Experimental Phenomenology of Perception.* Hillsdale: Lawrence Erlbaum, 209–217.

Stein, E. (1964 [1917]). *On the Problem of Empathy,* trans. W. Stein. The Hague: Nijhoff.

Stein, E. (1991 [1920–1931]). *Einführung in die Philosophie.* In *Edith Steins Werke,* Vol. 13. Freiburg im Breisgau-Basel-Wien: Herder.

Sobchack, V. (1992). *The Address of the Eye: A Phenomenology of Film Experience.* Princeton: Princeton University Press.

Sobchack, V. (2004). *Carnal Thoughts: Embodiment and Moving Image Culture.* Berkeley: University of California Press.

Chapter 5

Musical Group Interaction, Intersubjectivity and Merged Subjectivity

Tal-Chen Rabinowitch, Ian Cross and Pamela Burnard

A pair of wings, a different mode of breathing, which would enable us to traverse infinite space, would in no way help us, for, if we visited Mars or Venus keeping the same senses, they would clothe in the same aspect as the things of the earth, everything that we should be capable of seeing. The only true voyage of discovery, the only fountain of Eternal Youth, would be not to visit strange lands but to possess other eyes, to behold the universe through the eyes of another, of a hundred others, to behold the hundred universes that each of them beholds, that each of them is.

(Proust 1913: 347)

The joint creation of music, which we shall call musical group interaction (MGI), is a powerful social-emotional medium. At its simplest, each MGI participant may have an almost separate subjective experience of the musical encounter. At its richest, MGI may elicit a complex entanglement between individual players entailing a fluid sharing of intentions, emotions and cognitive processes, which we shall call here intersubjectivity. As intense as intersubjectivity may become, individuals still feel themselves to be distinct subjects. However, under certain circumstances, this sense of distinction may be elided, leading to what we shall term 'merged subjectivity'. This involves a different kind of experience, where one subject may regard another participating subject almost as himself, to the point that one may experience another's sensations as one's own. In this chapter we shall first seek to explain how certain specific features of MGI may contribute to eliciting and intensifying intersubjectivity, and then explore how MGI may induce merged subjectivity.

Throughout, we shall be conceptualising music in terms of the commonalities that it exhibits across cultures. While music, in its structures and its uses, is inextricably bound to specific cultural contexts, all kinds of music of which we are aware display commonalities of function – and of construction – that allow music, as a broad human capacity, to be interpreted as a communicative medium with generic properties that can have profound social efficacy (Cross 2009).

MGI and intersubjectivity

MGI as a social–emotional medium

Music has served as a medium for certain types of human interaction, most likely from the dawn of humanity. Musical group interaction (MGI) is an integral component of ceremony and ritual across cultures, as well as a significant form of art and entertainment. These types of interactions are typically characterised by a relatively high level of social significance and emotionality. We argue that this is not by chance, but is rather due to several very powerful aligning and coordinating features that MGI possesses along with its strong emotional charge. We shall delve into these various factors in detail below, but first we wish to characterise the concept of intersubjectivity more generally.

A continuum of intersubjectivity

As social beings, we are in constant interaction with others, noting others, signalling to others and communicating and collaborating with others. These interactions are so dynamic that if a boundary were to be drawn between the individual and the collective experiences it would at times be quite ambiguous and would change from one instance to another. One way to describe this state of affairs is to conceptualise it as a continuum, extending from fragmented individual subjectivity towards highly coordinated group intersubjectivity. Our definition of intersubjectivity, somewhat similar to that of the psychologist Colwyn Trevarthen (Trevarthen and Aitken 2001), is a sharing of intentions, emotions and certain cognitive processes amongst subjects. Our definition emerges from a cognitive scientific perspective and is focused specifically on collaborative group activity. Important to our formulation is that intersubjectivity does not annihilate subjectivity, defined as the sense of individual consciousness and intentionality (Trevarthen 1979). Instead intersubjectivity is characterised by a better understanding of and identification with the other, which is elicited by the joint task that is being pursued, and at the same time also facilitates the execution of the task, thus creating positive feedback. The intensity and richness of intersubjectivity may vary according to the type and circumstances of the interaction and the individuals involved. As we shall suggest below, MGI may provide all the ingredients for boosting intersubjectivity by virtue of several of its distinguishing features.

Intersubjectivity in MGI

We propose that MGI may furnish a most fertile ground for directing social–emotional interaction towards the more intense manifestations of intersubjectivity, but how may this happen? In what follows, we shall analyse various elements that constitute MGI, from its

core components through its underlying mechanisms to the social contexts that it induces, and discuss their potential contributions to the intensifying of intersubjectivity between MGI participants.

Movement: Music is a profoundly kinesthetic activity. When we play music or sing, or even listen to music we are moving; moving hands, tongues, vocal chords, fingers, hips, lungs and knees. This movement resonates with the flowing nature of music as it evolves in time, segment interleaved into segment, beat replacing beat, so that in a way we feel we blend with the music. It is for this reason that theoretical analysis has placed special emphasis on movement in music perception (Webb 1769/2003; Langer 1953; Scruton 1997), and not surprisingly, music is often described and connoted in terms of movement (e.g. the flow of a melody, its harmonic moves and ultimately, its sectioning into units called *movements*). A similar kind of sensitivity and receptivity to movement as manifested in the perception and performance of music may be important for intersubjectivity. One of the prominent explanations in cognitive science for how individuals are able to understand and connect to one another comes from motor theories of cognition. According to the motor resonance theory, for example, a corresponding representation of a movement is activated while observing another person's movement, implemented perhaps by the mirror neuron system (Sebanz et al. 2006; Keysers 2009). This process of motor resonance has been suggested to facilitate action understanding (Blakemore and Decety 2001), however not without disagreement (Hickok 2009).

Emotionality: Music is also a powerful source or conveyer or inducer of emotion (e.g. Meyer 1956; Kivy 1980; Juslin and Sloboda 2001). Interestingly, it has been suggested that movement is one of the elements that mediates emotion in music (Webb 1769/2003; Langer 1953; Juslin and Västfjäll 2008). Similar to music itself, emotional processes are often described metaphorically in terms of movement (see for example James 1932; Laban 1960/1963; Payne 2006), such that they have a particular course of progression that is dynamic and amenable to alteration, and sometimes evokes action consequences or an 'action tendency' (Frijda 1986; Frijda et al. 1989). Thus, engagement in music is essentially a movement-based emotional engagement, entailing the augmented openness to emotionality that is also necessary for the sharing of emotions in intersubjectivity. As an example we consider a special unilateral case of intersubjectivity: empathy, defined as the ability to have emotional and experiential responses to the situations of others that approximate *their* responses and experiences (Lieberman 2007: 264). Empathy shares substantial elements with intersubjectivity both in its appearance and in the cognitive mechanisms on which it relies. However, the focus of the empathic process is mainly on *the other* (rather than it being a mutual process) and it involves an emotional and experiential response to the other's emotional state.

Imitation: So far we have seen that directing one's attention towards another's movement and emotionality, such as occurs whilst engaging in music, may be conducive to taking

part in a strongly intersubjective interaction. What is missing in this account is an aligning mechanism that can coordinate between MGI participants so that the interaction may consist of individuals not merely attending to and understanding each other's intentionality and emotions, but actually *experiencing* similar intentionality and emotions. Imitation can be one such coordinating mechanism. Imitation assumes a crucial role already in the very first musical interactions in life, those created by the mother–infant dyad (Dissanayake 2000). This early-engrained pattern of proto-musical engagement through imitation most likely persists throughout life, almost compelling us to imitate musical movement in two orthogonal ways. First, imitation of the movement alluded to by the music itself, as can often be seen when players seem to echo with their body the musical phrases that they are playing and the emotions that they are experiencing. Second, as is well documented, musicians often imitate each other's bodily gestures when playing together (Juslin and Västfjäll 2008; Overy and Molnar-Szakacs 2009). Several psychological studies have emphasised the critical role of imitation (or pretend play in literature on children) in the process of understanding (Piaget 1962; Meltzoff 1999; Meltzoff and Decety 2003). The act of imitation helps to assimilate the imitated action within the imitating person, almost as if the act were done by oneself. This self-enactment brings one closer to that which is being imitated, giving a personal impression of what it is like to 'be someone else' and enabling one to understand the other person's intentions and emotions (Gordon 1986). Thus, imitation may align players and render each other's intentions and emotions more accessible. This, in turn, may enhance intersubjectivity, increasing also the quality of the musical interaction.

Synchronisation: Music is essentially a temporal medium; it unfolds in time, but the flow of music is almost always organised around, and partly experienced in terms of, a train of pulses in the form of beats, underpinning music's diverse rhythms. In particular, synchrony, an essential component of music perception and production (Merker 1999), is most clearly manifested as a simple and overt form of entrainment, meaning the propensity of diverse sources of rhythm to adjust one to the other. In this case, synchrony involves the mutual alignment of players' rhythms around the felt pulse (Clayton et al. 2004), which is a fundamental process that is prominent in almost any musical interaction. Notably, the pattern of beats in a musical piece is typically irregular, in that the intervals between the main beats can change in length, usually in a gradual manner. Thus, in order to synchronise one must not only follow the beat but also constantly adjust to these changes. Moreover, especially in group improvised music, rhythm is frequently modified by any one of the players, entailing a complex interaction of a player attempting to stretch or squeeze the rhythm and the rest of the players recognising this and adjusting their own rhythmic production. Thus, synchronisation is an additional prominent aligning mechanism that enhances attentional and motoric coordination and cohesion between listeners, and especially amongst performers (Cross 2005, 2007). In the context of intersubjectivity, several recent studies have demonstrated a central function for beat-based synchronisation in refining social interaction, including a role in enhancing person perception (Macrae et

al. 2008), social perception (Miles et al. 2009), social cooperation (Wiltermuth and Heath 2009), and increased affiliation (Hove and Risen 2009). Moreover, the continuous and mutual adjustment to another person's pace may align not just rhythm and movement, but also affective dynamics (Cross 2005, Cross et al. in press) and intentionality (Cross 2005; Kirschner and Tomasello 2009).

Affiliation and trust: Finally, certain characteristics of the musical intercourse distinguish MGI from other, typically language-based, forms of social interaction by creating a special environment of affiliation and trust. In a nutshell, unlike language, music does not require mutual recognition of explicit reference by the interacting participants; rather it possesses a property of semantic indeterminacy that has been termed 'floating intentionality' (Cross 1999, 2005). At the same time music appears to 'mean like it sounds', seeming to express meaning directly and 'honestly' (Cross 2009). Thus music may provide a social context in which, even if participants hold different interpretations of the collective experience (due, for example, to entirely different cultural and social backgrounds: Burnard 2006), the open-endedness of musical expression does not foreground this. Each participant's individual sense that they are experiencing the meaning of the music 'naturally' encourages the perception that the experiences of other participants must be in alignment with their own. These special qualities of MGI may establish a basic sense of openness, affiliation and trust amongst players, such, for example, seems to have been the intention behind the formation of the West-Eastern Divan orchestra, pioneered by Daniel Barenboim and Edward Said in 1999. Correspondingly, certain related forms of affiliation, such as past acquaintance and a close relationship between interacting individuals, have been shown to strengthen self–other bonding (Aron et al. 1991), and trust has been suggested to be a key to successful joint action (Frith 2008) and intersubjectivity (Seemann 2009). Thus, in addition to the fundamental components of MGI (movement and emotion), and to the mechanisms that make MGI work (imitation and synchronisation), MGI can potentially induce favourable conditions of afilliation and trust, for augmenting intersubjectivity.

All this being said, it is important to note that while MGI can potentially provide excellent support for intersubjectivity, there are obstacles to be aware of. MGI is not always successful. There are many factors that can disrupt the harmony within the group, such as personal conflict, excessive competitiveness, unbalanced musical skills, lack of patience, unwillingness to cooperate and perhaps more than anything else, the great difficulty of stepping aside and accepting the group as a whole where no member dominates but rather all members embark on a joint project. However, with proper guidance and attention (see Cross et al. in press; Rabinowitch et al. in press), MGI can offer a perfect setting for strong intersubjective interaction.

MGI and merged subjectivity

Although intersubjectivity consists of a sharing of subjective experience and a collective alignment of intentions and emotions, the subjective boundaries of the participating individuals remain intact. To conclude this chapter we would like to explore the hypothetical possibility of a breaking of these boundaries or at least their blurring, transforming intersubjectivity into what we shall call merged subjectivity, temporarily replacing the initial individual subjects in the course of the interaction. We shall examine two particular aspects of MGI that we speculate may potentially evoke merged subjectivity.

Synchronisation

We have illustrated above the prominence of synchronisation in MGI as an aligning mechanism for the movements and emotions of individual players and its possible role in enhancing intersubjectivity amongst players. We now wish to propose a potential additional effect that synchronisation may have on musical interaction. In contrast to a single player who is expected to experience complete register between every sound that he produces and every sound that he hears, a group of synchronised players continuously experience a many-to-many coupling between what they play and what they hear, entailing a certain sensorimotor mismatch. In this manner a player might occasionally attribute to one's self a note or a sound originating from another player, or conversely not acknowledge that a certain sound that he/she played was produced by him/herself. It is conceivable that such a mismatch may perturb, to a certain extent, the foundations of subjectivity, disrupting the link between one's own intentions and actions, leading to a blurring of the normally rigid boundaries separating each subjective player, and culminating in instances of merged subjectivity, whereby players experience other players as being themselves. While at first glance this may sound perhaps like fantasy, it is interesting here to briefly examine a number of instances in which investigators were able to induce in participants a similar experience of recognising an external target as being part of themselves, albeit in non-musical contexts. Importantly, all of these studies used synchronisation as a method for induction typically producing in participants a visual–tactile sensory mismatch. The first, fairly recent study was performed by Botvinick and Cohen, who were able to rapidly elicit in participants the sensation that a fake rubber hand was their own rather than their real hand (Botvinick and Cohen 1998). This effect, known as the rubber hand illusion, was achieved by placing a participant's hand outside of their field of view, and positioning a rubber hand in its place and then repeatedly and synchronously stroking both fake and real hand with a brush. A related effect, dubbed enfacement, was obtained by similar means with the face, arguably an even more personal and distinct body part than the hand. A participant's face was stroked simultaneously with either a morphed image of their own face and another's (Tsakiris 2008), or someone else's face (Paladino et al. 2010; Sforza et al. 2010), resulting in a striking merge

with the other face. Perhaps the most remarkable feat was accomplished in two studies, in which participants were led to experience themselves entirely outside of their own body, in another location in the room (Lenggenhager et al. 2007; Ehrsson 2007). Here too, the effect was generated by synchronous stroking of a participant's back or chest and that of a virtual reality-projected body. The impact was so powerful that participants showed a strong emotional response, as measured by skin-conductance response to a hitting of the virtual body (Ehrsson 2007).

All these examples rely on synchrony to obtain a merging of the subject with an external target, and are all based on a mismatch between visual and tactile sensory input related to an action (stroking) performed on their body and on the target. Since synchronisation is such an essential component of MGI, there is good reason to believe that MGI may evoke comparable merged subjectivity. The big difference between MGI and the experiments described above is that in MGI the synchronisation-induced mismatch that we expect is between motor outputs and auditory inputs (although, there might also be a mismatch between motor outputs and visual inputs of the movements of the other players), rather than visual and tactile inputs. In addition, whereas the experiments were conducted in specially designed, unnatural laboratory settings, MGI is completely natural. It would therefore be of great interest to reveal whether indeed merged subjectivity does occur during MGI, and thus to extend to additional modalities and settings what we interpret to be merged subjectivity in the aforementioned findings.

Bregman's auditory scene analysis theory

A completely different putative source for merged subjectivity in MGI stems from the Gestalt-like property of the music created in MGI. It is generally thought that the various sounds of a musical piece are perceived as different streams that are integrated into one coherent unit of information (Bregman 1990). Bregman's auditory scene analysis (ASA) theory suggests that we make inferences about sources of sound in the real world using a set of schemas (learned patterns) that help us integrate them into coherent musical units. Concomitantly, the use of schemas could make it harder for us to disintegrate what we are used to perceiving as a unit, for example, tracing a chord sequence back to its constituent tones. As our tendency to integrate different sound sources and make 'musical sense' out of them stems from a very basic feature of perception in general (Ehrenstein et al. 2001), it is likely that when playing music together, as one gets absorbed in the music, it becomes harder and harder to discern the sources of the different sounds, to the point that one can no longer clearly tell whether the sounds being played were one's own or another's. This postulated effect may indeed help to make more 'musical sense' out of the interaction and keep all players in tune, but may also lead the musical interaction towards merged subjectivity, where not only do participants experience a shared intentionality in the music-making, but they may also perceive themselves as the agents of others' actions (and

vice-versa), thereby redrawing the boundaries of subjectivity. We suggest that in musical interaction, when the joint musical piece is perceived as a whole rather than a collection of segregated streams, players may be led to perceptually blend with each other, even though they are each producing their own distinct musical line, so that it is ultimately 'we' that are producing music and not 'I', making the relation between what 'I' produce and the actual music one hears less consistent. One could compare this situation to semantic transparency whereby, for example, blind readers of Braille are not aware of the touch or the movements they perform but immediately transform them into meaningful semantic phrases (Fuchs 2005). Analogous to these transparent movements of the Braille reader for whom only semantic meaning counts, is the other player who is not considered to be a separate entity, but is rather naturally incorporated as an integral part of the 'music'. At the same time, the thoughts, intentions and actions of the other players are physically and affectively aligned with oneself, as discussed above; this may create confusion and make me feel as if it is actually someone else who is playing the part I am currently performing or vice versa.

Conclusion and summary

MGI has the potential to intensify the intersubjective experience of the players. This self-reinforcing loop is due to a number of inherent components of MGI, the underlying cognitive mechanisms that are required for its successful achievement, and the atmosphere that it induces. It is further suggested that in some cases, MGI may also induce a merged subjectivity, whereby the boundaries separating self and other become blurred and players are led to experience the actions of their fellow players, at least in part, as their own. This too is due to particular features of MGI. It would be of considerable interest and value to devise ways in which intersubjectivity and merged subjectivity can be identified and analysed in musical interactions in real-world settings.

References

Aron, A., Aron, E. N., Tudor, M. and Nelson, G. (1991). 'Close Relationships as Including Other in the Self'. *Journal of Personality and Social Psychology*, 60 (2): 241–253.

Blakemore, S. J. and Decety, J. (2001). 'From the Perception of Action to the Understanding of Intention'. *Nature Reviews Neuroscience*, 2 (8): 561–7.

Botvinick, M. and Cohen, J. (1998). 'Rubber Hands "Feel" Touch That Eyes See'. *Nature*, 391 (6669): 756.

Bregman, A. (1990). *Auditory Scene Analysis: The Perceptual Organization of Sound*. Cambridge, MA: MIT Press.

Burnard, P. (2006). 'The Individual and Social Worlds of Children's Musical Creativity'. In G McPherson (ed.), *The Child as Musician: A Handbook of Musical Development*. Oxford: Oxford University Press, 353–74.

Clayton, M., Sager, R. and Will, U. (2004). 'In Time with the Music: The Concept of Entrainment and Its Significance for Ethnomusicology'. *ESEM CounterPoint*, 1: 1–82.

Cross, I. (1999). 'Is Music the Most Important Thing We Ever Did? Music, Development and Evolution'. In S. W. Yi (ed.), *Music, Mind, and Science*. Seoul: National University Press, 10–39.

Cross, I. (2005). 'Music and Meaning, Ambiguity and Evolution'. In D. Miell, R. MacDonald and D. Hargreaves (eds), *Musical Communication*. Oxford: Oxford University Press, 27–43.

Cross, I. (2007). 'Music and Cognitive Evolution'. In L. Barrett and R. Dunbar (eds), *Oxford Handbook of Evolutionary Psychology*. Oxford: Oxford University Press, 649–667.

Cross, I. (2009). 'The Evolutionary Nature of Musical Meaning'. *Musicae Scientiae, Special Issue on Music and Evolution*: 143–159.

Cross, I., Laurence, F. and Rabinowitch, T-C. (2011 in press). 'Empathic Creativity in Musical Group Practices'. In G. McPherson and G. Welch (eds), *The Oxford Handbook of Music Education*. Oxford: Oxford University Press.

Dissanayake, E. (2000). 'Antecedents of the Temporal Arts in Early Mother–Infant Interaction'. In N. L. Wallin, B. Merker and S. Brown (eds), *The Origins of Music*. Cambridge: MA MIT Press, 389–410.

Ehrenstein, W. H., Neil, J. S. and Paul, B. B. (2001). 'Perceptual Organization'. In *International Encyclopedia of the Social & Behavioral Sciences*. Oxford: Pergamon, 11227–11231.

Ehrsson, H. H. (2007). 'The Experimental Induction of Out-of-Body Experiences'. *Science* 317 (5841): 1048.

Frijda, N. H. (1986). *The Emotions*, Studies in Emotion and Social Interaction. Cambridge: Cambridge University Press.

Frijda, N. H., Kuipers, P. and Schure, E. (1989). 'Relations among Emotion, Appraisal and Emotional Action Readiness'. *Journal of Personality and Social Psychology*, 57: 212–228.

Frith, C. (2008). 'Social Cognition'. *Philosophical Transactions of the Royal Society B-Biological Sciences*, 363 (1499): 2033–2039.

Fuchs, T. (2005). 'Corporealized and Disembodied Minds: A Phenomenological View of the Body in Melancholia and Schizophrenia'. *Philosophy, Psychiatry, & Psychology*, 12 (2): 95–107.

Gordon, R. M. (1986). 'Folk Psychology as Simulation'. *Mind and Language*, 1 (2): 158–171.

Hickok, G. (2009). 'Eight Problems for the Mirror Neuron Theory of Action Understanding in Monkeys and Humans'. *Journal of Cognitive Neuroscience*, 21 (7): 1229–1243.

Hove, M. and Risen, J. L. (2009). 'It's All in the Timing: Interpersonal Synchrony Increases Affiliation'. *Social Cognition*, 27 (6): 949–961.

James, W. (1932). 'A Study of the Expression of Bodily Posture'. *Journal of General Psychology*, 7: 405–437.

Juslin, P. N. and Sloboda, J. A. (2001). 'Music and Emotion: Introduction'. In P. N. Juslin and J. A. Sloboda (eds), *Music and Emotion: Theory and Research*. Oxford: Oxford University Press, 3–20.

Juslin, P. N. and Västfjäll, D. (2008). 'Emotional Responses to Music: The Need to Consider Underlying Mechanisms'. *Behavioral and Brain Sciences*, 31 (5): 559–575; discussion 75–621.

Keysers, C. (2009). 'Mirror Neurons'. *Current Biology*, 19 (21): R971–R973.

Kirschner, S. and Tomasello, M. (2009). 'Joint Drumming: Social Context Facilitates Synchronization in Preschool Children'. *Journal of Experimental Child Psychology*, 102 (3): 299–314.

Kivy, P. (1980). *The Corded Shell: Reflections on Musical Expression*. Princeton, NJ: Princeton University Press.

Laban, R. (1960/1963). *The Mastery of Movement*, 2nd edn. London: Macdonald and Evans.

Langer, S. K. K. (1953). *Feeling and Form; a Theory of Art*. New York: Charles Scribner's Sons.

Lenggenhager, B., Tadi, T., Metzinger, T. and Blanke, O. (2007). 'Video Ergo Sum: Manipulating Bodily Self-Consciousness'. *Science*, 317 (5841): 1096–1099.

Lieberman, M. D. (2007). 'Social Cognitive Neuroscience: A Review of Core Processes'. *Annual Review of Psychology*, 58: 259–289.

Macrae, C. N., Duffy, O. K., Miles, L. K.and Lawrence, J. (2008). 'A Case of Hand Waving: Action Synchrony and Person Perception'. *Cognition*, 109 (1): 152–156.

Miles, L. K., Nind, L. K. and Macrae, C. N. (2009). 'The Rhythm of Rapport: Interpersonal Synchrony and Social Perception'. *Journal of Experimental Social Psychology*, 45 (3): 585–589.

Meltzoff, A. N. (1999). 'Origins of Theory of Mind, Cognition and Communication'. *Journal of Communication Disorders*, 32 (4): 251–269.

Meltzoff, A. N. and Decety, J. (2003). 'What Imitation Tells Us About Social Cognition: A Rapprochement between Developmental Psychology and Cognitive Neuroscience'. *Philosophical Transactions of the Royal Society B Biological Sciences*, 358 (1431): 491–500.

Merker, B. H. (1999). 'Synchronous Chorusing and the Origins of Music'. *Musicae Scientiae, Special Issue on Rhythm, Musical Narrative, and Origins of Human Communication*: 59–73.

Meyer, L. B. (1956). *Emotion and Meaning in Music*. Chicago: University of Chicago Press.

Overy, K. and Molnar-Szakacs, I. (2009). 'Being Together in Time: Musical Experience and the Mirror Neuron System'. *Music Perception*, 26 (5): 489–504.

Paladino, M. P., Mazzurega, M., Pavani, F. and Schubert, T. W. (2010). 'Synchronous Multisensory Stimulation Blurs Self-Other Boundaries'. *Psychological Science*, 21 (9): 1202–1207.

Payne, H. (2006). *Dance Movement Therapy: Theory, Research and Practice*, edited by H Payne. 2nd ed. New York: Routledge.

Piaget, J. (1962). *Play, Dreams, and Imitation in Childhood*. New York: Norton.

Proust, M. (1913/1934). *Remembrance of Things Past: The Captive*, Translated by C. K. Scott Moncrieff. New York: Random House.

Rabinowitch, T-C., Cross, I. and Burnard, P. (in press). 'Long-Term Musical Group Interaction Has a Positive Influence on Empathy in Children', *Psychology of Music*.

Scruton, R. (1997). *The Aesthetics of Music*. Oxford: Clarendon Press.

Sebanz, N., Bekkering, H. and Knoblich, G. (2006). 'Joint Action: Bodies and Minds Moving Together'. *Trends in Cognitive Sciences*, 10 (2): 70–76.

Seemann, A. (2009). 'Joint Agency: Intersubjectivity, Sense of Control, and Feeling of Trust'. *Inquiry*, 52 (5): 500–515.

Sforza, A., Bufalari., I., Haggard, P. and Aglioti, S. M. (2010). 'My Face in Yours: Visuo-Tactile Facial Stimulation Influences Sense of Identity'. *Social Neuroscience*, 5 (2): 148–162.

Trevarthen, C. (1979). 'Communication and Cooperation in Early Infancy: A Description of Primary Intersubjectivity'. In M. Bullowa (ed.), *Before Speech: The Beginning of Interpersonal Communication*. Cambridge: Cambridge University Press, 321–347.

Trevarthen, C. and Aitken, K. J. (2001). 'Infant Intersubjectivity: Research, Theory, and Clinical Applications'. *Journal of Child Psychology and Psychiatry*, 42 (1): 3–48.

Tsakiris, M. (2008). 'Looking for Myself: Current Multisensory Input Alters Self-Face Recognition'. *PLoS ONE*, 3 (12): e4040.

Webb, D. (1769/2003). 'Observations on the Correspondence between Poetry and Music'. In R. Katz and R. HaCohen (eds), *The Arts in Mind: Pioneering Texts of a Coterie of British Men of Letters*. New Brunswick, NJ: Transaction Publishers.

Wiltermuth, S. S. and Heath, C. (2009). 'Synchrony and Cooperation'. *Psychological Science*, 20 (1): 1–5.

Chapter 6

Kinesthetic Empathy and the Dance's Body: From Emotion to Affect

Dee Reynolds

Sensation is neither in the world nor in the subject but is the relation of unfolding of the one for the other through a body created at their interface.

<div align="right">(Grosz 2008: 72)</div>

By analogy with what film scholar Vivian Sobchack calls 'the film's body' (Sobchack 2004), I coin here the expression 'the dance's body' to designate a body that is not identified with a fixed subject position of either performer or spectator, but which is both 'here' and 'there', invested as subject and object in the shared materiality and affective flow of choreographed movement. Philosopher Susanne Langer remarked that 'In watching a collective dance – say, an artistically successful ballet – one does not see *people running around*; one sees the dance driving this way, drawn that way, gathering here, spreading there – fleeing, rising, and so forth; and all the motion seems to spring from powers beyond the performers' (Langer 1953: 175). What does it mean to 'see' the dance driving, drawing, gathering, spreading, fleeing, rising? How do the senses work together and flow in and out of each other in perceiving the dance? And whose body are we watching and feeling: the dancer's, our own or the 'dance's body'?

From at least the early decades of the twentieth century, Western theatre dance, along with prominent art forms such as painting and literature, began to explore the expressive content of the medium itself (in the case of dance, the dancer's movement) for its own sake rather than as a representational tool to convey a likeness or recount a story. This had radical implications for the role of spectators, who were now called upon to engage more closely with the medium of expression. It was in this context that in the 1930s the influential American dance critic John Martin argued that through kinesthetic response – that is engagement with the medium of dance rather than its representational content – the spectator could 'mimic' the dancer's movement and experience similar emotions (Martin 1939/1965: 47). Martin's approach has been critiqued on the grounds of its universalist assumptions and its linking of kinesthetic empathy with communication of emotion (Foster 2011:158). However, kinesthetic empathy has recently attracted renewed interest, fuelled in part by discussion within neuroscience of the evocatively named 'mirror neuron' system, the workings of which appear to parallel the embodied imitation that is central to kinesthetic empathy, and for which it may provide a 'neural substrate' (Damasio et al. 2007; Preston et al. 2002).[1]

In this chapter I focus on some of the problems of tying kinesthetic empathy to emotion and explore the implications of linking it with discourses on 'affect'. In social situations

involving communication, 'kinesthetic empathy' can have the function of facilitating mutual understanding, for example, by mediating interpretation of another's thoughts or motivations. While some theatre dance choreography, particularly in narrative genres such as Romantic ballet, foregrounds character, narrative and emotion, in other contexts these features may be of minimal importance compared with the choreographing of energies as outlined by Langer.[2] In these circumstances, 'kinesthetic empathy' as a mode of relating to choreographed movement in a performance can be described as engagement with kinesthetic intentionality, which inheres in the choreographed movement, rather than in the psychology of individual dancers or even the characters they may embody.

Spectators' embodied, affective responses to the *dance's* body are grounded in responses to the *dancer's* body, which generates kinesthetic energies. With such responses I argue that it is more appropriate to think of empathy in 'affective' rather than emotional terms. Affect as I use it here can be understood as embodied and as preceding the kinds of cognitive differentiations that separate out emotions into distinct and identifiable categories (such as happy, sad etc.). Affect denotes a stage where emotions are still in the process of forming and have not yet taken on a definable identity; indeed, they resist such definition. In terms of embodiment, affect refers to that point at which the body is activated, 'excited', in the process of responding; but this process has not yet reached consciousness to the extent of producing cognitive awareness that can be translated into language. Affect is related to increase in energy level (Burt 2009: 207), and kinesthetic affect involves an impulse towards or anticipation of movement rather than actual movement.[3] Through vision I locate the dancer(s) out/up there on the stage, and kinesthetic response occurs if I also internalise the movement and sense its processes in my own body. As movement sensation, kinesthesia works across senses and confounds boundaries between what the subject experiences as 'outside' and 'inside' the body. Some choreographic practices, which I term 'affective', foreground intermodal sensory perception, which interferes with visual distance and intensifies the spectator's corporeal engagement.

Empathy and affect

Empathy and affect are currently areas of considerable interest and scholarly activity in the arts and humanities and, in the case of affect, also in the social sciences.[4] Kinesthesia, which refers to the sensing of movement and position, is a less well-known concept. The term was coined by Charles Bastian in 1880. Since then, definitions of its meaning, and in particular its relation to proprioception have varied considerably (see Introduction to this volume). Kinesthesia is strongly intermodal, meaning that it is 'constituted across sense modalities' (Gallagher and Zahavi 2008: 95). This intermodality means that a movement or action can be experienced, for instance, both as a visual image and as a movement sensation; when perception of another's action is also experienced as one's own movement sensation, this process becomes empathic.

Empathy itself is a problematic concept. (See Introduction to this book.) Theatre scholar Rhonda Blair asserts that 'across the literature, in one form or another, there is consistent agreement on three basic attributes of empathy' and she defines these as 'an affective response to another person'; 'a cognitive capacity to take the perspective of the other person'; and 'some monitoring mechanisms that keep track of the origins (self vs. other) of the experienced feelings' (Blair 2009: 98–99).[5] In its strongest form, empathy involves embodied simulation and imagined substitution of one agent for another: for a fleeting moment, perhaps, I simulate your action, and in so doing I imagine that I occupy your place, that I am the vicarious agent of your movement, your experience, your utterance. Emotion is frequently regarded as a fundamental component of empathy, as in the statement that 'empathy is the ability to perceive and understand other people's emotions and to react appropriately' (Leiberg et al. 2006: 419). From an evolutionary standpoint it has been argued that human emotions have evolved to deal with a specific set of adaptive problems. Many emotion theorists in cognitive psychology posit the existence of basic emotions that are universally 'hardwired' and can be identified and labeled.[6] 'A widespread assumption in theories of emotion is that there exists a small set of basic emotions. From a biological perspective, this idea is manifested in the belief that there might be neurophysiological and anatomical substrates corresponding to the basic emotions' (Ortony and Turner 1990: 315). If this were the case it would facilitate empathic communication, which is both cognitive and emotional, as defined by neurologist Paul Eslinger: 'Empathy refers to the cognitive and emotional processes that bind people together in various kinds of relationships that permit sharing of experiences as well as understanding of others' (Eslinger 1998: 193).

However, emotions are difficult to classify, and Ortony and Turner point out the difficulties created by nomenclature: 'Some theorists use the term *anger* and others the word *rage* while presumably referring to the same emotion; some speak of *fear* whereas others speak of *anxiety*; and the same pleasant emotion may be labeled *happiness* by one author, *joy* by another; and *elation* by yet another' (Ortony and Turner 1990: 315). Furthermore, there is disagreement as to whether cognition must precede emotion, as this depends on one's definition of both (Loewenstein 2007).[7] Reducing emotions to basic types is therefore problematic, and tying empathy to emotions as fixed, definable categories attributable to autonomous subjects leaves it open to the critiques elaborated by the philosopher and social theorist Brian Massumi. Massumi describes emotions as recognisable and identifiable categories that are confined in particular bodies and subjects, and can be inserted in language. Emotion is 'the conventional, consensual point of insertion of intensity into semantically and semiotically formed progressions'; this 'sociolinguistic fixing of the quality of an experience' defines it as personal (Massumi 2002: 28). These characteristics represent a severe limitation and shutting down of possibilities. Massumi argues that because 'received psychological categories' (Massumi 2002: 27) are restricting, it is therefore 'crucial to theorize the difference between affect and emotion' (Massumi 2002: 28).[8]

'Affective turn'

The so-called affective turn in the arts and humanities provides an alternative approach to empathy in which it can be decoupled from models of emotional communication or relations of identification between autonomous subjects. In *Empathic Vision*, Jill Bennett chooses to consider empathy in terms of 'affective encounter' in preference to 'emotional identification' (Bennett 2005: 10). To be 'affected' is to be moved in an embodied sense, rather than in the more cognitive sense, which may be implied by emotional response, for example, to a fictive character. Bennett contrasts the sense of being 'touched by the plight of a character in a fictional narrative' with 'the more literal sense of being *affected*, stricken with affect' (Bennett 2005: 29). This implies that affective responses are not voluntary: they seek us out. Such affective embodied states cannot be categorised in terms of emotion, and are not tied to cognitive judgements, although they may trigger them. Also they are embedded in the contexts and histories of personal and cultural uses of the body. In the words of the theatre director and theorist Eugenio Barba: 'Each one of us is an *inculturated* body. He uses a daily technology of the body which derives from the cultural context in which he was born, from his family environment, from his work. This inculturation which our organism absorbs right from the first hours of our life constitutes our spontaneity, in other words a network of conditioned reflexes or of unconscious automatisms' (Barba 1993: 253). This means that even if responses feel spontaneous or are automatic, they are to some degree learned, and it follows that one can train one's response.[9]

As the human geographer and social scientist Nigel Thrift notes, 'there is no stable definition of affect' (Thrift 2004: 59).[10] However, many contemporary discourses on affect have a common grounding in the writings of philosophers Gilles Deleuze and Félix Guattari, for whom both Henri Bergson and Baruch Spinoza are important precursors. The ecological approach to visual perception in the work of psychologist James Gibson (1979) and the systems theory of anthropologist Gregory Bateson (1973) have also contributed towards these discourses, which extend across diverse disciplines, and foreground a mode of thinking where relation precedes separation. 'Coming-together, or belonging-together, takes logical and ontological precedence over discreteness of components and, in particular, over the subject-object separation' (Massumi 2002: 231). Massumi argues that we need to move away from thinking in terms of 'form' to 'field', where 'regions are separated from each other by dynamic thresholds rather than boundaries' (Massumi 2002: 34). 'Flow' is a crucial leitmotiv in this mode of thinking, which questions the privileging of models of discreteness and containment over fluid interactions. Social anthropologist Tim Ingold refers to 'the *fluid* character of the life process, wherein boundaries are sustained only thanks to the flow of materials across them' (Ingold 2010, my emphasis). Ingold challenges the binarism of 'brute materiality' and human agency: 'Things move and grow because they are alive, not because they have agency' (Ingold 2010). The concept of emergence (which is evolving) replaces that of form (which is fixed); dynamic thresholds replace boundaries and in place of connections

between bounded entities we have 'flows and counter-flows, winding through or amidst without beginning or end' (Ingold 2010).

Affect as fluid relationality, where belonging together precedes separation, is at odds with the idea of interpersonal connections between discrete 'self' and 'other', which is widely associated with empathy. While empathy presupposes discrete entities, which are subsequently connected, affect is not predicated on relationships between autonomous subjects (such as individual dancers and spectators). It presupposes relationality and fluid boundaries, which put into question humanist assumptions about subjects conceived of as 'unitary, autonomous, self-sufficient' entities (Blackman and Couze 2010: 21) and problematises emotion as discussed above. This relational way of thinking is particularly pertinent at a cultural moment that is strongly influenced by digital media and where, as Susan Foster notes, 'new technologies, integrated into our physicality, are challenging and transforming our capacity for empathy in everyday life. The new cyborgian bodies ... catch fugitive, flickering glimpses of one another's corporeal status as it transits, blurred into the prosthetic devices that intensify even as they obscure physicality' (Foster 2011: 168–169).

Taking a look at the history of empathy gives a further basis for linking it with affect rather than with communication of emotion. Philosopher Theodor Lipps' (1851–1914) influential early theory of empathy was less concerned with the question of understanding another's emotion than with aesthetic function and shared dynamism between subject and object. The German word *Einfühlung*, of which the English word 'empathy' is a translation, was coined by Robert Vischer in 1873 to describe 'the projection of human feeling onto the natural world' (Pigman cited in Blair 2009: 7). Lipps elaborated the concept with reference to aesthetic experience involving a process of 'feeling into' an object of contemplation. He argued, for instance, that a vertical line 'rises up or sinks down, depending on my observation' (Lipps 1923: 226).[11] This meant that, although the primary stimulus was visual, the object's effects were felt through the subject's activation of what Lipps termed 'inner mimesis' (Lipps 1920: 98).[12] Inner mimesis (*Nachahmung*) makes us feel that we are acting in and through the observed person or object. In watching an acrobat, for instance, 'I carry out the movements ... I am therefore up there. I have been moved up there. Not beside the acrobat, but right there, where he is' (Lipps 1923: 122). This leads to a feeling of one's own 'striving and inner performing, inner activity' (Lipps 1923: 131), which induces pleasure. 'My pleasure in architectonic forms is without doubt above all a pleasure in my inner expansion and concentration, in the whole inner movement which I perform while contemplating the forms' (Lipps 1920: 97–98). This was not a cognitive process: Lipps explicitly dissociated *Einfühlung* as 'feeling' from thinking, believing or judging and defined it rather in terms of pleasure or unpleasure in one's own inner activity (Lipps 1920: 3). Aesthetic experience is an 'objectified self-enjoyment' (Lipps 1920: 102). Even if we had access to what the other person was experiencing, this would not be of interest, and in fact the more we are ourselves active, the less we are aware of what the other is experiencing (Lipps 1923: 131).

Lipps' *Einfühlung*, then, did not involve communication grounded in cognitive or emotional responses. Instead it is predicated on dynamism and inner movement, which

increase one's sense of being active, which is enlivening, and is also referred to as 'life feeling' (Lipps 1920: 15). Affect, too, involves a process of becoming active, and a *perception of one's own vitality*, one's sense of aliveness'. Indeed, 'it is the perception of this *self-perception*, its naming and making conscious, that allows affect to be effectively analysed' (Massumi 2002: 36). Unlike affect, however, *Einfühlung* was not an embodied process: Lipps dissociated the pleasure of 'inner movement' from any muscular activity or kinesthetic sensation. He affirmed that *Einfühlung* must not be confused with movement sensations and changes in bodily organs, which are a matter of indifference (Lipps 1923: 131). This contrasts with affect, which is a 'becoming-active, in parallel, of mind and body' (Massumi 2002: 32). Moreover, whereas *Einfühlung* involves relations between discrete subjects/objects, which can culminate in an internalisation of the other, which confirms the subject's interiority and self-sufficiency, affect produces sensations which follow models of movement and flow across thresholds that cannot be contained within the boundaries of discrete subjects and objects.

As Massumi describes with reference to Spinoza, affect produces an interface between body and world, 'a state of passional suspension in which it [the body] exists more outside of itself, more in the abstracted action of the impinging thing and the abstracted context of that action, than within itself' (Massumi 2002: 31). From the perspective of affect, sensation cannot be located either in the subject or the object, but constitutes what philosopher Elizabeth Grosz calls a 'zone of indeterminacy between subject and object, the bloc that erupts from the encounter of the one with the other' (Grosz 2008: 73). Affect is not contained in individual bodies or minds because it is always in the process of becoming something else (Grosz 2008: 72). It is an intensity produced by the impossibility of 'capturing' emotion, which can be experienced only indirectly, as an unfolding, emerging, virtual event. Affect is not the binary opposite of emotion, but is rather predicated on the impossibility of its 'capture'. It is 'not *directly* accessible to experience', but 'not exactly outside experience either […] Intensity and experience accompany one another like two mutually presupposing dimensions or like two sides of a coin' (Massumi 2002: 33, my emphasis). Vivian Sobchack discusses such an intensification and impact in what she calls 'mimetic sympathy' (Sobchack 2004: 76) as an embodied response where inside and outside are experienced as reversible and one's body is felt to be no longer simply one's own, while the other's body is no longer simply 'other'. This is exemplified in her description of watching the opening scene of Jane Campion's *The Piano*: 'At the moment when Baines touches Ada's skin through her stocking, suddenly my skin is both mine and not my own: that is, the "immediate tactile shock" opens me to the general erotic mattering and diffusion of my flesh, and I feel not only my "own" body but also Baines's body, Ada's body, and what I have elsewhere called the "film's body"' (66). Here, the visual modality is punctured by a haptic sense of touching and being touched, which is both intensified and 'diffused' by virtue of being experienced as if at oneself and other, within and outside the body (65). Sobchack argues that the pleasure of the (cinematic) text is linked with this 'carnal subversion of fixed subject positions', which she refers to as the cinesthetic subject (67).

Like the 'film's body' and sensation as described by Grosz, the dance is 'neither in the world nor in the subject but is the relation of unfolding of the one for the other through a body created at their interface' (Grosz 2008, epigraph). Just as affect is a relational process, dance is a movement through and across bodies rather than being an attribute of the dancer's body. I want to suggest that the dance spectator can be invested as both subject and object in a shared materiality and flow of choreographed movement across dancers' bodies. This is a possibility that can happen with different types of dance, depending on how they are viewed; however, as I will go on to explore, certain techniques and choreographic approaches are particularly conducive to this experience. Affective empathy does not take as its object a perceived other, such as the dancer, but rather the dance's body, which is neither 'self' nor 'other'. The impact of affect on the body intensifies sensation such that the 'dance's body' as object of vision is also felt from within, 'enfolded' through kinesthesia. This affective kinesthetic empathy is similar to Sobchack's 'mimetic sympathy' or what the media theorist Derek de Kerckhove calls 'bodily miming' where 'we imitate or mime the events with our neuromuscular responses' (cited in Hansen 2004: 231); through this process, de Kerckhove argues, vision is assimilated into the body.

Affective choreographies

My intention here is to suggest ways in which dance and its affects can map onto and impact on our current understandings of empathy and embodiment. Some choreographies can be described as 'affective' in terms of how they unsettle inner/outer boundaries based on vision and provoke reflexivity by extending bodily sensations and working across the senses. The examples I discuss focus on the impact of sound, and in particular the sound of breathing, on the spectators' responses to the 'dance's body' – which is at once their own and not their own. In the research project, 'Watching Dance: Kinesthetic Empathy' (www.watchingdance. org) we collaborated with choreographer Rosie Kay, from whom we commissioned a piece expressly designed to explore the effects of the sound on viewers' experience. 'Double Points: 3x' was choreographed by Rosie Kay and performed by Kay and Morgan Cloud in front of a small invited studio audience. The dance had three sections with the same movement sequence being repeated three times, once with music by Bach, once with electroacoustic music, and once with choreographed rhythmic breathing as the only soundscore.[13] The performance was followed by three focus groups, one with experienced dancers and two with a range of spectators, most of whom were not trained dancers and whose experience of watching live theatre dance ranged from very experienced (up to 11 performances a year) to complete novices.

Many participants across all three groups remarked (both positively and negatively) on the impact of the breathing soundscore on how they perceived the dance. We noted that the viewers' visual relationship to the dancer could be disrupted and internalised through sound, notably sounds of breathing, which connected visual and auditory channels and

impacted directly on the viewer's own breathing. Similarly to the tactile in watching film as discussed by Sobchack, the impact of sound in watching dance can open up an affective, reflexive space within the body. Brangwen,[14] a professional ballet dancer, commented that 'it was quite staggering actually how much [difference] the sound of the breathing made to the visuals'. Brian, a musician and moderately experienced dance spectator, described the breathing as 'giving like an extra rhythm to it you know even when there was no music there'; it was 'like an extension of the body' and at times it 'made me feel quite tense'. The breathing affected many spectators physically, increasing their sense of closeness to the dancer and impacting on their own breathing patterns. Some found these effects discomfiting, partly because they disliked the strong sense of physical presence and intimacy (Nicole, an experienced spectator of a range of dance styles, commented: 'when there was, when there was no music, I found that it was too intimate, I felt too close'), but also because it affected their bodily processes beyond their volition by making them 'hyperventilate' (Margaret) or 'feel uncomfortable and breathless' (Rebecca).

Cultural theorist Mark Hansen argues that bodily sensations are actions of the body on itself through which it can become both virtual and reflexive. The function of affect is to 'extend' bodily sensations such that they produce a reflexive, conscious experience of embodied virtuality. 'Bodily sensations are themselves extended: they *are themselves actions*, and as actions of the body on itself, they open up an expressive – that is, affective – space within the body' where 'the body is felt from within, rather than seen from without' (Hansen 2004: 224–225). This 'experience of one's own bodily virtuality' (Hansen 2004: 226) is bound up with interconnection of the senses, which act on each other in a transformative fashion. 'Affect is synesthetic … the measure of a living thing's potential interactions is its ability to transform the effects of one sensory mode into another' (Massumi 2002: 35). Rather than a fusion of senses (as in clinical synesthesia, where a sensory input is involuntarily 'translated' into another, such as seeing a sound), in this dynamic interchange the senses 'fold into and out of each' (Massumi 2002: 182). Where vision is affected in this way (in this case by sound), it can be enfolded into a proprioceptive feedback loop. Discussing 'skulls', a sculptural installation by Robert Lazzarini (2000), Hansen argues that this work disrupts visuality in a way that requires us to move '*from a modality of vision (perception) into a modality of bodily sense (affection)*' (Hansen 2004: 228, italics in original). The skulls have a warped shape whose complex folds and hollows 'generate a total short-circuiting of vision and a violent feeling of spatial constriction' (229–230). While Hansen describes an inflection of the visual by the tactile, in the case of 'Double Points: 3x', watching was inflected by the sound of breathing, a cross-modality of the senses, which for some spectators short-circuited visual distance, provoking a reflexive affectivity.

Another piece of research that showed how a soundscore can impact on spectators was based on very different viewing conditions: the film *Loose in Flight* (2000), choreographed and performed by Akram Khan and directed by Rachel Davies, was viewed on the Watching Dance website,[15] so on a relatively small screen, probably alone, and with the opportunity to re-view. Viewers were prompted by questions on the website to reflect on their experience.

Many of those who chose to leave comments (anonymously) described how the sounds that they perceived as breathing undermined visual distance, confusing boundaries between the dancer's body and their own: 'The sound of breath made me connect more to Khan's movements and feel them in my own body'; 'The breaths in the audio of the film immediately captured my attention and focus. In fact it made me feel uncomfortable. It made me connect with the entire film and dance in a personal, internal way. Very cool effect to achieve without being a live performance'. (Interestingly, the latter comment shows that what is uncomfortable can also be 'cool'.) Several viewers reported changes in their breathing and their own awareness of this effect. For instance, one viewer described 'the sensation of my breath being taken away … I literally felt my lungs pause for a moment'. Here, the visual stimulus of the dance is internalised in embodied responses, which are both the viewer's own and not their own: the impact of the dance is in body-to-body affect enacted in a kinesthetic mimesis, even against the viewer's volition, which produces an action of the body on itself and leads to a reflexive response. This embodied and reflexive affect again exemplifies a proprioceptive feedback loop, which can lead to embodied cognition. Moreover, as Massumi argues (cited above), the perception of 'self-perception', 'its naming and making conscious, allows affect to be effectively analysed' (2002: 36).

The work of contemporary choreographer William Forsythe provides another example of this kind of affective choreography in his deliberate exploration of spectators' modes of perception and experimentation with how bodily sensations can be extended by working across senses and opening up affective spaces where the body can act on itself and become both virtual and reflexive. Forsythe foregrounds embodiment and makes demands on performers and spectators that are sometimes overwhelming in their complexity. Freya Vass-Rhee, dance scholar and dramaturg for the Forsythe Company, describes Forsythe's recent choreography as 'an engagement with the intermodal potential of bodies in motion', and in particular aural-visual convergences based in 'the muscular contiguity of the dancing body's external surface and vocal apparatus' (Vass-Rhee 2010: 389). The dancers' moving bodies generate both visual images and aural perceptions, such that one 'hears the dance'. This process can be interpreted in terms of affect, where choreography functions as action of the body on itself, and draws attention to this process. 'Forsythe directs attention within and across the senses not only to heighten audience focus but also to direct attention to attention itself' (Vass-Rhee 2010: 390). For instance, the 'radical, emotionally driven corporeal dramaturgy' of 'Decreation' (2003) is based on 'complex, writhing counter-torsions of the entire body: limbs, spine, face, and eyes', which the spectator can see, but these torsions also produce a 'sonic rendering of the state of the body' (Vass-Rhee 2010: 393). In this way, the movement is both heard and seen; the visual and the aural do not function as bounded senses but rather flow in and out of each other. Through the breathing we experience the movement from the inside as well as see it from the outside; we feel the interweaving of kinesthesia and proprioception, and the object of our perception is at one and the same time the dancers' performance and our own intermodal processing. Affect escapes confinement in particular bodies, operating rather at the interface of body and world, and the 'body' in

question here cannot be equated either with my own body or with that of the dancer: this emergent, virtual body belongs neither to the dancer nor the spectator but 'is the relation of unfolding of the one for the other through a body choreographed at their interface' (Grosz 2008, cited above) – the 'body of the dance'.

Referring to his 1995 'Eidos: Telos', Forsythe declared in 1998 that 'There tends to be a universal desire to project narration into dancing, and one of the things I always want to say is that you don't have to understand this, you just have to watch it, and then maybe something will happen to you without thinking' (cited in Boenisch 2007: 17). In stating that conceptual understanding is not necessary to engage with dance, Forsythe is not saying that he does not care about epistemology. On the contrary, he sees dance as a field of knowledge and is hoping for a mode of engagement where the spectator will allow themselves to be 'affected' by the work in a way that can provoke epistemological shifts (Forsythe 2010). His former dramaturg Steve Valk described dance as an 'epistemological tool to deconstruct aspects of what we think, how we are in the world' (Valk 2010).

Affective empathy

Linking kinesthetic empathy with affect rather than emotion means that it can be viewed as embodied intensity that impacts the spectator kinesthetically. The punctual impact of affect can be described as a sudden shock, localised in an event (Massumi 2002: 36), which registers both perception and escape. Forsythe's technique of 'engaging thresholds of perception; saturating performance spaces with complex, competing information' and 'thwarting expectations through unexpected juxtapositions, shifts or interruptions' (Vass-Rhee 2010: 389) can produce such effects of shock. We cannot register what escapes, but we can register the escape itself, and this process leads to thought of a more profound kind than could be reached by a straightforward cognitive route. Through embodied response, affect has the capacity to 'act on thought' and to '*force* us to think' (Deleuze 1973: 160).

Certain choreographic practices are predicated on responses in which affective kinesthetic engagement with the 'dance's body' takes precedence over emotional, empathetic engagement with the 'dancer'. Clearly there are other strategies that drive choreography and motivate viewers to go and watch dance.[16] However, a significant strand of recent and contemporary choreography is concerned with extending embodied knowledge, not primarily through virtuosic movement but rather through exploring how 'the unknown manifests itself as present in what we know' (Valk 2010). This involves new ways of choreographing and also new ways of perceiving, which are 'directly about intensities, transformations' (Massumi 2010). Such choreographies break through habitual patterns of moving and perceptual modalities to explore the processual, relational and changing dimensions of embodied knowledge. Returning to the scenario outlined earlier of multiple dancers moving in changing configurations, this multiplicity can in itself challenge our way of perceiving by making us uncertain where to focus our gaze. Interestingly, discussing this

situation with Brian Massumi and Erin Manning, Forsythe expressed the view that 'to follow one individual is a disaster' (Forsythe 2010). On this view, the tension between focussing and unfocussing, which arises when what we see has not yet been formed into coherent, identifiable units (which could be described as 'chunking'), is a stimulating and valuable aspect of the experience of watching dance.

Some spectators may find this approach too extreme. Indeed, interestingly our research found that some spectators do very consciously follow individual dancers. For others, however, it is an opportunity to experience a mode of perception, which 'is directly about intensities, transformations', where the world 'hasn't yet chunked' (Manning and Massumi 2010). The words of Theodor Lipps on *Einfühlung* are pertinent here, when he refers to 'the giving oneself over to this or that which engrosses me; so that kind of being driven and allowing oneself to be driven … I mean this "'flow"' in contrast with all simple inner being or standing still at one point. In brief, I mean precisely that which I designate as "inner movement." … all that which inheres in our *life feeling*' (Lipps 1920: 8). In affect, such 'feeling' and 'inner movement' are directly embodied, and also hold open contradictory possibilities, thereby producing a virtual dance's body at the interface between performer and spectator, which challenges established frameworks of how we come to know and to move in the world.

Acknowledgements

Thank you to Fiona O'Neill and Freya Vass-Rhee for their helpful comments. The research referred to here was carried out as part of the Watching Dance: Kinesthetic Empathy project funded by the Arts and Humanities Research Council. While the author acknowledges support from colleagues on the project, the views expressed are not necessarily those of the whole project team.

Notes

1. 'Neuroscientific research has consistently found that the perception of an affective state in another activates the observer's own neural substrates for the corresponding state, which is likely the neural mechanism for "true empathy"' (Damasio et al. 2007: 254). Preston and de Waal write that 'While mirror neurons alone cannot produce empathy of any kind, they do provide concrete cellular evidence for the shared representations of perception and action that were postulated by Lipps (1903) and Merleau-Ponty (1962/1970) and behaviourally demonstrated by Prinz and colleagues (Prinz 1997)' (Preston et al. 2002: 10).
2. For a fuller discussion of energy in dance, see Reynolds (2007).
3. According to neurophysiologist Alain Berthoz, anticipation involves simulation of an action, which is accompanied by 'an accumulation of energy awaiting the moment of release' (Berthoz and Petit 2008).

4. See, for instance, the special issue of *Body and Society* on 'Affect' 16 (1).
5. This would be regarded by some as an attribute of sympathy rather than empathy.
6. For instance, Silvan Tomkins argued that it was possible to identify nine distinctive and innate affects, each with their corresponding biological expression. See Tomkins (1962, 1963, 1991 and 1992). Others argue that rather than being discrete, 'affective states are not independent of one another' (Russell 1980: 1161).
7. Neuroscientist Joseph LeDoux argues that the nature of emotions varies according to how they are processed, which can range from 'automatic subcortical processing' to higher cognitive, sometimes conscious processing. The latter is carried out by 'prefrontal areas that appraise (whether consciously or unconsciously) the situation in the light of external situations and contexts, episodic and semantic memories and emotional signals within the brain and body' (LeDoux 2007: 402).
8. For neuroscientist Antonio Damasio, emotion (like affect) is embodied. Massumi's 'affect' is closely related to Damasio's embodied, non-conscious 'emotion' and writing on Spinoza, Damasio uses the terms 'affect' and 'emotion' interchangeably (Damasio 2003: 11–12).
9. Yvonne Rainer referred to a 'well-toned empathy'. Cited in Burt (2009: 210). See also Sklar (1994).
10. Thrift's article gives an insightful account of different approaches to affect.
11. All translations from Lipps are my own.
12. John Martin cited Theodor Lipps and may have derived the term 'inner mimicry' directly from him. See Reynolds 2007.
13. See http://www.watchingdance.org/research/Research%20activities_RK/index.php, accessed April 2011.
14. All names have been changed.
15. http://www.watchingdance.org/discussion/discussion_2.php, accessed April 2011.
16. For a discussion of different viewing strategies adopted by dance spectators see Reason and Reynolds (2010) and Reynolds (2010).

References

Barba, E. (1993). 'Le corps crédible'. In Odette Aslan et al. (eds), *Le Corps en jeu*. Paris: CNRS, 251–61.

Bateson, G. (1973). *Steps to an Ecology of Mind*. London: Granada.

Bennett, J. (2005). *Empathic Vision: Affect, Trauma, and Contemporary Art*. Stanford, California: Stanford University Press.

Berthoz, A. and Petit, J.-L. (2008). *The Physiology and Phenomenology of Action*, trans. C. Macann. Oxford: Oxford University Press.

Blackman, L. and Couze, V. (2010). 'Affect'. *Body and Society*, 16 (1): 7–28.

Blair, R. (2009). 'Cognitive Neuroscience and Acting: Imagination, Conceptual Blending, and Empathy'. *TDR: The Drama Review*, 53 (4: Winter): 92–103.

Body and Society, Special Issue on Affect, 16 (1), March 2010.

Boenisch, P. M. (2007). 'Decreation Inc.: William Forsythe's Equations of Bodies before the Name'. *Contemporary Theatre Review*, 7 (1): 15–27.

Burt, R. (2009). 'What the Dancing Body Can Do: Spinoza and the Ethics of Experimental Theatre Dance'. *Writing Dancing Together*. R. Burt and V. Briginshaw. London: Palgrave Macmillan, 204–216.

Damasio, A. (2003). *Looking for Spinoza: Joy, Sorrow and the Feeling Brain*. London: William Heinemann.

Damasio, A. R., Preston, S. D., Bechara, A., Damasio, H., Grabowski, T. J., Stansfield, R. B. and Mehta, S. (2007). 'The Neural Substrates of Cognitive Empathy'. *Social Neuroscience*, 2 (3 & 4): 254–275.

Deleuze, G. (1973). *Proust and Signs*, trans. R. Howard. London: Allen Lane, The Penguin Press.

Eslinger, P. J. (1998). 'Neurological and Neuropsychological Bases of Empathy'. *European Neurology*, 39 (4): 193–199.

Forsythe, W. (2010). Motion Bank, Frankfurt, 6 November 2010. http://motionbank.org/en/. Accessed 2 January 2011.

Foster, S. (2011). *Choreographing Empathy: Kinesthesia in Performance*. London: Routledge.

Gallagher, S. and Zahavi, D. (2008). *The Phenomenological Mind: An Introduction to Philosophy of Mind and Cognitive Science*. London: New York.

Gibson, J. J. (1979). *The Ecological Approach to Visual Perception*. Boston: Houghton Mifflin.

Grosz, E. (2008). *Chaos, Territory, Art: Deleuze and the Framing of the Earth*. New York: Columbia University Press.

Hansen, M. B. N. (2004). *New Philosophy for New Media*. Cambridge, MA: MIT Press.

Hewitt, A. (2005). *Social Choreography: Ideology as Performance in Dance and Everyday Movement (Post-Contemporary Interventions)*. Durham, North Carolina: Duke University Press.

Ingold, T. (2010). 'Bringing Things to Life: Creative Entanglements in a World of Materials'. Retrieved from www.manchester.ac.uk/realities/publications/workingpapers/. Accessed 20 January 2012.

Klien, M., Valk, S. and Gormly, J. (2008). *Book of Recommendations: Choreography as an Aesthetics of Change*. Limerick: Daghda.

Langer, S. (1953). *Feeling and Form: A Philosophy of Art developed from 'Philosophy in a New Key'*. London: Routledge and Keegan Paul.

LeDoux, J. (2007). 'Unconscious and Conscious Contributions to the Emotional and Cognitive Aspects of Emotions: A Comment on Scherer's View of What an Emotion Is'. *Social Science Information*, 46 (3): 395–403.

Leiberg, S. and Anders, S. (2006). 'The Multiple Facets of Empathy: A Survey of Theory and Evidence'. *Progress in Brain Research*, 156: 419–440.

Lipps, T. (1920). *Ästhetik: Psychologie des Schönen und der Kunst. Zweiter Teil: Die ästhetische Betrachtung und die bildende Kunst*. Leipzig: Leopold Voss. First published 1906, Vol. 2.

Lipps, T. (1923). *Ästhetik: Psychologie des Schönen und der Kunst. Erster Teil: Grundlegung der Ästhetik*. Leipzig: Leopold Voss. First published 1903, Vol. 1.

Loewenstein, G. (2007). 'Defining Affect'. *Social Science Information*, 46: 405–410.

Manning, E. (2010). Motion Bank, Frankfurt, 6 November 2010. http://motionbank.org/en/. Accessed 2 January 2011.

Martin, J. (1965). *Introduction to the Dance*. New York: Dance Horizons. First published 1939.

Massumi, B. (2002). *Parables for the Virtual*. London: Duke University Press.

Massumi, B. (2010). Motion Bank, Frankfurt, 6 November 2010. http://motionbank.org/en/. Accessed 2 January 2011.

Ortony, A. and Turner, T. J. (1990). 'What's Basic about Basic Emotions?' *Psychological Review*, 97 (3): 315–311.

Preston, S. D. and de Wahl, F. B. M. (2002). 'Empathy: Its Ultimate and Proximate Bases'. *Behavioral and Brain Sciences*, 25: 1–72.

Reason, M. and Reynolds, D. (2010). 'Kinesthesia, Empathy and Related Pleasures: An Inquiry into Audience Experiences of Watching Dance'. *Dance Research Journal*, 42 (2, Winter): 49–75.

Reynolds, D. (2007). *Rhythmic Subjects: Uses of Energy in the Dances of Mary Wigman, Martha Graham and Merce Cunningham*. Alton: Dance Books.

Reynolds, D. (2010). '"Glitz and Glamour" or Atomic Rearrangement: What do Dance Audiences Want?'. *Dance Research*, 28 (1, May): 19–35.

Russell, J. A. (1980). 'A Circumplex Model of Affect'. *Journal of Personality and Social Psychology*, 39: 1161–1178.

Sheets-Johnstone, M. (1999). *The Primacy of Movement*. Amsterdam: John Benjamins.

Sklar, D. (1994). 'Can Bodylore be Brought to Its Senses?' *The Journal of American Folklore*, 107 (Winter): 9–22.

Smith, M. (1995). *Engaging Characters: Fiction, Emotion, and the Cinema*. Oxford: Clarendon Press.

Sobchack, V. (2004). *Carnal Thoughts: Embodiment and Moving Image Culture*. Berkeley: University of California Press.

Thrift, N. (2004). 'Intensities of Feeling: Towards a Spatial Politics of Affect'. *Geografiska Annaler*, 86 B (1): 57–78.

Tomkins, S. (1962). *Affect Imagery Consciousness, The Positive Effects*, Vol. 1. New York: Springer.

Tomkins, S. (1963). *Affect Imagery Consciousness, The Negative Effects*, Vol. 2. New York: Springer.

Tomkins, S. (1991). *Affect Imagery Consciousness, The Negative Effects: Anger and Fear*, Vol. 3. New York: Springer.

Tomkins, S. (1992). *Affect Imagery Consciousness, Cognition: Duplication and Transformation of Information*, Vol. 4. New York: Springer.

Valk, S. (2010). Motion Bank, Frankfurt, 6 November 2010. http://motionbank.org/en/. Accessed 2 January 2011.

Vass-Rhee, F. (2010). 'Auditory Turn: William Forsythe's Vocal Choreography'. *Dance Chronicle*, 33 (3): 388–413.

Part III

Kinesthetic Impact: Performance and Embodied Engagement

Introduction

Matthew Reason

When we as an audience watch performers – whether live or on screen, whether in theatre, dance or on film – we are watching other people who are explicitly presenting themselves for us to watch. It is an open and clear invitation for the audience to watch them – watch them act or dance or move or simply be – that is different to the way we might look at people in everyday life. There is a to-be-looked-at-ness of the *explicit performance* that is particular and worth considering within the context of kinesthetic empathy. This part explores kinesthetic empathy through three chapters that engage with kinesthetic impact, communication and embodied engagement in the particular contexts of film and theatre.

Of course the way we might watch another person in everyday life has many similarities with how we might watch an explicit performance. Most crucial is the shared embodied characteristic of the relationship. To put it abruptly, but hopefully without necessarily evoking an absolute universalism, the relationship is an intersubjective one of mutual and similar embodiedness. This is clearly the case in both everyday relations and in engagement with explicit performances in film and theatre. One difference, however, is that the explicit performance is carefully staged and constructed for us to watch; and moreover we know this and it influences how we watch, what we see and how we interpret and respond to this.

In her chapter 'Kinesthetic Empathy in Charlie Chaplin's Silent Films', Guillemette Bolens writes about the impossibility of translating the kinesthetic components of film in language, but then provides exquisite and powerfully evocative descriptions that almost disprove her own statement. One of these descriptions is of a scene where a scoop of ice cream slides inexorably down the trouser leg of Chaplin's character. Through Chaplin's performance the spectator is invited to bring the perceived experience into their own sensorial and cognitive system. Bolens describes kinesthesia as something that can only be known through direct immediate sensation, here the sensation of gestures and twitches caused by the ice cream slowly sliding down naked skin. In contrast, our audience experience of the ice cream sliding

down trousers is the product of kinesic communication, which is based upon perception and internal simulation drawing on our own kinesthetic memory. For Bolens, Chaplin's particular genius is in his use of kinesis to draw upon the audience's own kinesthetic sensitivity and induce precise, if vicarious, embodied sensorial perceptions.

There is a difference, therefore, between Chaplin's *explicit performance* of ice cream sliding down the trouser leg and what you might imagine to be the experience of watching ice cream slide down my leg in a café or similarly everyday context. This difference is not one of kinesthesia, that is of the degree or nature of the sensorial experience of the particular individual concerned, but rather a difference of kinesic communication, and the projection outwards through explicit performance. Bolens' chapter proceeds to outline various examples of this, exploring how Chaplin frequently seeks to implicate the viewer in screen actions, through devices such as the complicit gaze towards the viewer, and thereby boost our participation and kinesthetic engagement.

In her chapter, 'Effort and Empathy: Engaging with Film Performance', Lucy Fife Donaldson similarly remarks upon the difficulty of writing about what a body does in performance, noting that while clearly central to our experience of watching film, the challenge of accounting for the actor's performance has led to its general preclusion from scholarly consideration. Donaldson engages with the fluid and problematic relationship between the physicality of character and the actor's bodily performance. In this instance this is a relationship between Mia Farrow and the character of Rosemary in Roman Polanski's film *Rosemary's Baby*.

By engaging in a close reading of one particular scene from *Rosemary's Baby*, Donaldson explores how the audience's response is shaped and crafted through the access that the camera provides to the body of the actor. She notes how the scene provides little focus on Farrow's face but a great deal on her body, and this combines with point of view shots to invite the spectator to share Rosemary's physical position and construct an empathetic, embodied sensation of her vulnerability.

Again a crucial point to note here is that Farrow's *explicit performance* is staged for us: by her performance, by the camera and by editing. It is, as Donaldson notes, also mediated through our awareness of genre and our cultural understanding of form and media. All of these elements serve to invite the audience to participate kinesthetically and emotionally through internal embodied simulation of the seen actions of the performance. It is these crafted, constructed and artificial elements of the explicit performance that serve to heighten its communicative impact and kinesthetic effect on the audience.

Rose Parekh-Gaihede's chapter 'Breaking the Distance: Empathy and Ethical Awareness in Performance' shifts discussion from screen to live performance. The liveness of theatre removes the shaping and mediating role of the camera, but the theatre performance remains very much an explicit performance. Like Bolens and Donaldson, Parekh-Gaihede's chapter presents a number of meticulous and evocative close readings of particular performances, particular moments and even more particular gestures.

Parekh-Gaihede's own contribution to this debate is to explore how the spectator's empathetic and embodied engagement with an explicit performance has potential ethical implications. Drawing on Žižek and Lévinas, the chapter describes how the ethical challenge of this meeting is the paradox that distance between self and other is actually an intrinsic part of ethical empathic engagement, which necessitates a (potentially mutual) recognition of what cannot be shared. She explores how directors and performers can construct sudden and even shocking moments of empathy that break boundaries of detachment or critical distance. This invites a momentary meeting between the self and the other that creates interactions and tensions between the familiar and the unfamiliar. Through such empathic but 'non-possessive' encounters, which avoid folding the other into the self in a manner that elides difference, we recognise the limits of empathy. This of course is one of the central challenges for conceptualisations of kinesthetic empathy, which in claiming embodied intersubjective communication risks also asserting a universalism and sameness.

Away from the particularities of Parekh-Gaihede's argument I find it interesting to consider the ethical implications of kinesthetic empathy in relation to the other two chapters in this part. We might consider how Chaplin's kinesic communication is motivated to inspire a heightened sense of his character's humility and perhaps through that a heightened reflection on our own humility. For Donaldson the invitation via the camera to the audience is to adopt a particular relationship with Rosemary's body, certainly empathetic but at times also predatory to her vulnerability, which represents a filmic replaying of the complex social and cultural relationships with the female body.

The three chapters in this part provide an evocative insight into particular performances and together represent a meticulous working through of how kinesthetic engagement with film and theatre performance can alter a spectator's emotional and cognitive states. The overarching insight they provide is that through kinesthetic engagement with the explicit performance, the audience becomes more than a passive observer but a participant and witness who is implicated in the seen action. It is this kinesthetically driven implication that provides the enduring impact of witnessing the explicit performances of film and theatre.

Chapter 7

Kinesthetic Empathy in Charlie Chaplin's Silent Films

Guillemette Bolens

As a performer and director who came of age during the era of silent film, Charlie Chaplin resisted the pressure of turning to the 'talkies' for 13 years after the advent of audio synchronisation in cinema. The first film with synchronised dialogues, *The Jazz Singer*, was released in 1927 and Chaplin did not use synchronised dialogues until 1940 for *The Great Dictator*. Kenneth Calhoon points out that *City Lights* (1931), 'used sound largely to ridicule sound, remaining essentially a silent film' (Calhoon 2000: 381). The 'talkies' of the 1930s were excruciatingly talkative. I propose that such constant linguistic noise deflected the audience's attention from kinesis and the silent narratives Chaplin was able to create with so much acuity. The expressive register of kinesic and kinesthetic communication was paramount in Chaplin's art, more than discursive meanings and verbal conceptualisations. According to Alan Dale, 'slapstick doesn't *say* anything about our condition as physical beings, though that is its one great subject. It simply nudges our feelings about this condition, with an uncloying, anxious cheerfulness that doesn't force a resolution to those feelings' (Dale 2000: 27). Silent films were a perfect medium for a kinesic genius such as Chaplin, who was able to juggle with complex gestural expression and resist emotional simplification.

Irresistible kinesthesia

Kinesis is perceived and kinesthesia is sensed (Bolens 2008: 1–33; 2010). I cannot directly experience another person's kinesthetic sensations, whereas I may share kinesic perception with others, for instance, if we watch the same gesture. However, I may infer kinesthetic sensations in another person on the basis of the kinesic signals I perceive in her movements. In an act of kinesthetic empathy, I may then internally simulate what these sensations may possibly feel like, via my own kinesthetic memory. Kinesthetic empathy plays a central role in Chaplin's art, and several scenes strike me as particularly revealing of the artist's astute attention to it and to the expressive potentials of its manifestation. One of them is in *His New Job* (Essanay, 1915).[1] The Tramp (Chaplin) watches a solitary squatting gambler (played by Ben Turpin), whose strenuous dice throwing induces in Chaplin's legs increasingly pronounced empathic reactive gestures. The tempo and jerking tension of Turpin's resolute arm are transferred to the leg of the highly responsive character played by Chaplin. This scene is about nothing else but kinesthetic empathy, and it displays the kinesic manifestation

of this intersubjective phenomenon in a way that is simultaneously focused, nuanced and irresistibly funny.

Kinesthetic empathy is also staged in *City Lights*. The Tramp accompanies a millionaire to a fancy restaurant. When drunk, the millionaire sees the Tramp as his life-saving friend and, when sober, as a total stranger. In the restaurant, after dinner, the dance floor is suddenly covered with couples dancing with intense stamina. The shot initially shows the orchestra gesticulating along to the energetic musical sound track (of scores composed by Chaplin himself), and then pulls back to the dancers. The camera glides along the floor towards their rapidly shuffling feet, and then leads us towards the rhythmically stamping feet of the Tramp sitting tipsy at a table. He is entranced by the energy of the dance and the frenzy of the crowd. A lady walks onto the dance floor and, while awaiting her partner, launches into a choreography of vigorous body-shaking right in front of the Tramp. When, the next second, a more dignified lady passes by him, the Tramp can no longer resist the urge. Seized by a tornado of kinesthetic impulses, he grabs the dignified lady and zooms across the dance floor in a high-speed series of intense twirls. The husband of the dizzied lady quickly and strenuously intervenes, leaving the ever-spinning Tramp with empty hands that end up dangerously clasping a tray-holding waiter's waist. Almost killed by the autonomous momentum of his own body, the Tramp – after a last series of rapid twirls – finally collapses into the welcoming arms of the drunken millionaire.

This extraordinary scene centrally stages kinesthetic empathy in action. Watching dancers, the Tramp experiences a series of kinesthetic sensations, which build up into a motor urge that he has no means to repress. Chaplin's facial expressions humorously highlight the fact that the Tramp does not control his body's responsiveness to his empathic faculty: he cannot help feeling and enjoying what he sees. Chaplin's choreography calls to mind the idea that 'Through kinesthetic imagination, unforeseen movement possibilities are generated directly from kinesthetic events' (Reynolds 2007: 187). In relation to Merce Cunningham's expression 'slips of the feet', Dee Reynolds argues that 'If a choreographer can proceed through "slips of the feet", this undermines the notion that the dance is controlled by a sovereign subject. Indeed, kinesthetic imagination implies a decentred model of subjectivity' (Reynolds 2007: 187). The dance of the Tramp in *City Lights* is a remarkable incarnation of decentred subjectivity leading to unanticipated movement possibilities.

As far as the viewer is concerned, the effect is also that of 'de-centering' (Reynolds 2007: 14), through elation. Laughter for Chaplin's viewer has little to do, primarily at least, with social, rational, moral judgement, or any sense of superiority or incongruity, implying a self-possessed, ever-cohesive and coherent subject.[2] To begin with, if we laugh at the scene, we do so on the basis of our own kinesthetic empathy. Laughter here implies that we know kinesthetically why the Tramp starts dancing. This type of knowledge pertains to a cognition that is embodied (Gallagher 2005; Gibbs 2006; Pecher and Zwann 2006). If the viewer cannot rely on her own sensorimotor intelligence and kinesthetic knowledge to make sense of the Tramp's manifestation of empathy, then the scene is thoroughly incomprehensible. The fact that our self-control is perhaps greater (and so we remain seated in front of the screen) does

not diminish our readiness to make sense of Chaplin's movements via kinesthetic empathy. Thus, we do not laugh primarily because we feel superior in refraining from dancing; we laugh primarily because we know intimately why the Tramp starts dancing; we know what it feels like to feel like dancing when seeing others dance. In this sense, we are made to relate via laughter to a decentred subject who is shown to experience an overwhelming kinesthetic empathy. Sameness here (between the Tramp and the viewer) is that of a decentred subject (the Tramp and us), whose corporeity, in multifarious ways, makes sense of its lack of control and expresses it via dance and laughter.

Perceptual simulations

The expressive art form of silent films can serve as a magnifying glass focusing our attention on the ways that intersubjectivity feeds on kinesic communication, kinesthetic imagination and interlocutors' readiness to make sense of each other's gestures and expressive movements. Most physical comedies of the silent era are based on fast motion and complex gestures, which are unproblematically understood by spectators despite the speed and intricacy of the perceived movements.[3] The first stage of the viewer's comprehension is non-conceptual (Damasio 1999; Jeannerod 2007). A vast and fast-increasing number of neuroscientific studies suggest that 'the human brain understands actions by motor simulation', which is 'based on direct correspondence between the neural codes for action observation and for execution' (Calvo-Merino et al. 2005: 1243; Berthoz 1997 and 2009). Further, the neural simulation of movement appears to be instrumental in the comprehension of gesture and hence in social cognition and intersubjectivity.[4]

The astounding quality of Chaplin's acting constantly succeeds in triggering complex sensorimotor simulations. Beside motor sensation, a simulation may pertain to various senses, such as sight and touch. In *The Adventurer* (Mutual, 1917), for example, Chaplin's character escapes from jail and, one thing leading to the next, he finds himself courting the daughter of a judge in the latter's very own house. Sitting with the daughter (Edna Purviance) on a balcony, he is offered ice cream in a bowl. Baffled by this culinary novelty, he shoves the scoop in one piece onto his spoon in order to drink from the bowl. While he is drinking, the scoop falls into his trousers. The acting that ensues constitutes a moment of kinesic perfection, which is utterly impossible to translate verbally. My point, however, is that perceptual simulation is activated in the viewer by means of subtle and acute gestures of discomfort, following a first moment of surprise at the volatilisation of the ice cream. An alarmed but discreet awareness dawns on Chaplin's character, who slightly collapses his chest in consternation and then starts fidgeting, until he manages to divert the pretty girl's attention and make the ice cream glide down his trouser leg and exit onto the floor. During the time that the ice cream scoop has disappeared from sight into his trousers, Chaplin's kinesis induces an extraordinarily precise vicarious sense of the ice cream's tactile and thermic presence. The uncanny sensation is understood by means of a perceptual

simulation triggered by the quality of his acting. With a poorer actor, the viewer would certainly understand the situation conceptually and contextually, but the sensation of melting and gliding coldness would be less vivid or entirely missing. Thus, Chaplin's kinesis makes an absent, invisible and unfelt object (the scoop of ice cream) present in the viewer's sensorial and cognitive system via the multimodal perceptual simulation the latter is liable to produce.

In order to enhance the viewer's propensity to generate perceptual simulations, Chaplin frequently uses the technique of directing his gaze towards the camera. While fidgeting in discomfort and becoming aware of the ice cream's migration down his trousers, the Tramp looks towards the camera several times. Each glance lasts only a split second, and this sharp tempo heightens with extreme economy and efficacy the viewer's engagement in the scene. The audience's participation is strongly increased by such glances, as a gaze can be enough to elicit reactions of attention (Grosbras et al. 2005). The fact that Chaplin looks at the camera, not actually at the audience, does not hamper our responsiveness to the phenomenon of the gaze. We *feel* looked at and our participation is thereby boosted, fuelling our propensity to generate perceptual simulations. Chaplin's triggering gaze makes us vicariously feel the ice cream more intensely. The precise tempo and kinesic quality of his furtive peeks are key to the success of the effect. Indeed, other slapstick artists used the gaze towards the camera, but quite differently, and with various results. Roscoe Arbuckle, alias Fatty, would stare insistently towards the audience for sustained moments whose impact pertained to a humour of bold seduction.[5] Buster Keaton, in contrast, was reluctant to use the gaze towards the camera and, on the rare occasions when he did, the effect, equally powerful, is of increased distance rather than proximity with the viewer. For instance, in *The Scarecrow* (1920), Buster looks at 'us' right before deliberately dropping himself backwards off a wall; in *Sherlock Jr.* (1924), he suddenly stares at the camera with extreme anxiety when he finally understands that he is sitting on the handlebars of a racing motorcycle that lost its driver a while ago (Bolens 2010). Such scenes are aesthetically impressive and emotionally startling, but they do not induce a sense of complicity or proximity.

Chaplin practiced the gaze towards the camera in order to pull the viewer into the action via her perceptual simulations. Another scene in *The Adventurer* exemplifies this. The Tramp is sitting with Edna, watching dancing couples. One couple is formed of a gigantic and heavy lady clasped by her short and skinny partner. The camera frames the seated Tramp swiftly glancing sideways towards the lady's large moving behind, which happens to be rather close to his face. After the first discreet peeks towards the lady's posterior, the Tramp pulls out of his shirt a pin and looks at 'us' for half a second. Then he starts picking his teeth with the pin. The camera shifts to Edna who, slightly worried, bends a little forward towards the Tramp, who giggles. This scene is very short but is apparently the final result of many long takes and much discarded footage (Brownlow and Gill 1983). In the scene, Chaplin creates complicity by looking towards the camera, prompting the viewer to produce a potential gestural simulation and to infer the Tramp's intention. We seek to make sense of the Tramp's gesture, and we infer that he is pulling a pin out of his shirt in order to prick the moving rear

end of the dancing lady with it. Yet, the Tramp never performs this action. Rather, in our kinesic imaginations, we do – or at least those of us who chuckle at this scene do. For, our laughter suggests that we infer the thought flickering through the Tramp's mind. In an effort to figure out his intention, we simulate the unperformed gesture of pricking. In *Action in Perception*, philosopher Alva Noë states, 'As a matter of phenomenology, the detail is present not *as represented*, but *as accessible*. Experience has content as a potentiality. In this sense, the detail is present perceptually in my experience *virtually*. Thanks to my possession of sensorimotor and cognitive skills, I have access to nearby detail' (Noë 2004: 215). Thanks to her sensorimotor and cognitive skills, Chaplin's viewer simulates the potentiality of the pin – and her reaction may turn out to be of laughter or something else (a wince of empathic pain, perhaps, or embarrassment, spite, irritation for the ridicule inflicted on a woman because of her weight, etc.). Whatever the reaction, as long as there is one, it suggests that the viewer gained access to the potentiality in the Tramp's suggestive pin handling.

There follows the Tramp's own laughter. The meaning of his giggle is multi-layered because Chaplin's acting triggers the viewer's simulation and participation. By refraining from performing the transgressive gesture, the Tramp saves himself from a kind of social attention by which he would run the risk of disappointing beautiful Edna and of being noticed, caught and taken back to jail, a possibility reinforced by the fact that prison is the setting of the next scene. While not physically enacted, the Tramp's desire to violate the social protocol and find momentary gratification in shocking the lady's bottom is nevertheless fulfilled, owing to our perceptually simulated intervention. He does not do it, yet it is done – virtually, thanks to our complicity, regardless of whether we are reluctant or enthusiastic accomplices.

At this stage of my analysis, kinesic simulations are used consciously: I deliberately make inferences based on the fact that I recognise my simulations to be generated by Chaplin's movements. The possibility – and sometimes necessity – of using perceptual simulations consciously can be observed in the viewer's reception of two scenes in Chaplin's *The Immigrant* (Mutual 1917). The Tramp plays cards with a group of men. He shuffles the pack cut into two even halves. His gestures are lithe and expert, but when about to join the two halves of the pack to mix them, each of his hands shuffles only one half of the cards, keeping the two stacks separate from each other. Because his gestures are skilled, the other players do not react to the fact that the Tramp blatantly avoids mixing the pack while pretending to do so. The humour of the gag comes from the success of this overt moment of bluff, and Chaplin's audience understands the gag thanks to a kinesic simulation used consciously: unless we simulate the gesture that the Tramp avoids performing (i.e. mixing together the two halves of the pack of cards) and hence think of the missing gesture, we remain blind to his bluff, just like his game partners.

Later the same group plays dice. At one point, the Tramp, standing, throws dice three times, systematically performing the movements of a baseball pitcher as a prelude to the dice dropping. The baseball move consists in twisting the torso sideways while raising the elbow above the head before throwing the ball. This move usually goes with a sideways

lifting of the knee towards the belt. Chaplin performs the upper part of the move only, and rather poorly at that. Yet, this gestural misapplication achieves the comical illusion of professionalism. Cognitively speaking, the viewer enjoys the scene if she appreciates the way in which athletic pseudo-agility is applied to a game of chance. For, no skill is needed to play dice. By definition, dice is not a sport; one cannot train and thereby become a dice champion. Thus, Chaplin's art in this scene requires a reception that spans several levels of what may be called kinesic intelligence: neuronal in a spontaneous reactivity to motor stimuli; cognitive via perceptual simulations that mediate access to gestural meaning; and analytic when we use our knowledge of cultural practices, such as sport (baseball) or gaming with artefacts (card shuffling, dice throwing) to grasp the meaning, complexity and coherence of the perceived kinesic event. The ability to span these various levels constitutes kinesic intelligence, a form of intelligence that precludes a body/mind dichotomy.

Bluff and intensity

Kinesic intelligence is indispensable to decipher and practice the complex social and psychophysical phenomenon denoted by the term *bluff*.[6] An instance of kinesic bluff is in *The Kid* (First National 1921). At one point in this film, the Tramp chases the orphanage cart in which the kid has just been abducted. He succeeds in getting hold of the child again and forces the cart driver to run away. As the latter soon stops at a distance and looks back, the Tramp performs a hilarious movement of kinesic bluff, engaging in an overacted, hyperbolic gesture of physical threat, twisting his entire body in a mimicry of rocketing, albeit immediately halted, speed. His kinesis serves to show that he is *pretending to intend* to chase the driver. He reiterates this move three times, until the orphanage employee gives up and runs off.

 This beautifully ostentatious gesture of bluff contrasts with another scene in *The Kid*, where the Tramp, after struggling to the last, has nevertheless lost the child and all hopes of return. He walks towards his empty house and looks at its locked door. The extreme intensity of this moment is conveyed by one detail: the Tramp clumsily twirls his hat twice while looking at the door. Apparently nothing, yet a thousand times more powerful than any tear or facial contortion. The loss of the child is a catastrophe beyond qualification, which only silence can communicate. To communicate silence in a silent film, Chaplin expresses *nothing* and marks the deliberateness and forceful expressiveness of this choice with one of the most trivial of all possible place-holder gestures: twirling a hat. The effect of such a gesture at this point in the narrative calls to mind Carrie Noland's claim that 'The project of culture might be to marry modes of kinesis to specific meanings, but as embodied signifiers, gestures are more vulnerable to dehiscence (less fixed by convention to their signifieds) than scriptural signs' (Noland 2009: 39). Chaplin's expressive power is correlated to his playing with gestures' semiotic volatility.

Chaplin's art is unforgettable because it makes room for such volatility, thus gesturing towards the irreducible complexity and expressive resourcefulness of humans. Alan Dale stresses that Chaplin's 'great early inspiration' was to flout character coherence 'with both hands and a flourish' (Dale 2000: 38): 'in this early style, Chaplin always defers his ultimate definition of the figure by adding something out of the blue that doesn't add up but is unforgettable – *because* it doesn't compute' (Dale 2000: 39), say, twirling a hat when in despair.

> Chaplin's range as a performer is less restricted than Lloyd's or Keaton's. Neither of them ever played a character as stylistically volatile as the Tramp or as extreme as the ranting Great Dictator. Chaplin can go so far because he interprets his physique for us as implying that this wisp could never belong anywhere, to anyone, and so the common social restrictions on behaviour don't apply to him. Chaplin originally used this freedom to be less, as well as more, delicate: he would play the less against the more.
>
> (Dale 2000: 59)

Owing to Chaplin's expressive freedom and range, and because gestures are more readily vulnerable to semiotic *discoherence* than linguistic signs, delicacy in Chaplin's art cannot be reduced to sappiness.[7] In this regard, the last scene of *City Lights* is famous. Numerous interviews confirm that it is common for viewers not just to weep a tear or two, but to plainly sob at this short sequence.[8] Why? Are we all mawkish saps? An accusation of sentimentalism seems hardly sufficient to account for the pervading impact of this scene. The scene is silent on a double front. On the one hand, Chaplin was still resisting the 'talkie' when no one else would. By doing so, he maintained his audience's focus on kinesic expression. On the other, the acting of Virginia Cherrill (playing the Blind Girl) is remarkably sober. The documentary *Unknown Chaplin* by Kevin Brownlow and David Gill includes test footage of another actress performing this scene. Chaplin had great difficulties with Virginia Cherrill. He fired her and then hired her back; he clearly disliked her. The story is well known. At some point, he decided to ask Georgia Hale, the female lead in *The Gold Rush* (1925), to take a shot at the final scene, and he almost remade the film entirely with her. The extant test footage shows a stark difference in acting between the two, Georgia Hale, a fine actress, and Virginia Cherrill, an inexperienced actress. Hale keeps moving her face, putting forth expressions of endearment and amazement (that is, the signals she was expected to emote); Cherrill hardly moves a single facial muscle. And yet she is a million times superior. The moment of suspension created by her immobility and the concentration of her gaze are superior to any skilful and stylised gestures. Chaplin's genius shows in his ultimate choice of her performance over Hale's, despite the personal friction between them.

Cherrill's acting is remarkably powerful because it activates kinesthetic empathy in the viewer by means of kinesic suspension at the climax of the narrative. Here she stands, cured, able to see again thanks to the money dearly earned by the Tramp who unjustly spent almost a year in prison for it. When free again, the Tramp is in a state of misery

that exceeds his previous neediness. Right in front of the Girl's flower shop, he happens to be humiliated by newspaper boys, as they pull a piece of his shirt or underwear out of a hole in his trouser bottom. He angrily snatches away the torn piece of clothing, chases the boys in an effort to kick them with an extended leg, readjusts the shoe he almost lost in the action, and then wipes his nose with the torn rag before stuffing it into his breast pocket. In short, he is now on the very lowest rung of the social ladder, if not fallen off the ladder altogether, and just an inch short of losing his last shred of human dignity and composure.[9] Then, looking up, he suddenly finds himself face-to-face with the Flower Girl. She still believes her saviour to be a handsome millionaire; she spends her days waiting for his reappearance. Separated by the glass window of the shop, she sees a tramp spellbound by her sight and she giggles. Then, while forcing a charitable coin into the Tramp's hand, she recognises his touch and freezes. A shift in the musical score written by Chaplin highlights the event of her recognition. After a few seconds and one or two words on caption, instead of letting go of his hand, she minimally draws it towards her. This is delicacy raised to a remarkable expressive height. He is a living scar and she keeps hold of him. And the film ends. Nothing needs to be added.

I propose that the efficacy of the scene lies in the way in which the Flower Girl's minimalist movement activates the viewer's kinesthetic empathy more powerfully than any conventionally skilled and expressive yet 'noisy' gestures. Cherrill's absorption and immobility are vibrant and induce in the viewer the possibility to kinesthetically simulate and hence witness sensorially and emotionally the potential magnitude of an intersubjective contact based on radical reciprocal respect and acceptance. Cherrill's 'kinesic silence' opens a suspended time, where the viewer is liable to unfold her kinesthetic imagination. The scene is sappy when Hale skilfully emotes and produces ready-made meanings; it is not so with Cherrill, when she focuses her attention *and ours* on kinesthetic sensations.

Chaplin calls the viewer's attention to kinesic and kinesthetic communication. *City Lights* is the epitome of this pervading aspect in his art, because of the sequences already discussed and also because the story is that of a blind woman deprived, for most of the film, of access to visual inputs and yet so kinesthetically intelligent that, months later, she recognises the Tramp by touching his hand. This tactile recognition involves kinesthesia, for to touch a hand is to feel its skin and its shape, but also its sensorimotor style (Bolens 2008), fuelled by kinesthesia – a kinesthesia that, in turn, induces kinesthetic sensations in the touching hand (Merleau-Ponty 1945; Stankov et al. 2001). The Other is thus acknowledged by the mediation of this very particular type of reciprocity. The scene of recognition in *City Lights* is striking because it situates personal identity on a level that escapes from common social categorisations, such as class, wealth, age, ethnicity, physical conformity, etc. The locus of recognition is kinesthesia.

Back to bluff and the viewer's kinesic intelligence

I wish to conclude on two scenes that interlace bluff with tact. The interlacing of such contrasted notions is interesting because it suggests that Chaplin expected more from his viewer than a simple reactivity to an emotionally straightforward weeping face, or to strenuous slapstick pratfalls and racing gangs (Clayton 2007; Tessé 2007). Chaplin's viewer has to exercise her kinesthetic imagination and engage her kinesic intelligence. In the first scene, the Tramp, faking wealth, drives the Flower Girl home in the millionaire's borrowed Rolls. He lets her into the car and, instead of entering by the opposite door, climbs clumsily behind her shoulders and contorts himself into the driver's seat. Our kinesic understanding of his incongruous effort grounds our appreciation of the odd yoking of bluff and tact: tactfully striving to make her feel fine about her condition, he pays extreme attention to her through moments of behavioural pretence and also sudden lapses from pretence, such as this, linking a bluff of social ease with uncannily cautious efforts and contortions. The Flower Girl does not perceive the hiatus (she literally cannot see it): it is addressed to us.

Similarly, when sitting in her apartment and helping her roll up a ball of yarn, the Tramp lets her mistakenly unravel his jersey entirely. Because the woollen thread exits out from under his jacket, her gesture of tugging on the yarn looks like she is pulling his guts out, with him twisting and arching his torso to let her pull the yarn without alarming her by alerting her to the mistake. His movements tap directly into the viewer's propensity to make sense of gestures in a multi-layered way, using kinesthetic empathy when the Tramp contracts his chest to let the wool out; motor cognition as he holds the thread in order to facilitate her task; and kinesic analysis to perceive the interlacing of tact and bluff, as he tactfully conceals her mistake in a successful bluff of normality. Chaplin strongly relies on his viewers' kinesthetic sensitivity, kinesic intelligence and ability to span the multiple levels of gesture comprehension, whether he stages a formerly blind woman suddenly absorbed in the recognition of a touch, or whether he enacts a tactful bluffer faking ease with extreme care.

Chaplin's creative power was at its height with silent films because it made room for kinesthetic imagination in himself and in his viewer. 'Acts of kinesthetic imagination are not motivated by rationally calculated, discursively articulated decisions, but rather by a desire to find new ways of using energy that emerge through the process of moving itself' (Reynolds 2007: 213). The talkies limited the movements of bodies, whose primary expressive function had become speech. In order to keep exercising his own kinesthetic imagination and to keep finding new ways of activating his viewer's empathic litheness, Chaplin's art had to remain silent for as long as possible. Only the catastrophe of Nazism prompted Chaplin to step out of silence with *The Great Dictator* (1940). Given the American and European threats that were directed against him for making such a film, this was an act of resistance and courage that truly leaves me speechless with everlasting admiration.

Notes

1. This is Chaplin's first film made at the Essanay Studios, which he directed himself. Before that, he worked for Mack Sennett at the Keystone Studios, where he was a star but not a film director. On Chaplin, see Rohmer (1989), Bordat (1998), Bazin (2000), Magny (2003), Martin (2003).

2. In the history of philosophy on humour and laughter, the idea that it is a sense of superiority or of incongruity that elicits laughter has often prevailed. See Morreall (1987), Bremmer and Roodenburg (1997), Critchley (2002).

3. For example, in the films of Mack Sennett, Fatty Arbuckle, Harry Langdon, Max Linder, Harold Lloyd and Buster Keaton. See Dale (2000).

4. In Jean Decety and Jennifer Stevens' words, 'Simulation of movement has come to be recognized as a distinct modality of representation. It may be most aptly characterized as the fundamental and mental counterpart to motor behaviour. Simulation of movement precedes and plans for upcoming physical action and activates the same cortical and subcortical structures that mediate motor execution. But, the pragmatic value in motor simulation is that, at its core, it is the gateway to human social understanding. An embodied perspective moves us away both from a mentalistic view of cognition and from a dualistic view of a mind/body. It considers cognitive processes as rooted in bodily experience and interwoven with action in the world and interaction with other people. The fundamental ability of the motor system to resonate when perceiving actions, emotions, and sensation provides the primary means by which we understand others and can therefore be considered as a basic form of intersubjectivity' (Decety and Stevens 2009: 14–15). See also Adolphs (1999), Niedenthal et al. (2005), Berrol (2006), Foster (2008), Beilock and Lyons (2009), Decety and Sommerville (2009).

5. See, for example, *The Cook* (1918), where Fatty Arbuckle and Buster Keaton share a dance scene, in which Arbuckle parodies the pseudo-oriental Salome-type number made popular by Maud Allen's *The Vision of Salome*, inspired by Max Reinhardt's *mise en scène* of Oscar Wilde's *Salomé* in 1904.

6. The Oxford English Dictionary (second edition 1989) defines the verb *to bluff* as follows: '1.2. In the game of *poker*: To impose upon (an opponent) as to the value of one's hand of cards, by betting heavily upon it, speaking or gesticulating or otherwise acting in such a way as to make believe that it is stronger than it is, so as to induce him to 'throw up' his cards and lose his stake, rather than run the risk of betting against the bluffer. (Of U.S. origin.) Hence, *transf.* of other wagering, political tactics, international diplomacy, etc. *to bluff off*: to frighten off or deter (an opponent) by thus imposing upon him as to one's resources and determination. 1.3. *intr.* To practise or attempt the imposition described in 2; to assume a bold, big, or boastful demeanour, in order to inspire an opponent with an exaggerated notion of one's strength, determination to fight, etc.'.

7. I use the term *discoherence* in the sense expounded by Jonathan Dollimore (1991: 87): 'In highlighting the contingency of the social, the critique of ideology may also intensify its internal instabilities, doing so in part by disarticulating or disaligning existing ideological configurations. To borrow a now obsolete seventeenth-century word, the dislocation which the critique aims for is not so much an incoherence as a *discoherence* – an incongruity verging on a meaningful contradiction. In the process of being made to discohere, meanings are returned to circulation, thereby becoming the more vulnerable to appropriation, transformation, and reincorporation in new configurations'.

8. See, for instance, the interviews in *Charlie: The Life and Art of Charles Chaplin*, 2003, produced, written, and directed by Richard Schickel.

9. On this sequence, Kenneth Calhoon writes: 'two newsboys taunt him and grab at his clothing, which is soiled and tattered after months in prison. The tramp musters bourgeois indignation, glowering in the direction of his assailants while blowing his nose on a thread-bare rag, which he then tidily slips into his breast pocket. The pedantic gesture of nose-blowing proclaims superior affect-control, yet its inherently comical potential underscores the paradox of assimilation: efforts to achieve the poise of perceived superiors create, following Norbert Elias, a "peculiar falseness and incongruity of behaviour"' (Calhoon 2000: 387–388). This description suggests that the rag used as handkerchief is not the piece of clothing torn by the newsboys. As prosaic and apparently trivial as this detail may seem, it matters, I think, that we are dealing with one and the same object. The fact that the rear-end rag is the handkerchief increases the proximity between utter dereliction and resistance to it by means of gesture. This sequence shows a Tramp sunk so low that he does not smile anymore, a rare fact, given his usual tendency to sneer with a vengeance. In the final scene of *City Lights*, we are beyond the point of an actor-Tramp comically showcasing the failed acting of a proud derelict. People passing by in the street mock him, but the audience does not laugh.

References

Adolphs, R. (1999). 'Social Cognition and the Human Brain'. *Trends in Cognitive Sciences*, 3 (12): 469–479.

Bazin, A. (2000). *Charlie Chaplin*, préface de François Truffaut et postface d'Eric Rohmer. Paris: Petite bibliothèque des Cahiers du cinéma.

Beilock, S. L. and Lyons, I. M. (2009). 'Expertise and the Mental Simulation of Action'. In K. D. Markman, W. M. P. Klein and J. A. Suhr (eds), *Handbook of Imagination and Mental Simulation*. New York and Hove: Taylor and Francis Group, 21–34.

Berrol, C. F. (2006). 'Neuroscience Meets Dance/Movement Therapy: Mirror Neurons, the Therapeutic Process and Empathy'. *The Arts in Psychotherapy*, 33: 302–315.

Berthoz, A. (1997). *Le Sens du mouvement*. Paris: Odile Jacob.

Berthoz, A. (2009). *La Simplexité*. Paris: Odile Jacob.

Bolens, G. (2008). *Le Style des gestes: Corporéité et kinésie dans le récit littéraire*, préface d'Alain Berthoz, Lausanne: Éditions BHMS (Bibliothèque d'histoire de la médecine et de la santé). English translation forthcoming at the Johns Hopkins University Press in 2012.

Bolens, G. (2010). 'Les événements kinésiques dans le cinéma burlesque de Buster Keaton et de Jacques Tati'. *Studia Philosophica*, 69: 143–161.

Bordat, F. (1998). *Chaplin cinéaste*. Paris: Editions du cerf.

Bremmer, J. and Roodenburg, H. (1997). *A Cultural History of Humour: From Antiquity to the Present Day*. Cambridge: Polity Press.

Brownlow, K. and Gill, D. (written and produced by), *Unknown Chaplin* (DVD), narrated by James Mason, film editor Trevor Waite, 1983 Thames Television Ltd, Packaging Design 2006 Network.

Calhoon, K. S. (2000). 'Blind Gestures: Chaplin, Diderot, Lessing'. *MLN (Modern Language Notes)*, 115: 381–402.

Calvo-Merino, B., Glaser, D. E., Grèzes, J., Passingham, R. E. and Haggard, P. (2005). 'Action Observation and Acquired Motor Skills: An fMRI Study with Expert Dancers'. *Cerebral Cortex*, 15: 1243–1249.

Clayton, A. (2007). *The Body in Hollywood Slapstick*. Jefferson, North Carolina and London: McFarland and Company.

Critchley, S. (2002). *On Humour*. London and New York: Routledge, coll. Thinking in Action.

Dale, A. (2000). *Comedy is a Man in Trouble: Slapstick in American Movies*. Minneapolis and London: University of Minnesota Press.

Damasio, A. (1999). *The Feeling of What Happens: Body and Emotion in the Making of Consciousness*. Orlando, Austin, New York, San Diego, London: A Harvest Book, Harcourt, Inc.

Decety, J. and Sommerville, J. A. (2009). 'Action Representation as the Bedrock of Social Cognition: A Developmental Neuroscience Perspective'. In Ezequiel Morsella, John A. Bargh and Peter M. Gollwitzer (eds), *Oxford Handbook of Human Action*. Oxford: Oxford University Press, 250–273.

Decety, J. and Stevens, J. A. (2009). 'Action Representation and Its Role in Social Interaction'. In Keith D. Markman, William M. P. Klein and Julie A. Suhr (eds), *Handbook of Imagination and Mental Simulation*. New York and Hove: Taylor and Francis Group, 3–20.

Dollimore, J. (1991). *Sexual Dissidence: Augustine to Wilde, Freud to Foucault*. Oxford: Clarendon Press.

Foster, S. L. (2008). 'Movement's Contagion: The Kinesthetic Impact of Performance'. In Tracy C. Davis (ed.), *The Cambridge Companion to Performance Studies*. Cambridge: Cambridge University Press, 46–59.

Gallagher, S. (2005). *How the Body Shapes the Mind*. Oxford: Clarendon Press.

Gibbs, R. W. Jr. (2006). *Embodiment and Cognitive Science*. Cambridge: Cambridge University Press.

Grosbras, M.–H., Laird A. R. and Paus, T. (2005). 'Cortical Regions Involved in Eye Movements, Shifts of Attention, and Gaze Perception'. *Human Brain Mapping*, 25 (1): 140–154.

Jeannerod, M. (2007). *Motor Cognition: What Actions Tell the Self*. Oxford: Oxford University Press. First published 2006.

Magny, J. (dir.) (2003). *Chaplin aujourd'hui*, ouvrage collectif réalisé sous la direction de Joël Magny, avec la collaboration de Noël Simsolo, Paris: Petite bibliothèque des cahiers du cinéma.

Martin, A. (2003). 'Le mécano de la pantomime'. In Joël Magny et Noël Simsolo (éds), *Chaplin aujourd'hui*. Paris: Petite bibliothèque des cahiers du cinéma, 67–87. First published in *Cahiers du cinéma*, 86, August 1958.

Merleau-Ponty, M. (1945). *Phénoménologie de la perception*. Paris: Gallimard.

Morreall, J. (ed.) (1987). *The Philosophy of Laughter and Humor*. Albany: State University of New York Press.

Niedenthal, P. M., Barsalou L. W., Winkielman, P., Krauth-Gruber, S. and Ric, F. (2005). 'Embodiment in Attitudes, Social Perception, and Emotion'. *Personality and Social Psychology Review*, 9 (3): 184–211.

Noë, A. (2004). *Action in Perception*. Cambridge, MA and London, England: The MIT Press.

Noland, C. (2009). *Agency and Embodiment: Performing Gestures/Producing Culture*. Cambridge: Harvard University Press.

Pecher, D. and Zwann, R. A. (eds) (2006). *Grounding Cognition: The Role of Perception and Action in Memory, Language, and Thinking*. Cambridge: Cambridge University Press. First published 2005.

Reynolds, D. (2007). *Rhythmic Subjects: Uses of Energy in the Dances of Mary Wigman, Martha Graham and Merce Cunningham*. Alton, Hampshire: Dance Books.

Rohmer, E. (1989). 'L'Âge classique du cinéma: Le cinéma, art de l'espace'. In Narboni, J. (éd.), *Le Goût de la Beauté*. Paris: Flammarion, 33–45. First published in *La Revue du cinéma*, 14, June 1948.

Schickel, R. (2003). *Charlie: The Life and Art of Charles Chaplin* (DVD). Warner Bros.

Stankov, L., Seizova-Cajic, T. and Roberts, R. D. (2001). 'Tactile and Kinesthetic Perceptual Processes Within the Taxonomy of Human Cognitive Abilities'. *Intelligence*, 29: 1–29.

Tessé, J.-P. (2007). *Le Burlesque*. Paris: Cahiers du cinéma, coll. Les petits cahiers, et SCÉRÉN-CNDP.

Chapter 8

Effort and Empathy: Engaging with Film Performance

Lucy Fife Donaldson

The staging of film performance, and specifically the relationship between bodies on-screen and the camera (such as the proximity of the camera, whether it moves with the performer) is central to the way we experience film. This chapter explores the nature of engagement with film performance, through consideration of the physical qualities of performance and how it is presented to us, with particular attention to the invitation of empathetic response.

Consideration of the 'effort' of film performance, which has a great many potential technical and aesthetic meanings, aims to draw attention to the connection between the work of the body and our physicalised engagement with it. Taking a cue from Laban Movement Analysis, this chapter will look at 'effort' in performance as related to the expressive qualities of energies used in movement.[1] I will examine the work of the performer's body, the relationship between how we are invited to see the effort and its affective relationship to our bodies. At the root of my understanding of this affective relationship is the idea that the human body is perceived and responded to as corporeal, sensory and moving (both literally and figuratively) because we are watching with an awareness of our own human bodies. To engage with them is to engage with their body, to interpret and evaluate it through an embodied and empathetic response.

My argument will be developed using close analysis of the affect produced by a moment from *Rosemary's Baby* (Polanski 1968), a film which strongly emphasises the body. The prominence of Rosemary's pregnancy to the narrative places focus on her body in the first instance, and her physical changes become of great consequence to expression of her inner life. The film dramatises key moments through attention to Rosemary's physical presence or anxieties evoked by what her body is shown to be doing. Central to my analysis will be, as William Rothman puts it, 'what becomes of human beings on film and of the role of the camera in effecting their transformation' (Rothman 1990: 28). In approaching performance as a key aspect of film style, questions about who we are watching (character? performer?) are delineated by the specificity of the medium: the body is part of *mise-en-scène*; the character is involved in action; the performer is involved in the expression of that action and how we see it. In order to carry out the distinction between the two I will be careful to refer to character/performer as distinct bodies. Here the relationship is between responses to Rosemary's body through the achievement of the actor: Mia Farrow's own physicality and her expressive use of it. My methodological emphasis will be therefore on how the film invites the viewer to engage with the body through careful location of what the performer is doing and how this is presented to us,

moving from the particulars of performance analysis outwards to wider considerations of issues that further qualify engagement, including gender and genre.[2]

Throughout the chapter, the spectator I refer to (apart from my own personal responses) is the one implied by the formal presentation of people and events on-screen; I understand perception and response to be invited through the observable details of the film. When watching a film, the perceived effort, or qualities of movement within a particular performance are directly shaped by its formal placement; the decisions relating to its staging for the camera, as well as editing choices. In particular, the notion of generic expectation as a physical experience, as proposed by Deborah Thomas (Thomas 2000: 9), wherein one might adopt a specific physical watching position in response to the kind of film being watched, has specific resonance for the role of effort in our engagement with on-screen bodies.

Engagement with film: Introduction of terms

In approaching engagement with film, I am concerned with film's construction of events and what kind of access the spectator is given to them. I will disregard the term 'identification' in its common usage (that the spectator 'identifies' with a particular character over others, and thus associates themselves emotionally and evaluatively with their actions) as I do not feel that this accurately captures the complexity of our relationship to fictional characters, particularly when considering the work of the body, and the expressivity of its movement. The process of 'identification' presupposes what Murray Smith suggests is a 'singular and unyielding relationship between the spectator and a character; it conflates perceiving and constructing a character with affectively responding to a character; and it provides a crude dualistic model of response, in which we either identify, or we don't' (Smith 1995: 3). Such a one-dimensional understanding falls dramatically short of accounting for the complexity of viewer engagement and how films shape and control this.

Instead, I will draw on ways to describe our spatial, emotional and sensuous relationship to characters, using terms like access, alignment and allegiance, which significantly open out the processes of our engagement. Smith's suggestion is that the term identification be broken down into more precisely defined terms that instead constitute what he terms a 'structure of sympathy':

> In this system, spectators construct characters (a process I refer to as *recognition*). Spectators are also provided with visual and aural information more or less congruent with that available to the characters, and so are placed in a certain structure of *alignment* with characters. In addition, spectators evaluate characters on the basis of the values they embody, and henceforth form more-or-less sympathetic or more-or-less antipathetic *allegiances* with them.

> (Smith 1995: 75)

In mobilising such terms Smith argues for three stages forming the basis of our engagement with a character: recognition, alignment and allegiance. While his terms alignment and allegiance are particularly useful to discussion of the formal placement of performance, I will use 'access' in place of Smith's 'recognition', as this more accurately defines the starting point for the mediated relationship between performance and spectator.

Access concerns how much we see and hear of a performance: the spatial position of the camera in relation to the performer and how close it is to them, expressivity of voice or expression. The term alignment helps to qualify this access, further indicating how involved we might be with a performance: spatially (the camera moving with one performer over others), emotionally (to what degree a film invites our responses to match those of a character) and physically (this might be determined by the viewer's own physical make-up – race, gender, level of fitness or aggression etc. but is also determined by more intuitive kinesthetic relationships between bodies). Access and alignment address the degree and nature of the performer's spatial and temporal relationship with the camera, which in turn has specific impact on our engagement with them. Allegiance considers the nature of this engagement and is concerned with the figuring of character evaluation, encompassing the emotional and moral position we are invited to take towards a character. Most significantly for discussion of kinesthetic empathy, to be allied to a character suggests that we are being invited to experience and feel (both emotionally and sensorially) what they feel. The interrelationship of these dimensions of engagement is neither fixed nor straightforward – they differ from one character to the next; spatial access to a character does not necessarily lead to physical alignment and moral allegiance – and the only way to fully account for the intricacies of engagement with character is through detailed attention to a particular performance and how we see it.

The precise nature of our allegiance with a character could be further unravelled through consideration of sympathy and empathy. Whilst Smith's 'structures of sympathy' incorporate empathetic responses, as these 'are among the mechanisms through which we gain an understanding of the fictional world and the characters who inhabit it', he is careful to set out the differences between empathy and sympathy (Smith 1995: 103). Most significantly, he differentiates them as 'central imagining' (empathy), in which the viewer puts themselves in the place of the character, and in doing so potentially simulates the character's emotional state (voluntary) and/or affective experience (involuntary), and 'a-central imagining' (sympathy), in which the viewer is put in the position of imaginatively understanding a character's plight. Smith goes on to further suggest that there are two key differences between the two in relation to engagement with film: (1) that sympathy is related to our understanding of the narrative, while empathy is more intuitive; and (2) that a sympathetic response to a character's emotional state is dependent on our evaluation of that character, whereas empathy involves duplication of the emotion experienced by the character whatever our opinion of them. He places empathy as part of but ultimately subordinate to sympathy, which holds the more significant function for his focus on character and narrative, of cognitively filling out our experience. Nevertheless, his notion that empathy and sympathy

are connected and can operate in conjunction is important to my concern with movement and the perception of effort, which is more engaged with the construction of empathy and embodied response.

The body on-screen

The trickiness of conveying in writing what a person does on-screen, and what we understand by this, has generally precluded sustained attention to the subject of performance in academic writing within the field of film studies.[3] For Lesley Stern and George Kouvaros, attention to performance is about evoking the dynamics of our responsiveness to film, and crucially understanding the embodied connection between perception and affect; involving 'the ways in which human bodies are moved within the cinematic frame, the ways in which these bodily motions may move viewers' (Stern and Kouvaros 1999: 9). For Siegfried Kracauer, whose writing reflects not on performance specifically but the nature of the filmed image, such specifics of the medium are vital to understanding the complexities of what we see, and perhaps therefore our emotional or kinetic involvement with this: 'the camera … reveals the delicate interplay between physical and psychological traits, outer movements and inner changes' (Kracauer 1961: 95–96). This chapter considers not only emotional duplication, but a more physicalised connection, the way in which we might experience and thus crucially understand moments of film through the details of the performer's body presented to us. Although the observation that a performer's place in relation to the camera is as important as the camera movements themselves is perhaps commonsensical, it is a consideration oft elided in approaches to performance and is at the forefront of my concerns.

The framework of existential phenomenology offers further assistance to thinking about the sensory nature of film as rooted in a critical attentiveness to the detail of the film, to 'meaning and its signification born not abstractly but concretely from the surface contact' (Sobchack 1992: 3). Vivian Sobchack's writing emphasises the way our bodies respond to and understand film, her suggestion that 'the film experience is a system of communication based on bodily perception as a vehicle of conscious expression' (Sobchack 1992: 9) offers important connections between the body, perspective and engagement, which is most valuable to detailed consideration of bodies on-screen.[4] Although Sobchack has not foregrounded performance in the way I will, phenomenological approaches certainly offer potential to further enrich methodologies of performance analysis. Sobchack's writing provides a philosophical framework that vitally understands the impact of the physical on our perspective, and therefore the importance of the physical texture of film – anything that might qualify our responsiveness to the bodies on-screen, including rhythm, proximity and quality of movement, or effort.[5]

Effort

In order to think more about the impact of the physical on our perspective and the often intuitive nature of this, 'effort' can be a useful concept to capture and describe the physical texture of performance. As Lesley Stern indicates: 'gestural inflection has the capacity to move us (viewers) in ways that involve less semantic cognition than a kind of sensory or bodily apprehension' (Stern 2002). The connection that Stern makes between viewers' and performers' bodies here suggests the basic importance of kinesthetic empathy to our experience and understanding of cinema, the way in which we are often put in the position of understanding the bodies on-screen through our own bodies and physical responses, regardless of whether we share their physical make-up or have ever done the actions depicted.[6]

In discussing effort, Laban's movement analysis, developed in relation to dance but transferred here to the domain of film performance, is potentially very valuable. For Laban, effort is fundamental to the understanding of movement:

> Every human movement is indissolubly linked with an effort, which is, indeed, its origin and inner aspect. Effort and action may be both unconscious and involuntary, but they are always present in any bodily movement; otherwise they could not be perceived by others, or become effectual in the external surroundings of the moving person.
>
> (Laban 1950: 23)

In describing human movement, Laban formulated eight basic 'effort actions' – pressing, slashing, flicking, gliding, thrusting, wringing, dabbing and floating (Laban 1950: 23) – that in this context provide a focused vocabulary for looking at movement in film performance. Not only do Laban's efforts present a pre-formed rubric to approach performance analysis with, but their usefulness in film extends to their connection of movement and response. As Cynthia Baron suggests, these categories highlight 'the fact that audiences develop interpretations about the characters' actions ... by studying the shifts in the actors' energy that signal a change in the characters' tactics' (Baron 2006: 53). Her writing makes effective use of the ways in which Laban's effort categories offer opportunity to illuminate the differences and resemblances between performances, and thus the impressions and understanding of characters' inner lives, for actor and spectator. Significant for my attention to kinesthetic qualities of performance is the way in which Laban conceptualised the efforts as related to specific factors: time, space, weight and flow. As a result of this, each effort is characterised in qualitative terms as sustained or sudden (time), as direct or flexible (space), as strong or light (weight) and as bound or free (flow). These categories endow Laban's effort actions with a multidimensional expressivity, and thus offer an analytical framework to guide interpretation of film performance in a way that addresses the affective quality of movement. Moreover, Laban's terms connect interior and exterior, through Laban's understanding of effort as related to the impulses and attitudes of a movement. As Dee Reynolds observes

'Laban argued that the muscular activity of "yielding to" or "resisting" weight, space, time and flow produced different movement qualities, which corresponded to "inner" attitudes towards these motion factors' (Reynolds 2007: 7). Indeed, Laban's inclusion of flow, which relates to continuous movement, has particularly strong connections to inner life; the distinction between bound and free seeks to directly capture the attitude of motion. In consequence, such an interdisciplinary intervention has great potential to understand how engagement might be embodied. This is particularly valuable for approaches to a medium where the gap between the processes of production and our perception of and response to what we see on-screen, between perceived and actual effort, could be vast.[7]

Rosemary's Baby: Making sense of a moment

In order to develop my exploration of how the formal placement of performance shapes the nature of our engagement, I will turn now to *Rosemary's Baby*. The film centres on a young married couple and their impending parenthood, following their move to an old apartment in Manhattan, and its narrative is largely shaped through Rosemary's (Mia Farrow) experience of events.[8] The importance of Rosemary's body to the film, and the expressive connections made between her inner and outer experience, foregrounds the significance of the physicality of Farrow's performance to our understanding.

There is a moment towards the end of the film, which for me dramatically tips this close engagement, or sympathy, invited to Rosemary into a shared physical anxiety. Rosemary – now heavily pregnant and convinced that her husband Guy (John Cassavetes) and their neighbours are members of a satanic coven who wish to sacrifice her baby – attempts to escape from Guy and her obstetrician, Dr Sapirstein (Ralph Bellamy), who have brought her back to the apartment building after she has tried to escape their control. Once inside the building's lobby Rosemary drops the contents of her bag onto the floor and edges away into the lift whilst Guy, Sapirstein and the lift attendant move to pick up her things. Rosemary then manages to manoeuvre the lift to her floor, stopping it not quite level with the hallway so she has to jump out of it and onto the tiled floor beyond, stumbling to her knees and letting out a small cry as she lands. She then scrambles up and runs awkwardly down the hall, her movements encumbered and interrupted by her increasingly laboured breathing and physical discomfort as she starts to experience sudden contractions, which force her to stop and clasp her pregnant belly. Overcoming her pain, she rushes to the apartment door in the nick of time as the others arrive in the service elevator.

I find viewing this scene provokes anxious physical sensations; the combination of rapid movements and tense stillness, added to by the rhythmic but unpredictable and chaotic jazz soundtrack, making for an uneasy watching experience.

Performance and engagement

Discussion of the way engagement with a body is invited through the particularities of performance necessitates division between character and performer despite their physical indivisibility: the character carries out the action of the narrative, while the performer's body, in combination with the camera, dramatises the event. In recognition of this, my analysis will refer to Farrow regarding the specifics of her physicality (the expressive qualities or movement made) and how this is organised in the frame or through editing decisions, while reference to Rosemary will focus on her body, her emotional state and our engagement with her and the narrative action. The sequence is dominated by close access to, and spatial alignment with, Farrow's body, maintained through use of a handheld camera and instances of optical point of view. Alignment and allegiance with Rosemary's physicality is built up throughout the sequence (and the film as a whole), through the tension between the scant access granted to Farrow's face and the great deal given to her body.

At the beginning of the sequence the sudden change in the quality of Farrow's movement is communicated via a cut to a hand-held camera, which moves with her as she runs to the lift, the camera's unsteadiness replicating the anxiety of this burst of action. Once inside the lift, the film cuts between a medium close-up of Farrow looking out of the lift, a point of view shot of the lift gate and wall behind it and a medium long shot from behind Farrow, the hand-held camera wobbling slightly as the lift rises and then stops. These particular set-ups anchor our experience of space to Rosemary's, and even momentarily allow us to share her physical position and field of vision. Through the proximity of the camera, and its quality of movement this spatial access dramatises the vulnerability of Rosemary's physicality in vivid opposition to the abrupt capability she showed moments before, increasing the risk involved for her and felt by us. The instability of her bid for freedom is maintained by the continued presence of Farrow's hand on the lift's lever and then emphasised further by a cut to a close-up of Farrow's hands pulling the lift lever upwards.

On the two occasions when Farrow's face is captured in medium close-up, her tense expression reflects her determination, but nothing more as she remains contained. As these shots and the close-ups of her hand are in the context of more action, our experience is focused on physical doing and effort, rather than the specifics of her inner thoughts. The restriction of our cognitive access to her interiority, in favour of spatial access and alignment, more directly promotes sensuous engagement with the tensions of physicality.

The formal placement of Farrow's performance also invites empathy with Rosemary through close spatial and physical alignment with her movements. Invitation of empathetic response is continued in the moments after she jumps from the lift, through the combination of long shots that present her whole body rushing through the space, and closer shots that follow and replicate her movement. As Farrow jumps, we are placed behind her, a decision which, although it does not place us exactly in her position, does allow us to both witness the fall and be roughly in the position she was in before she jumped (Figure 8.1). The film then cuts to a long shot of her in the hallway getting to her feet and then running awkwardly

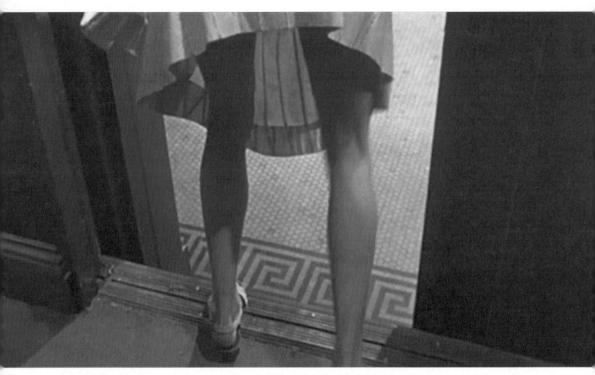

Figure 8.1: Rosemary jumps from the lift. *Rosemary's Baby* (dir Roman Polanski 1968).

towards the camera, which pans left with her as she reaches it. Another cut repeats this pattern of her running and the camera panning left, though when she reaches the camera this time Farrow pauses, her face momentarily in close-up until she reaches past to clasp a banister, on which she leans, the camera now slightly behind her. The camera then follows behind Farrow as she staggers further along the hall, pressing her hands against the wall for support as she struggles to regain her breath (Figure 8.2). Even though we are not put in exactly the same physical position throughout the scene, empathy is drawn continuously by Farrow's movement and highlighted further by the camera's attention to it. As a consequence of this, the close relationship between camera and performer becomes not just spatial, but emotional and sensory as well. Indeed, it is the connection of camera and performer that communicates the urgency and uncontrolled nature of Rosemary's effort. This is a connection that can be understood through Laban's effort factors, which articulate the mechanics and emotional dynamics of motion. In this instance, the conjunction of time (sudden) and flow (free) create a mobile state. The desperation of her struggle, communicated by the empathetic construction of the scene, perhaps also signals a crucial difference in responses invited by access to the face and access to the body. This difference fits broadly with the distinctions between a-central (sympathy) and central (empathy) imagining that Smith discusses.

Figure 8.2: Rosemary presses her hand against the wall. *Rosemary's Baby* (dir Roman Polanski 1968).

Effort and kinesthetic empathy

For me, the moment of Farrow's performance that is most crucial to provoking an empathetic response, and thus cementing a physicalised alignment with Rosemary, is captured in the sight of her frail frame coming into sharp contact with the floor's hard surface as she leaps from the lift: at this moment I feel myself flinching on her behalf.[9] Having considered how the relationship between performer and camera is constructed, and the extent to which we are being placed to imagine ourselves in her position, my flinch in this moment seems almost entirely related to the involuntary aspects of the affective or motor mimicry.[10]

Jill Bennett presents an account of the act of flinching or squirming at a film which offers a further complication to the kinesthetic empathy I might feel for Rosemary's leap:

Although the squirm is a recoil, a moment of regrouping the self, it is also the condition of continued participation, the sensation that works with and against the deeper-level response, which on its own is unbearable. The squirm lets us feel the image, but also maintain a tension between self and image.

(Bennett 2005: 43)

Figure 8.3: Inside the lift, Rosemary wipes her face with her hand. *Rosemary's Baby* (dir Roman Polanski 1968).

In contrast to Bennett's understanding of this response as a moment of separation, I would argue that it arises directly out of the empathetic relationship, constructed by a close rapport between camera and performer that I have been discussing. Indeed, Bennett's suggestion that 'in terms of spectatorship [the flinch can] constitute an experiential link between affect (sensation in the present) and representation' (Bennett 2005: 43) chimes with the connection I would draw between the representation of performance and engagement. The way in which I am invited to understand the affect of the moment through both the way it is embodied and the dynamics of my access to the embodied performer, determined by decisions about camera placement, framing, editing and so on, is crucial. This experiential link between what is happening and response relates to the phenomenological idea of comprehension coming from bodily understanding. However, it is not just the empathetic engagement we are encouraged to have with Rosemary that invites anxiety, but the impact of what Farrow's body is doing, her quality of movement or effort.

Coming back to Laban's eight effort actions I am struck by the series of pressing movements Farrow makes during the sequence that are revealed in moments of closer access to her: her manipulation of the lift lever; wiping her face in the lift; pausing halfway

Figure 8.4: As her contractions start, Rosemary presses down on her stomach. *Rosemary's Baby* (dir Roman Polanski 1968).

to lean on, and clutch a banister in order to catch her breath; pressing her hand against the wall as support; and finally as she presses on her bump, signalling pain as labour intervenes (Figures 8.3 and 8.4). Laban situates the pressing effort as being direct, sustained and strong. Although Rosemary's physicality is clearly vulnerable and frail, Farrow's gestures throughout the sequence have a density that calls attention to the impact of the fall, both before and after it happens. As Reynolds indicates, in Laban's efforts there is a tension between yielding to and resisting the dimensions of space, time, weight and flow, which corresponds to 'inner' attitudes. In consequence, the directness of the pressing movement further qualifies Rosemary's actions as resistant. Figuring her movement as such directly chimes with the narrative situation, and also more broadly underlines the dynamics of her physical trajectory through space as direct and strong.

The repetition of pressure, which itself directly captures the impact of the movement, powerfully accumulates across the sequences and thus heightens the moment of contact on the floor and beyond. The creation of a rhythm of pressing gestures, that punctuate this sequence of action and the flow of her movement, enables their density to be absorbed by, and felt with the body of the spectator. As Karen Pearlman observes, 'rhythm is a felt

phenomenon; the spectator's experience of rhythm ... is an embodied, physiological, temporal, and energetic *participation* in the movement of images, emotions, and events in the film' (Pearlman 2009: 62). Here the adoption of gestures of sustained effort elongates certain moments of Rosemary's flight as Farrow's movements are constructed from a tension between sustained/sudden, bound/loose effort qualities. Farrow's running expresses an unrestrained flow, flexible and yielding by virtue of being outward, ongoing but not straight, that is interrupted by pauses during which her body's weightedness is revealed. In these pauses the flow is temporarily restrained or curtailed (the effort she expends on the lift lever, her body forcing her to stop and pause), so that her desperation is further emphasised and heightened for the viewer through her struggle between resistance and submission. Through the combination of Farrow's movements and our relationship to them, which is brought by the camera's proximity and unsteadiness, the dramatic rhythm of the moment is embodied and felt, as Pearlman suggests, inviting a physiological participation in Rosemary's escape that responds to the expressive quality of effort expended in it.

Considerations of genre

The sensuous engagement constructed through the specific material qualities of Farrow's performance and our access to it actively overwhelms evaluation of Rosemary's actions. It seems to me that the anxiety experienced on her behalf momentarily takes precedence over the narrative's central hesitation between the existence of witches and what her husband dubs 'the pre-partum crazies' to place us in emotional and kinesthetic empathy with her, and as a result it is irrelevant whether she is wrong or right about the coven. That *Rosemary's Baby* is a horror film – complete with gothic tropes of Terrible House, endangered woman and possible Satan worship – clearly impacts on how the action of the sequence is seen and reacted to. Although I would not suggest that horror is the only genre in which the physical is important, horror films frequently operate through a specifically affective relationship between viewer and film.[11]

Within a generic context, two key considerations in terms of the watching experience are expectation (the replication or subversion of certain themes and motifs) and pleasure (why we watch, the popularity of a particular genre), both of which have a relationship to our embodied engagement in the action. As with Deborah Thomas' sense of having to 'steel' herself to watch 'films (from a variety of genres) in which it is clear that the main characters will be dogged by an unforgiving fate and that they will almost certainly be caught and punished in some way' (Thomas 2000: 9), the relationship between my body and Rosemary's body can be connected to genre, the chief expectations and pleasures of horror. My expectation has a physicality related to the kinds of fates experienced by women in horror, and more particularly the often physical nature of this in modern examples of the genre.

This perceived effort, and my experiential involvement and anxiety for it, can be further understood by placing it in relation to wider cultural contexts. Julianne Pidduck argues that

when the viewer is asked to experience violence from the physical and emotional point of view of the victim through an alignment created by the body on-screen and the way this is presented to the viewer, the film 'invites political, emotional and corporeal allegiances linked to known and imagined risk' (Pidduck 2001: 101). What we might situate as a physical alignment, as opposed to simply spatial, which refers to our proximity to the performer, becomes directly linked to our emotional allegiance to a character, making empathy a more crucial element than Smith's hierarchy of central and a-central imagining suggests. In her discussion of the powerful link between physicality and risk in terms of violence, and most especially the way in which the viewer is implicated in this, Pidduck identifies that it is the *quality* of the violence, and the specifics of the victim's body, that is an affective influence on our engagement in the context of 'western representational codes of gender violence' (Pidduck 2001: 101). In *Rosemary's Baby* it is revealing that while for the most part the camera has a close spatial relationship with Farrow, in the latter part of the sequence the camera is positioned more as pursuer, following Farrow's movements from behind. This change gestures towards certain tendencies in the presentation of violence against women that seeks to align the viewer with the pursuer rather than the victim, and perhaps reminds us of the importance of that dynamic to the experiential pleasures of horror.

The sense of risk created by endangering the female body – particularly that of a young, pretty, white, middle-class, and in this case pregnant, female – is a powerful force that can affect our sensuous experience of the film. It is clear that the socio-economic construction of gender, and the way this is expressed through specifically physical rhetoric, has an impact on how we are invited to respond to the body on-screen.[12]

Conclusion

Generic expectations and perceived risk clearly constitute one important part of engagement, but the relationship between empathy and physicalised experience must be unravelled first through attention to what the performer is actually doing, and how we are invited to see this. The dynamics of Rosemary's physical struggle revealed through consideration of Farrow's movements with Laban's multidimensional approach, recognises that performance necessarily invites us to engage with film not just cognitively but also through embodied response. The importance of a kinesthetic relationship or empathy is certainly not accounted for by the concept of identification as it is commonly articulated, even though such relationships directly support any process of identification. In light of this, we might come to understand the connection between bodies (ours and the performers'), as a response directed by the complexities of filmed performance: the quality of movement and characteristics of different efforts understood by it and our spatial access and physical alignment to the performer.

By joining together analysis of performance details and how we are invited to see them, I hope to have been able to indicate ways to bridge the implicitness of what we experience

on-screen, and its interpretation through criticism. Bringing effort into analysis of film performance invites further reflection on the intuitive aspects of our response to the physical, offering performance analysis a methodology that not only provides an expressive vocabulary for capturing what a performer is doing with their body, but also has the potential for drawing out its impact on the spectator's body.[13] This physicalised link between execution and perception of an action has also been established as neurological by the discovery of the putative mirror neuron system (the same neurons are fired whether you are doing or watching a particular activity).[14] As this phenomenon is only just starting to make an impact on the study of film, the connections between it and the experiential synthesis of performer and spectator I have been following here presents an exciting direction for further study.

Acknowledgements

My thanks are due to Matthew Reason and Dee Reynolds for their invaluable editorial perspectives on this chapter and for making 'Kinesthetic Empathy: Concepts and Contexts' such an inspiring and productive event, and to all those who offered comments and encouragement on the paper I delivered at it (both at the event, and through the Watching Dance Forum site).

Notes

1. Rudolf Laban, dancer, choreographer and theorist (1879–1958), developed an observational framework – referred to as Laban Movement Analysis (LMA) – for the qualitative and quantitative study of human movement, comprising the categories of body, effort, shape and flow, component parts that interact with one another and allow the observer to consider both units of action and their combination. Laban's attention to movement also derived from his interest in human effort more generally, as developed in his work with F. C. Lawrence.
2. As performances are often filmed entirely out of narrative sequence, with sound, both dialogue and breathing, added in post-production, they continuously structure our understanding of what the body is doing, resulting in a potential gap between what the spectator perceives and what actually happened during filming.
3. It is worth pointing out that this problem around the interpretation of performance is not restricted to Film Studies, and in some ways the trickiness of understanding what a performer is doing is made easier for scholars working with film than those concerned with theatre or other live performance, as they are able to re-watch a particular performance multiple times.
4. See the chapter titled 'What My Fingers Knew: The Cinesthetic Subject, or Vision in the Flesh'. Vivian Sobchack (2004). *Carnal Thoughts: Embodiment and Moving Image Culture*, 53–84.
5. One such further avenue of convergence between performance analysis and phenomenology is the way in which we make sense of performer's expressions by acting them out ourselves, whether consciously or not.

6. Of course, if these physical attributes or experiences are shared, the commonality is very likely to increase our engagement with the body on-screen.

7. A gap between production and response is also acknowledged by Manuel Alvarado in his writing on narrativity in photography (Alvarado 1979/80: 8). Alvarado's suggestion that narratives of production are typically repressed in favour of the narrative of events implied by a photograph has a relationship to debates about intentionality in writing about authorship and film style, and his consideration of both narratives and their intertwining relationships is of interest to approaches to film that attempt to consider style as the product of careful decision-making, bottom-up approaches, which move from the particular to political/ideological/cultural implications of style and meaning. My thanks to Matthew Reason for directing my attention to this useful parallel.

8. The flow of narrative information is primarily controlled through access to Rosemary, who is in every scene. Because of this alliance of perspective we tend not to concretely *know* more than her; we possess information about Rosemary unknown by others and are made aware of the restrictions this entails, that things are happening outside her (and our) awareness.

9. That this is part of a visual pattern throughout the film, where Farrow's vulnerable physicality has been placed in relation to hard surfaces (as when Rosemary and Guy make love on the apartment floor), builds a sense of fragility and threat towards Rosemary throughout the film, which culminates here.

10. As outlined by Murray Smith, who distinguishes between emotional mimicry ('via facial and bodily cues') and motor mimicry (Smith 1995: 98–102).

11. Noël Carroll's writing usefully notes horror's reliance on affect, in a way that picks up on the relationship between what we see and what we experience. See Noël Carroll (1990). *The Philosophy of Horror or Paradoxes of the Heart*. New York: Routledge.

12. Mirroring this emphasis on the cultural specifics of a performer's physicality would be that of the spectators, though this opens up a much larger area of debate. Nevertheless, it is clearly significant to my response to this moment that I too am a white, middle-class female of roughly Rosemary's age.

13. Laban's terms can be usefully applied to the quality of vocal delivery – is it direct, light or sustained?

14. Moreover, the mirror neuron system is not limited to a link between perception and execution of action alone, but to touch also. The mirror neuron was discovered by neurophysiologists Giacomo Rizzolatti, Giuseppe Di Pellegrino, Luciano Fadiga, Leonardo Fogassi and Vittorio Gallese at the University of Palma in the 1990s. An article by Rizzolatti, Maddalena Fabbri-Destro and Luigi Catteano usefully outlines the essence of the 'mirror mechanism': Rizzolatti, Fabbri-Destro and Catteano (2009). 'Mirror Neurons and Their Clinical Relevance'. *Nature Clinical Practice Neurology*, 5: 24–34.

References

Adrian, B. (2002). 'An Introduction to Laban Movement Analysis for Actors: A Historical, Theoretical, and Practical Perspective'. In Nicole Potter (ed.), *Movement for Actors*. New York: Allworth Press, 73–84.

Alvarado, M. (1979/80). 'Photographs and Narrativity'. *Screen Education*, 32/33: 5–17.

Baron, C. (2006). 'Performances in *Adaptation*: Analyzing Human Movement in Motion Pictures'. *Cineaste*, 31 (4): 48–55.

Baron, C. and Carnicke, S. M. (2008). *Reframing Screen Performance*. Ann Arbor: University of Michigan Press.

Bennett, J. (2005). *Empathic Vision: Affect, Trauma and Contemporary Art*. Stanford: Stanford University Press.

Carroll, N. (1990). *The Philosophy of Horror or Paradoxes of the Heart*. New York: Routledge.

Kracauer, S. (1961). *Nature of Film: The Redemption of Physical Reality*. London: Dennis Dobson.

Laban, R. (1950). *The Mastery of Movement on the Stage*. London: MacDonald & Evans.

Laban, R. and Lawrence, F. C. (1947, 1974). *Effort: Economy of Human Movement*. London: MacDonald & Evans Ltd.

Pearlman, K. (2009). *Cutting Rhythms: Shaping the Film Edit*. Oxford: Focal Press.

Pidduck, J. (2001). 'Risk and Queer Spectatorship'. *Screen*, 42 (1): 97–102.

Polanski, R. (1968). *Rosemary's Baby*. USA: William Castle Productions, Paramount Pictures.

Reynolds, D. (2007). *Rhythmic Subjects: Uses of Energy in the Dances of Mary Wigman, Martha Graham and Merce Cunningham*. Hampshire: Dance Books.

Rizzolatti, G., Fabbri-Destro, M. and Catteano, L. (2009). 'Mirror Neurons and Their Clinical Relevance'. *Nature Clinical Practice Neurology*, 5: 24–34.

Rothman, W. (1990). 'Virtue and Villainy in the Face of the Camera'. In Carole Zucker (ed.), *Making Visible the Invisible: An Anthology of Original Essays on Film Acting*. Methuchen, NJ: The Scarecrow Press, Inc., 28–43.

Smith, M. (1995). *Engaging Characters. Fiction, Emotion, and the Cinema*. Oxford: Clarendon Press.

Sobchack, V. (1992). *The Address of the Eye: A Phenomenology of Film Experience*. Princeton: Princeton University Press.

Sobchack, V. (2004). *Carnal Thoughts: Embodiment and Moving Image Culture*. California: University of California Press.

Stern, L. (2002). 'Putting on a Show, or the Ghostliness of Gesture'. *Senses of Cinema*, 21.

Stern, L. and Kouvaros, G. (eds) (1999). *Falling For You: Essays on Cinema and Performance*. Sydney: Power Publications.

Thomas, D. (2000). *Beyond Genre: Melodrama, Comedy and Romance in Hollywood Films*. Moffat: Cameron & Hollis.

Chapter 9

Breaking the Distance: Empathy and Ethical Awareness in Performance

Rose Parekh-Gaihede

In the last few years, I have had a number of experiences that have altered my understanding of empathy and my sense of responsibility to others. These experiences all occurred during live performances[1] in which I had the feeling of being simultaneously drawn in and pushed away. It is this paradox, of distance and closeness, that I will explore in this chapter. The first experience became the basis for my master's thesis, where I explored distance and empathy from an ethical perspective. In undertaking this thesis I developed a number of questions that are also relevant here: How can I become ethically aware of my responsibility in relation to the other? How do I engage in, without imposing on, the other? Exploring the paradoxical nature of relating to otherness further, this chapter will draw upon research within philosophy and neurobiology to discuss this central theme through the lived experience of performance and empathy.

I am interested in empathy that can be a bridge, between the subject and that which is unknown or unfamiliar, and which can evoke an ethical awareness. By ethical awareness I refer to a sense of seriousness and urgency, a sense of something being 'for real' and something of concern to me. In my work on this subject I named the experience an 'Inverted V-effekt' (Gaihede 2006). This concept refers back to Bertolt Brecht's *Verfremdungseffekt* (V-effekt), which uses distancing aesthetic elements to create a break with the empathy established with the audience in a performance (Brecht 1963, 1964).[2] The Inverted V-effekt, instead, refers to moments where an appeal to empathy is used to interrupt an established aesthetic distance.[3] Two important points of this concept are, first, that distance and empathy do not necessarily work in opposition to each other, at least not in a straightforward manner, and second, that empathy in performance can appear as a sudden break, without a predictable build up towards an emotional climax. This chapter explores the characteristics of empathy that can be manifested in live performance, and discusses some of their ethical implications.

Ethics and empathy

Is empathy fundamental for our ethical awareness? In neuroscience[4] it has been suggested that moral intuition is partly based on our (unconscious) emotions (Changeux et al. 2005: 93). In his *Looking for Spinoza* (2003), neuroscientist Antonio Damasio suggests that ethics depends on our emotional capacities (such as empathy). Philosopher Michael Slote in *The Ethics of Care and Empathy* directly stresses the relevance of our feeling of empathy to our sense of morality: 'empathy is essential to caring moral motivation, the broad

correspondence between empathy and morality doesn't seem as if it can be an accident' (Slote 2007: 8). Trusting emotions to guide our ethical judgement is, however, not without complications. Damasio reminds us that emotions not only generate ethical companionship but also set boundaries between people (between us and the others) (Damasio 2003: 163). Slote states that our feeling of empathy is strongest in cases of what he names 'immediacy', which includes spatial and temporal immediacy, or in cases involving family or friends (Slote 2007: 27).

Recently, a friend of mine told me about some hard experiences she had had as a young Jewish woman in Israel in the 1990s. The fact that she was a friend of mine and we shared similar interests and lived similar lifestyles should have made it easy for me to empathise with her story. However, I was trying to empathise with her in a situation that was distant from me in terms of time, space and experience. The reality that she was referring to was too foreign for me to fully realise and too painful for her to fully represent.

The distance experienced in this situation was of a profound kind. I was receiving a personal description from a friend and first-hand witness. But despite the 'immediacy' between me and the person sharing the story, her description did not translate into recognisable emotions in me. My system of reactions was working hard on trying to correspond to what it was confronted with. But I met a limit. I was never the witness, she was. Her verbal representation, and my own attempt to create images in my head of the incident, only exposed the limits of, and distance inherent in, representation, which are a challenge to empathy, and led me to reflect again on its limits and ethical implications.

This fundamental distance of representation between a person communicating an experience and receiver can be traumatic on the part of the individual trying to share his/her story. That same distance, however, is a starting point for our ethical meeting with the other. This is exemplified by a passage in Slavoj Žižek's *The Plague of Fantasies* (2008) where he refers to the inability of victims of extreme violence (e.g. the victims of rape in the Bosnian war) to truly bear witness to their own experience, because the recognition, or sharing, of the experience through symbolic representation necessarily fails. He states that this inability produces a second trauma (the first being the trauma of violence). Žižek's account interestingly deals with the *limits* of empathy (understood as the sharing of the other person's experience) as a fundamental condition of our ethical awareness – an awareness of the fact that, as he states, we cannot 'tell everything', that 'every articulated symbolic truth [is] forever not-all, failed'. Furthermore, we are 'always already' involved in the trauma of the other, in and through the attempts to understand and represent. Žižek states that there is an ethical dimension in the recognition of this involvement, and consequently, of the impossibility inherent in representation (Žižek 2008: 276–277).

In *Totality and Infinity*, Emmanuel Lévinas makes a similar point regarding the implications of the individual's attempt to understand the other. Lévinas poses the ethical question: how can you relate to the other without depriving the other of otherness? (Lévinas 2009: 27). Lévinas' ethics centres around the face-to-face meeting with the other human being. To Lévinas the ethical dimension in this encounter is that it surpasses the spontaneous impulse to 'possess'

the other (i.e. to include the other under oneself, depriving the other of its otherness). The ethical dimension of the human being, accordingly, is linked to the capacity to have a non-possessive meeting with the other human being (Lévinas 2009: 36–37, 235).

In this meeting, the face of the other expresses a fragility that is at the same time a strength: it expresses the ethical realisation that 'you cannot commit murder'[5] (Lévinas 2009: 217). The face of the other addresses me and commands me to answer back, to take responsibility. The face-to-face meeting is a confrontation with, simultaneously, the absolute separation from and the strong relatedness to the other (humanity expressed in the face of the other) (Lévinas 2009: 104–108, 233–235). To take responsibility for the other, in Lévinas' thinking, implies a recognition of these two sides of the relation.

How can these ethical premises materialise or be made clear to us? If empathy is important for our ethical relation to the other, the separation from the other as an ethical starting point constitutes a challenge. How do we empathise without violating this separation from the other? In the context of performance, as I shall explore in this chapter, empathy may be regarded as a pathway to 'ethical awareness' that recognises our involvement and responsibility in relation to the other rather than an assumption of 'understanding', which conflates the self with the other. In certain empathic moments performance can provoke a reflexivity that is tied to an immediate embodied experience. Through this experience it can bring us closer[6] to the other in a subtle, non-possessive way.

In our everyday life we do not empathise all the time, with every person and emotion we are confronted with (which would indeed be overwhelming) (Vignemont 2006: 181–182). But in the isolated setting of a performance, the possibility for empathy is intensified, not least because we pay extraordinary attention to the things that happen around or in front of us (Funch 1997: 236–237). Furthermore, performance can make reality more tangible to us by provoking emotive or physical movement of/in our bodies.[7] The importance of physical action and sense stimulation for the empathic experience can be illustrated by the conversation I had with my Israeli friend. Despite my inability to empathise fully with her story, one thing evoked my empathy more than anything else. It was her description of an incident where she found herself on the street during a suicide bombing that killed 25 people. 'I had pieces of other people on me', she explained. Again, impossible for me to share this, drawing upon my safe and relatively tame background. But then she told me about how the trauma of this experience manifested itself whenever she went through a difficult period in her life: she would then find herself pulling her hair, she told me, while at the same time doing the movement with her hand. Her hand continued to pull her hair as she explained that this action was miming her pulling out the body parts of another person after the bombing.

This performative action helped my imagination as well as my bodily response to what she told me. Although her experience would never be mine, her action let me participate in her physical re-enactment of her own experience. I was able to find that place within myself where I was pulling my own hair; and linking this imagined movement with the image of 'body parts' gave me an embodied realisation of the horror of the reality she described.

179

Furthermore, the performative action let me participate through my body in her body's repetitive attempt to cope with the inexplicable. The closeness given by the performative representation did not come from a permission to possess her experience, but from the fact that I could share its inexplicable nature.

Performance as an art form holds the capacity to provoke such close encounters with a given reality by evoking empathy in ways that stand out from everyday experiences. One such 'way' I have found is in moments of Inverted V-effekt. I am interested in how these empathic moments relate to ethics – informed by two central observations: one, that empathy with the other is relevant to our ethical awareness; and two, that ethics is related to maintaining a distance to, not possessing, the other. As much as these two observations represent a paradox, I find that they can illuminate the specificity of the empathic moments of the Inverted V-effekt. In the following I shall describe two such moments. These moments are examples taken from my own experience and certainly reflect my personal, cultural background. Nevertheless, I believe these moments may also be relevant for others.

Two moments

A silence in the noise

The first moment that I shall refer to here is from the performance *El Suicidio (Apócrifo 1)* (from here on referred to as *El Suicidio*) by the Argentinian performance group 'El Periférico de Objetos' performed at Espacio Callejón in Buenos Aires in August 2003 and January 2004 (Alvarado and Veronese 2002).[8]

The original creation of *El Suicidio* took place during the big economic and political crisis in Argentina in 2001[9] and was therefore coloured by these events. The theme of 'the suicide', which was the initial starting point of the creation, is the lens through which the performance views aspects of Argentinian culture and its history of violence. The themes materialise on a fairly empty stage in front of the audience, inhabited only by the four performers and a number of characteristic props and puppets. The props and puppets play an important role,[10] especially the human and animal puppets that function both as symbolic objects and as co-actors on stage. There is a big latex cow in one corner of the stage floor and a Vetruvian Man lookalike doll hanging, waving on the wall in the other corner. In between these two puppets, human beings and puppets perform and appear, sometimes as humans, and sometimes as human centaurs with animal heads. The boundaries between human, animal and object are blurred (see figure 9.1).

When entering, we cross the stage floor, passing the latex cow, a couple dancing wildly and a woman staring intensely and seriously at us. Shortly after, the game begins: a voice in the loudspeakers introduces us to an imaginary slaughter house. As beef production is a major industry in Argentina, the choice of location is not altogether surprising.

Figure 9.1: Alejandra Ceriani, Laura Valencia, Julieta Vallina and Guillermo Arengo in *El Suicidio*.

El Suicidio is characterised by an underlying ambivalence to the reality and fiction with which it deals. The main theme is generally treated in a humorous way, in a tongue-in-cheek kind of fashion. The implicit contract with the audience is that 'we are playing a game'. There is a constant 'showing' taking place of the performance as 'just a game', through timed laughter, giggling, pointing out of actions etc., often directed towards the audience. The audience is also a participant in the game. These elements build up a distance to the performance content, which has some similarity with the distancing elements in the Brechtian *Verfremdung* referred to in the introduction. Only, in this performance the *Verfremdung* is the general starting point for my experience – the distance is not a tool that *breaks up* my perception, but rather that which *needs to be broken*.

The game is not only one of laughter; it is also a game that plays with my perception. The means by which the performance appeals to the audience shifts between symbolic and pseudo-realistic, and between different layers of mediation (live performance on stage, through loudspeakers, on television). But something happens at certain points in the performance, where the game all of a sudden becomes serious,[11] and the reality of the themes dealt with on stage (in the game) cry out in front of me (see figure 9.2). How does it 'cry out'? Silently. Like a whisper in the middle of a noise of flickering images and sound. In these moments something asks me to take it seriously. It does not ask for my understanding, explanation or solution. It simply asks me to 'feel that *this* is real'. What is this 'it' then, which makes that demand? Or, I could start by asking, how do I as an audience get that impression in these moments?

The moment that stands most clearly in my memory is one with the performer Julieta Vallina as the central actor. Her face looks straight at the audience, with held-back tears in her eyes, moving her lips as if speaking, but without sound. Behind her a physical fight takes place between two other performers and music is heard from the loudspeakers. But the almost-crying performer commands the stage. She is directing herself to the audience in a way that both gives me a feeling of having eye contact with her and that she is all alone with her emotion – I am sharing an intimate moment with her. At the same time she is showing a scenario with a small puppet, that links the moment to the universe of objects in the performance, and the stories told on stage.

The empathy is provoked, not only through the eyes and face of the other human being, but also through the objects with which she interacts and through the performance space in its entirety. That is, empathy is not caused by the presence of another human being alone. It is also a reaction to what Erica Fischer-Lichte in her *Ästhetik des Performativen/ The Transformative Power of Performance* (2004) calls the 'atmosphere' of the performance space and which she compares to the 'presence' of the human actor on stage (Fischer-Lichte 2004: 202–203). The objects and the performance space project something, which affects me in a similar way to the empathy which I can feel as a result of the presence of another human being. The smells, the light, the sounds and objects are *there* and concretely share the space with me. Together we – objects, performers and audience – form a 'co-presence' (Fischer-Lichte 2004: 203). This means that I, rather than taking possession of

Figure 9.2: Laura Valencia, Alejandra Ceriani, Guillermo Arengo and Julieta Vallina in *El Suicidio*.

the space, participate in it. I become part of not only the pain of Julieta, but the whole 'situation', the background for her pain. The co-presence appears so strong to me in this moment partly because of the contrasts inherent in the performance space. As introduced earlier, distance is here the aesthetic starting point – the taken-for-granted norm that is broken by momentary instances of empathy. It thus functions as an inversion, or a double, of the Brechtian *Verfremdung*. The interplay between the noisy 'game' in the background and the stillness of Julieta's face creates a strong disharmony. Furthermore, because of the presentation of the themes as 'a game' – a distance which is broken in this moment – I am able to share also the trauma of Julieta's pain, as one that cannot be fully shared. The Inverted *Verfremdung* here both implies resistance to possession and a sharing of (the painful) impossibility of sharing.

Butterfly metamorphosis

Wunderland's[12] performance installation *Sommerfugleeffekter* (Aakjær, Matthis, and Rudel 2009) performed at Godsbanen in Århus in June 2009 is an example of how the performance space itself can provoke something similar to an empathic reaction to a human presence and face.

The performance installation consisted of different rooms along a hallway, where the audience was led up and down guided by a ringing bell and shining arrows. A couple of the rooms were pitch dark and/or I was asked to close my eyes before entering; but most of the rooms were lit and poetically decorated so as to engross me with each their particular atmosphere, which would often relate to and underline existential questions that appeared, for example, as written notes or spoken words. Like all audience members, I went though the installation alone, which also played a role in how the rooms affected me. In my analysis I will focus on a specific instance that made a deep impression on me. It happened in the transition between two rooms of the performance installation.

The first of these was one of the dark rooms, where I was told to close my eyes. I entered, and was taken by the hand by the performer, who was breathing loudly – a sound like something in between snoring and an orgasm. The performer's hands were a bit clammy, which may have been involuntary, but it worked with, rather than against, the whole atmosphere. The performer led me across the floor, we passed over some soft material, and ended on a mattress. Here the performer started pulling me down gently, first down on my knees then to a lying position. The performer lay down behind me, still breathing heavily, and started to caress my hair and cheek with a patting hand. I found it deeply disturbing. To me it was a situation of subtle violence. A test of my power over myself and my body. I chose to be there myself, although to open my eyes and step out of the room was not part of the performance's options. A note had been given to me in the beginning about how to act in the performance but it did not have rules for how to opt out of certain situations. So for me, stepping out of the room would mean cancelling the experience of the performance – and

I was too curious to do so. It might be valid to argue that, for ethical reasons, the option to leave should have been there.

Nevertheless, in my case, the lack of option, the uncertainty, added to the intensity of the experience. I felt as if placed in a different person's body, and as if my body was witnessing the experiences of this other body. I had been told to close my eyes, and I did not want to open them; because as much as it took away my power, it gave me protection to have them closed: I could hide from the situation as a person and let my body experience. Otherwise my guess is that the experience would have been coloured by a social timidness that would have drawn me out of the performative moment. I would not have been able to observe myself as an actor in this situation. Although I was 'hiding' I was using this hiding place to observe my own reactions.

Then the bell, which was the clue to leave the room and go to the next, rang. The performer led me into a new space with my eyes still closed. I noticed the new environment because of its characteristic smell of burned wood. It immediately gave me comforting associations of fireplaces and living rooms warmed by tiled stoves. This association was made stronger by the sound of ringing porcelain. I was thus ready for a homely, nice experience, as the actor helped me to sit down in something that felt like a living room chair. Then a recorded voice started reciting a poetic text from a loudspeaker behind me. It talked in a dark tone about animals encountering each other at the ford, about the sensing the bitter taste of humans, and about a door that closes.[13] My expectations were a bit altered by the darkness of this text. But I was still strongly affected by the shift that happened, when I was told by the recorded voice to open my eyes. I found myself in, yes, a living room, but a highly disturbing one. A living room that had been on fire – ashes and sand on the ground, half-burned, broken beams kneeling from the ceiling (see figure 9.3). And at the same time a living room that seemed strangely unaffected by the fire, as if burning down was its natural condition: coffee cups neatly aligned on the rectangular sofa table next to me, porcelain figurines of animals and bones of animals decorating side tables, corner cabinet with stained glass – all of it as if untouched by the burning. The cups, however, had old coffee in them, and they were being shaken by a recurring trembling.

The impression that it gave was a mix between a granny's living room and a war zone. Its atmosphere touched me with a feeling of decay and misery and a strong sense of urgency to change this 'situation' that I found myself in. My own temporary comfort had been transformed into, not only a misery, but a catastrophe – the experience was a bodily reminder of how the potential for a similar catastrophe forever lurks beneath my comfortable existence in the real everyday world. In that moment, I was confronted with my own position in, and responsibility towards the condition of that world outside, as it curiously reflected itself in the living room. It was as if I had entered the 'living room of the world' – and I was invited for coffee, and to 'make myself at home'.

Why did I feel such an urgency? How was I affected so strongly by the atmosphere of the room? Part of the explanation, I suggest, is to be found in the way my empathic sensation of something familiar and personal coincided with a setting, which I may otherwise have been

Figure 9.3: 'Burned-down livingroom' in *Sommerfugleeffekter*. Photographer: Michael Dinesen

able to perceive in a distanced way. The exposure to a familiar, comfortable sense impression (the smell of burned wood) seemed to open my receptiveness to the foreign impression that I was to experience immediately afterwards. I was thus stripped of my defensive shield of distance and cold, analytical observation. At the same time, I carried with me the disturbed, somewhat fearful emotion, related to my own personal body, from the previous room, as a recent memory. On the emotional level, I was experiencing quick shifts between pain, pleasure and pain, between unknown, known and unknown. These shifts played with my sense of familiarity and turned even my distancing reaction into a kind of sharp empathic experience.

I had gone from being exposed to violence/pain/threat on my own body, to feeling 'safe' and home again, to then witnessing a violence/pain/threat on a level otherwise remote from my direct everyday experience – remote, both from my particular identity, with its cultural and personal luggage, but also remote from my immediate comprehension. In other words, in the performance space there were things that I could recognise, but did not relate to as my own, and there were things that were ungraspable, as if hiding something more behind their immediate appearance, simultaneously known and unknown. But all these elements, paradoxically, evoked my empathy in that moment.

Faces of the other

The above close reading of two experiences with performance reveals concrete ways in which empathy works together with distancing elements and provokes/defines alternative modes of relating to the other. In the following I want to elaborate on these modes, regarding them as ethical encounters having to do with the 'face' of the other and the other within the self.

The other facing me

I shall approach the concept of the face in order to clarify the ethical aspects of the meetings with the other described in the analysis. Drawing upon Lévinas' description of the face-to-face encounter, the concept of face that I am concerned with refers to something more than the sum of physical features of the other person's face. Two things are particularly relevant here. First, that Lévinas describes the meeting with the face of the other as a relation in which the other 'resists' my possession (Lévinas 2009: 215). Second is the realisation of responsibility in the face-to-face encounter that is based on a reciprocal address – the face of the other is speaking to me and demands an answer, and by answering, I take responsibility for the other (Lévinas 1995: 83–84; 2009: 61).

Both of these aspects of the face-to-face encounter I found present in the empathic moments in *El Suicidio*, which focus on the human actor and the human actor's face – in the example analysed here, Julieta's face. The empathy felt in relation to this face is not a

climax of a conventionally built up narrative, rather it is a breakthrough, a sudden appeal to an emotional response. It is not based on a full understanding of a situation, that is I am not able to possess either the emotion, or the scenario from which it springs. But my empathic involvement in the co-presence of the space is, if not an 'answer', then a response to an address.

Julieta's face demands my attention – it speaks to me, and demands I take responsibility, by turning to and addressing me. It demands of me to take responsibility – but not only for her. In this performance setting, her face constitutes an opening into a world of emotions, which she expresses as her own, but which belongs as much to the other performers, the performance space and objects – and to the outside world which they reflect – as to her own. In this context her face initiates a moment of revelation. It is a revelation of a reality behind a game, provoked by the interplay between a distancing aesthetics and a sudden emotional expression. The face provokes an empathic experience, which simultaneously breaks through, and creates an ethical awareness of the distancing backdrop of the performance space.

The closest thing to a face that Lévinas admits, referring to objects, is what he calls the 'facade' by which they present themselves. But this facade keeps them enclosed and obscure – as opposed to the transcendent 'opening' of the *face* (Lévinas 2009: 210–211). The performance space in *El Suicidio*, however, seems to constitute a 'face' of its own, although a human face (Julieta's) takes part in mediating this 'face' of the objects and the space. As I shall elaborate below, these meetings with otherness, not least in the meeting with the non-human, in the performance are also meetings with (potential) otherness within myself.

The other in me

Not only does the performance bring me closer to the other through sudden empathic experiences as just described in relation to the moment with Julieta, it also invites me to try what it is like to *be* the other (the other state or the other human), and at certain moments it confronts me with an otherness within myself. This aspect I will explore further in this section in the context of my experiences in *Sommerfugleeffekter* and *El Suicidio*.

In her description of the co-presence of the performance space, Fischer-Lichte refers to empathy as a transformative power (*transformatorische Kraft*) (Fischer-Lichte 2004: 171). The performance offers the possibility to try what it might be like to be an other being by discovering otherness within oneself. In *Sommerfugleeffekter*, I experienced this with my whole body in the dark room: I felt as if I was in a different person's body, whereas actually I was just differently aware of my own body. The otherness of the second room, as much as it consisted of well-known elements, manifested itself as something unknown to me, unfamiliar and unpleasant. The aspects of otherness experienced in these two cases were at once infinitely remote to me (as in Lévinas' concept of the infinite separation), and yet at the same time curiously rooted inside of myself.

The burned-down living room is an example of a meeting with the 'face' of the objects without direct involvement of another human actor. The objects of the room affected me emotionally much like an encounter with another human being, by activating my memory of past emotions. The only human actor was me. Introduced in the context of familiarity, the objects, even in the new context, included *me* in their mute actions; and the antipathy I felt (because of, for example, the skeletons of animals and the actions associated with dead animals) was also directed towards myself. Since my perception of objects is shaped by my memory of previous similar sense impressions (Taylor 1999: 37), and by my imagination of things that I do not see (Skoyles 2008: 102) (for instance my mental images of coffee cups and fireplaces), the room also worked as a mirror turned towards me – I was facing myself.

Žižek 'argues for the necessity of subverting the objectification of the monstrous other. This bridging of the gap between self and other is ultimately impossible until the individual is prepared to recognize the other within' (Tynan 2009). In both of the above performances I felt confronted with the other within myself, with unrecognised (denied) or unknown sides of my being and behaviour. In *El Suicidio* it happened through my sudden inclusion into the co-presence of the performance room and thus realising my own role in the serious and violent game, which played out on stage. In *Sommerfugleeffekter*, I first felt empathy with the pain (burned, bare, dead, decaying) of the objects and the room. And then I felt antipathy[14] for the actions connected to the objects in the state they appeared in (the actions of burning, ripping, killing, abandoning). The antipathy was here the confrontation with the other within myself. The reflexivity that was at stake in both of these encounters was based on my physical participation in the performance space. In other words, I was led to embody different scenarios through the co-presence of the performance space. This embodiment in both cases left me with an urgent ethical awareness of my own involvement and responsibility in relation to the other.

Conclusion

Initially, I presented my interest in certain moments in performance – moments that I have described with the term Inverted V-effekt because of their quality of breaking through aesthetic distance with empathy. It is an empathy that can be evoked in performance, because of the art form's ability to employ sense impulses that disturb our expectations. I have discussed the impact of such moments on my ethical awareness to the other.

Central to the discussion is the paradoxical relationship between the importance of empathy for our ethical awareness and the ethical perspective in facing the ultimate failure of empathy – realising that we can never fully understand the other. One must have empathy enough to ethically realise this, to realise an involvement or responsibility towards the other, but without imposing oneself on the other.

The two experiences of performance which I analyse place themselves in the centre of this paradox. My analysis focuses on the shifts that happen in both performances in the type

of appeal to my body and mind. These shifts mean that the boundaries between the familiar/close and the unfamiliar/distant become blurred, because familiarity becomes integrated into distance as well as the converse.

What I choose to name 'empathy' (that which constitutes the breakthrough in the Inverted V-effekt) is made up of different elements that have to do with the way in which one relates to otherness. These are elements of the embodied experience of performance. In the moments of empathy the presence of the performers and the atmosphere of the performance space provoke an immediate and emotional response. On the physical, sensual level my perception and emotional reactions are twisted in unexpected directions – these twists constitute breaks which make me empathise with foreign, remote elements. In the first example this happens as a human face addresses me and thereby brings closer the pain of objects and story elements that have otherwise been treated in a distancing fashion. In the second example, empathy occurs as the distancing elements coincide, or are introduced along with sense impressions that my memory connects to as with something familiar. Not only do I come closer to the other but also, as my body activates its memory of earlier sense impressions, the mirroring processes become an internal mirror. I feel included in the pain of the other.

My experiences of empathy are sudden and urgent; and the impulses that appeal to me (such as the face of an actor) are not directed towards one thing or state that I need to conceptualise or explain in order to empathise. The experience is an embodied one, which makes me approach the other through a recognition of otherness within myself. That is, the empathy I experience paradoxically combines putting myself in the place of the other being with not imposing myself on this being. With the physical, emotional closeness of the other in the performance moment – in the breakthrough of empathy, that balances between the known and the unknown – the trauma of the simultaneous separation from and involvement with this other becomes real to me.

Acknowledgements

Thanks to Matthew Reason and Dee Reynolds for constructive comments. Thanks to El Periférico de Objetos and Wunderland for extraordinary experiences and to my Israeli friend for wanting to share her experiences with me. And last, thanks to Sunit Parekh-Gaihede for thorough critique and good spirit.

Notes

1. I refer to a concept of performance that includes theatre and contemporary forms of installation and immersive theatre.
2. The Brechtian *Verfremdungseffekt* (V-effekt) is characterised by a break with the established empathy in the performance by means of distancing. Bertolt Brecht contrasted the epic theatre

with its V-effekt to the theatre of his time, which he described as pure entertainment referring particularly to its use of the Aristotelian catharsis. An important argument for the epic theatre's V-effekt was that it would create a social, critical awareness.

3. I treat the concept of the Inverted V-effekt in more detail in Parekh-Gaihede (2010).

4. While there are earlier thinkers dealing with empathy and morality, for example, Adam Smith in *The Theory of Moral Sentiments* (1759), I choose to focus here on recent studies in neurology.

5. It is of course possible to commit murder, but there is a 'resistance' in the nakedness of the face, an infinity, which you cannot kill (Lévinas 2009: 217).

6. By 'closer' I mean both in the sense of a psychological connection to someone or something, and in the philosophical sense of approaching (a knowledge of) the surrounding world.

7. For example, through mirroring processes on a neurological level (Rizzolatti and Sinigaglia 2008: 115–138; Skoyles 2008: 101).

8. See also: http://www.analvarado.com/adultos.html. Date of access: 26 January 2012.

9. In December 2001 the Argentinian government carried through 'el Corralito', which meant a blocking of personal bank accounts in order to avoid bankruptcy. This led to some violent demonstrations, 'les cacerolazos', against the regime. Two weeks followed with four changes of presidency. In January 2002 an economic law was passed, which meant a devaluation of the Argentinian pesos that had been kept artificially tied in a one-to-one relationship to the American dollar. In the wake of the crisis close to half of the Argentinian population lived in poverty (Anon 2002).

10. El Periférico de Objetos started out in puppet theatre, which evidently influences their current work with what they themselves have characterised as object theatre (Alvarado 2003).

11. In his account on the nature of game playing, Johan Huizinga describes a point at which the game can become serious to the player, who is absorbed by its universe, in a similar way as a participant in the religious ritual (Huizinga 1963, 1993: 28–29).

12. See: http://wunderland.dk/. Date of access: 26 January 2012.

13. The text for this room was written by Sonja Thomsen.

14. Antipathy should in this context not be read as a counter concept of empathy, since I see my antipathy as part of my empathy in the situation.

References

Aakjær, M., Matthis, N. and Rudel, C. (2009). *Sommerfugleeffekter*. 'Wunderland', Århus, June 2009.

Alvarado, A. (2003). 'El Objeto de las Vanguardias del siglo XX en el Teatro Argentino de la Post-dictadura'. MA thesis. Instituto Universitario Nacional del Arte. Departamento de Artes Visuales.

Alvarado, A. and Veronese, D. (2002). *El Suicidio (Apócrifo 1)*. 'El Periférico de Objetos', Buenos Aires 2003/4.

Anon (2002). *Courrier International*, Hebdo no. 584, 10 January 2002.

Brecht, B. (1958). *Versuche 20-26/35*. Hft. 9–11.

Brecht, B./W. Hecht (ed.) (1963/64). *Schriften zum Theatre 1–7*. Frankfurt am Main: Suhrkamp.

Changeux, J.-P., Damasio, A. R., Singer, W. and Christen, Y. (eds) (2005). *Neurobiology of Human Values*. Berlin, Heidelberg and New York: Springer.

Damasio, A. (2003). *Looking for Spinoza: Joy, Sorrow and the Feeling Brain*. London: Vintage.

Fischer-Lichte, E. (2004). *Ästhetik des Performativen*. Frankfurt am Main: Suhrkamp.

Funch, B. S. (1997). *The Psychology of Art Appreciation*. Copenhagen: Museum Tusculanum Press.

Gaihede, R. (2006). 'Fremmedgørelsens Fordobling'. MA thesis. Copenhagen: University of Copenhagen Press (Institut for Kunst- og Kulturvidenskab/Moderne Kultur og Kulturformidling).

Hall, E. (2003). 'Proxemics'. In S. M. Low and D. Lawrence-Zúñiga, *The Anthropology of Space and Place: Locating Culture*. Oxford: Blackwell Publishing, 51–73.

Lévinas, E. (1995). *Etik og uendelighed*. (Éthique et Infini), Copenhagen: Hans Reitzels Forlag. First published 1982.

Lévinas, E. (2009). *Totalité et Infini. Essai sur l'Extériorité*. Paris: Librairie Générale Française. First published 1971 by Martinus Nijhoff.

Parekh-Gaihede, R. (2010). 'Activating Knowledge. Organic Documentation as Ethical Endeavor'. In C. Friberg, R. Parekh-Gaihede and B. Barton (eds), *At the Intersection between Art and Research. Practice-Based Research in the Performing Arts*. Sweden: NSU Press, 165–196.

Rizzolatti, G. and Sinigaglia, C. (2008). *Mirrors in the Brain: How Our Minds Share Actions and Emotions*. New York: Oxford University Press. First published 2006.

Skoyles, J. R. (2008). 'Why Our Brains Cherish Humanity: Mirror Neurons and Colamus Humanitatem'. *Avances en Psicologia Latinoamericana/Bogota (Colombia)*, 26 (1): 99–111.

Slote, M. (2007). *The Ethics of Care and Empathy*. Canada and USA: Routledge.

Taylor, J. G. (1999). *The Race for Consciousness*. London and Massachusetts: The MIT Press.

Tynan, M. (2009). 'Irretrievably Divided, Unavoidably Connected: Encounters of Self and Other'. *Double Dialogue Issue* 10, summer 2009: *Approaching Otherness*, http://www.doubledialogues.com/issue_ten/tynan_intro.html. Accessed 13 October 2000.

Vignemont, F. de (2006). 'When Do We Empathize?' In *Empathy and Fairness*. Novartis Foundation Symposium 278, UK: John Wiley & Sons Ltd., 181–196.

Žižek, S. (2008). *The Plague of Fantasies*. London & New York: Verso. First published 1997.

Part IV

Artistic Enquiries: Kinesthetic Empathy and Practice-Based Research

Introduction

Matthew Reason

The growth in the prominence of practice-based research in the arts over the last decade has been significant, often liberating and at times contested and problematic. It is a prominence that is reflected in this book, and not just in this part, with other chapters such as those by Nicola Shaughnessy and Bonnie Meekums in Part I and Sarah Whatley and Brian Knoth in Part V also pursuing research through practice.

Practice-based research describes a diverse range of cross-disciplinary approaches that position arts making as a methodological research practice. The word 'making' in this context is crucial, for practice-based research describes research that occurs within and through the *doing* of arts making (rather than for example the thematic factual or background research that an artist might conduct before beginning to make a work). The particular forms of knowing that can be generated through arts practice are those of embodied, tacit and material knowledge, where discovery happens through the action of arts making, and in reflection in and upon that action. Located within action, the particular claim of practice-based research is that it offers not just a different way of doing things than more traditional research methodologies but rather, and more importantly, access to different forms of knowledge. In particular practice-based research advances notions of 'embodied knowledge' that might be experientially known through art and that suggest limits to discursive forms of knowing.

The prominence of practice-based approaches within this book is far from coincidental. Firstly, kinesthetic empathy is a theme that has particular resonance within the arts, where there is a natural interest in how artists and audiences experience the presence (and indeed absence) of others in a manner that is embodied and sensorially driven. As discussed in the general introduction, kinesthetic empathy has long been used as a concept that enables us to consider this process and to conceptualise embodied and experiential affects. It is therefore no surprise to see arts-led enquiries seeking to further refine ideas of kinesthetic empathy. Additionally, however, there would seem to be a natural synergy between a concept that

describes the embodied experience of things outside of ourselves and a research methodology that asserts its suitability to exploring forms of embodied knowledge.

The first chapter in this part, 'Re-Thinking Stillness: Empathetic Experiences of Stillness', begins very much with the embodied. In this chapter Victoria Gray reflects upon how her history of dance training had left her with a particular kind of body that is also implicitly representative of certain kinds of aesthetic and cultural values, notably of fluency and virtuosity. The dancer's trained body is an exemplary instance of embodied knowledge, with movements encoded into muscle memory and the shape and texture of the body refined for particular kinds of movement and expression.

Gray's chapter describes how she used her own practice, and her personal artistic trajectory away from dance, to engage with stillness, a state that is often perceived as antipathetic to the values of dance and as the dead space between actions. Stillness, however, is far from simply the absence of movement but rather a moment in which perception is allowed to settle upon the 'microscopy' of reverberation, of detail, of closeness, of difference. Reading Gray's analytical discussion of her practice – a self-reflective mode that is itself a key methodological marker of practice-based research – it is interesting to note that the first perception of stillness in performance might be of embarrassment or awkwardness. Her performances evoke a hyperawareness, on the part of both herself as performer and of her audience, which actively resists demands for spectacle and constant movement. Gray explores how stillness, combined with closeness, can result in a strongly empathetic encounter between audience and performer. She articulates this as an exchange, which at times has a physical impact on her as a performer and which can also be mentally and physically effortful experience for the spectator.

In her chapter, 'Empathy and Exchange: Audience Experiences of Scenography', Joslin McKinney also describes performances as a kind of exchange, this time in the encounter between scenography and an audience who are invited to become participants and even co-creators in an interactive theatre environment. We might traditionally perceive scenography as a fairly passive or static form, the painted backdrop or stage design that situates and illustrates a performance that happens in front of it. In contrast McKinney is a theatre practitioner working with scenography as a dynamic form that contributes to the kinesthetic experience of performance. Here McKinney describes a project that emerged as part of her continuing reflections on her practice and her interest in the ways in which an audience has an embodied encounter with the spatial and material elements of a performance. As a piece of practice-based research, therefore, this chapter explores how the making of a piece of theatre can be a methodological process designed to explore and analyse particular questions about the experience of performance.

In this chapter McKinney complements her own practitioner-orientated reflection with analysis of qualitative audience research, using participant observation during performances combined with interviews conducted with audience members after the event. This combination of methodologies allows her to step out from the moment of making to examine aspects of reception with clarity and attention to detail. Amongst a number of points

within this discussion it is worth noting the ways in which immersion and interaction are negotiated processes, as the audience turned participants construct and agree on temporary rules of behaviour, adhoc narratives and fluid aesthetic structures. McKinney also notes those instances of resistance, when participants seek ways of testing or subverting the call to participate, and considers how these too might be conceived as the result of strongly experienced empathy of others.

One recurring debate within practice-based research is the question of whether the knowledge generated is manifest (is in a sense knowable) only within the practice itself or what the potential and implications are for articulating the knowledge in writing outside of the practice. We might consider, for example, the extent to which we can only truly encounter stillness in the manner Gray describes through experiencing personal proximity with her body in performance, or only appreciate the empathetic exchange with McKinney's scenographic objects through being in the audience. For some purists within practice-based research (a group which certainly does not include Gray or McKinney) there is a contradiction and even betrayal in the notion that such knowledge might be 'written up'. The fear, of course, is that the enduring, more easily circulated and more 'scholarly' or 'proper' discursive analysis will be read in isolation, usurping and replacing the practice-based enquiry.

The last chapter in this part, 'Photography and the Representation of Kinesthetic Empathy', engages with this question through a textual/visual duet with photographer Chris Nash, where my writing provides a discursive accompaniment to his non-discursive practice. For this chapter I invited Nash to respond photographically to the concept of kinesthetic empathy, thereby asking him to think visually and to communicate presentationally about the subject matter of this book as a whole. In this instance the nature of the medium means that Nash's photographs can be reproduced and fully present here in print, with the discourse consequently presented alongside rather than speaking for the practice. While the photographs are unequivocally by Nash and the text by myself, the process of discussion and collaboration that formed the development of this chapter means that there is a mutual infusion and infection of ideas and perspectives. The result is something that seeks to weave visual and discursive forms of knowledge together, utilising the presentational and experiential strength of the photographs with the particular analytic tools of language.

Moreover, Nash's photographs also invite a kind of intertextual reading alongside other parts in this book, as his visual engagement with kinesthetic empathy touches on themes of mirroring, stillness and the virtual that are developed in other chapters. Such an intertextual reading need not be about hierarchies of knowledge, but instead seeks to generate a series of open encounters.

Chapter 10

Re-Thinking Stillness: Empathetic Experiences of Stillness in Performance and Sculpture

Victoria Gray

This chapter will explore ways in which stillness has the power to move both our physical and emotional faculties. It will argue that in its apparent absence, movement becomes more present and we acknowledge that binary oppositions between stillness and movement do not and cannot sensibly exist; stillness is within movement and movement is within stillness, each reciprocating the other. As an artist working with performance and sculpture I intend to draw upon my own practice-based explorations of stillness in live performance coupled with analysis of engagement with two art works from different disciplines that allow me to test and illustrate this argument. In particular I will draw upon contemporary European choreographer La Ribot and her performance work 'Another Bloody Mary' (2000), and the sculpture 'Stuck' (2010) by 2010 Turner Prize nominee Angela de la Cruz, making connections back to my own practice with each discussion. This analysis requires an ability to draw upon complex interconnections between visual and corporeal modes of reception and thus employs an interdisciplinary methodology. Through each phase of this exploration I hope to articulate the kinesthetic experiences of stillness and the empathetic exchange that takes place between spectator/performer and spectator/art object.

Moving towards stillness

My own performance practice began as a professional dancer and has been significantly shaped by my physical and psychological experiences of rigorous conservatoire training. This training, engaged in for over a decade, was something that I undertook in order to transform my body into one that could move with strength, stamina, flexibility and apparent ease, the prerequisites of professional dance training. In my experience, the trained dancing body aims to communicate language and images through the body with a fluency based upon an efficiency of movement and an economy of kinetic effort in a manner that is not natural but is learnt. As such, my experiences of stillness have been troubled by dance, given that historically the art form has been driven by the promise of movement and a pleasure in the kinetic. In many respects, stillness in dance is used as a contrast: a temporal compositional tool that underlines movement; a choreographic device that offers the possibility of a dramatic suspense when placed in dynamic juxtaposition with movement. Stillness used in this way is always in debt to and in service to the potential for movement.

My current practice seeks to perform a critique of the prerequisites of this history and training in dance performance, and has involved a strategic shift away from dance into

realms of performance art and sculpture. Not coincidentally this has led to a shift towards stillness that has offered me a critical pause from the kinetic, a time and space to re-explore the rich potentiality of the kinesthetic. Sally Gardner offers a distinction between the two, suggesting that the kinetic derives from a modernist appreciation for the sensational, manifested in the visibility of movement, and that kinesthetic appreciation is concerned with what is corporeally sensed (Gardner 2008). The term 'kinesthetic' is therefore used in this investigation to refer to sensate and subtle bodily perceptions. Perhaps more crucial to this investigation, one that foregrounds empathetic experiences of kinesthesia between performer and spectator, is Gardner's assertion that kinesthetic modes of perception are 'intersubjective and intercorporeal'(Gardner 2008: 56). Thus, the corporeal exchange *between* performer and spectator will be foregrounded throughout this investigation considering the spectator as an active embodied subject.

Initially, I met this performance of stillness with some concern, given that the desire to please an expectant spectator by moving was strong, as was the pressure to make explicit the act of 'doing'. However, stillness remained crucial to my investigation as it facilitated the time and space necessary for kinesthetic perceptions of the body to evolve between performer and spectator, as Henri Bergson states, 'Perception is prolonged in nascent action' (cited in Gardner 2008: 56). Dance critic Laurent Goumarre relates this approach to the work of La Ribot and comments, 'La Ribot, motionless, is not waiting *for* anything, especially not for the "birth" of motion. Her mobility is attentive *per se*; it is a posture in itself' (Goumarre 2004: 60).

By defining perceptual differences between the kinetic and kinesthetic, my intention is not to establish a binary position whereby one is deemed exclusively preferable to the other, rather I hope to propose a constructive tension. Conversely, throughout this investigation I intend to highlight that the two are not mutually exclusive by evidencing works whereby stillness is utilised to draw attention to the subtlety of movement within stillness itself. However, as Elizabeth Dempster reminds us, 'regimes of production and reception of performance work rarely foreground kinaesthetic (as opposed to the more spectacular "kinetic") value' (cited in Gardner 2008: 55). Therefore, by defining and articulating the value of kinesthetic perceptions (admittedly with a persistence that might seem to edge towards a bias) I simply aim to address this incomplete project of apprehending the kinesthetic (Gardner 2008).

Intuitively, a personal response to over a decade of dance training, whereby all possibilities for new movement had seemed exhausted, pushed me to the point of a stalemate. This rupture in my own practice is one informed by a critical discourse, brought to the fore in the early 1990s in contemporary European dance theory and embracing the work of choreographers such as La Ribot, Xavier le Roy, Mårten Spångberg, Jérôme Bel, Boris Charmatz, Jonathan Burrows and Tino Sehgal, in an ongoing critical and choreographic project that seeks to reconsider the politics of movement in relation to dance practices. As opposed to stillness being a negative transgression for dance, this critique reconceptualises the still act as a positive progression, one that has shifted the paradigm of movement-based performance. A key voice here, and one who has significantly transformed my own work, is

that of André Lepecki, in particular his book *Exhausting Dance* (2006).[1] In this work Lepecki suggests that the practised obedience of the dancer arrests their body in a system whereby it becomes a mute currency in an economy of movement, one that potentially erases the body's autonomy. This dancing body that Lepecki refers to is often unaware of its complicity; he refers to the naive 'willingness of this body to subject to commands to move' (Lepecki 2006: 46). Having engaged with this critical debate I felt compelled to reconsider both the politics and aesthetics of my own movement language, reflecting that '*my*' movement language had in fact been somebody else's; '*my*' body – the vessel – had transported a choreographed language of actions via virtuosic coded techniques.

In stillness I was able to reconsider the impact this training and its implicit ideology had made on my body and my self, having been interpolated into a powerful ideological system. This critique is not exclusive to dance but is one that resonates in wider performance and cultural contexts. It positions stillness as an act that challenges the politics of movement and economy of bodies in performance but also, as German philosopher Peter Sloterdijk claims, challenges 'the ethics of modernity' (Sloterdijk 2009: 4). This drive to move is one that Sloterdijk finds bound up in the modern impulse to be active and here movement becomes synonymous with an imperative to be productive. He comments, 'Ontologically, modernity is a pure "being-towards-movement"' (Sloterdijk 2009: 6) and we might argue that the common ontological perception of the dancing body is that it too is a being towards producing movement (Lepecki 2006; Sloterdijk 2009).[2]

A radical reduction of movement in performance, particularly for practices such as dance or those where action is intrinsic, potentially threatens the foundations upon which movement practices have been built. Stillness, as a mode of critiquing this is not, however, a strategy exclusive to the most recent developments in dance, having already been explored significantly by postmodern dancers and choreographers throughout the 1960s and 1970s. Gardner states, 'The strategies of post-modern dance could be said to have grown out of artists' conviction that "the body" is always, already dancing. Movement is not something added to the body' (Gardner 2008: 56). A clear example of this strategy is Steve Paxton, recognised for his investigation of 'The Small Dance' taking place within 'The Stand', where for Paxton the simple act of standing still is not necessarily so simple or still at all.[3] In fact what is taking place is an intricacy of activity performed on a micro, seemingly invisible scale due to internal neuromuscular movements. The circulatory and cardiovascular systems, the skeleton's distribution of weight in the act of balancing on two feet and its resistance of gravity in the verticality of the stand contribute to this. Modernist dance critic John Martin asserted that 'perception itself was a neuromuscular event, an activity of and with our bodies' (Gardner 2008: 56). This claim suggests that as spectators perceive a performer, they too are performing neuromuscular movements by experiencing and perceiving the performance through their own bodies. This strongly supports the notion of kinesthetic empathy as applied to this investigation as a micro, intercorporeal exchange between performer and spectator. Emphasising this 'microscopy of perception' (Lepecki 2001: 2) through stillness, for both performer and spectator, became my own strategy in performance.

As an act of post-spectacle, stillness carries with it a history and therefore a weight of responsibility. Paradoxically, inaction becomes action, artistically and politically, physically and conceptually. Thus, stillness performs both a conceptual movement towards new modes of being in and watching performance; and a cultural movement towards new ways of being in and watching the world.

Embodying stillness

My own practice has been informed by these theoretical debates and can also, I believe, be used to illustrate them. One example is a work that I made at the end of an MA in Performance research process at York St John University in 2009 titled 'Pleat' (figure 10.1).[4] 'Pleat' aimed to explore the relationship between performance and sculpture and was concerned with the reciprocal relationship between the materiality of objects and the body in live performance. Using my body and white bed sheets, 'Pleat' culminated in a series of 11 performed sculptures that I articulate within the tradition of action sculptures.

I use the term 'action sculpture' to define a type of sculpture that incorporates the live body as well as objects and other materials. It is a mode of sculpture akin to action painting that requires the physicality of the body for its coming into existence. Stillness became an integral part of this process given that each of the 11 actions within 'Pleat' resulted in a prolonged stillness, emphasising this moment, the product of the action, as sculpture. In addition, I also consider the process of arriving at this stillness as a form of sculpture, although a kinetic one. Influenced by La Ribot and choreographers who work in the space between dance and fine art practices, my own work also moves in between these territories. Adrian Heathfield, writer and curator of contemporary performance, describes this territory in saying: 'Its terrain is the place where dance dissolves into action, the movement of stillness and the exposed materiality of the flesh' (Heathfield 2006: 195). In 'Pleat' the affective experience of these action sculptures and bodily exposures, made possible via a prolonged stillness, is contingent upon a shared temporal and spatial relationship between my own body, the white sheets and their empathetic relation to the spectator's body.

Proxemic relations

I believe that the performance space is crucial in order to create the conditions for a relationship whereby the spectator kinesthetically empathises with the performer's own bodily state. The mechanics that a choreographer employs to make these conditions possible is what Gerald Siegmund describes as the 'apparatus' (Siegmund 2009). In the work, 'héâtre-élévision' (2002–2004), which I experienced at the 'Move: Choreographing You: Art and Dance' exhibition at the Hayward Gallery in 2010, choreographer Boris Charmatz constructs a performance environment for one spectator.[5] To experience the work the spectator enters

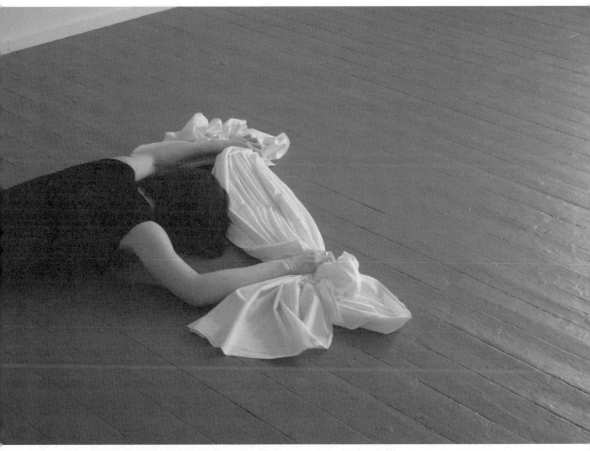

Figure 10.1: Victoria Gray, Pleat, 2009. Performance stills. Image courtesy Nathan Walker.

a dark room and is instructed to lie down, with blanket and pillow, on a large object that is difficult to identify, but is described in the exhibition guide as a 'pretend grand piano' (Luckett 2010). A pre-recorded dance performance is playing on a single channel television that is suspended inches from the spectator's face, whilst small speakers are positioned close to the spectator's head. This proxemic apparatus enabled a private, very intimate and intense experience whereby a heightened microscopy of perception was made possible. Of this work Gerald Siegmund comments that, 'The Apparatus produces attention. Attention depends on exclusion and focus. I see and hear more when I see and hear less' (Siegmund 2009: 335). This experience provoked me to consider what apparatus I use in my own performances to produce this level of attention and through 'Pleat', and my performances in general, I realise that stillness is this apparatus, one that seeks to exclude an excess of movement so that the spectator has time to see and feel more. Additionally, stillness is an apparatus that allows a closer proximity between performer and spectator, one that excludes an excess of visual stimulation and distraction. This apparatus gives the spectator specific conditions of time and space to re-focus their attention onto the detailed materiality of my body and materials used.

Contemporary performance theorist SanSan Kwan comments that, 'When the body is at rest our powers of introspective proprioception experience a world of microscopic tremors, vibrations and pulsations happening within the body' (Kwan 2003: 17–18). This echoes Steve Paxton's claim to the activity integral in 'The Stand' and as a performer and spectator, I found I too experienced this heightened perception whilst in stillness.

It is intended that spectators of my own performances (figure 10.2) empathise with my physical state and enter into this acute mode of perception by being enabled to witness my body close up, or as Adrian Heathfield articulates, to witness 'the exposed materiality of the flesh' (Heathfield 2006: 195). They may notice fine age lines and veins under my skin, marks and scars accrued from past performances, or, perhaps witness the hair on my skin respond to changes in temperature in the room. Sweat may be apparent from the effort of the action, coupled with small bodily tremors caused by the physical and mental exertion of adrenaline and nerves.

Here, a magnitude of intricacies become visible, which are often illegible to the eye in the distancing that takes place between performer and spectator in traditional performance conditions. This is particularly true of classical ballet for example, or performances more generally that situate themselves within the context of the proscenium arch. The visibility of this detail in 'Pleat' was intended to give the spectator an opportunity to engage with the finite materiality of my body, not as a distant representation in theatrical space and time, but as an honest and vulnerable presentation of my own body.

Stillness and 'Another Bloody Mary' (2000)

There is a connectedness between my own methodology and La Ribot that I wish to articulate in relation to her work 'Another Bloody Mary' (2000) (figure 10.3). In his essay,

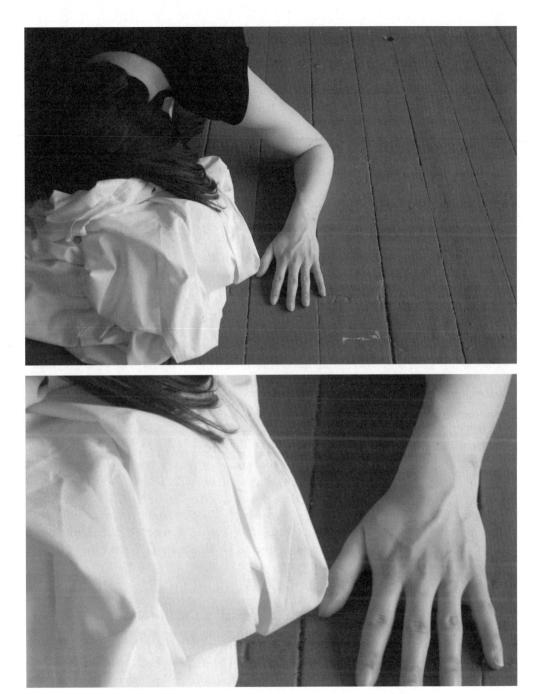

Figure 10.2: Victoria Gray, Pleat, 2009. Performance stills detail. Image courtesy Nathan Walker.

'After the Fall: Dance-Theatre and Dance-Performance' (2006), Adrian Heathfield describes how La Ribot's body of choreographic practice has reconfigured understandings of the body by transforming the spatial and therefore social relations between performer and spectator in performance situations. Echoing my own reflections on 'Pleat', of 'Another Bloody Mary' (2000) Heathfield comments;

> For here, the round of gallery spectatorship replaces the theatrical frame; the frontal cedes to panoramic exposure; and the binary division of the performer–spectator relation is dispersed. The spectator is liberated from a static place by the choice and fluidity of the promenade. This aesthetic side-step of the theatrical plane deftly brings the spectator into a field of social and sensory engagement.
>
> (Heathfield 2006: 195)

As well as the dispersion of the performer–spectator, it is the subtler point concerning social relations in the performance space that are for me crucial when considering ways in which sensory empathetic exchanges are possible. La Ribot demonstrates the effects of this in 'Another Bloody Mary' as she arranges a selection of red coloured objects, garments and clothes on the floor until this chromatic arrangement begins to resemble a pool of spilled blood. Wearing green heels that contrast with this pool of red she fixes a blonde wig to her head that covers her face, obscuring her identity and her ability to make eye contact with her audience. After applying a smaller equivalent wig to her pubic area she commences a slow fall to the floor, toppling over her green heels. Here she remains for some time in stillness amongst this sculptural, yet un-monumental arrangement, having choreographed the objects and space into a living sculpture that now incorporates her own body.

Her body holds itself, apparently inanimate, apart from evidence of her steady breathing, as a sculptural being, manifesting what I have already discussed in terms of 'action sculpture'. The horizontality of this action and the dispersal of her objects and items of clothing echo the plane of the spectators. Their bodies, bags and coats are distributed on the floor of the space and this incidental choreography of objects and bodies appears to enter into the work. Of these incorporations La Ribot comments,

> My objects, their bags or coats; their commentaries and my sound; sometimes my stillness and their stillness. Everything and everyone is scattered around the floor, in an infinite surface, in which we are moving quietly, without any precise direction, without any definite order.
>
> (La Ribot 2000 in Heathfield 2004: 30)

Here La Ribot identifies a contingency that includes the spectator as she suggests that her own stillness and spectators' stillness, their commentaries and her sound, become and belong to the same realisation of the work. There is a reciprocal exchange taking place here between performer and spectator, and it is one that I too experience and encourage in my

Figure 10.3: La Ribot, Another Bloody Mary, 2000. Image courtesy Hugo Glendinning.

own performance. To maintain the point I make above, I feel this is where the potential for affective kinesthetic empathy lies, in a blurring of spatial and social boundaries, in an incorporation of other bodies and objects.

I have noticed a similar blurring of experiences between performer and spectator in a variety of ways in my own work. For example, I notice in my performances that the longer I remain still, the more the spectator seems to have a desire to move. Like the need to fill an uncomfortable silence, the spectator fills my uncomfortable stillness, putting movement where there previously was none. There is a tension in the expectancy of the spectator, manifested in their slight shifts of weight, in heavy and often impatient breathing and in occasional talking. These shifts and occasional commentary make tangible their physical and mental struggle, both to remain still and to witness stillness, presenting a threshold of boredom to be surpassed. My apparent lack of activity requires a perceptive adjustment and a silent agreement must be made between performer and spectator to give sufficient time and attention to these small details. As theorist Antonia Payne comments, 'To witness the stillness of another is an act of complicity – a necessary empathetic transaction, a performance of mutual attentiveness to the body, space, the incidental details of each other' (Payne 2006: 121). I witness this complicity as slowly, the spectator and I settle into a mutual stillness, the positioning and shape of our bodies tessellates, occasionally mirroring or accidentally echoing the other. If my stillness requires a standing position, it is common that the spectator shares this plane by standing too. If my stillness requires a move to the floor, I have known spectators to lie or sit with me and so consciously or unconsciously we begin to share a similar distribution of weight. This is particularly true of the largely horizontal action sculptures of 'Pleat' and can also be seen happening in the image of 'Another Bloody Mary' where audiences share the ground with La Ribot. In a levelling of planes I hope that spectators experience a physical sense of what it might feel like for me to maintain stillness in difficult positions for what can sometimes be a long time. Post-performance, spectators of 'Another Bloody Mary' are known to have verbally expressed specific empathy and perhaps sympathy for La Ribot as she held her final contorted position on the floor.

Like La Ribot's slow and sustained fall, I also experience a settling down taking place, often manifested in a synchronicity of breathing between performer and spectator. This strategic slowing down brings attention to the rhythm of stillness through breath and serves to evoke a 'dense slow-moving sensorium' (Heathfield 2004: 8) in the work. Here, the temporal properties of the work are emphasised as having an important function in the underlining of its sensorial qualities. As Heathfield comments:

> Things take their time, and time itself is exposed as a product of bodies, senses and perceptions. This time as it is experienced is not the normative, progressive time of culture, but a time that is always divided and subject to different flows and speeds: a time out of time.
>
> (Heathfield 2004: 8)

I find Heathfield's last phrase 'a time out of time' particularly relevant. As discussed earlier in relation to my own training as a dancer, the temporality of the art form was continually hinged upon being '*on*' time for a cue or '*on*' time in relation to other dancing bodies moving in space. Stillness as a mode of being in time that would allow me to justify a falling '*out*' of time appealed as a transgression from the dancing norm. Not only does this represent another way of experiencing time in performance situations, but as suggested by Heathfield might also sidestep the progressive time of modern culture. Peter Sloterdijk comments, 'The categorical impulse of modernity is: in order to be continuously active as progressive beings man should overcome all the conditions where his movement is reduced, where he has come to a halt, where he lost his freedom and where he is pitifully fixed' (Sloterdijk 2009: 5).

Stillness in my own work and in the work of such contemporary European dance performance makers as La Ribot operates against this model of time and therefore against the impulse of modernity. Practising stillness becomes an embodiment of these critical theories and, as opposed to fixing bodies, stillness has the effect of freeing bodies from the frenetic kinetic drive of modernity. Here, the body might experience time kinesthetically as opposed to the more dominant kinetic experience, creating a space where 'orthodox clock time slides into the immeasurable fields of sensory time' (Heathfield 2004: 8).

This paradigm of performance work negates the constant delivery of more and more new images and asks audiences to be active in observing single images for longer. It aims to steady the fast, mediated pace of our times and resists the obligation in performance to entertain. So, whilst stillness in my performances denies a spectator the spectacle of the kinetic, this resistance simultaneously offers them something different. My body in stillness seeks to underline the activity going on at the periphery of the space, under the surface of the skin, for both performer and spectator. Therefore stillness in 'Pleat' was harnessed as a methodology to engender a hyper-awareness, to promote a search for something where there first appears to be nothing.

Stillness, 'Stuck' and activating sculpture

One discussion that has been prominent in performance practices and theory in recent years, particularly since the early 1990s, is the relationship between dance and fine art practices.[6] This relationship is not new and should be acknowledged as a re-visitation of collaborations between dancers and fine artists in the 1960s, particularly between Judson Dance Theater and minimalist and conceptual artists practicing at the time. This shift historically and currently negotiates a move from the theatre into the gallery space, where as Heathfield commented (cited above), 'the round of gallery spectatorship replaces the theatrical frame'.

As mentioned earlier, the 'Move: Choreographing You: Art and Dance' exhibition focused precisely on this interrelationship between dance, installation art and sculpture.[7] In connection with this exhibition, a symposium was held where panel discussions sought to interrogate the politics of stillness and movement and draw parallels between dance and

sculpture. It reconsidered sculptural objects as performative choreographic objects, which despite their apparent inanimacy could be activated by spectator's bodies. In turn these works physically affect and mobilise the choreography of spectators' bodies in the process. This animation took place most clearly with works that required the spectator to physically interact by holding, climbing into or carrying elements of the work. For example, to experience William Forsythe's choreographic object, 'The Fact of Matter' (2009), spectators must navigate their way across the space whilst balancing on a series of climbing rings, hanging from the ceiling at various heights, posing various degrees of physical difficulty. In this example the kinetic effect on the performative object and spectator was explicit. I am keen, however, to consider the animating effects of sculptural objects whereby no literal choreographed physical contact or visible manipulation is made. Here, I am considering instances where a more sophisticated, subtle and implied sense of movement and sensation is transferred between static art object and spectator through empathy. Having already considered these possibilities in relation to live performance I wish to test these theories against a sculptural object.

An experience of the exhibition *After* (2010) at Camden Arts Centre London by artist Angela de la Cruz served as a powerful reminder of why I am moved by stillness. One sculptural piece in particular, appropriately or inappropriately in this context named 'Stuck' (2010), underlines the tension held within an object caught between animate and inanimate states, tensions I empathise with in my body's stillness in performance (figure 10.4). Initially, I visually registered the work's synthetic materiality, and noted that the gallery description of the work was 'Oil on Canvas'. However, 'Stuck' disrupted traditional notions of oil on canvas as a 2D and static form; as such this 'painting' appeared to be oil spilling from the wall and took on 3D and dynamic sculptural qualities. The sculpture itself did not move but it moved me, both physically and emotionally, leaving a melancholic resonance. This dynamic visual image translated synesthetically into a physical sensation of thick oil pouring through my hands, causing a haptic shift in senses. I wanted to touch it yet, unlike my playful and tactile experience of William Forsythe's 'The Fact of Matter' (2009), the conventions of the gallery would not let me.

The canvas had folds that I felt a desire to fit my hands into, the depth of which would tell me something of the structure's weight. I could feel my own weight balanced in relation to an estimation of its sturdiness; the heaviness of 'Stuck' made my body feel light in comparison. I watched 'Stuck' be still from a number of perspectives: from the floor, from the opposite side of the room; I stood by its side, I kneeled at its feet and I faced it head on. The closer I came to 'Stuck', the taller it seemed and the smaller I became. The further away I stood, the smaller it seemed and the taller I became. I was an amalgamation of weak and strong in its presence.

Up close, afforded by our mutual stillness I could see that the grain of the canvas resembled lines on human skin and the black oil paint had a patina to it that when witnessed up close reflected me in its surface; its shine reflected and repelled my body as I edged closer. Here I am reminded of Jenn Joy's observation, on seeing her own reflection in the

Figure 10.4: Angela de la Cruz, Stuck, 2010. Oil on canvas. Courtesy the artist and Lisson Gallery.

glass of a framed photographic work 'Cyc-7, C-Print' (2007) by Bill Durgin, 'Standing in front of the photograph, my reflection disturbs the surface, casting a shadow that imposes a particular way of seeing that obscures the image in the very moment that I attend to it' (Joy 2009: 64). My corporeal reflection caused by the light cast on 'Stuck' from the gallery ceiling caused me to shift so that my own body did not impose itself when viewing the work. I moved in relation to the stillness of 'Stuck', both avoiding seeing myself yet knowing that I am always projecting myself and my readings onto its surface. I could see qualities of my own action sculptures in 'Stuck', recognising aesthetic and material similarities that either already exist in my own work or that I strive to bring into existence. When I make work like 'Pleat', I would like to think that spectators have a physical experience, somewhere close to the one that I had looking at 'Stuck'. Whilst proximity and stillness are apparatuses that allow the spectator to look closely at the *performer*, I hope that, like 'Stuck', this stillness also promotes a reflexive awareness of the *spectator's* own corporeal materiality, and of the movement taking place within the stillness of their own body. This is where affective and empathetic experiences can be located, through an apparatus for a heightened perception of an experience that is both physically and emotionally moving, a contact made without touching.

Empathy, affect and language

In the previous discussion I would identify within my language and reflections what Kate Love, artist and writer of fine art history and theory, has named a 'muzziness' (Love 2005: 170). The proximity to my own work when writing about it and my subjective experience of the other artworks discussed risk a closeness that might distort my ability to see or articulate things clearly. These empathetic experiences seem to surpass words and, for me, have caused a blurring of distinctions between emotion and kinesthetic affect, emotion becoming interchangeable with affective experience despite being different. Often when asked to describe what we experienced during a performance, both as a performer and spectator, our emotions take precedence over an articulation of the sensorial qualities of the work, those that Heathfield described as belonging to 'immeasurable fields' (Heathfield 2004: 8). For example, in the case of 'Pleat' I have often experienced emotions of sadness during a performance, prolonged by the melancholic resonance of stillness. Both as a doer and a watcher of performance, I have used this emotion as a quantifier and defining term of my sensorial experiences. However, this assignment of an emotion seems to be shortcutting or devaluing the complexity of these affective experiences. Theorist of affect and sensation Brian Massumi articulates this clearly in commenting,

[A]n emotion is a subjective content, the sociolinguistic fixing of the quality of an experience which is from that point onward defined as personal. Emotion is qualified intensity, the conventional, consensual point of insertion of intensity into semantically

and semiotically formed progression, into narrativizable action–reaction circuits, into function and meaning. It is intensity owned and recognised.

(cited in Caspao 2009: 134)

This 'action–reaction' process that Massumi identifies, whereby affect is qualified by the linguistic articulation of an emotion, causes a delay. This delay is connected to German phenomenologist Bernhard Walfendels' idea that we experience something before we register it is happening and once we do it is too late. Walfendels comments that, 'This deferral means that here and now I am somewhere else, where I never was and never will be. That which we perceive happens too early, the remarking happens too late' (cited in Siegmund 2009: 335). We are past the point of experience, already moving into and out of a new one, therefore, unable to comment from within experience itself. Everything I describe, post-performance, and indeed everything I reflect upon during the performance becomes an approximation, an after-effect of affect. As Paula Caspao comments, 'That is the reason why an emotion is just a very partial expression of affect' (Caspao 2009: 134). However, I would argue that this is not to imply that these emotions, although partial and often abstract reflections, are less important or embodied. In fact, however mediated and changed, these reflections are still very real, lived experiences. As emphasised earlier, as perceptions, these reflections are neuromuscular events and are therefore experienced with and through our bodies (Gardner 2008).

These moments of recalling empathetic exchanges are for me powerful yet difficult to articulate as they are experienced fleetingly. What are we left with if all that we have are abstract and partial expressions? Somehow my loss of words demonstrates the fullness of something else that I cannot seem to articulate. Gardner asks, 'What are we *doing* when we apprehend with our sense of movement? There is difficulty in language. We cannot culturally "index" a particular level or modality of sensing that is in the joints and our relation to gravity and instability' (Gardner 2008: 55). And so, I have often tried (but failed) to be more concrete, to pinpoint the place on my body where the affective experience of stillness leaves its impression on me: is it my neck, is it in my stomach, is it my back, is it my chest? As a performer I can be certain that I most often leave the performance sore, my muscles aching from the exertion and the tension. I also consider where my own stillness might leave its impression on the spectator's body. I believe the spectator carries similar pains sympathetically in their own body. Watching can sometimes be a painful experience, manifested in the physical, mental and emotional effort involved. An active spectator is as active as a performer, particularly if through kinesthetic empathy they embody and partake in a shared experience with me.

An economy of stillness

These moments of empathy, as interrelated and reciprocal experiences, necessarily invite an engagement with the phenomenological dimension of our perceptions. Thus, I have

often experienced a difficulty in articulating them in a way that renders them visible or communicable via language. Emma Kirby explains that, 'Our sense of materiality of matter, its palpability and its physical insistence, is rendered unspeakable ... for the only thing that can be known about it exceeds representation' (cited in Bolt 2004: 154). The only thing I appear to 'know' about my empathetic experiences, and this is not a short cut, seems to be rendered unspeakable in linguistic terms. This therefore undermines the economy of representation through the body's resistance to the fixity of any sociolinguistic terms. In parallel, stillness is an apparatus that has offered me the spatial and temporal conditions to escape the economy of bodies that I once circulated within in the fixity of conservatoire training. Paradoxically, in stillness I have moved my body towards an experience identified by Lepecki as a freedom from 'its commitment to produce a pure being-towards-movement, a dazzling dumb mobile' (Lepecki 2006: 52).

As a result, stillness can become an active performative space for empathetic experience, which identifies affect as a very difficult yet crucial mode of criticality. As an act of artistic and political criticism, we could say that stillness is the physical realisation of a 'quiet theory of loud mobilization' (Sloterdijk 2009: 11), the physical embodiment of a mode of criticism that Peter Sloterdijk suggests is crucial. Stillness is a movement that pushes against and is different to the type of movement that it sets out to criticise, performing the difficult act of challenging movement from within movement itself.

Notes

1. Mark Franko's essay (2007) is also significant to this debate.
2. A reading of Sloterdijk's 'Mobilization of the Planet from the Spirit of Self-Intensification' (2009) is key to this discussion.
3. Relevant discussion of this can be found in Goldman (2004). Ramsay Burt also discusses this in relation to Paxton's works 'Satisfyin Lover' (1967) and 'State' (1968) in Burt (2008).
4. This work was also presented at Axis Arts Centre, Manchester Centre for Contemporary Art, January 2010, as part of Curating Knowledge, curated by Jane Linden, Manchester Metropolitan University, UK. Further documentation can be viewed at www.victoriagray.co.uk.
5. The 'Move: Choreographing You: Art and Dance' exhibition was curated by Stephanie Rosenthal, October 2010–January 2011, Hayward Gallery London, www. move.southbankcentre.co.uk.
6. Ramsay Burt relates minimalism and conceptual art practice to postmodern dance and particularly to Judson Dance in Burt (2006). André Lepecki (2006) addresses this in his chapter. Siobhan Davies Studios have an ongoing programme that addresses links between Fine Art and Performance.
7. Rosenthal, S. (2010). *Move: Choreographing You, Art and Dance Since the 1960's.* Hayward Gallery Publishing accompanies this exhibition. MoMA's Performance Exhibition Series presented a programme of live performance and dance in conjunction with the group exhibition 'On Line: Drawing Through the Twentieth Century', in 2011.
8. The Move Weekend symposium took place between 26 and 28 November 2010 at the Southbank Centre, London.

References

Bolt, B. (2004). *Art Beyond Representation: The Performative Power of the Image*. London and New York: I.B. Tauris.

Burt, R. (2006). *Judson Dance Theater: Performative Traces*. London: Routledge.

Burt, R. (2008). 'Revisiting "No To Spectacle": Self Unfinished and Véronique Doisneau'. Forum Modernes Theater, 23 (1): 49–59.

Caspao, P. (2009). 'Stroboscopic Stutter: On the Not-Yet-Captured Ontological Condition of Limit-Attractions'. In A. Lepecki and J. Joy (eds), *Planes of Composition*. India: Seagull Books, 121–159.

Franko, M. (2007). 'Dance and the Political, States of Exception'. In S. Franco and M. Nordera (eds) (2007), *Dance Discourses, Keywords in Dance History*. London and New York: Routledge.

Gardner, S. (2008). 'Notes on Choreography'. *On Choreography: Performance Research Journal*, 13 (1): 55–61.

Goldman, D. (2004). 'Steve Paxton and Trisha Brown: Falling in the Dynamite of the Tenth of a Second'. *Dance Research: The Journal of the Society for Dance Research*, Summer, 22 (1): 45–56.

Goumarre, L. (2004). 'Die Another Day'. In M. Peuch-Bauer and F. Fabre (eds), *La Ribot, Volume II*. Centre nationale de la danse, Pantin/Merz-Luc Derycke, Gent, 60–69.

Heathfield, A. (2004). 'Alive'. In A. Heathfield (ed.), *Live: Art and Performance*. London: Tate Publishing and Routledge, 6–13.

Heathfield, A. (2006). 'After the Fall: Dance-Theatre and Dance-Performance'. In J. Kelleher and J. Ridout (eds), *Contemporary Theatres in Europe: A Critical Companion*. London and New York: Routledge, 188–198.

Joy, J. (2009). 'Anatomies of Spasm'. In A. Lepecki and J. Joy (eds), *Planes of Composition*. India: Seagull Books, 64–82.

Kwan, S. (2003). 'Hong Kong In-corporated: Falun Gong and the Choreography of Stillness'. *Moving Bodies: Performance Research Journal*, 8 (4): 11–20.

La Ribot (2000). 'Panoramix'. In A. Heathfield (2004) (ed.), *Live: Art and Performance*. New York: Routledge, 28–37.

Lepecki, A. (2001). 'Undoing the Fantasy of the (Dancing) Subject: "Still Acts" in Jerome Bels The Last Performance'. In Steven de Belder and Koen Tachelet (eds), *The Salt of the Earth: On Dance, Politics and Reality*. Brussels: Vlaams Theater Instituut.

Lepecki, A. (2006). 'Choreography's "slower ontology": Jérôme Bel's critique of representation'. In *Exhausting Dance*. New York: Routledge, 45–64.

Lepecki, A. (2006). 'Toppling Dance: The Making of Space in Trisha Brown and La Ribot'. In *Exhausting Dance*. New York: Routledge, 65–86.

Love, K. (2005). 'The Experience of Art as a Living Through of Language'. In G. Butt (ed.), *After Criticism: New Responses to Art and Performance*. USA, UK & Australia: Blackwell Publishing, 156–175.

Luckett, H. (2010). *Move Choreographing You Exhibition Guide*. London: Hayward Gallery, Southbank Centre.

Payne, A. (2006). 'Still'. *A Lexicon: Performance Research Journal*, 11 (3): 121.

Siegmund, G. (2009). 'Apparatus, Attention and the Body: The Theatre Machines of Boris Charmatz'. In A. Lepecki and J. Joy (eds), *Planes of Composition*. India: Seagull Books, 318–345.

Sloterdijk, P. (2009). 'Mobilization of the Planet from the Spirit of Self-Intensification'. In A. Lepecki and J. Joy (eds), *Planes of Composition*. India: Seagull Books, 3–14.

Chapter 11

Empathy and Exchange: Audience Experiences of Scenography

Joslin McKinney

This chapter considers how kinesthetic empathy might impact on the audience experience of scenography. Traditionally, the scenic dimension of performance has been dealt with as spectacle, focusing on the visual transmission of information or symbolic ideas.[1] However, more recent scenographic practice has been characterised by work that is multi-sensorial in its appeal and engages audiences bodily as well as visually and intellectually. While ideas of kinesthetic empathy in relation to performance are most strongly developed in terms of intersubjectivity (Reason and Reynolds 2010), this chapter explores how the concept might illuminate the relationship between spectator and object in the context of scenography. Considering empathy in relation to my own practice, I discuss how this is a reciprocal relationship, centred on an 'exchange' through the medium of scenography, where the audience can, potentially, become co-creators.

Scenography here refers to the spatial aspect of performance environments, and the orchestration of materials and constructions (costumes, objects, architectonic elements, light and sound) as an intrinsic part of performance. Not limited to simply supporting scripted theatre performances, contemporary scenographic practice emphasises spatial, material and multisensory aspects, thereby locating scenography as an integral component of performance or even as a mode of performance itself (McKinney and Iball 2011: 1). For example, the Italian company Socìetas Raffaello Sanzio uses visual and aural stimuli sometimes to the point of sensory overload (fast moving projected images, a rumbling bass, which is felt as much as heard) in order to pull the audience members into 'an atmosphere with different density, an unfamiliar gravity' (Castellucci et al. 2007: 162). Contemporary practice includes work by companies such as Punchdrunk,[2] who use scenography to transform non-theatre venues and to stage performances where audiences, immersed in a scenographic experience, are invited to find their own way through evocative spaces. This kind of work gives as much attention to the performance environment and the carefully selected objects placed within it as to the performers or to text and affords the possibility that significant encounters might occur between the audience and objects.

Scenography in this context challenges and problematises notions of audience, who are no longer distant spectators of images and pictures that are laid out before them. It is important to consider both the audience as a collective entity and the responses of individual spectators within those audiences. As Helen Freshwater points out, an audience is an assembled group and accounts of a single reaction or response cannot do justice to the range of dispositions, beliefs and experiences within that audience (Freshwater 2009: 5–6). In this chapter, I use the term spectator to identify the experience of individuals. However, in the context of the

type of contemporary practice I have described above, spectators placed within (rather than before) the scenography should also be considered as participants. While I recognise that uncritical claims for the empowering and emancipating effects of participation need to be treated with caution (Freshwater 2009: 70), the collage-like structure and the rich sensory content typical of this type of work offer an active and potentially creative role for the audience. Recent scenographic practice, therefore, appears to reframe the role of the audience. Audience members are implicated physically as part of the scenic space and can, within limits, construct their own experience as participants through the ways in which they choose to interact with the scenographic environment.

Despite the enthusiasm for this kind of work, there is little research that helps us understand its 'affective impact' or that of theatre more generally (Freshwater 2009: 11). A significant reason for this is the challenge, both methodological and philosophical, involved in attempts to investigate the ephemeral and often intangible nature of theatre experience (Reason 2010a: 15). To address this, I have adopted a practice-led approach, where I develop performances that focus attention on the scenographic. Alongside this, I have developed methods for capturing and examining audiences' experiences (McKinney 2008).

The research that forms the basis for this chapter is a piece of immersive, participatory performance, *Forest Floor* (2007), which I developed to explore audiences' creative engagement with scenography. The central thesis being investigated through *Forest Floor* was that engaging with and responding to scenography is a process of exchange between the scenography and the spectator, which takes place through the medium of objects and materials.

Roland Barthes' discussion of the nature of images suggests three levels at which scenographic images might operate. As well as the informational and symbolic levels of meaning a scenographic image might convey, there is another poetic or 'obtuse' meaning (Barthes 1977: 52–68). This third level can have a powerful impact even though it is hard to describe; the 'obtuse' meaning 'is outside (articulated) language whilst nevertheless within interlocution' (Barthes 1977: 60). The 'scenographic exchange' I am investigating refers to a process of individual spectators apprehending levels of meaning, especially the 'obtuse', through speculatively creating images of their own.

The notion of scenographic exchange is an attempt to model the way objects in the context of performance might function as a medium of communication. Using my own creative practice enables me not only to work with audiences to see the way they respond, and hear at firsthand about their experiences, but also to develop forms of performance where audience engagement and evidence of a 'scenographic exchange' can be registered through the performance itself in a tangible form.[3] The role of audiences as co-creative participants in this research has been crucial; the form of *Forest Floor* was developed through workshops with audiences and shaped in the light of their responses, both reported and observed.

This chapter looks first at how concepts of kinesthetic empathy can assist with conceptualising scenography as a bodily as well as a visual experience and how empathetic sharing of bodily sensation might influence conscious reflection on scenography. I then turn

to *Forest Floor* and examine the findings, drawing on and developing ideas of kinesthestic empathy as they relate to scenography. Finally, I incorporate a phenomenological perspective on empathy to develop the idea of reciprocity or exchange between the spectator/participant and the scenography

Kinesthetic empathy and scenography

Originally associated with scene painting and with architectural perspective drawing (Hannah and Harsløf 2008: 11; Rewa 2004: 119 n.1), the term 'scenography' has more recently been used to describe the way the performance environment constitutes a dynamic and 'kinesthetic contribution' to the experience of performance (Rewa 2004: 120). Critical accounts where the scenic space is 'given as spectacle to be processed and consumed by the perceiving eye, objectified as a field of vision for a spectator who aspires to the detachment inherent in the perceptual act' (Garner 1994: 3) reflect a type of practice that emphasises scenography as a coherent and totalising statement. But these accounts are not adequate to address contemporary practice. The audience experience of scenography now needs to be considered as an embodied experience, embracing the spatial and material elements of performance (McKinney and Iball 2011: 24). Focusing on the kinesthetic dimension of scenography assists with that shift by emphasising bodily engagement and the interaction of the senses as the foundation for emotional and intellectual engagement.

In the 1970s Bernard Beckerman claimed that audience response to theatre 'relies upon a totality of perception that could be better termed kinesthetic' (Beckerman 1979: 150). But he was thinking mainly about the way a seated audience respond to 'the texture and structure of action' as revealed through the bodies and movements of the performers on stage. In considering kinesthetic empathy in relation to scenography I have found Susan Leigh Foster's (2011) investigation of the development of concepts of kinesthesia and empathy and choreography insightful and relevant to the context of my own practice and research. In particular I have followed Foster in engaging with James Jerome Gibson's formulation of kinesthesia as central to the operation of perceptual systems. Gibson observed that kinesthesis relates to detection of a whole range of movements in the body, vestibular, cutaneous and visual as well as muscular, and 'cuts across the functional perceptual systems' (Gibson 1968: 111). Although visual perception may appear to be central to the experience of scenography, it involves all perceptual systems through kinesthesis. Foster explains how visual kinesthesia is integrated with other kinds of movement:

The eyeball itself could tell us very little about the visual world around us, but the eyeball combined with the ocular musculature that surrounded it and the vestibular system that oriented it with respect to gravity could give very precise information about one's surroundings.

(Foster 2011: 116)

Kinesthesis functions as a means of picking up or detecting information through the interaction or 'flux of energy' between our bodies and the everyday environment (Gibson 1968: 319). The eyes, Gibson says, should be thought of not as 'cameras' but as 'apparatus for detecting the variables of contour, texture, spectral composition, and transformation in light' (Gibson 1968: 54). This, as Foster points out, suggests 'an ongoing duet between perceiver and surroundings' where an active observer is alert to 'constancies' and changes in their surroundings (Foster 2011: 116). This awareness of the outside world through one's own body can be considered as the foundation for empathy.

Although empathy is clearly related to intersubjectivity, the term originally described aesthetic experience, specifically 'the relationship between an artwork and the observer, who imaginatively projects herself into the contemplated object' (Gallese 2001: 43). It was Robert Vischer, who in the late nineteenth century, sought to describe the operation of the artistic impulse, particularly the 'subjective content' that the viewer brings to 'aesthetic contemplation' of objects (Mallgrave and Ikonomou 1994: 21).

Vischer articulated three levels or stages of a spatial and bodily understanding of forms. First, he distinguished between sensory, immediate feeling and a kinesthetic or responsive feeling (Vischer 1994: 92). The former is simply an automatic physical reaction to stimuli whereas responsive feeling requires a more active engagement of the body, 'scanning' rather than just 'seeing', moving beyond a first impression of an object or a scene and making a more active effort to 'finding our bearings amid its relationships' (Vischer 1994: 94). This more conscious attention involves the whole body in adjusting one's gaze or in reaching out to feel. Considering scenography, bodily response might be stimulated by scanning the patterns (or rhythms) created by architectonic structures, colours, textures and sounds, shifting intensities of light or movement of fabrics. As in choreography, the effect of empathy with objects means the spectator finds themselves pulled into the 'volumetric totality' of the experience through paying close attention to the dynamic interaction of body, space and objects (Foster 2011: 155).

The final stage of Vischer's account is where, through a process of imaginative projection, it is possible to 'incorporate our own physical form into an objective form' and effect an empathy between oneself and an object:

> When I observe a stationary object, I can without difficulty place myself within its inner structure, at its center of gravity. I can think my way into it, mediate its size with my own, stretch and expand, bend and confine myself to it. With a small object, partially or totally confined and constricted, I very precisely concentrate my feeling. My feeling will be compressed and modest ... When, on the contrary, I see a large or partially overproportioned form, I experience a feeling of mental grandeur and breadth, a freedom of will.
>
> (Vischer 1994: 104)

The pantheistic and transcendental dimension to Vischer's line of thinking, where 'the human being is seen to merge with the universe' (Mallgrave and Ikonomou 1994: 26), was criticised by those, succeeding Vischer, who sought an account of aesthetics more clearly rooted in psychology (Mallgrave and Ikonomou 1994: 28). But in the 1960s Michael Polanyi took up the notion of empathy with objects again, this time considering how empathy with objects might facilitate scientific knowledge as well as aesthetic appreciation. Polanyi says that when we perceive an object we 'incorporate it into our body – or extend our body to include it – so that we come to dwell in it' (Polanyi 1976: 16). In contrast to Vischer, where some conscious effort and imagination seems to be required, Polanyi describes 'indwelling' as a tacit process, 'which we are quite incapable of controlling' (Polyani 1976: 14), but which operates alongside the conscious process of attending to something. Through tacit processes we come to know 'more than we can tell' (Polanyi 1976: 18). For example, the skill of a car driver, acquired through indwelling, is not the same kind of understanding as knowledge of the 'theory of the motorcar' (Polanyi 1976: 20).

Vischer's account of aesthetics suggests complete empathetic merging between the observer and the object, whereas Polanyi describes indwelling as a reciprocal relationship between the body and the object; at the same time as we are using our body to attend to objects, we notice the effect of these objects on our body. Simon Shepherd shows how Polanyi's theory influenced Beckerman's account of kinesthetic perception in the theatre (Shepherd 2006: 75) and how this leads, 'through shifts in tension', to empathy between 'ourselves and the performers' (Beckerman 1979: 149). In what follows, I consider how empathy, stimulated by kinesthetic perception, might arise between spectators and scenographic objects as well.

Forest Floor

Forest Floor was developed to explore the idea of a 'scenographic exchange' through transforming its audience into active co-creators. Audience members were able to respond directly within the performance itself through interacting with scenographic materials and contributing to the direction and content of the performance through creating new scenographic images. It was through this interaction that I hoped to see evidence of this exchange.

Creating an environment and structure for the performance where audience members had real agency was a central concern. A basic level of participation was achieved quite easily through the design of the event and through setting expectations of the audience.[4] However, the challenge was to create a situation where the audience felt enabled not simply to join in as participants but to make their own creative interventions in response to the performance. This meant attending to the stimulus to participation and potential co-creation that the performance itself could provide. The aim was to create an immersive experience, which provided, as expressed by Alison Griffiths, 'the sensation of entering a space that immediately identifies itself as somehow separate from the world and that eschews conventional modes of

spectatorship in favour of a more bodily participation in the experience' (Griffiths 2008: 2).The sensory quality of the scenography, the distinctiveness of the environment and the particular nature of the objects within in it were all important in establishing *Forest Floor* as an immersive space. At the same time the performance itself needed to leave room for participants to make a meaningful contribution and influence the event. Griffiths considers interaction in the context of immersive environments to be 'an activity that extends an invitation to the spectator to insert their bodies or their minds into the activity and affect an outcome via the interactive experience' (Griffiths 2008: 2). The main way this was achieved was through the use of a narrative structure that was open-ended.

Three fairy stories ('Little Red Riding Hood', 'Hansel and Gretel', 'Bluebeard') provided a framework for the performance. The familiar patterns of these stories would, I speculated, give narrative structure to scenographic images without the necessity of a script. At the same time, the potency of fairy tales, as discussed by Bruno Bettelheim (1976) and ways in which they might be inflected and subverted, as, for example, in Angela Carter's *The Bloody Chamber* (1981), seemed to offer plenty of opportunity for wider resonances, variations, extensions, adaptations, deviations and, potentially, new stories to be developed during the performance.

My role in *Forest Floor* was that of director. In addition, there were five performers – two actors and three scenographers – and audiences of between 10 and 14. Before the start of the show the performers helped the audience members to dress in the same hooded white overalls and headlights that they were wearing. The audience was led into a performance space defined by silk tubes, suspended from the ceiling like stylised birch trees. A collection of objects – shoes (heavy black brogues, women's red slippers); a fur overcoat with a red lining; a full white net skirt; a top hat; a chair; 12 palm-sized puppets; buckets of theatrical snow, rose petal confetti and chalk – was arranged at the back of the space. The lighting was low, and the space was filled with haze. The soundtrack consisted of layered, rhythmic sounds of scraping and tapping organised into five sections, each longer than the last and gradually building in intensity over 45 minutes. This environment structured the duration of the performance and provided cues for the performers.[5]

The first three sections (which lasted 15 minutes in total) were conceived as an induction for the audience into the world of *Forest Floor*. Cumulatively they became acclimatised to the particular themes and aesthetic language of the performance, and to the degree of agency that they had as participants. In the first section the two actors used movement alone to relate key episodes from the fairy stories. In the second section these actions were repeated and the scenographers introduced objects and costumes to embellish and give context and meaning to the movement: Red Riding Hood's granny was given a chair to rock in, the wolf a big red-lined fur coat; Bluebeard's wife was dressed in the net skirt and long white gloves for her wedding and the puppets became the previous wives. The scenographers also chalked on the floor images of pine tree forests and sweets and cakes for Hansel and Gretel, wolf footprints and words of warning. They sprinkled snow, and threw confetti at Bluebeard's wedding. Members of the audience were offered chalk and confetti and invited

to help.[6] Then the objects and costumes were swept into a heap and the actions began for a third time, but now with the interventions on the part of the scenographers becoming more intuitive and improvised, for example the silk tube 'trees' were made to move and impede the actors or the Granny was dressed in the wolf coat. This necessitated responses from the actors, which created new lines of action and variations on the original fairy stories. This induction was intended to establish a common language of objects and ideas as a foundation for creative responses through the rest of the performance.

The range of audience engagement and participation was observed in each performance by myself (in costume and taking part alongside the audience) and by the scenographers and performers. Following each performance we discussed and made notes on the detail of what had happened and this was supplemented by studying videotapes of each performance from fixed cameras that recorded the whole space. We paid particular attention to the different ways in which participants contributed, the materials they were drawn to, the interactions that occurred between participants and objects, participants and performers and between participants. After each performance we considered how our response as scenographers and performers facilitated or inhibited the contributions from the participants and how it incorporated our growing understanding of how performers might facilitate participation and creative interaction.

In addition, immediately after each performance I led a semi-structured group discussion with the whole audience. They were asked to reflect on their experience of the performance, their role in it and the contributions they had made or witnessed. The six post-performance discussions were transcribed and extracts from what the participants said are included in the following analysis.

Bodily engagement and interaction

In looking at both the responses from the post-show discussions and the participant observation, one striking factor was that the headlights worn by both performers and participants served to amplify the act of looking as a mode of engagement:

> I could choose to look at whatever I wanted with my headlight. If I couldn't see something clearly I could put my own light on it and look at it, which is how I felt engaged from the start.

This account reflects Vischer's idea of scanning as a means of engaging and orientating ourselves in relation to a scene or an object. But whereas Vischer is concerned with the experience of an individual, the *Forest Floor* participants were often conscious of being part of a group. The headlights meant that each participant was able to see where other people were looking. While some felt inhibited by this, some used their lights to draw other people's attention to something they were doing or looking at, and some enjoyed misdirecting others

by adopting a technique of looking obliquely at something so that the light did not give away the object of their attention. The headlight beam meant that even standing and watching the actions of other people was to make an active choice about where to place themselves that impacted upon the space. Although the white overalls made participants largely anonymous and difficult to distinguish from the performers, some reported feeling initially self-conscious about handling the materials. But gradually this subsided, often through the agency of the materials themselves:

> I was pretty disengaged when it started and it wasn't until I had the snowflakes in my hand I felt impelled to do something. And then I did and suddenly I was great. And actually I found my mood lightening.

For this participant, handling the snow was a catalyst to immersion in the world of *Forest Floor* and this was accompanied by a loss of self-awareness and a change in emotional state. Usually by this point the majority of the participants would be actively joining in (using the puppets, the chalk, the snow and the petals, investigating the silk tubes, wearing items of costume) and the roles of actor, scenographer and spectator became blurred. The original fairy stories disintegrated and spawned hybrid stories. This, together with the build up of materials in the space, assisted participants in feeling more free in their contributions; the messier the space became, the more juxtapositions and layers that accrued, the less inhibited they became. Over the course of each performance it could be seen that participation, which would generally start out as imitation of what the scenographers were doing, developed into actions that were initiated by audience members who participated through making their own scenographic interventions.

In *Forest Floor* this prospect of affecting the outcome was crucial to the motivation to participate. The stimulus to interaction and some form of scenographic exchange seemed to be the immersion through bodily participation in the performance. One person described using chalk to draw a forest of trees on the floor in their own style and being aware of how what they were doing was altering the bounds of performance space as a small but significant contribution as 'my own little thing … it felt really good'.

Interaction and empathy

Whilst the majority of the audience felt comfortably able to contribute as participants within the structure of the performance, there remained a range of dispositions towards active involvement. At the extremes, some felt inhibited by what they perceived to be the expectations on the part of the performance makers and their anxieties about fulfilling them; whereas others felt their actions would be inconsequential in the face of what they suspected must be a predetermined plan. Even though both of these of these reactions might be considered negative responses, they arise, nonetheless, from empathetic awareness. In both

cases the participants were trying to picture the intentions of the performers and director. Anxiety about making the right kind of contribution was remarked upon by a participant who said they thought they needed more practice throwing the snow. They had noticed how the performers did it, how they made it fall, and decided that what they had done did not have the same effect. On the whole, concerns about tokenistic participation were assuaged as the performance progressed and it was seen that participants could, in fact, alter the course of the performance. By about 20 minutes into most of the performances, we aimed to let audience members take the initiative. This meant paying close attention to what participants were doing and responding in ways that registered and validated their contributions. One of the performers described how a participant drew around a pair of shoes, which were then moved. The performer, conscious this same person would be watching, put them back in exactly the same place 'because they would like that'.

At first the performers found it hard to hand over control to the audience because they worried about the performance losing shape and momentum. Often, around the mid-point, it did. Although we were aiming to effect a seamless transition from the early part of the performance where the performers were in control to the later part where the participants could determine what happened, this was rarely achieved. Most of the performances contained periods where nothing much appeared to be happening and momentum would drop. For the performers (and for some participants) this could be very challenging as they felt a responsibility to 'keep things moving'. But we came to understand that we had to allow this to happen. It was a question of trusting the participant and finding ways to show them that trust. Key to this was being alert to participant interventions and, where it seemed right, making a response. The performers learned to attune themselves to the feeling in the room and pay attention to how the participants were handling materials and the images they were creating. When this was achieved the performers described this as 'a kind of conversation', a reciprocal relationship that was really satisfying.

Moments like this sometimes came about through intense moments of connection between a performer and a participant through the medium of the puppets. A performer recalled how she and a participant stood face-to-face, each with a puppet in the palm of their hands, slowly articulating the arms so that they almost touched. It was 'a really personal moment … the two of us connected, nobody else … it was really equal'. What took her by surprise was the intensity of the experience. Video footage of this moment shows the performer and the participant concentrating on their puppets and not looking directly at each other. They are making the stiff arms of the puppets move and gesture towards each other and this is the means by which a moment of connection, of empathy, comes about.

Kinesthetic empathy with objects

The puppets in *Forest Floor* seemed to be a key site where empathy operated kinesthetically and emotionally. As well as operating as a vehicle for empathetic sharing as in the example

above, there was also a strong sense that the participants' direct encounter with the puppets themselves was rooted in an empathetic response. After every performance at least one participant commented that they did not like to see the puppets being badly treated (thrown about, stood on). One participant said 'I saved one life. I felt they were trampling on them and it was an awful sight. I just grabbed one that was left'. Another commented on 'the profound sadness of those children … They could go off to Auschwitz at any moment. They could be taken away from the world'.

To consider a puppet as a living thing is to respond to the 'magic and wonder' of theatrical illusion. This is a view that has often been attributed to children or 'folk' audiences, whereas 'sophisticated' viewers see the 'grotesquely comic' effect of the puppets in the 'attempt to animate the inanimate' (Reason 2008: 343). Reason proposes that the principal pleasure afforded by puppets is that the two aspects – an object and a life – are intertwined and seen simultaneously. This 'double vision' of puppets (Reason 2008: 342) challenges assertions that puppets are perceived exclusively as either living beings *or* as inanimate objects. From watching and listening to participants in *Forest Floor*, their appreciation of the construction of the puppets as objects was not a sophisticated or knowing response. It seemed to be wholly connected to their emotional reaction to them as living beings.

There was little reference in post-performance discussions to the puppets as objects. Nonetheless, their construction seemed to me to be significant in the responses they aroused. Their material qualities (their size, their weight, the way they looked and moved) were discovered through spectators handling and manipulating them. Their stiff arms and legs were attached to bean-bag bodies so that they would flop and dangle. Although expressionless, their heads, with small boot-buttons for eyes, tended to lean to one side suggesting an attitude of resignation or helplessness.

Other objects, too, had the capacity to arouse empathy. Referring to a coat left lying on the floor a participant commented: 'a costume alone on the floor that had a human configuration touched me emotionally'. The costumes in *Forest Floor* were all 'found' items rather than specially designed and constructed for the performance. On several occasions participants got into the costumes and could feel the weight and movement of the fabric for themselves. They were all clothes with signs of previous use and ownership – a slightly crumpled net skirt, worn shoes, a battered top hat – and this, I think, added to the empathetic effect reported. Looking at the coat may have reminded this participant of a living person wearing something similar or they perhaps recall wearing something like that themselves. Or perhaps this participant was responding to the way the coat had fallen in a frozen gesture, crumpled and with one arm outstretched, through an empathetic process of 'indwelling'.

Attention and empathy

During the second half of *Forest Floor* there were usually multiple and competing images and actions being generated simultaneously with people doing things in twos or threes

and on their own. Only once was there a moment where everyone in the room seemed to be focused on the development of the same idea.[7] But perhaps the apparent lack of order was in itself productive. Theatre maker Tim Etchells observes that ceding responsibility to audiences means that as well as trusting they will go to 'useful' places, it may mean 'trusting that a trip through the ostensibly not so useful places (boredom, drifting, free-association) can be more than useful or constructive in the longer run' (Etchells in Brine and Keidan 2007: 29). Frustration at what they judged to be a lack of development in the performance led to one participant initiating the creation of a swinging 'hammock' from a silk sheet and filling it full of objects: 'I purposefully changed the dynamic at one point because I was getting a bit ... losing concentration.'

Lack of attention has often been seen as disruptive and yet diverted attention might also be associated with 'creative, intensive states of deep absorption and daydreaming' (Crary 1999: 4). It appeared that *Forest Floor* participants generally found themselves oscillating between speculative and playful engagement, often between two or more people and states of focused purposeful concentration on a particular object or image. This suggests two different modes of kinesthetic empathy.

One was characterised by a concern to connect with other people (participants or performers) through the objects. Often small groups of participants could be seen collectively developing a scenario using a combination of materials. For example, a pair of participants gathered a group of puppets and balanced red heart-shaped petals on their heads. Without talking they responded to each other's interventions to create an image together.

Another type of kinesthetic empathy was principally between the participant and the objects themselves in ways that reflect both Polanyi and Vischer. What participants said about the puppets and the coat seemed to reflect a tacit understanding of the objects. However, on a few occasions a more conscious merging with objects was reported: 'I was looking at my own hand in a white glove with this little heart ... generating its own image.' The speaker here seems to be reporting on the process of thinking their way into the object, as Vischer describes, placing them 'within its inner structure' (Vischer 1994: 104) and mobilising empathy of the sort that arises from a sensorial experience of the qualities of the object.

As discussed earlier, the materials utilised scenographically were intended to stimulate the audience's sensitivity to colours, patterns, qualities of objects and the juxtapositions of objects. Several reported being caught up in a kind of reverie where they were focusing on the details and material qualities of the objects. This participant is talking about the petal confetti:

I was looking at these things and felt, oh, they're all cut in the shape of hearts. I didn't do anything with the thought, but I just thought it. I was kind of purposeful. Purposeful and thinking oh, they're all in hearts. I liked it for its own sake, not a narrative. There were pleasing things that didn't come together as a narrative at all.

Connections with other images and ideas beyond the performance were often evident, even if these links were fleeting: 'I chucked the top hat, I just felt curious about what it might mean to people so I thought, oh, I'll try that, it reminded me of an expressionist movie, but I didn't quite know what it was'. Objects seemed to arouse imaginative speculation through their material qualities. This process often stopped short of making clear sense, arrested at the point where multiple possible meanings are generated but always deferred.

Conclusions: Empathy and exchange

In immersive scenographic performance there is often an invitation to engage in an open-ended experience of sensing and feeling through imaginative enagagement with the material qualities of the environment. The experience of scenography in this context is one that appeals to the whole body through a spectator's awareness of the material qualities of the environment. Kinesthesic awareness of the 'flux' of energies (Gibson 1968: 319) is the means by which spectators sense changes in sound and light, the movement of costumes and objects, the implied movement in the shifting composition of the environment (through noticing rhythm or pattern) and themselves, through their spatial positioning, as part of the scenography. It is not simply placement within the environment that allows spectator/participants to become creative agents. It is also the nature of the environment itself. The 'obtuse' nature of the images (Barthes 1977: 52 – 68) suggests an active role for the audience, which works at the level of the individual spectator. In *Forest Floor* spectator/participants were able to engage physically with these images and speculatively suggest new images of their own in response.

From *Forest Floor*, the following account refers to a group of three people using puppets and red petals. It shows that the original images that the performers and I had created were reconfigured through an engagement with the materials and transformed into a new image:

> We were playing with the puppets … I know this sounds really stupid, but I was seeing domestic violence, like when a man hits a woman but then I kept blowing her kisses afterwards. I kept hitting her and blowing her kisses.

This appears to be a spontaneous act ('this sounds really stupid') arising from the group playing with the objects. These participants seem to be in the process of developing the themes of the performance into significant images of their own through the medium of scenographic materials. What begins as improvised and playful is on the point of becoming a more serious, socially situated image. This could be a reflection of the violence inherent in the fairy stories or it may be drawing on other bodily and psychic experiences of space, objects in the everyday. Either way, it is shaped by the quality of the materials that they have to use. It is not clear whether this was a game, an emblematic scene or something rooted in real experience. The underlying theme of *Forest Floor* facilitated a productive ambiguity

around this exchange between the original scenography and the contribution of these participants.

Maurice Merleau-Ponty says 'no painting completes painting' (Merleau-Ponty 1993: 149) by which he means that artworks are a beginning of something, not a definitive event; they 'open up onto a perspective that will never again be closed' (Johnson 1993: 209). Merleau-Ponty proposes that there is a reciprocity at work between ourselves and the things we perceive: 'between my body looked at and my body looking, my body touched and my body touching, there is an overlapping or encroachment, so we must say that the things pass into us as well as we into the things' (Merleau-Ponty 1968: 123). A 'strange system' of exchanges occurs through the correspondences between things looking and the thing being looked at. In the case of paintings, for example, 'Quality, light, colour, depth, which are there before us, are there only because they awaken an echo in our bodies and because the body welcomes them' (Merleau-Ponty 1993: 125). It is this reciprocal relationship between spectators and objects that I believe forms the basis of a scenographic exchange. The theatrical frame of scenographic objects – that is the fact that they have been carefully selected to be looked at, and the spectator is conscious of this selection – makes doubly sure that a system of exchange is set in motion.

Kinesthetic empathy in the context of scenography emphasises the body as a means of detecting and locating ourselves in relation to an environment, to other objects and to other bodies. In immersive participatory performance this active role can be extended so that participants can contribute to and affect the outcomes of the performance. Conducted through the sensuous medium of objects and environments, this kind of performance can bring about a creative exchange between the scenography and the participants so that the participants become co-creators, augmenting and extending the original work as they take up images, which have resonance for them and develop them further.

Notes

1. Foundational texts such as Denis Bablet (1975) and Donald Oenslager (1976) deal with scenography as a visual art and emphasise the links between the work of key scenographers and stylistic movements in art history.
2. For example, Punchdrunk's *The Masque of the Red Death* (2007) at the Battersea Arts Centre. Other examples of companies working in this vein include Shunt, dreamthinkspeak, wilson+wilson and Fevered Sleep.
3. In *Homesick* (2005) spectator/participants produced drawings straight after the performance. This method was developed as a way of eliciting responses in a form that has some affinity with scenography and also in an effort to access immediate, individual response before any verbal discussion took place. See McKinney (2005).
4. They consisted of arts professionals and students and scholars of theatre, and it must be acknowledged that they were likely to be predisposed to joining in. Furthermore the e-mails inviting them to take part and the pre-performance introduction made it clear that some degree of

participation on their part would be sought. Therefore the *Forest Floor* audiences were, even before the performance, prepared as participants.

5. Because this was to be a performance that was repeated several times in different venues (Leeds and Hull) it was decided that a fixed time frame was a practical necessity.

6. There was no script but we found it helpful in inducting the participants to use a few simple, if slightly enigmatic, requests. For example in the 'Bluebeard' sequence a performer would offer a participant the end of a long piece of silk cloth and ask questions such as 'Will you help me make a marble hall?'

7. Everyone was either watching or actively participating in a 'scene' where the puppets were perched in shoes navigating the rapids of a silk cloth river (with the net skirt as a kind of Niagara Falls) amid blizzards of snow.

References

Bablet, D. (1975). *Les révolutions scéniques du XXe siècle*. Paris: Societe Internationale d'Art XXe siècle.

Barthes, R. (1977). *Image Music Text,* trans S. Heath. London: Fontana Press.

Beckerman, B. (1979). *The Dynamics of Drama: Theory and Method of Analysis*. New York: Drama Book Specialists.

Bettelheim, B. (1976). *The Uses of Enchantment: The Meaning and Importance of Fairy Tales*. New York: Alfred Knopf.

Brine, D. and Keidan, L. (eds) (2007). *Programme Notes: Case Studies for Locating Experimental Theatre*. London: Live Art Development Agency.

Carter, A. (1981). *The Bloody Chamber and Other Stories*. London: Penguin.

Castellucci, C., Castellucci, R., Guidi, C., Kelleher, J. and Ridout, N. (2007). *The Theatre of Societas Raffaello Sanzio*. London and New York: Routledge.

Crary, J. (1999). *Suspensions of Perception: Attention, Spectacle, and Modern Culture*. Cambridge, MA and London: MIT Press.

Freshwater, H. (2009). *Theatre and Audience*. Houndsmill, Basingstoke: Palgrave Macmillan.

Foster, S. L. (2011). *Choreographing Empathy: Kinesthesia in Performance*. New York and London: Routledge.

Gallese, V. (2001). 'The "Shared Manifold" Hypothesis: From Mirror Neurons to Empathy'. *Journal of Consciousness Studies*, 8 (5–7): 33–50.

Garner, S. B. Jr. (1994). *Bodied Spaces: Phenomenology and Performance in Contemporary Drama*. Ithaca and London: Cornell University Press.

Gibson, J. J. (1968). *The Senses Considered as Perceptual Systems*. London: George Allen & Unwin.

Griffiths, A. (2008). *Shivers Down Your Spine: Cinema, Museums, and the Immersive View*. New York: Columbia University Press.

Hannah, D. and Harsløf, O. (2008). *Performance Design*. Copenhagen: Museum Tusculanum Press.

Johnson, G. (1993). *The Merleau-Ponty Aesthetics Reader: Philosophy and Painting*. Evanston: Northwestern University.

McKinney, J. (2005). 'Projection and Transaction: The Spatial Operation of Scenography'. *Performance Research*, 10 (4): 128–137.

McKinney, J. E. (2008). 'The Nature of Communication between Scenography and Its Audiences'. Ph.D. thesis, University of Leeds.

McKinney, J. and Iball, H. (2011). 'Researching Scenography'. In Baz Kershaw and Helen Nicholson (eds), *Research Methods in Theatre and Performance*. Edinburgh: Edinburgh University Press, 111–136.

Mallgrave, H. R. and Ikonomou, E. (1994). *Empathy, Form, and Space: Problems in German Aesthetics*. Santa Monica: Getty Center for the History of Arts and the Humanities.

Merleau-Ponty, M. (1962). *The Phenomenology of Perception*, trans. C. Smith. London, New York: Routledge.

Merleau-Ponty, M. (1968). *The Visible and the Invisible*, trans. A. Lingis. Evanston: Northwestern University.

Merleau-Ponty, M. (1993). 'The Eye and Mind'. In G. Johnson, *TheMerleau-Ponty Aesthetics Reader: Philosophy and Painting*, trans. M. B. Smith. Evanston: Northwestern University, 121–149.

Oenslager, D. (1976). *Stage Design: Four Centuries of Scenic Invention*. New York: Viking.

Polanyi, M. (1976). *The Tacit Dimension*. London: Routledge and Kegan Paul.

Reason, M. (2008). '"Did You Watch the Man or the Goose?" Children's Responses to Puppets in Live Theatre'. *New Theatre Quarterly*, 24 (4): 337–354.

Reason, M. (2010a). 'Asking the Audience: Audience Research and the Experience of Theatre'. *About Performance*, 10: 15–34.

Reason, M. (2010b). *The Young Audience: Exploring and Enhancing Children's Experiences of the Theatre*. Stoke on Trent: Trentham Books.

Reason, M. and Reynolds, D. (2010). 'Kinesthesia, Empathy, and Related Pleasures: An Inquiry into Audience Experiences of Watching Dance'. *Dance Research Journal*, 42 (2): 49–75.

Rewa, N. (2004). *Scenography in Canada: Selected Designers*. Toronto; London: University of Toronto Press.

Shepherd, S. (2006). *Theatre, Body and Pleasure*. Abingdon and New York: Routledge.

Vischer, R. (1994). 'On the Optical Sense of Form: A Contribution to Aesthetics'. In H. R. Mallgrave and E. Ikonomou, *Empathy, Form, and Space: Problems in German Aesthetics*. Santa Monica: Getty Center for the History of Arts and the Humanities, 89–123.

Chapter 12

Photography and the Representation of Kinesthetic Empathy

Matthew Reason, with photographs by Chris Nash

P hotography has long been utilised as a medium that allows us to capture, see and reflect upon the world around us. This is not least the case with movement, where the ability of the camera to freeze motion has revealed visual experiences otherwise beyond the scope of the human eye. Whether it is Eadweard Muybridge demonstrating to a nineteenth-century public that a galloping horse removes all feet from the ground at once or Howard Edgerton showing a twentieth-century audience the impact of a bullet passing through the flame of a candle, these images have raised questions about our perception and understanding of movement. While the work of Muybridge and Edgerton draws upon our faith in the objective veracity of the photographic image, this chapter takes a different approach to the relationship between still photography and movement, exploring a collaboration with photographer Chris Nash that asked him not to capture movement in the still image but instead to represent the concept of kinesthetic empathy itself.

The chapter discusses Nash's images, produced especially for this publication, and also the debates they raise about practice-based research, about forms of knowledge (practitioner knowledge, embodied knowledge, discursive and non-discursive knowledge), about the possible differences between a cognitive understanding of movement and an embodied or experiential feeling of movement. Between and through these debates, this chapter also seeks both to say within the text and to present within the images something about kinesthetic empathy.

Practitioner knowledge

Nash is an internationally respected dance photographer, with a reputation based on over sixty one-person shows worldwide including an exhibition of his work at the Victoria and Albert Museum in 2011. Photographing dance since the 1980s, Nash has done much to determine the photographic appearance of contemporary British dance, working with choreographers including Michael Clark, Lea Anderson, Javier de Frutos, Richard Alston and Lloyd Newson among many others. Nash's approach to photographing dance is unique, working in a very deliberate manner that is actively digital in its use of a painterly and theatrical compositional style. Rather than relying upon the speed of the shutter to freeze-frame movement captured from live dance, Nash carefully constructs images and moments *for* the camera in the studio. As Val Bourne writes, Nash's photographs are 'carefully designed, almost choreographed, and atmospherically lit, treating the studio as if it were a

stage. In collaboration with the choreographer, he creates images that somehow contrive to evoke the essence of the piece' (2001: iii).

As a vastly experienced, accomplished and reflective practitioner, Nash possesses a distinct and considerable expertise in the representation of dance and the moving body. As a photographer, Nash is someone attuned to seeing and assessing the movement qualities of dance and experienced in working with choreographers to produce still images that are evocative of movement and the experience of dance. I had previously written about Nash's work in terms of this relationship between stillness and movement (Reason 2003), and it was with awareness of and respect for his practice-based expertise that I approached him again to discuss ideas of kinesthetic empathy. The questions we explored were both wide ranging and consciously direct. We discussed whether Nash himself felt kinesthetic empathy while watching dance; whether he wanted viewers to experience kinesthetic empathy in relation to his images and if that could be taken as a judgement of their success or failure as photographs of dance. We discussed whether kinesthetic empathy was something that could be described as embodied within an image (or indeed within a dance), if it was something that a viewer brought with them, or if it was the result of a particular combination and encounter between viewer and work.

The result was a small-scale project, in which I asked Nash to engage reflectively and practically with the concept of kinesthetic empathy. This took two forms, firstly a paper about his work at the 'Kinesthetic Empathy: Concepts and Contexts' conference, hosted by the University of Manchester in April 2010 (Nash 2010); and secondly, a practical commission for Nash to spend some time in a studio producing a photographic representation of, and/ or personal response to, the concept of kinesthetic empathy.

The photographs that resulted from this commission are reproduced and discussed in this chapter (and on the cover of this publication) and I will explore them in detail. Please allow yourself, however, also to skip ahead and look at these images first and develop your own responses to them, independently of my discussion, based upon your experiential response to their embodied content. The chapter is therefore something of a hybrid, combining and setting alongside each other Nash's practice-based investigation into kinesthetic empathy and my own discursive thinking into and around the relationship between the still images, practice-based knowledge and ideas of kinesthetic empathy.

Process as methodology in practice

Within practice-based research an artist's working processes – that is the iterative structures of planning, doing and reflecting that inform how they go about making and remaking a work – are comparable to the methodological processes of more traditional research. This is particularly the case when it is reflective, informed and conscious process, as it certainly is with a practitioner such as Nash. With this commission asking Nash to think

about kinesthetic empathy through his photography, it is therefore vital to understand the methodology of his particular practice.

As a photographer Nash is somebody who is pre-eminently rooted – aesthetically, conceptually and in terms of his working processes – in the digital era. His work routinely employs montage, the rotation of the frame and flipping of the image, digital manipulation, combination of multiple images, bright and contrasting colours and other graphic interventions made on the computer to achieve particular ends. What is important about this observation is that it marks a break with one of the defining conceptualisations of photography as a revelatory medium that captures a 'piece of the world' (Sontag 1979: 93). The dominant objective and revelatory discourses of photographic practice have positioned the medium as one that is functionally and aesthetically different to more subjective forms of representation such as painting. John Szarkowski, for example, writes that 'the invention of photography provided a radically new picture-making process' with a fundamental if basic difference. While 'paintings were *made* … photographs, as the man on the street put it, were taken' (2003: 97). Although such perceptions were always problematic, digital technology challenges this positioning more than ever before, with William J. Mitchell arguing that digital imaging erodes this division between artist and photographer and between the boundaries of objectivity and subjectivity: 'The distinction between the causal process of the camera and the intentional process of the artist can no longer be drawn so confidently and categorically' (1992: 31).

An artist very much of the digital age, Nash produces photographic images that are very explicitly *made*, not taken. So while Christopher Isherwood's famous opening line to *Goodbye to Berlin* – 'I am a camera with its shutter open, quite passive, recording, not thinking' – could be considered the dominant motif for photography as objective record, Nash is very much an active and thinking practitioner. His work often foregrounds his own intentionality and involves the pre-visualisation of a composition that he then proceeds to generate for and in the digital camera.

As a result the emphasis is not on capturing something within existing dance movement, but instead on working collaboratively with choreographers to generate material for the camera. Consequently, when working in the studio with a choreographer and dancer, Nash describes a process whereby they work through movement material looking for something that he thinks has potential. He then gets the dancer to repeat a section for the camera, and the images are viewed and considered in terms of what might improve them. Nash describes what he is looking for as 'clarity of line and a narrative of the body that will explain quickly and easily what is happening within the figure to the viewer'. The image, begun in the studio and already transformed for the camera, might then be further refined on the computer: it might be flipped, cropped, digitally manipulated in shape, texture, colour or any number of other small or large adjustments made to build a dynamic composition that invites the viewer to engage with the picture – as I will discuss, this engagement might variously be emotional, sensorial or narrative based.

Often the process of pre-visualisation will go further than this, with Nash mentally conceiving images prior to entering the studio and then consciously – in a process involving choreography, design and lighting – bringing the elements together to realise the imagined concept. In this manner Nash's work blurs the boundaries between photography, painting, drawing and digital art. With Nash's work the spectator is often very aware of the medium and the artistry, which in turn become the focus for our empathetic investment in the image.

First explorations

Nash's approach to this commission of representing kinesthetic empathy through photography was, therefore, never going to be one of finding or staging a movement that he felt to be spectacularly or memorably loaded with kinesthetic empathy. Instead it would be an approach determined by his methodological processes: pre-visualising of concepts and bringing together in the studio elements that would then be edited digitally. His principal interest was in the visual qualities of the image – its composition and arrangement of line, shape, colour – and the effect that these would have on the viewer.

With these working processes in mind, Nash organised a studio session, about which he comments:

> The principle that drove the session was that of mirroring. With this in mind, I used two dancers with similar build and hair colour and asked them to wear similar clothes. I asked the two dancers to stand side by side so that they could only see each other in their extreme peripheral vision and then asked them to try and mirror exactly any movements that they thought the other was making. This gives rise to a very particular physical vocabulary that starts from the tiniest movements and builds to unexpected crescendos, reverberating between the performers. It requires the performers to channel movement from each other using more than just their visual sense. It results in an odd sense (both for the performer and for the onlooker) that they are being somehow controlled by another person, or that they are taking on someone else's physical character. I thought this would provide a good metaphor for kinesthetic empathy (Figure 12.1).

As he outlines here, Nash's response to the commission was to search for something that might form a metaphor or visual analogy for the conceptual ideas of kinesthetic empathy. In other words rather than seek to communicate or embody the sensation of movement – which might have been an alternative approach, and which is the common goal of much dance photography – the photograph is acting as metaphor or visualisation of the concept, it is suggesting that kinesthetic empathy is *something like this*. And the conceptual ideas of Nash's visual metaphor are apparent: kinesthetic empathy is presented as the interplay between self and other; the sense of difference and sameness; of movement from outside the self being sensed or replicated inside the self; of an intersubjective sense of doing through

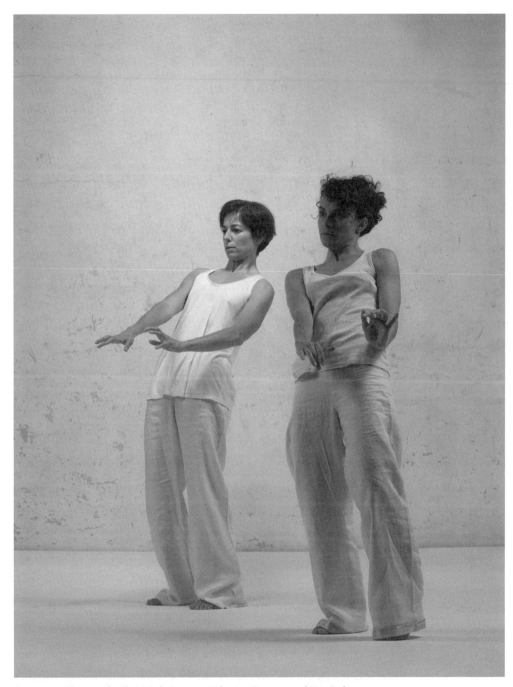

Figure 12.1: Photograph: Chris Nash. Dancers: Valentina Formenti and Kate Jackson.

the doing of others. These themes – mirroring, intersubjectivity, the self and other – are all ideas that are explored and engaged with discursively in other chapters of this book. Nash's image represents an initial non-discursive attempt to visualise these concepts.

Equally as a metaphor expressed within artistic practice, the image represents a kind of thinking out loud: *might* kinesthetic empathy be like this? This provisionality is central to the methodology of practice-based research, which often draws upon trial, upon doubt and flux as positive and valuable qualities within knowledge. This is present in Donald Schön's discussion on 'knowledge in action':

> The practitioner allows himself to experience surprise, puzzlement, or confusion in a situation which he finds uncertain or unique. He reflects on the phenomena before him, and on the prior understandings which have been implicit in his behaviour. He carries out an experiment which serves to generate both a new understanding of the phenomena and a change in the situation.
>
> (Schön 1983: 68)

The reflective practitioner therefore is a 'researcher in the practice context' (Schön 1983: 68), whose practical knowledge of his or her medium requires us to consider experience of arts making 'as a form of knowledge gained first hand, knowledge gained from praxis' (George 1996: 23). With this commission I was asking Nash to work as a reflective practitioner to explore the concept of kinesthetic empathy through the prism of his practice-based knowledge. The knowledge produced is non-discursive, but instead is incarnate (embodied) and achieved through encounter: firstly, encounter between Nash and his own practice (in the creation of the emerging work); secondly, knowledge is generated in the encounter between viewer and artwork.

There are, of course, a number of challenges about the nature of knowledge in this context: is it possible to say that an artwork contains or embodies knowledge, especially given the ambiguous nature of any aesthetic work? As Sullivan states we might ask 'whether knowledge is found in the art object, or whether it is made in the mind of the viewer' (Sullivan 2005: 87), although equally such questions might also be asked of a book or piece of writing. While these are challenges that the field of practice-based research needs to grapple with as it develops its own increasingly sophisticated methodology, it is necessary to acknowledge that any 'answer' is dependent on the particular epistemology one 'believes' in. In this context the widening of theories of knowledge from the positivist or propositional to the experiential, presentational and practical forms of knowledge (for example Heron 1996) has enabled us to recognise and talk about the particular qualities of knowledge that are generated through reflective arts practice.

Nash's photographs therefore represent his own non-discursive thinking about kinesthetic empathy and, moreover, stage and communicate this thinking in the encounter between the viewer and the image. We should see this moment of encounter as attempting to communicate knowledge in process and at the stage of in-between-ness and flux, a set

of metaphorical likenesses rather than propositional certainties: between ineffability and articulation; between the work and the spectator; and most significantly in-between the embodied and the conceptual.

Experimentation with form

In the next set of images produced through this process Nash explored ways in which the initial studio images might be refined through digital intervention. With the dancers still standing and moving shoulder-to-shoulder, he took multiple images of the same specific movement moments at regularly spaced intervals (about every 3 or 4 seconds) and layered them together (Figure 12.2).

Although reminiscent of the more familiar stroboscopic technique, where multiple exposures are made on the same print (in the tradition of nineteenth-century photographic pioneer Étienne-Jules Marey), the effect here is produced by separate images (and therefore separate instances of repetition) layered on top of each other digitally. Conceptually this raises questions about repetition, about moments being single isolated instances of time or movements that are embodied and repeatable. Additionally the distorting effect introduces an anonymity and similarity to the figures, to that extent that they begin to possess a transparency as if darting or dashing out of existence. The sense of them being particular people, with particular motivations or relationships, retreats; instead the image is more abstract, more simply of movement and something for the viewer to experience sensorially.

As a development upon the first image, the utilisation of a stroboscopic effect introduces something that viewers would conventionally read in terms of movement – the road-runner effect, moving too fast for the eye to see. In some ways this image is closer to more conventional dance photography that frequently seeks to present something that communicates excitement and movement through visual signifiers. Dance images, including those by Nash, frequently use what researchers within cognitive psychology have identified as the five main pictorial devices that are evocative of movement within the still image: posture, orientation, ground plane, multiple images, action lines (Carello et al. 1986, see also Cutting 2002). These are all qualities of *implied motion* that prompt the viewer to read movement into the still image and are hugely culturally familiar to us across visual media (photography, painting, cartoons and so on).

That we 'anticipate' or 'unfreeze' motion held implicitly within the frame of a still photograph is something that we intuitively know from our own experience and has been confirmed by psychological research. Jennifer Freyd, for example, undertook a range of experiments in the 1980s to test this hypothesis and concludes that 'people form a mental representation of movement when viewing frozen-action photographs' (1983: 579). More recently Zoe Kourtzi and Nancy Kanwisher used fMRI to explore how the viewing of different static images – some containing implied motion, some not – impacted on the part of the visual cortex involved in the processing of visual motion. Indicating a clear

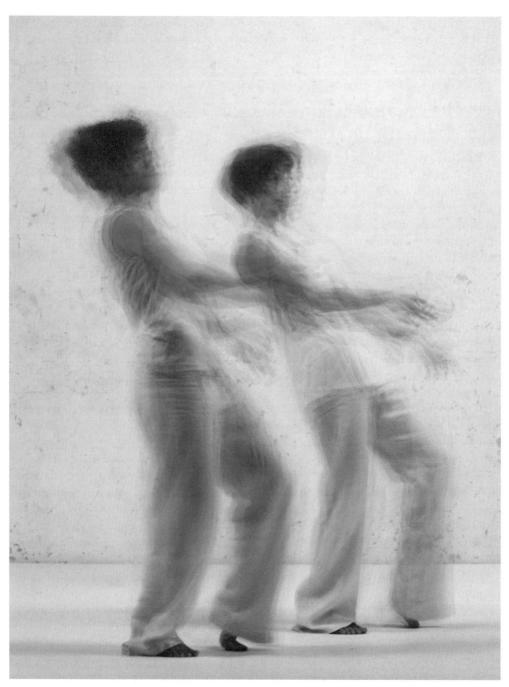

Figure 12.2: Photograph: Chris Nash. Dancers: Valentina Formenti and Kate Jackson.

neurophysiological response to the still image, their results suggest that the 'cortical areas involved in the analysis of physical stimulus motion can also be engaged automatically by static images that merely imply motion' (Kourtzi and Kanwisher 2000: 52). In other words the same regions of the brain involved in processing the watching of actual movement are engaged when processing motion that is only implied in a still image.

Being moved: As opposed to the perception of movement

In the laboratory experiments described above interest was focussed on the cognitive perception of movement: on whether viewers gained a by-proxy knowledge of movement through the still image. When considering kinesthetic empathy, it is interesting to contrast this perceptual knowledge of movement with the empathetic experience of being moved. Phrasing it simply, does the communication of movement itself equate to kinesthetic empathy or is it important to acknowledge a difference between cognitive movement knowledge and a more experiential response that might be described as emotional or sensorial and which is often embodied rather than cognitive.

This contrast could become too schematic, but broadly movement knowledge might be defined as a perceptual awareness that in any given still photograph movement was occurring or was about to occur. With photographs the particular value of this knowledge has traditionally rested in our understanding of the medium's veracity; although eroded by digital manipulation there is nonetheless a cultural trust in photography to show us the world objectively and we therefore read the presence of movement through the various signifiers of movement discussed above. Movement experience, by contrast, describes something more: those moments when we do not just perceive within a photograph that something moved or was about to move but begin to embody or internalise or be affected by that perception of movement.

E. H. Gombrich describes a similar contrast between perception and experience of movement through still images when he writes of what he calls the 'strange paradox' that 'the understanding of movement depends on the clarity of meaning but the impression of movement can be enhanced by lack of geometrical clarity' (1982: 58). Here clarity of meaning relates to the empirical knowledge of movement, while impression of movement describes the experiential engagement with that movement. Gombrich suggests that our subjective perception of movement in static forms might well be enhanced by representational devices – such as blur or multiple images – that actively hinder objective knowledge of movement. In the context of our engagement with images of dance it is clear that we are most often less interested in movement knowledge – the empirical observation that movement happened – than in the subjective response to movement. This is clearly the case in dance critic Edwin Denby's frustrated condemnation of much dance photography when he writes: 'You don't see the change in the movement, so you don't see the rhythm, which makes dancing. The picture represents a dancer, but it doesn't give the emotion that dancing gives you when you watch it' (1986: 89).

Here there is a shift from seeing movement to obtaining emotion from experiencing movement. This shift parallels the description of watching dance found in John Martin's writings about kinesthetic empathy, where for the ideal spectator the exterior experience of seeing is translated into a felt experience of kinesthetic empathy: 'When we see a human body moving, we see movement which is potentially produced by any human body and therefore by our own … through kinesthetic sympathy we actually reproduce it vicariously in our present muscular experience' (Martin 1936: 117). Under these criteria the objective of dance photography would be not to merely and objectively represent the dancer – to depict a frozen moment in time – but instead to re-present the experience of the dance and evoke a kinesthetic empathy through the medium of the image. While the reading of movement knowledge in a still image is certainly kinesthetic, it is the embodied experience of movement emotion or affect that is the realm of kinesthetic empathy.

Being moved by stillness

With this commission, of course, the objective was not to represent a piece of dance, or indeed to communicate movement to the viewer, but instead to construct a photographic visualisation of the concept of kinesthetic empathy itself. In the next stage of his process Nash therefore made the decision to explore the possibilities of stillness, calm and intimacy (Figure 12.3). On this occasion the dancers faced each other before again being asked to mirror each other's movements. This time the camera was located behind one of the dancer's shoulders, with the invitation for the viewer to assume their perspective, an invitation enhanced by the facial anonymity of this figure. The presumption of the same point of view of the dancer draws both the camera and the viewer into the frame.

Meanwhile, the mirroring of two similar figures presents a momentary conceptual puzzle, the reverberation between alikeness and difference being more resonant than that of exact duplication. In this instance the quality of mirroring, or rather and perhaps more powerfully of *only almost mirroring*, is much more evident. There is a very strong attentiveness evident in eyes and face of the figure facing us. This is not directed towards us as a viewer but instead towards the other figure (and possibly therefore to us as a participant by proxy). More particularly of course it is directed towards the hand and arm, which significantly is presented underside up. This presentation of a soft, vulnerable part of the body is an invitation to touch and to empathise – this frozen moment is an example of the kinds of micro-performances of small gestures, invitations and empathetic connections that make up live dance choreography. The result is a kind of hall of mirrors, with sightlines building upon sightlines and attention upon attention.

The result is a strongly communicated engagement between the two figures, which seems indeed an appropriate metaphor for kinesthetic empathy. Interestingly, at the same time, these images contain very few of the movement signifiers described by Cutting and Carello. Indeed, it could be argued that of the five described (posture, orientation, ground plane,

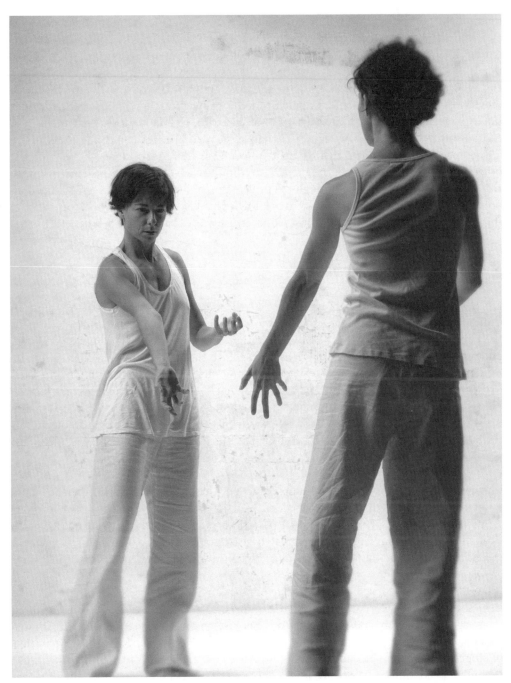

Figure 12.3: Photograph: Chris Nash. Dancers: Valentina Formenti and Kate Jackson.

multiple images, action lines), they utilise none. However, while the moments themselves are serene, and the postures could potentially have been statically held, they do not read as frozen. What there is instead is a tension within and more importantly between the figures that is evocative of *potentiality* of movement. The result is an image that invites us to sit back and reflect, it has a calmness to it that might conventionally be considered antipathetic to movement (there is no dramatic leaping or mad rushing about here) and it certainly does not assist us in a cognitive knowledge of movement. Yet in inviting us to contemplate the relationship between these two figures I would argue it also invites us into a non-discursive encounter with ideas of kinesthetic empathy – with ideas of mirroring; of the self and the other; of touch without touch; of movement without movement. For me this is both a reflective encounter and also, through the presentational form of the photograph, one that provides a sensorial and embodied form of knowledge. It is, despite my own requirement in this chapter to strive to articulate, one that necessarily resists articulation outside of itself.

Ambiguity and movement potentiality

Often dance photographs capture figures at the heights and most extreme points of a movement: at the perfect moment of the choreography: the pinnacle of the leap or the perfectly outstretched toe. This is a tradition that is particularly dominant in ballet photography, where an image that does not capture the perfect moment can simply be termed wrong (Mitchell 1999: 74). Partly in resistance to this, Nash's work is often interested in the reverse, in the infinitesimal and in the moment before the movement becomes active. This is not least because, as Nash points out, a photograph is always about 'the possibility of movement, rather than the certainty of movement' or indeed the fact of movement. This distinction is important as it can be argued that it is the potentiality that gives the image power. As Nash elaborates, his images are projections or representations of

> that moment where you decide on course of action. That's always seemed to be a much more interesting moment than the actual course of action, when you've actually made up your mind about what you're doing. I think that's what art's about, it's about asking questions. It's about looking at something and having to have a response to it. So it's not about being told what it is that you're thinking. It's about ambiguity. A starting point not a conclusion.

Indeed, Nash's work has frequently been praised for its evocativeness, with Peter Ride suggesting that his work has the ability to 'beguile and draw in the viewer' through making the image suggest more and 'give a full story, not just a moment of fact' (Nash 1993). In this they match what John Berger and Jean Mohr write in *Another Way of Telling* that, 'An instant photographed can only acquire meaning insofar as the viewer can read into it a duration extending beyond itself. When we find a photograph meaningful we are lending it a past and a future' (1982: 89).

These images here are very much about this potential, and the presentation of an ambiguous starting point from which movement seems possible but where – crucially – the exact nature and indeed meaning of that movement is determined by the viewer's imaginative and emotional engagement. For Nash this engagement is central to his own experience of watching dance, which he states is not so much about the sheer physicality of movement for its own sake but informed rather by the nature and intent of the encounter:

> what I'm not wanting to do is move. I'm not thinking about the actual physical feeling of moving, what I'm thinking about is why are they moving? Why are they doing what they're doing? What are they thinking? What are they feeling?

Crucially, therefore, any movement which the viewer is encouraged to imaginatively construct from these images is movement with intent, movement with feeling between these two figures that are so intimately connected and concerned with each other, a movement with intent held between the eyes and the bodies and the soft underbelly of the outstretched arm. That the viewer's reading of this movement intent might be entirely unrelated to any actual intent, or the actual history of the movement itself, is irrelevant. That empirical history is unknowable and much less real to us than this empathetic engagement with the evocative qualities of the image. For Chris Nash therefore the relationship is between the viewer's imagination and this new photographic meaning that is constructed in the encounter between performers, camera, photography and viewer.

In some of his recent work this has led Nash to explore how little might be necessary to evoke ideas of movement in a photograph. This is most present in a set of images titled 'A Moment in Time' (2007), which feature a series of stark grey and white interiors and individuals or pairs figures standing or sitting in explicitly and very consciously non-dynamic postures. Rather than the presence of movement being read into signifiers of movement – such as in blur, in forward lean, in figure caught falling in mid-air – the result is a tension between the figures and between the figures and the space itself that suffuses the images with potential. Potential for what exactly is, of course, unclear – for change, for conflict, for narrative, for motion – but a tension that in the very lack of anything dramatically happening asserts that something has either just happened or is about to happen. There is a kind of similarity here with Antony Gormley's series of still human-sized iron figures, particularly *Another Place* (Crosby Beach, England) and *Event Horizon* (London 2007). Here the figures are posed passively, feet together, hands hanging down the sides, but this very understated but utter stillness and their positioning in public places provides them with a dynamic that exists in the viewer's imaginative encounter with the sculptures.

Nash states that his interest was directed by the awareness that much of the significance of his photographs is what takes place in the viewer's imagination. He was therefore interested in what it is that sparks off people's trains of thought: 'What do you have to put into a picture to start stimulating that? What are the clues you need? How much or little does an image have to have to make people think about movement?' In a process that parallels ideas of

kinesthetic empathy, he moved from there to think about inner movements, movement of the emotions or the imagination.

Final processes

In engaging with the concept of kinesthetic empathy, it is striking that Nash found these ideas of the emotionally and imaginatively loaded potential for movement in non-dynamic poses more fruitful that the utilisation of images more explicitly containing implied motion. If we think of the archetypal dance photograph – of the performer hanging almost miraculously in mid-leap – then clearly such images invite us to consider a moment of spectacular movement. However, it is also one where the drama and dynamism of that movement is already pretty much resolved. Only certain things are possible from this point and the spectacle is empty of further resonance. By constructing non-dynamic images that are loaded with potential, Nash is placing all the drama and dynamism in our imaginative encounter with the image. This can be usefully understood in terms of the distinction outlined earlier between movement knowledge and movement experience; and in the understanding that as an aesthetic concept kinesthetic empathy describes more than the competency of reading or seeing movement, but also involves an affective and imaginative engagement.

In a final session in the studio Nash again asked the dancers to stand looking at each other, to focus in on each other's stomachs as a central point in their bodies and to then use the same mirroring technique of following and leading each other in movement. Again he articulates his objective in finding a visual metaphor for the concept he was exploring:

> As this whole process [of kinesthetic empathy] entails a certain amount of mental disassociation with the self (replaced by a mental and physical association with someone else) I wondered how that process might be represented visually. It seemed to me that there was a continual crossing of a somewhat murky divide between the two performers (and indeed, between myself and them) and that the space between them (mental, emotional and physical) was becoming somewhat blurred, rather than crisp and clear cut.

This time Nash took the resulting images through a different photographic process, about which he comments:

> I wanted to blend the two performers into their surroundings a little more by making the images more monotone. Also, following on from the idea of each performer being a mirror of the other, I thought that a good metaphor for what was happening would be the concept of positive/negative, as in the photographic printing process. To this end, I have solarised the images, whereby the highlights of the images are flipped into negative (Figure 12.4).

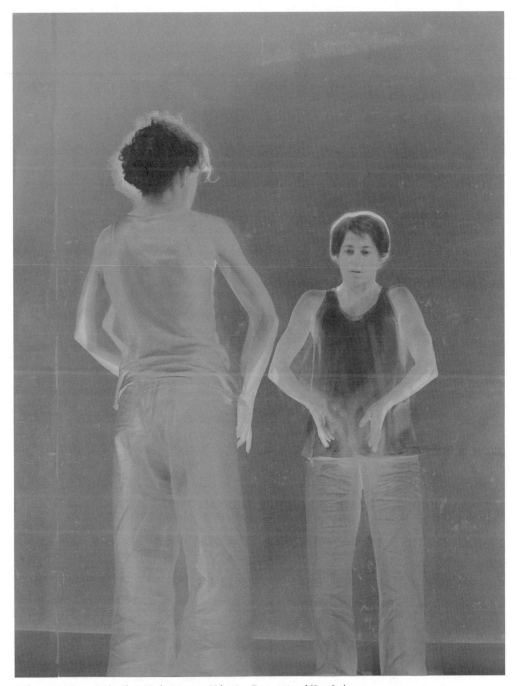

Figure 12.4: Photograph: Chris Nash. Dancers: Valentina Formenti and Kate Jackson.

The impact of these choices on the viewer is two-fold. Firstly the figure with her back to the camera is even more anonymous than in the images discussed earlier. The result is a simpler, stripped down figure that is less real but more universal – at once both proxy for our viewpoint and a doppelganger for the dancer facing us. The gesture itself clearly directs attention towards the figure's core – their stomach, belly, womb – in a manner that is symbolic of ideas of embodiedness. It seems to me that both the symbolic focus and emotional impact of this image is gut-felt.

What Nash has created as a result – within this image but also in different ways across all four images reproduced here – is a visual metaphor for the concept of kinesthetic empathy. My discussion has paralleled this, drawing out the themes of mirroring, duplication/repetition/distortion, the substitution of the self for the other and the imaginative dynamism of potentiality. The images also present and perform received and returned attention. Such readings draw on the visual and compositional structure of the photographs that we encounter as a form of presentational knowledge and upon the cultural and critical strategies that we bring to the images. As visual forms this encounter is perceived through our eyes but experienced through a combination of our physical and conceptual awareness.

Conclusion: Non-discursive knowledge

As a conclusion I therefore want to briefly consider the relationship between my commentary and the images. In engaging with the photographs as visual metaphors for kinesthetic empathy, my words hope to be exegeses, making explicit, drawing out, establishing connections. Yet it must be acknowledged that by definition the metaphor is visual and the linguistic speaking for it is always an act of translation, with translation of the metaphorical (something that works within the rules, diction and references of a particular medium and context) often destined for disappointment.

This returns discussion to the question of knowledge. We recognise that the photographs as visual metaphor contain (or communicate) something about the concept of kinesthetic empathy. Further we recognise that this something is not directly transferable to language as a different and non-visual form of communication. Does this therefore suggest that the form and manner of knowledge about kinesthetic empathy that they embody is particular, and particularly visual as well?

In thinking about this relationship, and indeed in thinking about the nature of the commission as a whole, it is useful to consider Suzanne Langer's articulation of the difference between discursive and non-discursive knowledge (Langer 1942), which Steven Taylor usefully summarises:

There are presentational/aesthetic forms of representation and discursive/propositional forms, which are fundamentally different. For example, presentational forms represent

wholes, while discursive forms represent parts; presentational forms represent tacit knowledge, while discursive forms represent explicit knowledge.

(Taylor 2004: 73)

As an exercise that seeks to communicate knowledge in and through practice, the images make a non-discursive statement about kinesthetic empathy that contributes to the same field of knowledge as each of the other chapters in this book. The form of Nash's communication might be very different, and it is a challenge to our linguistically dominated culture to view its contribution to discourse and to a body of knowledge as equally significant to the textual discussions, but it is this challenge that the chapter seeks to advocate. As Eisner writes, 'the liberation of the term knowledge from dominance by the propositional is a critical philosophical move' (2008: 5).

Nash's thinking through kinesthetic empathy is a form of visual thinking and visual knowledge that is understood visually – in our embodied encounter with the visual – rather than discursively. Look again at the images in this chapter and at the cover of this book and consider them as presentational forms of knowing that engage with mirroring and almost mirroring; with movement and the anticipation of movement; with empathy and invitations to touch and feel. Think also of the dynamic relationship between and within the different images, which stage a debate around kinesthetic empathy that is non-discursive but nonetheless extremely highly developed and that advances our understanding of the issues at stake in a manner that is both embodied and conceptually stimulating.

References

Bourne, V. (2001). 'Introduction'. In *Stop Motion: The Dance Photography of Chris Nash*. London: Fiat Lux.

Berger, J. and Mohr, J. (1982). *Another Well of Telling*. London: Writers and Readers Cooperative.

Carello, C., Rosenblum, L. and Grosofsky, A. (1986). 'Static Depiction of Movement'. *Perception*, 15: 41–58.

Cutting, J. E. (2002). 'Representing Motion in a Static Image: Constraints and Parallels in Art, Science and Popular Culture'. *Perception*, 31: 1165–1193.

Denby, E. (1986). *Dance Writings*, edited by R. Cornfield and W. Mackay. New York: Alfred A Knopf.

Eisner, E. (2008). 'Art and Knowledge'. In J. G. Knowles and A. L. Cole, *Handbook of the Arts in Qualitative Research*. Sage: London.

Freyd, J. J. (1983). 'The Mental Representation of Movement when Static Stimuli are Viewed'. *Perception and Psychophysics*, 33 (6): 575–581.

George, D. E. R. (1996). 'Performance Epistemology'. *Performance Research*, 1 (1): 16–25.

Gombrich, E. H. (1982). *The Image and the Eye: Further Studies in the Psychology of Pictorial Representation*. London: Phaidon.

Heron, J. (1996). *Co-Operative Inquiry: Research into the Human Condition*. London: Sage.

Kourtzi, Z. and Kanwisher, N. (2000). 'Activation in Human MT/MST by Static Images with Implied Motion'. *Journal of Cognitive Neuroscience*, 12: 48–55.

Langer, S. (1942). *Philosophy in a New Key*. Cambridge, MA: Harvard University Press.

Martin, J. (1936). *America Dancing: The Background and Personalities of the Modern Dance*. New York: Dance Horizons.

Mitchell, J. (1999). 'Capturing Emotion in Motion'. *Dance Magazine* (December): 66–75.

Mitchell, W. J. (1992). *The Reconfigured Eye: Visual Truth in the Post-Photographic Era*. Cambridge, MA: MIT Press.

Nash, C. (1993). *A Glance at the Toes: The Dance Photography of Chris Nash*. Croydon: Contemporary Portfolio Series. Creative Monochrome.

Nash, C. (2010). 'The Oscillating Moment – Perceiving Movement in Dance Photography'. Kinesthetic Empathy: Concepts and Contexts Conference, University of Manchester April 2010. Available: www.watchingdance.ning.com/video/panel-4-chris-nash.

Reason, M. (2003). 'Still Moving: The Revelation or Representation of Dance in Still Photography'. *Dance Research Journal*, 35 (2) and 36 (2): 43–67.

Schön, D. A. (1983). *The Reflective Practitioner: How Professionals Think in Action*. New York: Basic Books.

Sontag, S. (1979). *On Photography*. New York: Penguin Books.

Sullivan, G. (2005). *Art Practice as Research: Inquiry in the Visual Arts*. London: Sage.

Szarkowski, J. (2003). 'Introduction to the Photographer's Eye'. In L. Wells (ed.), *The Photography Reader*. Abingdon: Routledge.

Taylor, S. S. (2004). 'Presentational Form in First Person Research: Off-line Collaborative Reflection Using Art'. *Action Research*, 2 (1): 71–88.

Part V

Technological Practices: Kinesthetic Empathy in Virtual and Interactive Environments

Introduction

Dee Reynolds

Τhe ways in which people experience kinesthetic empathy change across different historical and cultural contexts. A particularly striking example of this is how evolving technologies affect both our experiences and our conceptualisations of kinesthetic empathy. For instance, today we have a whole range of digital media with which to be 'in touch' and in constant 'contact with' people we have never met, across vast distances. It has become common to live in a state of digital connectedness and to regard this as a default way of being. As with Merleau-Ponty's famous example of how objects can become integrated into the space of the lived body such that we can intuitively manoeuvre a car or feel the position of keys on a keyboard, digital technologies have the potential to alter our capacity for empathy and also to extend our sensory experience. Considerable impact has been made by digitally generated gaming environments, which have introduced us to new sensory stimuli where players enact roles that enhance their physical capacities and motor skills, opening up possibilities for new kinesthetic and empathic experiences.

In addition to play and gaming, these technologies can be used for purposes of facilitating skills and interaction with others, such as in sport or rehabilitation exercises. They also open up artistic possibilities to explore how our experience of kinesthesia and empathy with each other and our environment can be transformed and intensified. This part explores innovative practices involving technology and kinesthetic empathy in sports equipment design and in performance and interactive environments.

In her chapter 'Kinesthetic Empathy Interaction – Exploring the Role of Psychomotor Abilities and Kinesthetic Empathy in Designing Interactive Sports Equipment', Maiken Hillerup Fogtmann describes the process of designing an item of interactive sports equipment, TacTowers, to enhance handball playing skills. This design was influenced by awareness of the role of kinesthetic empathy in developing psychomotor skills and of the benefits of using interactive technology designed to take its lead from the body's capacities and interactions between players rather than being driven by technical imperatives. When playing open sports (involving opponents and or team members), players' levels of skill

259

depend upon responses to their own sensory feedback as well as their ability to decode and react to the movements of others playing the game. Skill in anticipating the consequences of actions performed by others involves simulation of action (as explicated by the mirror neuron system), and Fogtmann's interactive sports training equipment is therefore designed to exercise and improve psychomotor abilities in conjunction with kinesthetic empathy. It requires users to develop their decision-making and tactical abilities; the degree of difficulty is determined by the players' level of performance and the equipment can provide them with instant and augmented feedback.

Fogtmann's TacTowers design involves two players competing through a computer, where the opponent's movements need to be decoded and utilised as a ground for deciding how to act. Players are required to anticipate their opponents' moves and to employ strategies that anticipate the game. What is new about this approach to sports equipment design is the degree of interactiveness in the design, which foregrounds physical interaction through kinesthetic empathy.

In his chapter, 'Interactive Multimedia Performance and the Audience's Experience of Kinesthetic Empathy', Brian Knoth discusses his work, which was also inspired by ideas of kinesthetic empathy and mirror neuron research. As a digital media artist, musician and interactive systems designer, he set out to explore how interactive digital performance systems could be used in live performance to enhance the audience's 'embodied simulation' of dance and music. He created *Unless*, a multimedia performance environment utilising two interactive music systems and one graphics system through which multisensory elements would be triggered by the dancer's movements. Knoth started from the premise that technologically mediated performance, where movements or sounds made by the performer are digitally transformed and experienced by the performer themselves as innovative proprioceptive feedback, could reconfigure their corporeal experiences and sensations. He was interested to discover whether, through embodied and empathic simulation, this effect could also be experienced by the audience. He hypothesised that creating novel, cross-sensory connections would encourage audience members to simulate the dancer's activation of these connections and thereby become more aware of their own kinesthetic and empathic experience. He also wanted to explore themes of connectivity and disconnect, both intersubjective and with the environment, by inviting the audience to experience them implicitly, on a visceral level, rather than by making them explicit. Following performances of *Unless*, Knoth explored audience responses and found that feelings of connection with the dancer were linked with heightened kinesthetic awareness produced by cross-sensory experience. In particular, sound–movement interactions were cited as intensifying sensitivity to movement qualities.

Sarah Whatley's chapter, 'The Poetics of Motion Capture and Visualisation Techniques: The Differences between Watching Virtual and Real Dancing Bodies', explores the potential for dance artists (here, Ruth Gibson) to use motion capture technology (i.e. data from the bodies of live dancers, which is digitally 'captured' and fed into virtual visualisations) to animate virtual immersive environments. These environments are immersive in the sense

that the spectator is no longer positioned outside the piece, and is indeed no longer a spectator but, similar to computer gaming, is a 'visitor' in the virtual space, activating the technology and animating the space, through which s/he then moves, as if 'taking a journey'. Whatley describes how such experiences construct a sense of 'liveness' from the visitor's active participation and its effect, rather than from the physical presence of the performer.

At the same time, this immersive space has the effect of troubling the boundaries and distinctions between doing and watching and also between the virtual and the real, which can be unsettling and 'uncanny'. Rather than relating to the dancing figures through kinesthetic empathy based on motor simulation, here the 'visitor' themselves animates the body of the avatar, thereby in a sense experiencing the virtual environment not as themselves but by becoming (empathically and kinesthetically) 'other'. However, although they are virtual and therefore non-human, the digital bodies in the immersive environment also have characteristics of human embodied existence, which function as a ghostly reminder to the visitor of their own embodiedness. This creates a reflexive attitude in which the visitor is aware of themselves as both embodied and virtual; self and other. Whatley explores how these tensions between the real and the virtual are intensified in Gibson's work. Gibson's experience as a Skinner Release Technique practitioner emphasises the somatic and 'natural' dimension of embodied experience, thereby giving her a very strong foundation from which to explore interactions and tensions between embodiment in real and virtual environments.

As Whatley explains, the way the 'visitor' interacts with the environment in Gibson's work is similar in some respects to computer games. Indeed, for all the contributors to this part the notion of interaction is central to their uses of technology and how they envisage it as facilitating and enhancing our kinesthetic and empathic relations with others and with a multisensory environment. A crucial part of this interaction is the sensory feedback, which can be constructed to enhance psychomotor skills (as in Fogtmann's sports equipment) and which can also become an object of perception in its own right (as in Knoth's and Gibson's work), leading to heightened reflexive and sensory awareness.

Chapter 13

The Poetics of Motion Capture and Visualisation Techniques:
The Differences between Watching Real and Virtual Dancing Bodies

Sarah Whatley

for
alex

This chapter explores how kinesthetic empathy is implicated in the experience of watching live and virtual dance, and specifically how digitally produced bodies for immersive virtual environments might provide new viewing experiences. The work of dance artist Ruth Gibson provides a focus for the discussion. Gibson is a Skinner Releasing Technique (SRT) practitioner, and an expert in using motion capture technologies who is now bringing together these two very different practices to create new visualisations for immersive environments. The chapter will explore the viewer's experience, to ask what it is that the viewer might be drawn to, 'looks for' and attends to: How do embodied human experiences, such as gravity, skin, tactility and materiality, communicate through visualisations made for immersive environments? And how might they awaken the senses through a sense of orientation, dislocation or displacement? The chapter argues that virtual environments do not imitate live performances but offer a more intense kinesthetic experience.

Digital technologies have had a profound influence on how dance makers are producing work. Many dancers are exploring novel ways to interact with a growing number of different technologies, altering how audiences encounter dance and interpret what they see.[1] At one end of these explorations, dancers are fascinated with how they can remove themselves from performing 'live' whilst retaining the sense of the 'living' dancing body in their work. My aim in this chapter is to explore the way in which visualisations generated through motion capture technology can capture the dancing body as a fleshy, feeling, intentional and sensing entity to produce new kinds of watching experiences. I will be focusing particularly on the work of dance artist Ruth Gibson because of her expertise in using motion capture for immersive environments.

Gibson is one half of igloo and with her collaborator Bruno Martelli, she has worked for many years exploring electronic media and performance, motion capture and 3D worlds, for international festivals, exhibitions, installations and performances. Their investigations have also taken them to extreme landscapes and habitats, to gain a deeper understanding of real places as field research for their site specific/responsive/sensitive work, which accompanies their 3D computer graphic environments. Perhaps because these projects are so novel, igloo's work tends to sit outside mainstream dance criticism but attracts writers and theorists who look to artists and works that 'trip the line and trouble the boundary between technological advancement and emergent performance (and performative) processes' (Chatzichristodoulou et al. 2009: 2). Hence igloo uses a range of technical processes that

might be said to produce 'new forms of hybrid human and machine subjectivities calling on us to shift our analyses of performance' (Salter 2009: 29).

What also makes Gibson's work interesting in the context of this discussion is that she has begun a research process, funded through an Arts and Humanities Research Council Fellowship in Creative and Performing Arts award,[2] which brings together the technological process of motion capture with the body-based practice SRT to generate new visualisations for performances and installations. The project will be the first time that SRT has been 'captured' in this way. Gibson's research will open up a range of new questions, which are provoked by watching dance generated by motion capture technologies and which concern the relationship between movement tracking technology and the dancing body. These questions include: how are embodied human experiences, communicated through the visualisations? What is it that the viewer is drawn to? And then what kind of responses does the presence of a recognisable human form stimulate in the viewer? The unifying quest that underpins all Gibson's work is how to bring the live and virtual together, and this is likely to be the most challenging issue when these two seemingly disparate systems, motion capture and SRT, interact with one another.

I draw on examples of Gibson's past work as well as conversations with her[3] to discuss what might be described as the poetic properties of motion capture. I will explore how her work negotiates the relationship between embodiment and technology to question the different ways in which kinesthetic empathy is implicated in watching virtual dance. Moreover, I will argue that particular kinds of viewing environments, and specifically immersive environments, provide the viewers of virtual bodies with an intense and transformative kinesthetic experience, quite different from that which is produced in a 'live' encounter with real dancing bodies.

The real and the virtual in dance

First I want to address what might be seen as a problematic distinction between the 'real' and the 'virtual'. My intention is not to present these terms as oppositional, acknowledging that much performance practice today is interdisciplinary and breaks down traditional binaries of the digital/analogue, human/machine and natural/artificial. However, in simple terms, the presence of a 'live' dancer might be said to involve the viewer sensing in a more immediate, co-present way the dancer's effort, breath, weight and so on. But even here the dancer's body is frequently mediated through, or by, some form of machine, technology or screen, producing illusory effects.

The traditional theatre environment is one of the most familiar settings in which the viewer is in the same physical space as the live performer. But proximity and distance between dancer and viewer, whether constructed through spatial configuration or through devices 'designed to reduce distance between spectator and dancer' (Reynolds 2010: 19), can influence the experience of the 'real' encounter. In the live encounter, audiences may

be more attuned to the dancer's corporeality, potential vulnerability and even injury. So in a virtual environment, does the viewer attend to the virtual body differently? Do spectators continue to bring a reading of vulnerability to their encounter with the virtual dancer? Or might the nature of the interaction in the virtual environment mean that a condition of vulnerability is transferred to the viewer? Such is the blurring of the real and the virtual. Dance artist and writer Susan Kozel is one writer who cautions against what might be seen as a dangerously dualistic reading, which equates the real with mass, and the virtual with the abstract (2007: 236). She asks whether the virtual is necessarily disembodied; indeed she asks what 'a body' is, arguing that

[to] deny the abstract qualities of the real building or body, like denying the sensuous qualities of a virtual creation, is to ghettoize both the real and the virtual in definitional constructs that are incomplete. Experience is social as well as sensual, political as well as material, conceptual as well as physical. Virtual environments and dances are not devoid of sense, materiality, and physicality.

Kozel writes from her own embodied experience as artist and theorist, set within a phenomenological framework of thought and action, rather than addressing in any detailed way the experience of the viewer when encountering her (and others') work. The argument she puts forward for the physicality of the virtual from the point of view of the performer has yet to be made for the spectator.

The distinction I therefore want to draw out here is between the viewer in the traditional theatre environment, whose role tends towards being physically passive, and the viewer in the virtual environment, who is frequently called upon to 'perform' some action her/himself in order to engage with the work, whether it is activating a simple keyboard, mouse or joystick, or moving more fully into and through a physical space. What is 'real' and what is 'virtual' is therefore determined as much by the relationship between the work and the viewer as by the use of technology. It follows then that the definition of the 'viewer' requires some further discussion. In Gibson's work, as in much work that similarly crosses boundaries between performance, media, art and technology, the viewer is rarely allowed to be a passive observer. Frequently immersed in the experience and almost always active in making choices about how s/he navigates through an environment, the watcher becomes implicated in the viewing, as co-creator, thereby active in realising the work.

One of igloo's earlier works, which set them on a path of thinking more about the dynamic relationship between viewer and performer, is *dotdotdot* (2002). Providing an experience that is quite different from those projects where the visitor enters a physical environment, *dotdotdot* is an online,[4] interactive motion capture and radio 3D animation project. It was designed for the home computer where the viewer (or more accurately, the user, or player) plays the dance for him/herself. Users are taken through a series of instructions, inviting them to play between the visual imagery on the screen whilst tuning into different radio shows to accompany the screen images. The user effectively enters into a dialogue with

the imagery, performing with, or even 'through', the avatar on the screen, caught between partnering with the avatar and experiencing the avatar as a representation of him/herself. The image can be manipulated with the mouse and keys, producing a motion capture dance character study, in duet with the user/player. Movement is simulated through the moving avatars; each of which is named (for example, 'red', 'ice', 'dot', 'plane', 'bendy') and emerges as a combination of shape, weight and texture brought alive and embodying more human properties through the interplay with sound and the user's own direction.

Composed of particular symbols and colours, the character studies in *dotdotdot* might invoke certain readings and interpretations.[5] Ultimately, the screen interface and the many options available to the viewer for manipulating, rotating and 'playing' the moving figures to create novel visual and sound combinations mean that the viewer is less a witness to the dance as it unfolds, but is rather active in the primary work of making the dance. It thus follows that if kinesthetic empathy relies principally on an attentive relationship between the mover and the viewer, which also assumes a distinction between each role, then *dotdotdot* invites a different kind of kinesthetic engagement. Here it is not a question of viewers being able to watch and experience the dance as if it is within their own body as they dance along with the avatar, because the avatar is lifeless without the player's instigation. A more complicated relationship exists between performer and viewer in this online 'game' environment.

Motion capture technology and dance

In very simple terms, motion capture (or 'performance capture') is a digital technique whereby an actor's (or dancer's) movement is captured by means of having sensors (reflective or magnetic markers) attached to various body parts. It often takes place within a dedicated 'lab', where cameras (positioned around the space) then capture the motion of the markers. It has many applications and is used by the entertainment industries, the military, in sport and by health professionals. Depending on the purpose of the capture this raw data is then put through various computer processes that clean the data and convert it into a composite figure, which can be animated using different computer animation software.[6] For artists, like Gibson, this production pipeline can sometimes unhelpfully 'smooth out any nuances or interesting glitches' (Gibson, cited in Jefferies 2009: 47). What are complex technical processes can take many hours of expert human intervention and are therefore costly. Though still out of reach for many artists because of these costs as well as the time and specialist skills involved, those who have developed expertise, such as Gibson, are fascinated by the limitations and potentials of motion capture technology in relation to the moving body. Like Kozel (2007), Gibson is interested in the possibilities brought about by the transmission of corporeality through the avatar.[7]

Kozel worked with Gibson between 1997 and 2000 for several projects (*Multi-Medea: Exiles, Liftlink, Ghosts and Astronauts, figments, Contours*). She describes her experience when working on *figments* (1999), a motion capture installation using an ultrasonic tracking

system.[8] She outlines how sonic data was translated into a visual figure and how that translation might have lost the presence of the moving body of the performer, and observes that 'in the motion capture system, my bodily movement was animated against a backdrop of nothingness, but I knew that this nothingness was alive with ultrasonic waves and created a personality for the figure that was more than simply a mapping of my movement' (Kozel 2007: 261). What Kozel points to here is the potential liveness of the virtual environment and how a capture retains the human properties of the dancer. Her comments also show why artists are frequently dissatisfied with the term motion 'capture', 'because it implies that the motion is contained once it is captured, like a bee in a net' (Kozel 2007: 220), whereas many artists believe that an animation or avatar is waiting for life to be breathed into it by the artist/viewer/user. For Gibson, liveness is also concerned with how both the moving body and the physical environment translate to a virtual world. As she explains:

> In one sense we're looking to translate live-ness into the virtual world, that is individual qualities, authenticity of capture, weight and gravity. We also try to do this in the way we construct the landscapes, building with great textures, shadows, light, reflection, water, grass which blows in the wind. In virtual worlds there is also the opportunity to create totally new places, new bodies and new performance material, which is impossible in the real world.
>
> (Gibson, cited in Jefferies 2009: 53)

Erin Manning offers another view on the liveness of dance by asking what it is precisely that is being 'captured' with sensory technology (2009: 61–76). She argues that what she terms 'experiential transformation' is rare; it is limited because new kinds of events created by the relationship between new technology and dance tend to 'call forth a docile body, both in the software-conformist dancer and in the technologically attentive spectator' (2009: 64).

Manning's concerns are not unfamiliar to artists, such as Gibson, who seek to make the technology work for them rather than following technology's lead. Gibson is intrigued by the potential for capturing the moving body in process and movement's incipiency or 'preacceleration' (Manning 2009: 62). Manning uses the term 'preacceleration' to describe the tendency towards movement through which a displacement takes form, and which, she believes, motion-detecting technology tends to overlook. It is this aspect of motion capture technology that interests Gibson and that has led her to ask how motion capture might be able to read and capture the breathing, fleshy body with its own history. Moreover, Gibson seems to be concerned with enabling the viewer to experience what Manning describes as the 'technogenetic' body: a body that emerges through technology rather than pre-existing (2009: 61) in order to generate the experiential transformation, which, according to Manning, eludes the viewer. Arguably, immersive environments offer an intense kinesthetic experience and hold the most potential for this experiential transformation.

The immersive environment and experiential transformation

As part of her work with igloo, Gibson has made several works for immersive environments. *Summerbranch*[9] (2006) perhaps reveals most clearly her fascination with the feeling, sensing body and its potential for 'tapping into the senses'. *Summerbranch* is a computer game engine environment, exhibited as a site-responsive immersive installation for gallery display. The viewer physically enters a gallery space to experience the virtual environment of the forest; the interrelationship between the real and the virtual is at the heart of the work. It resists being straightforwardly situated within a frame of dance, art object, nature documentary or game. As with other works by igloo, which employ the technologies of game engines,[10] interactivity between the player and non-player characters is built into the experience. The result is that the player/viewer can trigger different actions but there is no goal, reward or prescribed outcome to be achieved. Gibson acknowledges how she considered carefully the role of the visitor[11] in the development of this work, and questions where the boundaries lie between artwork and viewer. Birringer goes further to suggest that interactive art of this kind marks 'the dissolution of the distinction between artwork and process and between artwork and audience' (Birringer 2007: 46).

Summerbranch was made as a result of a residency in the New Forest in the UK where the dancers spent time in camouflage in the forest to observe movement, and to get a feel for forest life. Gibson explains how a Gyroscopic kit provided by Animazoo[12] enabled the dancers to work outside on uneven terrain, so unusually the dance was not captured in a studio. She was keen to explore the notion of the natural by responding to the branches and leaves, grass and foliage, and importantly, the irregular footfalls of the dancers, explaining that when she motion captures outdoors, data is, in her view, 'authentic':[13] 'within the framework of perfect 3D geometry the presence of the figure dancing is a trace of the real, the human' (igloo, cited in Jefferies 2009: 45).

The avatar's design is influenced by ideas of camouflage and pattern recognition; it becomes a diffuse image moving through the landscape and yet the body is still clearly visible: breathing, hesitant, vulnerable. Birringer describes a journey-like interaction with *Summerbranch*:

> We discover ourselves to be pathfinders, fiddling with the quaintly old-fashioned joystick and carefully walking through a computer generated virtual forest in which we might, per chance, encounter elves and fairies or other creatures. These others, however, are performers 'disappeared' into the background of the forestscape, remaining motionless and barely visible …, or they might enact a trance-like dance in the leaves of the unreal forest. The creatures are animations, and like the forest a photorealist dream which looks so real that it is uncanny and thus unsettling.[14]

(Birringer 2007: 48)

The viewer is drawn in to the natural environment, surrounded by sound of the forest, seeking out the sentient and graceful creatures that inhabit the virtual forest to discover herself in the uncertain, nervous, transient world of the avatars. The environment thus effectively reflects back to the viewer her own experience of being human, illustrating how the technology can interact with the living body, sensitive to its subtleties and syntax.

Gibson talks about a central concern that is evident in *Summerbranch* and much of her work before and since: how the transformation of the dancing body into virtual environments might retain or retell something of corporeality? Steve Dixon recognises this concern when reflecting on an earlier work by Gibson and Martelli, *Viking Shoppers* (2000). He observes: 'the numeric and abstracted computer symbols evoked the complex pattern of cells and genes underlying the human form, and how the bodily transformation seemed simultaneously startling, eerie, uplifting, mystical and *natural*' (cited in Jefferies, 2009: 53; italics in the original). Gibson's own commentary and those of others who have discussed her work, such as Dixon, tend to refer to how both scientific concepts and notions of organic form and the natural body form the substance of her investigations.

A very different world from *Summerbranch* is generated by the computer game environment of *SwanQuake: House* (2008), which is documented in the related publication *SwanQuake: The User Manual* (2007). *SwanQuake: House* takes the viewer, or visitor, via a customised dressing table into a dark, urban landscape, instantly moving between different virtual spaces and 'temperatures'. As Scott deLahunta observes, '[e]merging from the overall design collaboration is something more akin to an orchestration of image, sound, immersion and experience folded together, aimed to elicit a mixture of feelings, curiosity and wonder' (2007: 25). Taking a journey through *SwanQuake* means entering and navigating through curious and mysterious locations where the sonic and visual worlds interact to create a series of vivid and 'realistic' rooms, corridors and stairways. Describing this journey is hard to do; it eschews a linear experience and leaves behind a memory of atmosphere and impressions rather than a narrative form. Some of what is encountered might feel familiar and yet is made strange by juxtaposition or inversion.

SwanQuake only exists as an interactive experience. By controlling a joystick set within the customised dressing table, the player or visitor 'enters' the house, inhabiting and observing the house from the perspective of an avatar. The visitor is thus somewhere between 'player', able to make choices about where to move and what to see, and 'viewer' by being able to retain a distance, or separation, from the avatars who 'occupy' the house.

Taking my own journey through the house, I find I am momentarily trapped in windowless rooms. Although I am aware that there is no time limit, no lives to lose or points to be won, I am eager to find my way to a 'safe' place. I am aware of my own embodied presence; still 'me' but in a world where I can get close to characters who emerge in different spaces, dancing through phrases of movement that suggest an easy relationship with their environment and with each other. I arrive on what appears to be a city rooftop at night. It is raining. The city casts light on a single dancer who moves in the semi-darkness. Intrigued, I want to stay and see how this resolves but I know there is more to discover so I navigate my way to re-

enter the building. I travel through more corridors, down more stairs until I emerge in what seems to be a vast underground chamber. An ensemble of dancing figures spread across the space, moving through sensuous, fluid and grounded sequences. There is something deeply human about their dancing, set within the cold, industrial environment but a close reading reveals that these are dancing clones; each is a replica of the other, and yet again, not quite. I find myself strangely connected, because their dancing feels familiar, but also distanced by their 'normalized anonymous form' (Westecott, cited in Jefferies 2009: 51).

These dancing visualisations are generated by mapping a model of Gibson onto six dancers' movement (including her own). Motion capture sequences of each dancer are then sewn together and intermingled. The body becomes a particle system, open to manipulation, multiplication, disappearing and reappearing. The multiple bodies, performing the subtlest of movement variations, reinforce rather than undermine the human presence, thereby softening the strangeness and harshness of the perplexing 'house'. Westecott captures this well when she writes:

> Our gaze is drawn to the dance, a dance in world, a dance of enquiry in which she moves in her landscape, both part of the code that builds the gamespace and alien to her machine-generated environment in her expression of human movement, she fascinates in her otherness. The ghost in this machine is the reminder of our organic nature.
>
> (Westecott, cited in Jefferies 2009: 51)

Westecott also hints at what else the viewer might grasp in this particular world: an acute sense of structure, whether the dancer's bodily structure, the underlying structure of digital coding, or the overarching 'choreographic' structure that shapes the dancer's phrases. For Gibson, the virtual volume of the digital space in the motion capture studio is somehow mirrored in the room they made in *SwanQuake: House*. This volume is then tested and experienced by the visitor who can use the mirror on the dressing table 'controller', which transports them from physical to virtual space, to see inside the 'house' as if from the viewpoint of an avatar. This transition complicates the visitor's sense of embodiment whilst offering a new kind of experiential transformation.

These two works form just part of igloo's output, which has recently moved into modelling real space and physicalising 3D space, and experimenting with putting the real and virtual side by side (igloo, cited in Jefferies 2009: 44). During a recent residency at the Banff Centre in Canada, igloo worked with the CAVE[15] system, which as a different kind of immersive environment led to the development of new avatar visualisations and new questions about the role of perception and the senses. These projects have prompted Gibson to think more about disorientation, about chaos, and the play with vertigo she encounters when working in virtual worlds,[16] which are akin to the risk taking she experiences in her SRT practice.

SRT and virtual environments

SRT is one of several somatic movement practices that collectively provide an experience that aims to enhance kinesthetic awareness and engagement for the mover. These practices have emerged more confidently during the last decade or so and draw on theories and practices that constantly question traditional modes of doing, ways of seeing and experiencing dance. They are characterised by a return to the self and sensorial awareness, to cultivate a new consciousness of bodily movement, hence the term 'soma' (of the body) and 'somatic' as a reference to the first-person perception. In connecting to the self, somatic practice also seeks to cultivate awareness of the self within the world, in relationship to the environment. As a dancer, this awareness is gained through experience, through being in process. For those who teach somatically informed practice, the somatic education discourse 'supports the development of an internal authority which refers to the capacity to make decisions based on sensory discriminations that accentuate the singularity of one's body, thus the somatic is conceived of as a technology of the self that counteracts the dominant discourse and supports a transformation of the power relations in dance' (Fortin 2009: 50). SRT is now increasingly taught within dance programmes in higher education whilst mature dance artists are drawn to train in SRT to enhance their practice and to become certified teachers,[17] hence it is gaining popularity worldwide amongst the professional dance practitioner community.

SRT is a certified practice, created by the American dancer Joan Skinner and governed by the SRT Institute, which states that SRT 'utilizes image-guided floor work to ease tension and promote an effortless kind of moving, integrated with alignment of the whole self'.[18] Regarded as a system of kinesthetic training that refines the perception and performance of movements, the technique is characterised by attention to the senses and includes concentrated periods of apparent stillness and minimal movement, and movement which is on the floor or enacted through contact with a partner. Although there is no requirement to be an experienced dancer to participate in SRT, to teach the technique requires a sustained period of training. A growth in the number of qualified teachers has generated interest in its impact on dance teaching and practice, some of which is documented.[19]

A participant will discover that poetic guided imagery leads the dancer into movement, encouraging the mover to experience a holistic, 'authentic' mode of response. Concepts such as 'nothingness', 'emptiness', 'sensory imaginings', 'reacting in the moment' and 'constant becoming' are frequently drawn upon. Spontaneous movement guides the creative exploration of technical principles such as multi-directional alignment, suppleness, suspension, economy and autonomy. The practice promotes the idea that nothing is fixed or static.

The imagery cited in SRT teaching often alludes to nature and the natural world. It helps the dancer to access the subconscious through deep meditation to explore the unexplored in individual movement creation. This very particular imagery makes SRT distinct as both a practice and pedagogy. The dancer may be curious about how to translate this practice

into composition, choreography, performance and perhaps other modes of arts-making. What might be a felt experience for the dancer is then tested by the environment and context in which the dancer meets the viewer. Although SRT is a practice that is primarily concerned with the experience of the mover and not the evoked experience of the viewer, it is nonetheless interesting to ask whether the dancer's lived experience can be 'read' by the viewer; and whether the viewer becomes aware of (for example) the dancer's use of time, space, her physical exertion and breathing patterns.

Gibson's dual interests in SRT and virtual environments provide the ground for her exploration of how SRT can be 'transported' into the motion capture lab. But as a process of movement generation and encounter, SRT might seem to be radically different from the process of making movement for virtual environments in which technology intervenes in myriad ways. So bringing SRT together with the scientific and technological process of motion capture to generate visualisations of the dancing body is in itself highly novel, and promises to produce a new 'coupling' of human movement and digital technology (Solano 2006,[20] cited in Birringer 2007: 44) but is almost certain also to lead to tensions and frictions. There are numerous potential contradictions between the two systems. For example, motion capture frequently requires the dancer to repeat a relatively short amount of movement many times. Decisions have to be made about which parts of the body are 'captured' (in other words, where the sensors are placed) and depending on the purpose of the capture, this might need many adjustments and repeat captures. Capturing more than one dancer at a time can compromise the 'accuracy' of the data and a dancer moving into and out of the floor can produce incomplete data. Also the technology is more suitable for capturing dynamic movement so the subtleties of somatic work, such as breathing and the contact (physical and sensory) between dancers, are harder to register. Stillness, and the concept of internalisation[21] are central to the practice of SRT but how these will translate through the process and transmit through the animations is yet unknown. A key question for Gibson will therefore be whether stillness remains invisible when no motion can be tracked or whether stillness becomes replete with life as the visualisation process gives life to the dancing avatar. As Gibson herself says, '[s]tillness isn't really still – the viewer should be able to see the idling character breathing' (cited in deLahunta 2007: 24). She is therefore aware that some aspects of SRT might evade capture or be undetectable, if not stillness, perhaps some minute shifts of weight or motion that takes place beneath the layers of the skin towards the inner spaces of the body.

For many dancers, the motion capture 'lab' can feel like an alien environment where they are subject to the complex gaze of the cameras, operator and their own preoccupation with their 'digital twin' projected image. The dancer's experience of moving within the lab is thus often as a researched subject – the body being offered up for measurement and scrutiny – rather than as a collaborating artist. Motion capture is unavoidably a controlling technology and moreover, an external control. As Kozel points out, motion capture 'is a technology that makes some people fear for their physical essence and causes others to burn with the possibilities for extending what it means to exist as embodied beings' (2007: 232). By contrast,

SRT is person-centred and emphasises the 'natural' and yet the images and particular methods of SRT present a different kind of external control in the demands it makes upon those who participate in the practice, even if it places the individual at the centre of that participation.

When asked what she thought would be the main challenges involved in taking SRT into the motion capture studio, Gibson pointed to the difficulties in ensuring that the studio environment is conducive to research. Dancers are often unfamiliar with the suit that they wear for the marker system, so they may overcompensate for the suit, thereby not responding honestly and authentically in terms of movement. She is also aware that SRT encourages a body that is in constant flux; the dancer's engagement with the practice may be unpredictable on any one day. It may require Gibson to work on whole classes within the studio to capture data rather than choosing and recording responses to specific imagery from SRT pedagogy.

As outlined earlier, SRT asks that the dancers 'tune-in' to breath, inner sensation and imagination, working towards a state of being that does not translate easily to a process that is principally concerned with accuracy of measurement. As a deeply internal process, SRT accesses what is yet to occur and that which has not yet happened. What is of interest then is how the technology may need to be adjusted or applied differently to support the reading and capture of the 'invisible', the labile, the dancer's 'inner landscape' and 'internal' processes; and how these processes, which are so specific to the sensorial experience of movement, produce particular kinds of visualisations and transmit the kinesthetic world of the dancer to the viewer. Kozel describes the 'kinaesthetic human poetics' (2007: 234) of the slight wavering that can occur when the motion capture data is used in real time in performance, where the dancer is moving simultaneously with her own projected image. This 'wavering', which might be experienced as the autonomy of the data in the projected image, paradoxically seems to capture something of the human condition, reminding us of the presence, not the absence, of the body. Although Gibson is not dancing alongside her projection in performance, the animations she uses produce a comparable effect because they are inspired by fluctuations in 'tone' between the live body moving and the data capture in the studio/lab. These animations both reinforce the intangible nature of the dancing body and reveal information about it, which may tell us more about the principles that underpin SRT, thereby increasing access to the subtleties and particularities of the practice.

SRT provides the practitioner with a method to deepen connections with the self, in order to gain new insights, which emerge over time. The motion capture and animation processes do the reverse; the expressive body is captured and the individual dancer relinquishes her/ his self to the visualisation process. The dancer is 'rendered' through to skeleton, 'electric skin' and then the model is mapped, in a process where the body is unavoidably fragmented prior to being built back up through reanimation into visualisations. The living form is stripped of life in order to restore life through the avatar (so 'breathing' life back into the capture, as described earlier). However, this need not run counter to the principles of somatic practices, such as SRT. Gibson acknowledges her interest in disappearing as a performer, saying that she has 'always longed for the ability to metamorphose as a performer

and it's a potent drive. For example, in the early days of our work the idea of losing the self, becoming the landscape and being invisible was key in what we did next' (Gibson, cited in Jefferies 2009: 47). Whilst the dancer might well find the idea of metamorphosis appealing, the dots, lines and animations that result from the captured data are often identifiable as the individual dancer; the dancer's idiosyncrasies, muscle tone and movement 'signature' seem to remain and carry forward into the visualisations. This suggests that more is visible to the cameras than that which is on the surface of the body.[22] But just how much sensors are able to transmit will be tested through Gibson's research; thought and intention are unlikely to be any more 'readable' than in a live performance.

Concluding thoughts

I began this chapter by proposing that digitally produced dancing bodies for immersive virtual environments provide new and transformative viewing experiences. Gibson's work, as part of igloo, is a useful case study in this context as it is characterised by a curiosity about the relationship between the natural and the artificial, the real and the imaginary. In many of her works, the viewer is confronted by a visualisation, generated through a scientific and technological process. The dancing body is therefore not 'real' but split, transformed and multiplied. But when placed within an immersive environment, the encounter between viewer/user and dancing avatar tends to offer a more sensorial experience. It is this engagement with sensation that provides viewers with an intense kinesthetic experience; the immersive environment is not literally embodied but it is designed to make the viewer's sense of embodiment more forceful.

In a live performance, both performer and viewer are aware of some kind of exchange; the transaction is two-way even if the dancer may not see 'me', or dance for 'me' as an individual viewer in the live space. Works such as *Summerbranch* and *SwanQuake* bring the user into the work as an active player or participant. It is the user's actions that animate and 'give life' to the avatars. Within this immersive, gaming environment, the distinction between viewer and performer becomes blurred. The viewer/player moves through these interactive environments, often getting close to the avatars, constructing her own personalised dance with the avatar, even dancing herself 'through' the avatars. The human form, however transformed, retains its volume, its materiality and vulnerability in the viewer's imagination. It is this reminder of the human body that prompts the viewer to reflect on her own sense of embodiment when viewing a digital body; this is different from what happens in a live performance, not a replication of it. The viewer may be in a one-to-one reciprocal form of exchange with the avatar, leading to different desires. For example, Gibson recalls a comment by neuroscientist Phil Barnard,[23] who said to Gibson after his viewing of *Summerbranch*: 'I don't necessarily want her [the avatar] to take my hand and walk with me through the forest I just want her to notice me' (personal communication).

Gibson's new project will test out the immersive interactive virtual environment as a space or 'platform' to explore the interface between motion capture and SRT. She is well aware of her responsibilities to SRT, not least because it can be a very powerful practice, which taps into different feelings and sensing states. She has spoken in depth with the SRT Institute and faculty members who relish the idea of Skinner's imagery from the natural/organic world somehow being visualised for virtual environments, thereby enhancing critical engagement with the practice. She will be working with other SRT practitioners to find out how they experience their role as active agents in the generation of interactive, technologically mediated works. Will it change their practice? Will something more be exposed through the animation process? Gibson is interested to discover whether SRT as 'raw material' or the environment, which is created by and for the visualisations, have an effect on kinesthetic empathy. Working collaboratively and interacting with other motion capture experts and game technologists, Gibson hopes that any tensions can be productive, opening up new insights to SRT and possible modifications and enhancements to technology such as the design and placement of markers/sensors on the body.

Virtual environments do not imitate live performance but visualisations can awaken the senses through an awareness of orientation, dislocation or displacement. The poetic imagery that is so central to SRT is a potentially rich resource for exploiting this further. By incorporating aspects of SRT in the generation of dance events for immersive environments, the viewer is offered an even more intense kinesthetic experience, which makes clear the differences between watching real and virtual dancing bodies.

Acknowledgement

I am grateful to Ruth Gibson for her generosity in providing me with her comments and her feedback in preparation for this chapter.

Notes

1. The development of these practices and the impact they have had on the production and reception of dance owe much to the growth of interest in digital culture in general. For a succinct account of some of the artists and practices, which have been influential over the last two decades or so, see Birringer (2007).
2. The Fellowship, from 2010 to 2013 is based at Coventry University.
3. Conversations took place during summer and early autumn 2010, in person and by e-mail.
4. See http://www.swanquake.com/OldSite/dotdotdot/Dswmedia/index.htm. Accessed 15 March 2011.
5. For example, the 'plane' character incorporates images of aeroplanes and jets, including a 'Stealth Bomber', which may be troubling for some viewers, but which Gibson chose to signify a sense of

the driving force of power and emotion, and even *danger*, which is situated at the centre of the solar plexus to the haunches.

6. This can mean extrapolating from what is recorded to provide a more full anatomical figure, which requires careful mathematical calculations. Or if the movement is very complex, the data can break up, which then requires intervention to build up a fuller polygon structure to support the transfer of the capture to generate visualisations (see deLahunta 2007 for more information on this process in relation to the creation of *SwanQuake*).

7. Whilst 'avatar' and 'environment' are terms that tend to be used most often for the animations of dancers and the place(s) they inhabit, Gibson prefers to use the terms 'figure' and 'landscape', reflecting her concern with human presence and poetic structures.

8. See Kozel (2007: 258–267) for a detailed description of this project.

9. The title for *Summerbranch* is a play on the title of two choreographic works by Merce Cunningham, *Summerspace* (1958) and *Winterbranch* (1964). Other titles are similarly derived from established dance works, for example, *SwanQuake* is a play on the well-known ballet *Swan Lake*, combined with a reference to the computer game *Quake*.

10. See deLahunta (2007: 26, *n*.3) for a useful quick description of a game engine.

11. Gibson prefers to use the term 'visitor' to describe those who experience her work, rather than 'viewer' or 'player'. The term is to indicate a more interactive relationship, in which those who visit are also active in what they view, potentially changing what is presented, in contrast to the passive spectator who may have no effect on what is performed.

12. Animazoo is a UK-based manufacturer of motion capture systems.

13. By 'authentic' Gibson is pointing to a process of data capture that allowed the dancers to move through the landscape without the burden of wearing a motion capture suit, situated within a 'lab' surrounded by a complex camera system.

14. 'Uncanny Valley' is a hypothesis put forward by Mori (1970) and now widely referred to as the emotional response of humans to increasingly human-like entities (like robots or animated characters); see *SwanQuake: The User Manual* (2007) for more discussion of this.

15. Cave Automatic Virtual Environment.

16. This point refers to Gibson's interest in the work of scenic painter Hein Heckroth and the extraordinary suspension of disbelief generated by his production design when working in collaboration with Michael Powell, Emeric Pressberger and Jack Cardiff (see http://www.screenonline.org.uk/people/id/464379/. Accessed 3 April 2011).

17. For example, Coventry University in the UK is incorporating SRT as part of the curriculum when members of teaching staff become qualified in the practice. Coventry is also the UK host for the annual SRT intensive teacher training programme.

18. See http://www.skinnerreleasing.com/ for more information about SRT, and http://www.skinnerreleasing.com/articles.html for further articles about SRT. Accessed 2 November 2010.

19. See for example articles by Agis and Moran (2002), Alexander (2001), Emslie (2009), Skinner et al. (1979) and Skura (1990).

20. Dance-tech mailing list, August 15 2006.

21. Internalisation refers to the internalising of self knowledge, which is a characteristic of many somatic movement practices including SRT.

22. In the context of injury prevention for example, an expert in biomechanics might extrapolate information from this data to determine what might be taking place within the deeper structures of the dancer's anatomy.

23. http://www.mrc-cbu.cam.ac.uk/people/phil.barnard/. Accessed 17 April 2011.

References

Agis, G. and Moran, J. (2002). 'In Its Purest Form: A Rare Insight into the Work of Joan Skinner'. *Animated*, Winter 2002, Foundation for Community Dance: 20–22.

Alexander, K. (2001). 'You Can't Make a Leaf Grow by Stretching It: Some Notes on the Philosophical Implications of Skinner Releasing Technique'. *Performance Journal 18*, Winter/Spring, Centre for Movement Research in New York: 8–9.

Birringer, J. (2007). 'Data Art and Interactive Landscapes'. In S. deLahunta (ed.), *SwanQuake: The User Manual*. Plymouth: Liquid Press, 37–52.

Chatzichristodoulou, M., Jefferies, J. and Zerihan, R. (eds) (2009). *Interfaces of Performance*. Farnham: Ashgate.

Chatzichristodoulou, M., Jefferies, J. and Zerihan, R. (2009). 'Introduction'. In M. Chatzichristodoulou, J. Jefferies and R. Zerihan (eds), *Interfaces of Performance*. Farnham: Ashgate, 1–5.

deLahunta, S. (ed.) (2007). *SwanQuake: The User Manual*. Plymouth: Liquid Press.

deLahunta, S. (2007). 'Choreographing Cycling Anims'. In S. deLahunta (ed.), *SwanQuake: The User Manual*. Plymouth: Liquid Press, 17–26.

Emslie, M. (2009). 'Skinner Releasing Technique; Dancing from Within'. *Journal of Dance and Somatic Practices*, 1 (2): 169–176.

Fortin, S. (2009). 'The Experience of Discourses in Dance and Somatics'. *Journal of Dance and Somatic Practices*, 1 (1): 47–64.

Jefferies, J. (2009). 'Blurring the Boundaries: Performance, Technology and the Artificial Sublime – An Interview with Ruth Gibson and Bruno Martelli, igloo'. In M. Chatzichristodoulou, J. Jefferies and R. Zerihan (eds), *Interfaces of Performance*. Farnham: Ashgate, 43–54.

Kozel, S. (2007). *Closer: Performance, Technologies, Phenomenology*. Massachusetts: MIT Press.

Manning, E. (2009). *Relationscapes*. Massachusetts: MIT Press.

Reynolds, D. (2010). '"Glitz and Glamour" or Atomic Rearrangement: What do Dance Audiences Want?'. *Dance Research*, 28 (1): 19–35.

Skinner, J., Davis, B. Davidson, R. Wheeler, K. and Metcalf, S. (1979). 'Skinner Releasing Technique'. *Contact Quarterly*, V (1 Fall): 8–12.

Skura, S. (1990). 'Releasing Dance: Interview with Joan Skinner'. *Contact Quarterly*, Fall: 11–18.

Salter, C. (2009). 'Environments, Interactions and Beings: The Ecology of Performativity and Technics'. In M. Chatzichristodoulou, J. Jefferies and R. Zerihan (eds), *Interfaces of Performance*. Farnham: Ashgate, 27–42.

Chapter 14

Interactive Multimedia Performance and the Audience's Experience of Kinesthetic Empathy

Brian Knoth

This chapter presents exploratory artistic research and thought regarding the development of an interactive multimedia performance environment and the audience experience of kinesthetic empathy. In collaboration with movement artist Emily Beattie, I created a digital performance piece, titled *Unless* (2009), featuring a dancer and movement activated digital media environment. With *Unless* I wanted the movement of the dancer to clearly influence the sound and imagery of the performance space and, at the same time, I wanted the audience to perceive that the interactions between her movement and the media had an artistic purpose and were not mere technical demonstrations. During the early stages of the artistic process, I realised that my work was related to current research on dance and the concept of kinesthetic empathy. It quickly became apparent that the interactive multimedia performance environment I was developing might have implications for the way audiences experience kinesthetic empathy.

It has been argued that spectators observing any physical action have the capacity to internally simulate movement sensations such as 'speed, effort, and changing body configuration' (Hagendoorn 2004: 88). These phenomena, in essence, define the concept of kinesthetic empathy as it is explored in this project. Interestingly, audiences can tap into these sensations even while sitting still, and can feel that they are participating in the movements they observe. Creating strong impressions of kinesthetic empathy in the audience (especially regarding their connection to the dancer) was extremely important to the overall goal of the work.

I hypothesised that a movement-activated multimedia environment might enhance feelings of kinesthetic empathy in the audience. Due to the novel cross-sensory relationships presented during the performance, linking the dancer's movement and the interactive multimedia environment, I felt that the audience would be more aware of their perceptions and consequently more conscious of their empathetic relationship to the mover. Audience research surveys were administered after each performance in order to gauge the impact of the performances in this regard. The theoretical foundations, artistic processes, research and results will now be discussed in detail.

Embodied simulation

The brain is often compared with a computer and the body its 'all-purpose tool' (Bennett 2008). However, an expanding collection of research suggests that something more

interactive is going on. This new model of mind is often referred to as 'embodied cognition'. In the embodied view, perception and cognition are much more than isolated brain functions. What is going on inside the brain integrally depends on what is happening with the body and how it is interacting with its environment. As in the slogan for the University of Wisconsin's Laboratory of Embodied Cognition, 'Ago ergo cogito': 'I act, therefore I think'.

Although still somewhat controversial, the reputed discovery of 'mirror neuron' systems has also helped to advance thought on the topic of mind/body interaction. It was found that a system of neurons could respond similarly whether one performed an action oneself or observed someone else performing the same action (Rizzolatti et al. 2008: 190). The function of mirror neurons may support the notion that acting and perceiving are not so separate after all. Researchers have also found that individuals who scored higher on an 'empathy' scale activated the system more strongly, adding evidence to claims linking the mirror system with human traits such as compassion (Gazzola et al. 2006: 1824).

> Even if they involve different cortical circuits, our perceptions of the motor acts and emotive reactions of others appear to be united by a mirror mechanism that permits our brain to immediately understand what we are seeing, feeling, or imagining others to be doing, as it triggers the same neural structures (motor or visceromotor respectively) that are responsible for our own actions and emotions.
>
> (Rizzolatti et al. 2008: 190)

Such mechanisms may not only be triggered by visual observation. An auditory-motor mirror system has also been suggested (Lahav et al. 2007: 308). Gazzola et al. (2006) found that auditory-motor mirror neurons responded while monkeys both performed mouth actions and while they listened to the sounds of such actions. Preliminary fMRI evidence supports the existence of a similar multimodal system in humans (Gazzola et al. 2006: 1824).

These ideas fit with Rolf Godøy's model of music perception and cognition, which is grounded in his concept of 'motor-mimesis'.

> I believe this points in the direction of what I would like to call a *motor-mimetic* element in music perception and cognition, meaning that we mentally imitate sound-producing actions when we listen attentively to music, or that we may imagine actively tracing or drawing the contours of the music as it unfolds.
>
> (Godøy 2003: 318)

Godøy's model transposes the notion of embodied simulation suggested by both mirror-neuron theory and phenomenological research regarding dance into the realm of music perception (Hagendoorn 2004; Gallese 2005). Kinesthetic empathy, a seemingly related phenomenon, may also derive from similar mechanisms.

Such ideas offer useful foundations for both the creation and investigation of interactive music and multimedia art forms. Marc Leman, for instance, has explicitly championed the

embodied cognition perspective in his book, *Embodied Music Cognition and Mediation Technology* (2007). He provides the first thorough look at the relationships between action-oriented theories of perception, embodied simulation and interactive music and new media technologies. The connections are clear to me as the practices of interactive music and multimedia art forms inherently relate to these scientific and philosophical domains.

Therefore, I drew from these scientific and philosophical domains both to inspire the artistic process and inform research. For one, the literature surrounding the concept of kinesthetic empathy inspired the creation of an interactive multimedia environment that could engage audiences in novel perceptions of cross-sensory interactions involving computer-driven soundscapes and imagery activated by human movement. I thought it would be interesting to experiment with tricking the perceptual system (of both the audience and dancer) with virtually linked but physically disconnected movements, sounds and imagery.

In addition, this literature was integral to the conceptualisation of the audience research portion of the project. It informed the way in which I constructed the survey in order to extract specific insights from the audience regarding their perceptions of both the multisensory interactions constructed by the technologically mediated environment and their experiences of kinesthetic empathy. What resulted was at once a legitimate artistic production and an exploratory audience research study.

Bodies, technology and virtual environments

For years virtual reality was bogged down by 'cumbersome gear and prohibitive costs' (Hansen 2006: 1). Recently, an economically and artistically motivated trend has emerged that offers an alternative to the old concept of virtual reality. Dubbed 'mixed reality', it does away with virtual reality's disembodied approach using head-mounted displays (HMDs), instead creating experiences that merge the virtual with existing physical spaces. As Mark Hansen states in his book *Bodies in Code*, 'today's artists and engineers envision a fluid interpenetration of realms' (Hansen 2006: 2).

Hansen cites interactive arts pioneer Myron Krueger as a father figure to the mixed reality movement. For Krueger, the development of immersive environments aims to put us in touch with our most primitive perceptual capacities: 'Whereas the HMD folks thought that 3D scenery was the essence of reality, I felt that the degree of physical involvement was the measure of immersion' (Krueger 1993: 147).

Krueger's seminal ideas still have great influence over the work of interactive artists today. Passages from the book *Interact or Die* (Brouwer and Mulder 2007), an Ars Electronica media research award winner, represent some current waves of thought on the subject. In an interview with Arjen Mulder (one of the editors), Brian Massumi offers an example of one such artistic derivative, as he discusses *Artaudian Lights* (2006), a movement and responsive

architecture experiment created by Michael Montanero and Harry Smoak at Sha Xin Wei's Topological Media Lab.

In the process, Mulder and Massumi's discussion turned to the specific realm of digital performance in relation to the larger context of interactive art. Referring to the piece, Mulder remarked, 'There's the traditional theatrical separation between the performers and the audience. The interaction is only between the performers and the technology' (Massumi and Mulder 2007: 89). To this, Massumi responded:

> While it is true that the audience was not in on the interaction, they were in on the relation. You couldn't not see the relation between movement and vision being recomposed before your eyes. You felt the dancers making an actual sight of their bodies' imperceptible movement talents. Kinesthesia was not only fused with movement, it was like vision itself was emerging from it. Body-vision.
>
> (Massumi and Mulder 2007: 89)

Here, Massumi describes an intriguing instance of multisensory perceptual interaction while also evoking the human capacity to feel the movements of others. One could argue that even though an audience may not be 'in on' the technological processes at work in the interaction between a performer and digital media performance system, our capacity for kinesthetic empathy allows for a simulated experience of the relationships at work. This is an important concept to consider in the creation of interactive arts involving a performer and audience.

In aesthetic practice and experiential research many artists throughout recent years have explored cross-sensory relationships and interactions between a performer and interactive digital performance systems. For instance, Todd Winkler offers this interesting insight concerning human movement, or more specifically a dancer's gesture, as input for a digital music instrument:

> The underlying physics of movement lends insight into the selection of musical material. Thus, a delicate curling of the fingers should produce a very different sonic result than a violent and dramatic leg kick, since the size, weight and momentum alone would have different physical ramifications.
>
> (Winkler 1995: 2)

Winkler's insights come from many years of practice-based artistic research resulting in works such as *Dark Around the Edges* (1997), *Songs for the Body Electric* (1997) and more (Winkler 1998: 1).

Similarly, Palindrome (a performance group specialising in motion tracking technology) collaborated with Butch Rovan (computer musician) on the piece *Seine hohle Form* (2002) taking the goal of creating music based solely on bodily movement very seriously. In this collaboration, the choreography was influenced by the sound just as much as the movement

created the music. Thus, a blurring of roles took place between composer/choreographer and musician/dancer (Broadhurst 2007: 114).

As in all of their work, Palindrome considered issues of 'gestural coherence' to be paramount to the experience. Specifically, they were interested in exploring the perceptual coherence between sound and the movement that gave rise to it. Underscoring their efforts is a belief in the premise that 'an emergent integrity arises when the relationship between dance and music is believable' (Rovan et al. 2001: 3). For them, this credibility is founded on a perceptual coherence between sound and movement. A creative yet plausible transposition must occur between the physical inputs of an interactive music system and its musical output (Broadhurst 2007: 114).

Julie Wilson Bokowiec and Mark Alexander Bokowiec's article titled 'Kinaesonics: The Intertwining Relationship of Body and Sound' has also examined the relationship of the body with computer-driven music. In practice the development of their Bodycoder interactive music system resulted in a performance work titled *The Suicided Voice* (2005). The Bodycoder system featured a sensor interface worn on the body of a performer that wirelessly transmitted data generated by physical gesture to a software-based sound generation engine. In *The Suicided Voice*, the performer was required to generate vocal sounds, which were then 'processed and manipulated by the body' producing multiple 'voices' and soundscapes (Bokowiec and Bokowiec 2006: 52).

Out of this examination, they discovered that technologically mediated performance could reconfigure 'the experiences and sensations of the body' for the performer (Schroeder 2006: 3).

The intervention of technology into the space between body and world as tool, as prosthesis and as a medium, a 'virtual reality' for various forms of interaction in close proximity or at remote distance, has prompted the mind/body to develop new patterns of proprioception. Kinaesonic gestures made possible by the development of interactive technologies are opening the door to the possibility of new sensations and experiences.

(Bokowiec and Bokowiec 2006: 57)

Because such sensations and perceptions are new to the mind–body system, this novel form of constructed perception is actually experienced consciously (Bokowiec and Bokowiec 2006: 56). Since the perceptual events we most often encounter on a daily basis come and go via unconscious processes, such works that offer new conscious experiences of sensory reconfiguration are meaningful to our understanding of perceptual experience. One might even argue that such events could heighten experiences of the perceptual act in general.

Thus, with *Unless*, I wondered if my specific approach to technologically mediated performance could provoke the audience to be more consciously aware of their perceptual relationship to a dancer. By extension, I hypothesised that such awareness could also serve to enhance their experience of kinesthetic empathy. Since, in this case, the dancer would not be merely reacting to pre-composed music and imagery, but actively influencing its

production, one might feel those movements even more palpably. A more mindful awareness of virtually linked cross-sensory relationships could induce stronger empathic impulses and lead audiences to feel more fully the dancer's sound-producing movements. Such ideas have inspired the following work.

Overview of Unless

It seems that at this moment in time many people feel that our world is on a fast track towards utter collapse. If we do not attempt to connect with each other and our environment in a more empathetic way, this threat could quickly become an unshakeable reality. Thus, *Unless* became a meditation on this juncture in our collective human history. Structurally, the performance piece comprised three sections abstractly exploring this theme in relation to humanity's inherent connectivity versus the disconnect and chaos we often struggle with as we try to find a new balance between ourselves and with our environment.

An interactive multimedia environment approach to performance seemed appropriate to express some of these complicated relationships. At the same time, I was not intent on forcing explicit themes on the audience. I wanted the experience to be largely appreciated for its visceral qualities alone.

Overview of the interactive multimedia environment

With that end in mind, I designed the interactive multimedia environment to respond to the dancer's physical gestures by introducing connections between certain aspects of the movement and the media. The environment included two interactive music systems and one graphics system. The physical interface for the interactive systems consisted of two Nintendo Wiimote game controllers (one held in each hand by the performer). They were used to detect the motion of the dancer utilising their built-in accelerometer technology. The pitch, roll and overall acceleration data from the accelerometers proved to be the most useful for expressivity. In aviation or nautical terms, when a vessel pitches, the nose moves up or down, and when it rolls, the nose will tip left or right. Those movements were interesting for Emily to explore in relation to the interactive music systems.

I dubbed one of the systems the 'connected' interactive music system. The connected interactive music system was responsive and predictable for Emily to interact with. It also offered a varied sonic palette. The other music system was dubbed the 'chaotic' system. The response character of the chaotic system was more aggressive and indeterminate in nature. It was also sometimes rougher in texture when compared to the 'connected' system. The graphics system, which contributed significantly to the overall atmosphere and mood of the performance world, was designed to be directly reactive to the sonic elements of the piece. The system analysed sound in the performance environment and reacted according

to fluctuations in loudness. Thus, the dancer had subtle control over the graphics indirectly through sound.

Presenting *Unless*

In the following paragraphs I will describe the first version of the piece as it was performed, first in conjunction with Boston Cyberarts on 1 May 2009 at Grant Recital Hall (Brown University) in Providence, Rhode Island and later in a revised form on 1 November 2009 at the Machines With Magnets gallery space in Pawtucket, RI.

In its first iteration three projectors were used for a partial surround (frontal horseshoe shaped) graphics display, while a 5.1 speaker system offered surround-sound music and sound design. The piece comprised three continuous sections. This iteration of the piece ran about 17 minutes and 40 seconds total, with section 1 at 7 minutes, section 2 at 5 minutes, and section 3 at about 5 minutes and 40 seconds.

Section 1

The opening section of the piece emerged from Emily's movement experiments with the more 'connected' interactive music system. This section served to abstractly represent our capacity (as humans) for interconnectivity and empathy. Emily articulated this connection in post-performance reflections:

> In full improvisational mode a dancer must offer equal energy dancing as well as listening. This type of listening occurs in the full body, not just the ears. As I traveled through the first section, I was easily able to hear my impulses in sight and sound.
>
> (Emily Beattie on the 1 May performance)

These themes were further augmented with the graphics system providing an additional focal point for Emily's interconnectivity. The graphics system produced projected patterns that had the effect of representing an abstract energy field that Emily tried to connect with (Figure 14.1).

The interactive sound design for this section was meant to be both fluid and frenetic. I was pleased with how the sound of Emily's movement conveyed an almost electro-magnetic connection with her surroundings. The held interfaces (Wiimotes) helped to make the interactions believable as they provided a distinct locus of control, while the holistic impression of her connection to the environment remained a full-body movement experience. As Emily states:

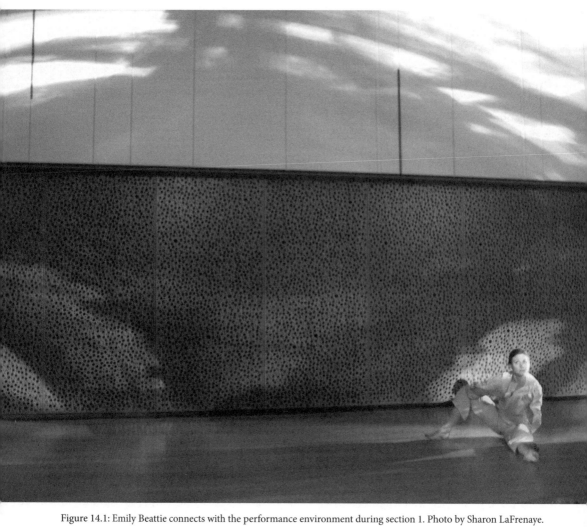

Figure 14.1: Emily Beattie connects with the performance environment during section 1. Photo by Sharon LaFrenaye.

The most satisfying movements that altered sound were twisting and spiraling from the spine to the arm that held the remote ... Although the remotes were located at the extremities of my body, I wanted to be sure that my most internal impetus activated them. Whether I was standing, leaning, curled up, or arched, the remotes were pulled along with my entire body in action.

<div align="right">(Emily Beattie on the 1 May performance)</div>

Emily's ability to navigate her connection to the media environment was compelling. Although she sometimes struggled to maintain her connection, as feelings of interconnectivity for all of us are indeed fleeting, this constant yearning for a bond forced a more 'in the moment' movement improvisation style. Rather than being dependent on an automatic gesture vocabulary, her movement was more a fluid reaction to the situational flux.

Section 2

The second section of the piece featured a pre-composed music piece, thus offering a respite, for both Emily and the audience, from the fully interactive media environment featured in section 1. In addition, this section allowed Emily to concentrate her focus on the audience (without needing to mind the physical interface) and construct an empathetic connection with them in a more emotional (rather than kinesthetic) way.

Conceptually, I wanted the section to reflect a sense of hope. For instance, by suggesting that the notion of realising a more enlightened connection among humans, and between humans and their environment is still possible. Thus, the music, now serving as an underscore element, rather than a diegetic source related to specific actions in the performance world, created a more dream-like atmosphere in concert with the projected light patterns (now much more ambient in nature). The sound design was most fluid and wave-like in this section with very gradual crescendos and swells of spectral brightness further augmenting the meditational nature of the scene.

Some interactivity between Emily's movement and a live input camera to the graphics system was also implemented in a subtle way, creating ghostly blobs of abstracted movement in the projected atmosphere. In addition, I performed manual control of the graphics system's brightness intensity, which allowed me to follow the music and Emily's movement with measured accents.

Section 3

The final section of the piece could be considered in two parts. The first part segued seamlessly from the final decrescendo of the set music piece into the static, jittery and quiet initialised state of the 'chaotic' interactive music system. The tense and ominous sound design of this moment underscored the transition to an audience participation segment. As Emily explains:

> I selected and spaced the audience members in an effort to engage them in the work. As the presentation mode shifted from proscenium stage to theater in the round, our hope was that the audience would perceive a connection to the work that was unfolding.
>
> (Emily Beattie on the 1 May performance)

After connecting to the audience with direct and focused body language, Emily's relationship to them undergoes a shift from connected and empathic to controlling and 'other'. Conceptually, I argue that this moment calls attention to the duality of intersubjective experience. Our ability to understand the experience of others in an empathic way also allows for manipulation.

Thus, this section represents the potential for a more ominous future, *unless* we decide to act with a collective wisdom at this juncture of our evolution, and fully embrace our capacity to connect with and understand 'others' and our environment. Hence, the title of the work reflects the precarious situation we are now faced with as a species.

After Emily selects and 'sculpts' the audience members on stage, the next transition unfolds with her returning to the physical interface and subsequently bursting into a more oppositional struggle with the 'environment' (Figure 14.2). Emily's relationship to the sound world of this section is very telling.

> As my energy was whipped up evermore, the sound responded with equally opposed force. I moved repetitively in reaction to the incessant sound. I felt overwhelmed by this section. Finally, I surrendered beneath its intensity.
>
> (Emily Beattie on the 1 May performance)

The projected world of the graphics engine is reduced to a faint residue at this point with the addition of abstract and minimal light design creating looming shadows of the human statues (selected audience members) and Emily's frenetic movements. As she wilts beneath the intensity of the sound world, the lighting fades to black and the music decrescendos into complete silence.

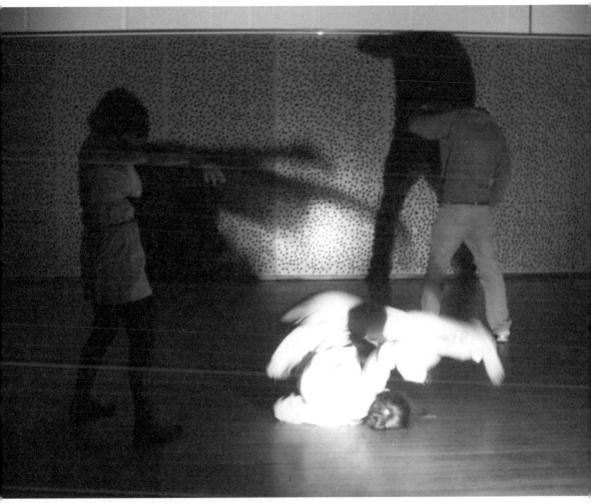

Figure 14.2: Emily Beattie struggles with her surroundings during section 3. Photo by Sharon LaFrenaye.

Unless v.2

For its second iteration at the Machines With Magnets gallery space in Pawtucket, RI, *Unless* ran about 16 minutes and 4 seconds total, with section 1 at 4 minutes and 40 seconds, section 2 at 5 minutes and 20 seconds, and section 3 at about 6 minutes and 4 seconds. By comparison with the first venue, this space was much more intimate and only offered floor seating. The non-traditional nature of the performance setting in conjunction with its spatial limitations created new challenges while also inspiring some unique and interesting aesthetic possibilities. It became clear from the start that the piece would need to be re-evaluated in relation to this new context including Emily's interaction with certain aspects of the media environment.

For instance, the new space and its more intimate character required some significant revisions in terms of media output. The audio system was scaled back and reconfigured for three outputs in an irregular triangle shape immersing the entire audience and performer. In addition, the graphics system was rearranged for two mirrored projection outputs in a V shape behind the performer, facing (yet still partially surrounding) the audience.

Thus, the most experientially impacting modifications were due to the spatial limitations of the gallery space, which now required the media elements to exist on a more equal vertical plane with the performer and audience creating a more sensually immersive atmosphere, especially for Emily. The projections were placed on bisecting walls at about head height this time. The fact that Emily could touch the projections made her connection to them more palpable. They also splashed more light on to her body allowing her to feel 'activated' more of the time. 'I was more actively in conversation more of the time' (Emily Beattie on the 21 November performance).

In addition, the gallery space offered less room for physical exploration. What resulted was an increased focus on the emotional life of her 'character'. With less room to move and decreased distance between her and the audience, expressive behaviours such as facial expressions and more nuanced body language could be more impacting. The spatial limitations actually augmented the potential for a more heightened dramatic experience.

That being said, many aspects of the piece in terms of basic structure and conceptual flow remained the same. Also, most of the interactive systems and interface mechanisms were unaltered, thus allowing Emily to continue developing her relationship with them.

Audience research

The first version of *Unless* was performed for over 60 people. The audience was surveyed right after the performance with a questionnaire asking them to describe their impressions. Over 50 audience members responded. Specific questions were designed to elicit responses related to their embodied multisensory experience of the piece, such as:

- How do you think the sound and imagery may have impacted your perception of movement?
- What aspects of the performance did you connect to?
- In your experience, what was the relationship, if any, of the sound, mover, and visuals?
- How do you think your perception of the movement would have changed if there were no music and/or visual component?

The second version of *Unless* was performed for about 30 people. Instead of being surveyed right after the performance, I gathered e-mail addresses and invited audience members to respond to an online survey (via surveymonkey.com), after the fact, using the same questionnaire format. Nine audience members responded within two weeks of the performance.

Although demographic data was collected, it would be interesting to attempt a more structured approach to the research in the future that might allow for deeper analyses of the relationships between levels of artistic experience (with the various media types involved) and perceptions of the event. Some of the responses pointed towards the existence of possible correlations between skill and experience levels in the artistic medium and the way in which attention was focused on specific aspects of the performance (e.g. those with advanced visual arts backgrounds were more focused and critical on the interactive graphics).

The contrasting post-performance research methods in May and November produced some interesting variations in audience feedback. The more immediate style of surveying in May elicited a greater percentage of responses overall. However, in November, although much smaller in number, those that did decide to respond were able to express their impressions in a more detailed manner.

In analysing the qualitative data I sought to organise statements made by the audience members according to specific research concepts that had shaped the nature of the project, particularly with regard to ideas surrounding multisensory interaction and kinesthetic empathy. This process was directed by the use of certain key words or phrases. At the same time, I permitted myself to be conscious of 'allowing categories to emerge from the data' and included these in my analysis (Richards and Morse 2007: 158). For instance, the category of 'audience participation' emerged from patterns of response highlighting that specific section of the piece. With these frameworks established, I could parse out the nuances of audience experience within each category.

In the following analysis, excerpted and anonymous quotes are categorised in relation to the three specific research-related concepts I identified: firstly kinesthetic empathy, followed by multisensory interactions and audience participation.

Kinesthetic empathy

As already mentioned, people observing any physical action have the capacity to internally simulate and relate to that movement. In analysing the data, I became sensitive to phrases

and words that could relate to the spectator's experience of kinesthetic empathy, such as 'feel', 'felt', 'movement', 'move', 'imitating', 'sympathizing', 'connected', etc. Overall, about 70 per cent of audience members surveyed during the first version of *Unless* responded with such terminology. For example, spectators' comments included:

- 'I felt small in a big place, shaking with Emily as I witnessed her movement. Wanted to move myself.'
- 'I was aware of myself imitating and sympathizing with the movements.'

These comments clearly suggest a physical engagement by the spectator with the movement of the dancer, a sense of wanting to move oneself perhaps in direct imitation or in more subtle physical sympathy. 'I felt small in a big place' also suggests a more general heightened awareness of physicality, something present in other comments, such as: 'The performance was exciting. It made me feel sharp and awake ... I felt movement in the room and I felt energized.'

Another spectator reported how their own body interiorised not the literal movements of the dancer, but rather a sense of tension and muscular effort:

- 'I liked the tension between the sound and movement – I felt like the sounds gave a special tense quality to Emily's movements, as if I could feel the tightness in her muscles, just watching.'

Interestingly this quotation also makes the connection between kinesthetic empathy as a felt response and the performance's exploration of the relationship between sound and movement. Other spectators made this same connection:

- 'Felt connected to the dancer, consistently. It's the opposite of a "typical" dancer responding to music, the dancer seemed to be creating the sound.'

This theme will be developed further in a moment. First, however, it is worth noting that impressions of kinesthetic empathy in the November audience seemed less explicit, yet more connected to other aspects of the performance. So comments similar to those explored above were present, such as:

- 'Very interesting. I definitely felt movement while viewing the performance. The sound and movement created a very visceral experience.'

However, on the whole, I surmise that the web-based survey meant that such immediate, physical and felt responses started to dissipate, with the time for more thinking allowing instead for a holistic experience of the piece to emerge, which gave rise to more nuanced responses that transcended impulses to answer the questions quickly and directly. For

instance, in some responses the awareness of a sensory gestalt emerged, evoking commentary on how raw sensations could give way to higher level thoughts about form and vice versa.

- 'I felt very surrounded. It was an entire sensation, yet was focused in direction. Sometimes this could be overwhelming … when this occurred the continuity of the piece was stressed.'
- 'The sound and imagery added to the movement of the dancer. I connected to the part when Emily was dancing around the 4 people, it seemed like they had negative energy and she didn't want to absorb that into herself … Without the music or visuals, the piece would not have made as much of an emotional impact. Without the dancer it would have appeared to be technologically interesting, but more abstract.'

The connections that are being made here between the mover, sound, visuals and the spectator's experience clearly link directly to one of the central themes of the project, which was the construction of an interactive multisensory environment.

Multisensory interactions

In developing this project, I speculated that a movement-activated multimedia performance environment could enhance such impressions of kinesthetic empathy in the audience through the close aligning of movement with their other sensorial experiences. As already seen in the responses above, the audience research questionnaire was able to tap into some of the audience's perceptions of the dancer's relationship to the multimedia environment and their experience of the technologically mediated multisensory interactions taking place. For instance, the music/sound and movement relationships seemed to be the most palpable, as illustrated by some of the following quotes responding to the first version of *Unless*:

- 'The music added a dynamic edge to her movement.'
- 'The movements would not have alerted me without the sound.'
- 'If the sounds were indeed generated live with the white remotes, then it is a new way of amplifying movement … like a human synthesizer.'
- 'The movement was dramatic and was intensified/amplified/focused by sound.'
- 'The dance/sound combination was the most beautiful and the best (most synergetic) combination.'

One person, however, speculated that prior knowledge of the physical interface's relation to the multimedia environment was necessary for comprehension.

'I really think that some explanation is needed for the audience, as I heard a lot of feedback that if one hadn't known previously about how the Wiis worked, they would have been frustrated and lost.'

Based on the feedback in May and my knowledge of the audience in November, I know that the majority in attendance were not privy to the mechanics of the interaction and still reacted very positively to the experience. My general conclusion is that the piece did not require a verbal explanation of the technologies involved in order to be appreciated. For instance, audience members experiencing version two articulated the following:

- 'The machine and the dancer were remarkably synchronous in intention. She moved in a way that was totally believable, the lines blurred.'
- 'The performance was great! I think all 3 components (music, dance, video) complemented each other very well. If one element were missing it would have felt less intense. I really enjoyed how the movement affected the sound.'
- 'The music and movement and visuals were very tightly integrated.'
- 'Connections between movement/dancer-expression, projected images and sonic elements were very strong. Abrupt movements translated to abrupt sonic/imagery changes. Subtle-to-subtle as well.'

It seems that the audience was engaged by the way in which the elements interacted. It also seems that perceived multisensory interactions not only impact the aesthetic experience of an audience, but also could enhance kinesthetic empathy due to the increased awareness of motion-activated responses in the multimedia environment. Statements above that highlight the music's 'added' and 'amplified' effect on the perception of movement suggest that the audience's experience may have been heightened in this regard.

What is most remarkable about the spectator responses is how often the coherences between the movement, sound and visuals were mentioned. Words like 'synergetic', 'synchronous' and 'integrated' all highlight this fact. It seems that people's judgements regarding the work's efficacy often correlated with their perceptions of how well the various components of the experience were integrated. Also, the nature of the interactive technology, with the soundscapes responding to the dancer's movement, most likely emphasised the 'liveness' of the occasion in a manner that increased audience attention and awareness of their perceptions.

Audience participation

One aspect of the piece that created anxiety for Emily and me was the audience participation segment. We were not sure how the audience would react to being brought up on stage and sculpted (at least those we did not invite to participate beforehand!). In the end, this segment served as an integral structural element, which seemed to reinvigorate the room for the final moments of the piece. For some of the audience members it may have actually been one of the most engaging moments of the performance as evidenced by these remarks regarding version one:

- 'I connected especially with the audience section.'
- 'I really liked the audience participation. It helped me feel more connected to the performance.'

Repeated use of the word 'connected' in addition to some obvious emotional reactions like 'My blood pressure went up' and 'I felt fear' in response to the threat of being chosen for participation most likely added to feelings of connectedness, also enhancing the audience's experience of 'being in the moment'.

Reflections

Overall, I believe that both versions of the piece were successful in offering a dynamic aesthetic experience that stimulated those in attendance to actively engage in processes of reflection regarding the novel sensory experience they were presented with. Whether or not the work actually enhanced perceptions of kinesthetic empathy for those in attendance, however, is not clear. In fact, there is no way to confirm such a hypothesis without a baseline experience for comparison. This is one area where my approach to the qualitative artistic research fell short. Based on the detail of the anecdotal evidence offered, future collaborations with other scientific and/or artistic researchers may be warranted in order to investigate this further.

However, it is safe to conclude that a majority in attendance walked away from the performance feeling as if their mind had been exercised in a new and exciting way. For instance, the audience's experiences of the dancer's interactions with the sound and visual elements of the interactive media environment were extremely vivid. Such lucid impressions indicate a heightened awareness of the cross-modal interactions taking place. Overall this exploratory arts research project provides concrete anecdotal evidence supporting future investigations into the effects of interactive multimedia performance environments on the audience's experience of kinesthetic empathy.

References

Bennett, D. (2008). 'Don't Just Stand There, Think'. *The Boston Globe*. Available at: http://www.boston.com/bostonglobe/ideas/articles/2008/01/13/dont_just_stand_there_think/.

Bokowiec, J. W. and Bokowiec, M. A. (2006). 'Kinaesonics: The Intertwining Relationship of Body and Sound'. *Contemporary Music Review*, 25 (1): 47–57.

Broadhurst, S. (2007). *Digital Practices: Aesthetic and Neuroesthetic Approaches to Performance and Technology*. UK: Palgrave Macmillan.

Brouwer, J. and Mulder, A. (eds) (2007). *Interact or Die: There is Drama in the Networks*. Rotterdam: NAi Publishers, 52–69.

Gallese, V. (2005). 'Embodied Simulation: From Neurons to Phenomenal Experience'. *Phenomenology and the Cognitive Sciences*, 4 (1): 23–48.

Gazzola, V., Aziz-Zadeh, L. and Keysers, C. (2006). 'Empathy and the Somatotopic Auditory Mirror System in Humans'. *Current Biology: CB*, 16 (18): 1824–1829.

Godøy, R. (2003). 'Motor-Mimetic Music Cognition'. *Leonardo*, 36 (4): 317–319.

Hagendoorn, I. (2004). 'Some Speculative Hypotheses about the Nature and Perception of Dance and Choreography'. *Journal of Consciousness Studies*, 11: 79–110.

Hansen, M. B. N. (2006). *Bodies in Code: Interfaces with Digital Media*, 1st edn. New York, USA: Routledge.

Krueger, M. (1993). 'An Easy Entry Artificial Reality'. In A. Wexelblat (ed.), *Virtual Reality: Applications and Explorations*. Boston, MA: Academic Press Professional.

Lahav, A., Saltzman, E. and Schlaug, G. (2007). 'Action Representation of Sound: Audiomotor Recognition Network While Listening to Newly Acquired Actions'. *J. Neurosci.*, 27 (2): 308–314.

Leman, M. (2007). *Embodied Music Cognition and Mediation Technology*, 1st edn. Cambridge, MA: The MIT Press.

Massumi, B. and Mulder, A. (2007). 'The Thinking-Feeling of What Happens: An Interview with Brian Massumi'. In J. Brouwer and A. Mulder (eds) *Interact or Die: There is Drama in the Networks*. Rotterdam: NAi Publishers, 70–91.

Merleau-Ponty, M. (1962). *Phenomenology of Perception*. London: Routledge & Kegan Paul.

Mulder, A. (2007). 'The Exercise of Interactive Art'. In J. Brouwer and A. Mulder (eds), *Interact or Die: There is Drama in the Networks*. Rotterdam: NAi Publishers, 52–69.

Richards, L. and Morse, J. M. (2007). *Readme First for a User's Guide to Qualitative Methods*, 2nd edn. London: Sage.

Rizzolatti, G., Sinigaglia, C. and Anderson, F. (2008). *Mirrors in the Brain*. Oxford, UK: Oxford University Press.

Rovan, J., Wechsler, R. and Weiss, F. (2001). 'Seine hohle Form: Artistic Collaboration in an Interactive Dance and Music Environment'. In 1st International Conference on Computational Semiotics in Games and New Media. Amsterdam, The Netherlands.

Schroeder, F. (2006). 'Bodily Instruments and Instrumental Bodies: Critical Views on the Relation of Body and Instrument in Technologically Informed Performance Environments'. *Contemporary Music Review*, 25 (1): 1–5.

Winkler, T. (1995). 'Making Motion Musical: Gesture Mapping Strategies for Interactive Computer Music'. In *Proceedings of the 1995 International Computer Music Conference*. Banff Centre for the Arts, Canada, 261–264.

Winkler, T. (1998). 'Motion-Sensing Music: Artistic and Technical Challenges in Two Works for Dance'. In Proceedings of the 1998 International Computer Music Conference. San Francisco. CA: Computer Music Association. http://www.brown.edu/Departments/Music/sites/winkler/research/papers/motion-sensing_music_1998.pdf. Accessed 11 May 2011.

Chapter 15

Kinesthetic Empathy Interaction: Exploring the Role of Psychomotor Abilities and Kinesthetic Empathy in Designing Interactive Sports Equipment

Maiken Hillerup Fogtmann

In this chapter I discuss the process of designing prototype sports training equipment, which requires players to respond using psychomotor abilities and kinesthetic empathy. I propose principles for designing new types of interactive equipment that take into account the bodily co-presence of others sharing in a collective kinesthetic experience.

This work takes place in the interdisciplinary field of interaction design where researchers and practitioners from disciplines such as computer science, humanities, engineering and design collaborate on joint projects and contribute diverse sets of knowledge within the same community (Rogers 2005). The field is rapidly growing, with the escalation of available technologies expanding the possibilities for designing new types of interaction. So far, the interaction design community has focused primarily on making interactive systems and interfaces oriented towards personal use, for example in ubiquitous computing.[1] Designing interactive systems to be collectively shared (Petersen and Krogh 2008) means that the participants have to negotiate, fight and communicate in order to create their joint experience mediated by interaction with the system.

In designing interactions where the body is a key factor, not only in the interaction but also in designing the collective user experience, sport has become an obvious choice of domain, since here bodily actions and reactions are paramount. It is especially profitable to look at open sports,[2] which are types of sport where the athlete's performance is highly dependent on how the opponent and possible team members allow him or her to play, as opposed to individual sports (e.g. swimming) where interactions between the participants are kept to a minimum. In open sports, athletes make use of psychomotor skills, which are motor skills practised in an unpredictable and ever-changing environment that dictates how and when the skills are performed. Kinesthetic empathy is brought into play when movement actions of others are interpreted and anticipated, using knowledge based on past training and one's own kinesthetic experiences.

Research on both psychomotor abilities and kinesthetic empathy has formed the theoretical foundation for the design of TacTowers, a new type of interactive training equipment that builds upon and cultivates kinesthetic relations. In training with TacTowers, a kinesthetic connection is formed between the interacting athletes, encouraging them to train their ability to recognise and respond to movements made by others. By encompassing the interactive element inherently present in open sports, TacTowers aims at training a combination of stamina and psychomotor skills. The system allows the players, through strenuous exercise games, to practice their decision-making skills without necessarily being concerned with performing certain skills correctly. Furthermore, it exemplifies the potential

for developing a new type of technology-enhanced system by incorporating considerations of kinesthetic empathy into the design. In their interactions with each other, mediated by the system, the players collectively construct their joint kinesthetic experience, thus establishing a kinesthetic connection comparable to that of two athletes either competing or collaborating. In such a system, as within open sports, the choice of which action to apply in a given situation is defined by the actions of the other participants.

In the following discussion I shall first explore the psychological aspect of human motor skills in the context of open sports, and then make connections with kinesthetic empathy. These connections led to the development of kinesthetic empathy interaction, a new direction within interaction design, which underpins the TacTowers prototype. To operationalise this new type of interaction in future design, five design aspects are introduced: decision-making, anticipation, degree of difficulty, interpersonal feedback and system feedback. In designing artefacts, installations and spaces based on the concept of kinesthetic empathy interaction (defined below) the focus is on the user's relation to the other interacting participants, as well as stimuli from the surrounding environment, which can affect the movements generated through technology-enhanced interaction with sports equipment such as TacTowers. The aim is to develop the participant's awareness of their own body and their kinesthetic perception of the other player(s)' body in motion, and of how these elements relate to and influence each other.

Mind the body – psychomotor abilities

The way we perform actions and the choice of activities that we engage in are highly dependent on the neurological feedback we receive from the body. We use sensory feedbacks to determine an adequate response to our surrounding environment, such as the way we use sight in order to know when to stretch out our arm to catch a ball (Thompson 2004). Psychomotor skills involve organised muscle activity in response to stimuli from the environment (including teammates and opponents) and are complex movement patterns that have to be practised (Czajkowski 2006). They are often placed on a continuum from 'closed' to 'open'. While closed skills, such as a tennis serve, are predictable and usually internally paced, open skills are externally paced and characterised by adapting to unpredictable aspects of an ever-changing environment. The environment controls the rate of performing the skill and the athlete must pay attention to external events in order to control his/her rate of movement (Allard and Starkes 1991). Psychomotor skills, such as tactics, anticipation and deception involve production of motor actions but also the recognition of environmental conditions that trigger actions (Fadde 2010; Coh et al. 2004).

To gain a practical understanding of the notion I turn to sports. For a soccer player to excel at the game, it is not enough for him to be able to kick the ball precisely or kick it hard. He also needs a sophisticated insight into the game – an ability popularly known as 'reading the game'; in sports science this is referred to as decision-making. The soccer player needs

continuously to decode and react to his teammates' and opponents' movements around the field and from these choose an adequate response (Baker et al. 2003; Jackson et al. 2006). It is not only vital to know how to execute a certain action but also to know where and when to apply it (Czajkowski 2006). When the performance of an athlete is dependent on how the opponent allows him or her to play, the ability to recognise the right time to attack becomes of great importance and is a key element in psychomotor learning. An athlete may wait for such an opportunity to arise, or try to create a suitable situation for him/herself by utilising carefully chosen and executed preparatory actions (Czajkowski 2006; Flynn 1996).

In TacTowers, through a discovery learning process utilising the principles of kinesthetic empathy interaction, players are encouraged to find and assemble their own unique solutions to the task at hand. Through the learning process, the athletes are able to concentrate on exploring potentially important new sources of input and solutions to ever-changing tasks, as opposed to satisfying demands prescribed by the coach. There is little intervention from the coach, whose role is to manipulate constraints in a given exercise in order to facilitate the discovery of functional actions by the athlete. Constraints are to be understood as boundaries, which influence the expression and form of action employed by the athlete. When given a clear set of goals and left to themselves, most learners can be very resourceful in finding appropriate solutions (Davids 1998; Davids et al. 2003). Instead of the movement of the body being dictated by a coach, game rules or sports training equipment, the interaction is designed in a way that allows the person to freely explore the potentials inherently present within the body. This enables the athletes to explore how to adapt, refine and assemble existing basic coordinative structures in order to increase flexibility in behaviours (Davids et al. 2003). The process will ultimately improve the athlete's ability to recognise and take advantage of the appropriate situations, which requires the practice of kinesthetic empathy as well as psychomotor skills.

Designing interactive systems, where the interactive experience is co-created by the participants and meaning is constructed through their human-to-human interaction, requires the users to relate kinesthetically to one another. When the kinesthetic experience is collectively constructed through bodily engagement, the notion of kinesthetic empathy becomes a relevant consideration in the system design.

Perception, anticipation and kinesthetic empathy (with Dee Reynolds)

Most commonly empathy is understood in emotional terms, as a rapport where a person identifies with or has an understanding of another person's situation, feelings and motives. By contrast, dance ethnologist Deidre Sklar (1994) describes *kinesthetic* empathy as a contraction between kinesthesia and empathy, meaning 'the capacity to participate with another's movement or another's sensory experience of movement … it is a translation capacity that we all inherently possess' (Sklar 1994: 15–16). This, then, is empathy with another's movement, rather than with their emotions. Sklar recognises kinesthetic empathy

as a skill involving bodily memory and bodily intelligence and as a process of recognising kinesthetically what is perceived visually, aurally or tactilely.

Seeing a movement being performed by others, our body has some capacity to know that movement from the inside, through the subtle motor activity that can occur in our own body as it watches another person's movements. This form of 'seeing' is so quick that we are even able to respond to movement intent in others. These so-called pre-movements contain information about the postural schema and perceptual orientation produced when the body organises itself before it moves (Frank 2008). According to Frank,[3] it is through kinesthetic empathy that we use our peripheral vision to both see and feel movement. Similar arguments are made by psychologist Ernest G. Schachtel (1967) who asserts that in kinesthetic perception involving empathy, induced by visual perception of movement, the person observing the movement ceases to remain a mere outsider registering what goes on. Instead, he experiences in himself the kind of kinesthetic sensation that he would have felt had he been in the other person's place. The nature of the kinesthetic sensation felt is a product of the observing person's past experiences and life history unique to him. The empathic part of this experience is the sensation in one's own body of the movement, tension or posture seen in the other person (Schachtel 1967).

In *Choreographing Empathy: Kinesthesia in Performance* (Foster 2011), choreographer and dance scholar Susan Leigh Foster explores kinesthesia in relation to empathy and perception. Experiments have shown that mirror neurons in monkeys are activated both when a gesture is being made and when it is merely observed (Gallese et al. 1996). Foster discusses neuroscientist Vittorio Gallese's argument that as a result of mirror neuron activity, given the right context, observed movements can produce a physical 'resonance' or internal motor representation in the observer. This resonance (which could also be described as an empathic internal simulation of observed movement) is responsible for our 'ability to predict the actions of others, and to know what will result if we move in a certain way' (Foster 2011: 165). The research on mirror neurons indicates, as argued by Berthoz (Berthoz 1997; Foster 2011), that the brain is able to simulate movement actions and from the simulation choose the most adequate response. Foster also discusses Ivar Hagendoorn's account of the anticipatory function of mirror neurons and its role in watching dance. Hagendoorn argues that the viewer anticipates the trajectories of movements observed, and he compares this with sporting situations (Hagendoorn 2004). According to Hagendoorn, anticipation of the other's movement comes about when visual perception activates pre-motor areas of the brain, causing the observer to respond as if they themselves were about to move.

This means that there is a close relationship between kinesthetic empathy and anticipation of movement – it is our internal, empathic resonance with the other's movement that leads us to anticipate their movement trajectory. The ability to predict others' actions therefore involves a process of motor simulation or kinesthetic empathy as a 'translation' of observed actions into one's own motor system. One is not simply observing another's movement, one is reproducing it in oneself and thereby anticipating the next step as it were – it is because one is doing it with the other person (through pre-movement) that one can read the opponent

and, to a certain degree, foresee what the next move might be. Based on this information, a decision is made about what to do next. This ability to 'read the play' is essential in open sports where the speed of the game means that decisions must typically be made in advance of an opponent's action. This gives the athletes additional time to formulate and execute an appropriate response in order to counter the intentions of opponents (Williams et al. 2010). For instance, to know how and when to make the perfect pass that ultimately will place a teammate in a favourable position, a soccer player utilises psychomotor skills, which involve the predictive function of kinesthetic empathy, and also learned experience. Seeing allows us to know the movement of another from our own body's sensory experience and to make interventions informed by internal information (Frank 2008).

Specific anticipation skills differ from sport to sport and range from very simple ones such as predicting the bounce of a ball to the more complex ability to read the play sufficiently well to counteract, for example, a fast-paced ball hit by an opponent disguising his actions (Flynn 1996). In the one-on-one combat situation in open sports, such as handball and basketball, the attacking player has to get the ball past the defending player in order to score a goal. In doing so the attacking player will often try to make use of deceptive actions to gain advantage. Deceptive actions, such as feints, are cues that signal one action when another is actually intended. The aim of deception is to provide misleading information that ultimately will encourage opponents to make a wrong judgement (Jackson et al. 2006). According to Jackson (2006), it is reasonable to assume that there is a clear conceptual link between anticipation and deception. When expert athletes are good at anticipating the actions of others, the opponents will try to counteract this by trying to disguise their actions utilising deceptive actions or by minimising the availability of the movement information by the delaying the onset.

Kinesthetic empathy interaction (with Dee Reynolds)

In interactive systems promoting kinesthetic empathy interaction, the kinesthetic experience is defined by the interplay between the participants as mediated by the system. This is a new approach to designing interaction that cultivates and builds upon kinesthetic relations between two or more co-located people. The aim of systems facilitating kinesthetic empathy interaction is to provide a means to enable participants to achieve a shared goal either by collaborating with or working against one another. For kinesthetic empathy interaction to be successful the participants have to come to an understanding of others' actions in collectively creating the kinesthetic experience through collaboration, opposition or a combination of these.

While psychomotor abilities provide a physiological framework for designing interactive situations, where the participants' choice of action is influenced by environmental conditions, considerations of kinesthetic empathy guide design decisions on how participants interact with each other. The concept of movement anticipation links the two notions and established

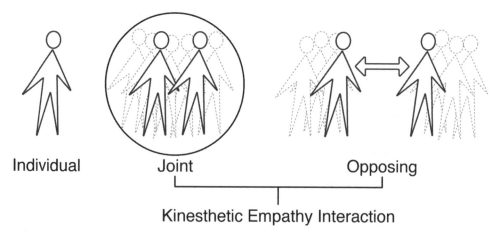

Figure 15.1: Kinesthetic Empathy Interaction.

the foundation for outlining new types of interaction design models that build upon and cultivate kinesthetic relations of multiple co-located participants mediated by an interactive system.

Gréhaigne et al (1999) defines four different tactical notions in team sports: opposition to opponents, cooperation with partners, attack on the opposing camp, and defence of one's own camp. It is possible to roughly divide these types of bodily interaction into three categories: individual, joint and opposing; the last two are variations of kinesthetic empathy interaction.

Individual kinesthetic interaction is where one person interacts with a space or an artefact. The single use of BodyBug is an example of design based on this type of interaction. BodyBug (Moen 2006) is a small box that detects movement and responds by moving up and down a metal wire attached to one user or suspended between two users. The idea of the prototype is for the people interacting with BodyBug to be inspired by its movements and to respond by generating new and otherwise unexplored movements. By utilising the body's capability to engage in bodily interaction, the user is invited to explore and challenge their body through a kinesthetic experience based on movement input (generated by the user) and movement output (generated when the BodyBug moves up and down the string: Moen 2006).

Joint kinesthetic empathy interaction is where two or more people collaborate to reach a common goal. In this type of interaction, it is crucial for the players to be able to relate to the co-participants in order to build upon their actions.

Opposing kinesthetic empathy interaction is where two or more people battle against each other to reach the same goal. Tactics play a huge role here and this is the most complex of the three types of interaction as it embodies all of the tactical notions defined by Gréhaigne (1999). The players not only have to focus on the goal but also thwart the opposite player

or players. It is crucial for the players to be able to indicate intent without the signals being intercepted by the opponents.

Both joint and opposing kinesthetic empathy interactions promote an increased sensibility to other people's movement intentions and actions. The way players choose to interact is directly influenced by the actions of others. In this type of interaction, the environment is continually changing, which then forces the people engaged in the interaction to change with it.

The five design principles described below all draw on notions of psychomotor abilities and kinesthetic empathy and are informed by the concept of kinesthetic interaction as well as by the sporting context. They aim to create an interactive system where the primary interaction is between the users and where the interaction with the artefact, installation or space becomes secondary, as in TacTowers. In this interactive training equipment the athletes are placed face-to-face to give them the possibility of reading and responding to each other's movements (a full description of TacTowers can be found later in this chapter). The overall object of psychomotor ability is to organise muscle activity in response to stimuli from the environment by combining several of these skills at the same time. TacTowers facilitates the athletes' interaction through different games, but which action to apply and when to apply it is left up to them. When designing according to the principles of kinesthetic empathy interaction, the aspects below should be taken into consideration. This is not to be understood as the finalised list but should rather be seen as design concerns that are known at this point in time. As kinesthetic empathy interaction grows and migrates into different contexts, more elements are bound to follow.

Decision-making – To encompass the body as a whole, the installation or artefact frames the kinesthetic experience by encouraging the use of several movements, or their combination, as input into the computer system. This design aspect is inspired by discovery learning and promotes the idea that the participants' decision of which action to apply and where and when to apply it is primarily dependent upon other people's engagement with the system.

Anticipation – It is used to read the other participants and, to a certain degree, try to foresee what their next move might be. Based on this information, a decision is made about what to do next. This ability to 'read the play' is essential in systems where the speed of the game means that decisions must typically be made in advance of an opponent's action. This gives the participants additional time to formulate and execute an appropriate response in order to counter the intentions of opponents. Kinesthetic empathy involving anticipation of the movement intentions of others enhances psychomotor skills.

Degree of difficulty – By letting the degree of difficulty be controlled by the users' growing skills, the system functions as a frame for the interaction rather than controlling it. In much the same way, a ball facilitates a game of soccer, but how well each individual is allowed to play is determined both by teammates and opponents. This design aspect stems from open

sports where the athletes' skills continuously grow as they invest more and more time in training through the system.

Interpersonal feedback and system feedback – Within the field of human–computer interaction, feedback traditionally refers to the response given to the user by the interactive system. By designing interaction that builds on the concept of kinesthetic empathy, the interpersonal relations between the participants are highlighted, thus de-emphasising the interaction with the computer, which in turn gives room for pivotal feedback promoted through the human-to-human interaction. *Interpersonal feedback* refers to the instant feedback provided by the other participants in their joint interaction with the system. By learning how to read, react and build on the actions of teammates and opponents, the users will slowly reach an understanding of what works and what does not work in a given situation, much in the same way as an athlete gradually learns which actions work on a given opponent in a given situation. *System feedback* on the other hand is given by the computer and refers to feedback from the interactive system, for example, lights flashing or a score, which can explicitly tell or show the users how well they are doing by, for example, giving them a score or showing them in which areas they need to improve. </List>

Catch me if you can… – The interactive training equipment, TacTowers

The interactive prototype, TacTowers, implements the idea of designing a new and engaging type of sports training equipment that facilitates athletes in training psychomotor skills, such as anticipation and decision-making.

As part of an ongoing project on how to integrate IT in sports, the research team at Interactive Spaces, a research centre, in Aarhus, Denmark, which combines computer science, engineering and design (www.interactivespaces.net), has been looking at handball to uncover the potential of utilising interaction design in sports. Handball, also known as team handball or European handball, is an open sport where two teams of seven compete by defending or attacking a goal at either end of a field. It is a fast-paced game, where ball possession changes quickly and goals are scored frequently. The sport was chosen for the study because it is one of the highly open sports where close body contact is allowed and where it is crucial for the athletes to be able to choose an adequate response in a continuously changing environment.

In handball, as with any sport that includes both teammates and opponents, an important element is interpreting the movements of the other players in order to make informed decisions on how to respond. In the one-on-one confrontation between a defending and attacking handball player, being able to anticipate how the other person is going to act may give an attacking player the needed advantage to get past the defender or give the defender the time needed to stop him. TacTowers provides the athletes with the opportunity to train the one-on-one confrontation, which continuously occurs in handball, without having to

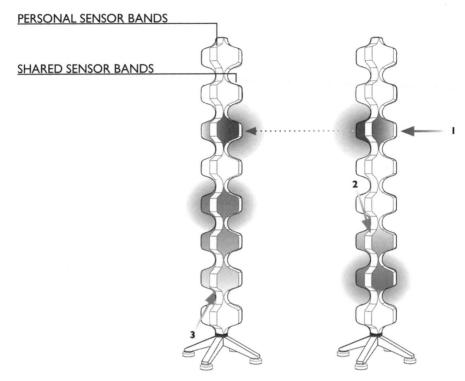

Figure 15.2: TacTowers – shows how hitting the touch sensor will send the light signal in different directions.
1. By hitting the middle sensor the light moves horizontally in the direction it is hit onto another tower.
2. By hitting one of the top sensors the light is moved down the tower.
3. By hitting one of the bottom sensors the light moves up the tower.
Illustration: Majken Kirkegaard Rasmussen

relate to other parameters of the game at the same time. The training equipment specifically targets training of psychomotor skills involved in reading, decoding and reacting to movements made by an opposing player, and it does so by involving kinesthetic empathy.

Instead of having one player train with a computer, two players are competing with each other through a distributed and see-through interactive surface formed by four TacTowers. By having two players placed on opposite sides of the equipment, the interactive element of sport is reintroduced in the equipment and this allows the players visual contact, thus reinforcing their kinesthetic empathic relations. Decision-making is practised due to the fact that the movements produced by the equipment are generated through the interaction accruing between the players and which action to apply in a given situation is always determined by what the other participant chooses to do.

The TacTowers prototype consists of four towers (2.25 m tall), each made up of eight plastic balls stacked on top of one another and held together by a steel rod. Each ball is a little larger than an actual handball and functions both as interaction surface and a display that can light up

in numerous colours. Twelve touch sensors are placed in four bands running down the sides of the towers. Hitting a touch sensor placed at the top or bottom of a ball sends the light signal up or down a TacTower (see Figure 15.2). Hitting a lit ball horizontally will send the light signal in the direction of the hit onto another tower, depending on how hard the ball is hit.

When placing the towers on a line, a distributed display and interaction surface is formed, thus separating the two players and minimising the amount of physical contact (see Figure 15.3). This set-up calls for traditional sideways movement as seen in handball and split-vision is trained due to the fact that the players not only have to focus on the opponent but also on the digital movements displayed in the equipment.

During the conceptualisation process, a range of game plays were developed and more will come as the prototype evolves. The game 'Blocker' is an example of a gameplay that illustrates opposing kinesthetic empathy interaction design principles (see Figure 15.3). In 'Blocker' the emphasis is on tactical understanding. One player (B) controls the 'ball' represented by a red light signal, and his objective is to move it into a goal zone (the green light signal). The opposing player (A) uses two 'blockers' (blue lights) to defend the goal zone and corner his/her opponent (see Figure 15.4). In this game the players continually have to anticipate the actions of the opponent, think ahead and plan what to do next to either obstruct the attacking player from reaching the goal or to keep him from hitting the blocks placed by the defending player.

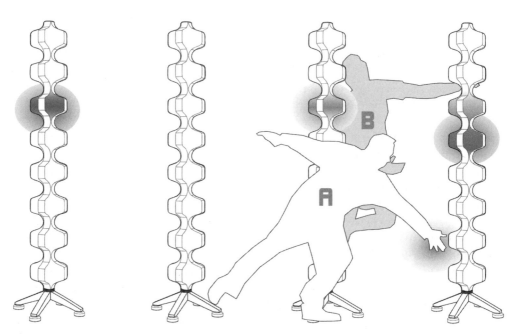

Figure 15.3: TacTowers – illustrates the game of blocker. Player A is about to place a block to obstruct the intentions of player B. Illustration: Majken Kirkegaard Rasmussen.

Figure 15.4: Two handball players are playing a game of "Extinguish" on the TacTowers prototype. The first player to hit the white lights that randomly light up, wins the point. The player who reaches 7 points first wins the game. Handball players: Jakob Thoustrup and Kasper Larsen Photo: Kaj Groenbaek

The TacTowers create and facilitate a playing field of interaction where the movements made by one player can be decoded and utilised as a ground for deciding which action to apply next. When interacting through TacTowers, the opponent's precise movements are so important that feints can be made by pretending to hit the ball in one direction and then in a split-second change direction. The athletes need to respond kinesthetically and empathetically as discussed above, in order to anticipate the position, direction and speed of the 'ball' while using split vision skills to constantly monitor the opponent. Initial tests have shown that when first trying this type of training equipment, the players are concentrating on the lights moving around the TacTowers and on hitting the right sensors. But over time focus will move from the equipment to the other players' actions, as is the case, for example, when playing a game of soccer. Here skilled players do not have to look at their feet to know where the ball is, they can just 'feel' it. Focus is instead on the other players' movements around the field. To excel in the exercises practised through TacTowers, it is necessary for the players to think ahead of the game. It is not enough to act in an instant; they need to have a strategy that goes two or three plays into the future, otherwise they will continually be one step behind. This strategy will of course be ever-changing depending on the actions of the opposing player. Tactics become a part of the game, because the players are able

to thwart each other by reading the intent of the opponents' actions and blocking them. Instead of only having one player interacting with the computer, the computer is used to stimulate opposing kinesthetic empathy interaction between two players. The computer is not dictating where and when the player should or should not strike; this is now decided by the actions of the opponent.

Through discovery learning, the players are exploring their bodily potentials and finding creative solutions to the task at hand. The degree of difficulty is based on how well each player performs. Implicit feedback is given through the game by the athletes figuring out which action works best on the opponents in a given situation. The computer will be able to analyse the data and give the players an indication of their improvement by giving system feedback on reaction time and showing which areas of the playing field the players are overlooking or when they are taking too long to react. By employing the design principles of kinesthetic empathy interaction, the TacTowers is constructed to include the interactive element inherently present in sports where psychomotor abilities and kinesthetic empathy are of considerable significance.

Conclusion and future work

The combination of kinesthetic empathy and psychomotor abilities is new to interaction design. The interplay between the two provides a basis for the design of interactive sports training equipment, which foregrounds the predictive function of kinesthetic empathy in developing users' psychomotor skills.

In systems designed based on kinesthetic empathy interaction, the primary interaction is between the participants, and consequently the interaction with the system (e.g. the interactive-artefact, installation or space) becomes secondary. Basing interaction on kinesthetic empathy implies facilitating human-to-human interaction, where it is crucial to be able to read, react and build on each other's movements, thus encouraging a kinesthetic empathic connection.

Two types of kinesthetic empathy interaction have been presented here. Both joint and opposing kinesthetic empathy interactions frame a kind of kinesthetic interaction that takes into consideration the users' kinesthetic empathy. The design principles of kinesthetic empathy interaction have been exemplified in the context of sports through the design prototype, TacTowers. Here it is shown how these principles can be applied when designing new types of sports equipment.

Future work on this research topic includes further testing of the TacTowers prototype and the development of new games. In addition, a new prototype aimed at play environments is under development. The two cases combined will provide feedback on how the theoretical framework works in 'real life', real domains and in the hands of real people. As described earlier, humans explore and experience through the body, and designing for these new contexts will further develop the concept of kinesthetic empathy interaction design, thereby also helping to expand understanding of kinesthetic empathy.

Acknowledgements

I would like to thank Dee Reynolds for providing essential feedback in writing this article. Furthermore, I would like to thank the iSports research team and my supervisors Kaj Grønbæk and Peter Gall Krogh, for their work and inputs in the project. This work has been supported by Center for Interactive Spaces and the Aarhus School of Architecture.

Notes

1. Ubiquitous computing denotes the idea of computers in everything. The term was coined in 1991 by Mark Weiser to describe how computers are woven into the fabric of everyday life. People no longer only access computers through the traditional personal computer but engage with many computational devices and systems simultaneously, and may not necessarily even be aware that they are doing so (Weiser 1991).
2. Open sports, also known as interactive sports (e.g. Hagemann 2009; McCutcheon and Ashe 1999) include sports where there are no teammates, like tennis and taekwondo, and are characterised by the fact that the performance of the individual athlete is no longer solely dependent on his or her own set of skills, but more importantly, on how well opponents and potential teammates perform (Knapp 1977). It includes both team sports, for example, handball and individual sports like tennis and taekwondo. In highly open sports, for example, basketball and taekwondo a space is shared by the participants and body contact is allowed.
3. A certified advanced Rolfer (www.rolfing.org).

References

Allard, F. and Starkes, J. L. (1991). 'Motor-Skill Experts in Sports, Dance and Other Domains'. In K. Anders Ericsson and Jacqui Smith (eds), *Toward A General Theory of Expertise: Prospects and Limits*. Cambridge: Press Syndicate of the University of Cambridge.

Baker, J., Côte, J. and Abernethy, B. (2003). 'Sport-Specific Practice and the Development of Expert Decision-making in Team Sports'. *Journal of Applied Sports Psychology*, 15: 12–25.

Berthoz, Alain. (1997). *The Brain's Sense of Movement*. Cambridge, MA: Harvard University Press.

Boucher, M. (2004). 'Kinetic Synaesthesia: Experiencing Dance in Multimedia Scenographies'. *Contemporary Aesthetics*, 2. http://www.contempaesthetics.org/newvolume/pages/article.php?articleID=235. Accessed 7 March 2011.

Coh, M., Jovanović-Golubović, D. and Bratić, M. (2004). 'Motor Learning in Sport'. *Physical Education and Sport*, 2 (1): 45–59.

Czajkowski, Z. (2006). 'The Essence and Importance of Timing (Sense of Surprise) in Fencing'. *Kinesiology*, 16: 35–42.

Davids, K. (1998). 'How Much Teaching is Necessary for Optimal Learning of Football Skills?: The Role of Discovery Learning'. *insight: The F.A. Coaches Association Journal*, 2 (2): 35–36.

Davids, K., Araujo, D., Shuttleworth, R. and Button, C. (2003). 'Acquiring Skill in Sport: A Constraints-Led Perspective'. *International Journal of Computer Science in Sport*, 2(2): 31–39.

Fadde, P. J. (2010). 'Training Complex Psychomotor Performance Skills: A Part-Task Approach'. In K. H. Silber and W. R. Foshay (eds), *Handbook of Improving Performance in the Workplace. Volume 1: instructional design and training delivery*. A publication for The International Society for Performance Improvement. New York: Pfeiffer.

Flynn, R. (1996). 'Anticipation and Deception in Squash'. Presented to the 9th Squash Australia/ PSCAA National Coaching Conference. Canberra, Australia: Australian Institute of Sport, 2–8.

Foster, S. L. (2011). *Choreographing Empathy: Kinesthesia in Performance*. New York: Routledge.

Frank, K. (2008). 'Body as a Movement System'. *Structural Integration*, 36 (2): 14–23.

Gallese, V., Fadiga, L., Fogassi, L. and Rizzolatti, G. (1996). 'Action Recognition in the Premotor Cortex'. *Brain*, 119: 593–609.

Gréhaigne, J. F., Godbout, P. and Bouthier, D. (1999). 'The Foundations of Tactics and Strategy in Team Sports'. *Journal of Teaching in Physical Education*, 18 (2): 159–174.

Hagemann, N. (2009). 'The Advantage of Being Left-Handed in Interactive Sports'. *Attention, Perception, & Psychophysics*, 71 (7): 1641–1648.

Hagendoorn, I. (2004). 'Some Speculative Hypotheses about the Nature and Perception of Dance and Choreography'. *Journal of Consciousness Studies*, 11 (3–4): 79–110.

Jackson, R. F., Warren, S. and Abernethy, B. (2006). 'Anticipation Skill and Susceptibility to Deceptive Movements'. *ActaPsychologica*, 123: 355–371.

Knapp, B. (1977). *Skill in sport: the attainment of proficiency*. London: Billing & Sons Limited.

McCutcheon, L. E. and Ashe, D. (1999). 'Can Individualists Find Satisfaction Participating in Interactive Team Sports?' *Journal of Sport Behavior*, 22: 570–577.

Moen, J. (2006). 'KinAesthetic Movement Interaction', Ph.D. Thesis. Sweden: KungligaTekniskaHögskolan.

Petersen, M. G., Iversen, O. S., Krogh, P. G. and Ludvigsen, M. (2004), 'Aesthetic Interaction – A Pragmatist's Aesthetics of Interactive Systems', *Proceedings of the 2004 Conference on Designing Interactive Systems (DIS): Processes, Practices, Methods, and Techniques*, Cambridge, MA, 269–276.

Petersen, M. G., Krogh, P. G. (2008), 'Collective Interaction–Let's join forces', *Proceedings of COOP'08*, Carry-le-Rouet, France, 193–204.

Rogers, Y. (2005). 'New Theoretical Approaches for Human-Computer Interaction'. *Annual Review of Information Science and Technology*, 38 (1): 87–143.

Schachtel, Ernest G. (1967). *Experiential Foundations of Rorschach's Test*. London: Tavistock Publications.

Sklar, D. (1994). 'Can Bodylore be Brought to Its Senses?' *The Journal of American Folklore*, 107 (423): 9–22.

Thompson, C. W. (2004). *Manual of Structural Kinesiology*. New York: McGraw-Hill.

Weiser, M. (1991). 'The Computer for the 21st Century'. *Sci. Am*, 265, 3 (Sept.): 66–75.

Williams, A. Mark, Ford, P. R., Eccles, D. W. and Ward, Paul (2010). 'Perceptual-Cognitive Expertise in Sport and Its Acquisition: Implications for Applied Cognitive Psychology'. *Applied Cognitive Psychology*. Published online in Wiley Online Library (wileyonlinelibrary.com) DOI: 10.1002/ acp.1710.

www.dartfish.com (accessed January 2012).

www.dynavision2000.com (accessed January 2012).

www.intelligym.com (accessed January 2012).

www.interactivespaces.net (accessed January 2012).

www.konami.com (accessed January 2012).

www.nintendo.com/wii (accessed January 2012).

www.octopustrainer.dk (accessed January 2012).

www.rolfing.org (accessed January 2012).

Conclusion

Dee Reynolds and Matthew Reason

At the beginning of this book, we pointed to the timeliness of the topic of kinesthetic empathy as a field where debates in different contexts and disciplines are currently converging. Across 15 chapters we have presented research from a range of methodological, creative and social contexts, which as well as the authors' insights and arguments provides the opportunity for readers to make new and valuable connections of their own. And yet, as we come to this conclusion we are inevitably very much aware of all the things left unsaid or unexplored or unanswered. Owing to the richness and diversity of work being conducted around kinesthetic empathy, this book can only give some indications of a vibrant area of research and also point to possibilities for further exploration.

For these reasons in this conclusion, rather than reflect backwards on what has already been said in this book, we would like to project forwards and outwards, somewhat speculatively at times, to think about other possible areas, inspired by those discussed in the book, where the concept of kinesthetic empathy might be a catalyst for ongoing research and/or practice. In thinking about these and other questions we would like to invite you to make the debate interactive through contributing to our online discussion forum, at http://watchingdance.ning.com/.

Kinesthetic empathy and consciousness

As we compiled this book and worked on the Watching Dance project one of our most frequently recurring questions was whether we as individuals are always consciously aware when we experience kinesthetic empathy. And if not, which seems likely to be the case given its embodied, sometimes momentary and involuntary nature, what is the relationship between our conscious and non-conscious (or pre-conscious) processes of kinesthetic empathy? This question has different implications depending on one's disciplinary standpoint, such as

contrasting perceptions about the nature of consciousness and the relationship between our reflective processes of meaning making and our neurobiological processes. However, there is increasing recognition of the necessity to connect different standpoints. For instance, neuroscientist Antonio Damasio argues that feelings are 'mental events in the conscious mind', which interface between embodied emotions and the conscious self (Damasio 2003: 177). He brings together neuroscience and philosophy by connecting the 'neurobiology of feelings' to questions of 'how we live' (287), opening onto discussions of ethics and even spirituality. Further exploration of the articulation between conscious and non-conscious dimensions of kinesthetic empathy will require making connections between different fields of enquiry. Vitally we would argue that such connections should be made in a manner that does not attempt to flatten disciplinary differences, that does not play methodological or epistemological trump cards, but respects different sets of expertise and knowledge.

Kinesthetic empathy 'training'

Various chapters in this book have prompted us to wonder about what might be described as kinesthetic empathy 'skills'. Is kinesthetic empathy the kind of thing one can 'learn'? Can one catch it, cultivate it, become an experiential expert in it? Within this book discussions touching on this area have included Fogtmann's exploration of sports training through innovative methods of enhancing players' ability to read 'intuitively' the movements and flow of a game in the moment itself. Kinesthetic empathy training might also relate to the skills of performers, particularly dancers who have traditionally learnt through imitation of the body of another, thereby engaging with questions of self and others and of kinesthetic awareness and projection. Also, the children and researchers who engaged in play in the multisensory, immersive performance environment discussed by Shaughnessy, and the musicians and listeners discussed by Rabinowitch in the context of Musical Group Interaction, are involved in processes of discovery and learning about interacting with others through shared, embodied sensory experience. Indeed, for a number of authors in this book, sensory stimuli are considered to play a crucial role in activating empathic responses.

Such ideas of training to enhance kinesthetic empathy might also relate to the roles of spectator and observer. Can the dance movement therapist discussed by Meekums be considered a kind of expert in kinesthetic empathy? Similarly, the 'client', or the group, with whom the therapist engages in a dialogical rather than a hierarchical relationship, acquires enhanced awareness of the other through a 'mirroring' process, which also enhances self-knowledge. Or perhaps the spectators of Gray's performances of intimate stillness, who are invited to become more physically conscious of their relationship to the other of the performer and also to their own body, are engaged in a process of discovery and enhancement of kinesthetic empathy.

A related question that arises here is whether kinesthetic empathy is something that those who perform and/or watch a lot of movement, whether professionally (critics,

directors, choreographers, sports trainers) or recreationally (the dance aficionado or sports fan) become progressively more adept at? Do such 'expert' spectators develop enhanced kinesthetic empathy and, if so, what brain or observational exercises might be appropriate in facilitating this development? This emphasis on watching also connects to questions of how kinesthetic empathy might be relevant to movement rehabilitation. It appears to be the case that simply watching an action can, given the right conditions, lead to a simulation where the process of perception mirrors or imitates aspects of the action being performed. This then has implications for rehabilitation in situations where patients' ability to move is restricted, but where observation of others' movement may have beneficial effects. Can such processes be considered a kind of kinesthetic empathy training? Might kinesthetic empathy training involve a kind of 'brain training' and if so, what would be its moral, social and intercultural implications?

Kinesthetic empathy with things and spaces

Rabinowitch, Cross and Burnard discuss the plasticity of the body schema, whose boundaries can adapt to include interactions with 'others' beyond the self. Interestingly this can involve objects and environments as well as people, and is an embodied, kinesthetic experience, which involves the participation of several senses. The emphasis on the multisensory in kinesthetic empathy resonates with research on the role of touch and hearing in the mirror neuron system, which has been discussed in this book. Several chapters have explored kinesthetic empathy with things – objects, puppets, shapes – or spaces – in terms of multisensory scenography or designed, interactive environments. McKinney, for example, discusses how multisensory scenography stimulates embodied responses, where audience's bodies are directly impacted by the performance space, and cites Vischer's observation of how the body 'swells when it enters a wide hall'. We might all think of our own embodied examples of this, perhaps with objects that we use regularly and that seem to merge with our own bodies (bicycles perhaps) or with spaces and places that have a physical impact on us as we enter or pass through them. We might think of how a well-designed theatre, lecture hall or parliamentary debating chamber is constructed to focus attention and energy. Our kinesthetic empathy interactions with architecture, urban environments, everyday products (as discussed by Hayes and Tipper) and so on are rich areas for exploration and potentially provide a fruitful focus for design practice. What would it mean to design to enhance kinesthetic empathy? To what extent are such responses culturally encoded or intrinsic? What is the relationship between a sense of flow, of 'fine lines', of grace, of handleability and ergonomics and kinesthetic empathy?

Kinesthetic empathy and cross-cultural interactions

The intertwining of the cultural and the corporeal in the discourses and practices of kinesthetic empathy is an area of ongoing discussion, which also raises the question of how kinesthetic empathy can operate across diverging identities (including gender, race and disability) and in situations of conflict. Parekh-Gaihede's chapter engages with the limits of our ability to empathise across differences in experience and culture. She also explores how theatre might have the potential to address such limitations. Although embodied experience can be mobilised to exploit and reinforce differences (such as cultural identities), in crude oppositional terms, for instance through foregrounding stereotypes, it can also activate embodied connections with others, which break down monolithic identities by raising awareness of differences within the self. As Amelia Jones writes in her foreword to this book: 'we are never whole and final as subjects but always porous, through kinesthetic empathy perhaps, to the impact and impression of other subjective expressions around us'. Moreover, movement, physicality and the non-verbal have the potential to articulate levels of difference and intersubjective connection in ways that intersect with but are not always reducible to language, thereby bringing new complexities into play (cf. Norridge 2010). It may be that for research engaging in cross-cultural arts practice and arts practice in places of conflict, kinesthetic empathy can provide a valuable focus.

Kinesthetic empathy and gaming

Some chapters in this collection have engaged with virtual environments, including interactive systems, but have not addressed computer gaming directly. However, in the works by Gibson discussed by Whatley, the viewer is also a 'player' who, as in computer gaming, controls/animates the avatar and interacts with the environment. The relationship between the self and a game-based avatar is clearly an extraordinarily rich area to explore, raising issues of projection and intersubjectivity and movement in virtual realms, which hold a powerful fascination for keen players. While other factors are clearly also at work in gaming – not least systems of reward for progressing that hook the gamer in to return again and again – the investment of the self into a virtual world or character is likely to draw on responses of kinesthetic empathy, where the viewer is engaged through sensory experience, which draws him/her to experience the virtual environment through the avatar.

This can involve a degree of direct physical response to the movement going on in the game (e.g. where a gamer involuntarily moves in relation to the screen movement) as well as a more intense simulated physical engagement going on in the mind.

Negative experiences of kinesthetic empathy

The overwhelming focus of much research on kinesthetic empathy has tended to describe it as a positive communicative tool of social interaction. Rabinowitch, Cross and Burnard, for example, explore the potential for musical interaction to aid group cohesion and empathy, while Meekums discusses the potential of 'mirroring' movement to effect positive change. At various points in our research we have been asked by people whether kinesthetic empathy is always positive and here, although there seems to be less research, we feel there are connections to embodied experiences of 'negative empathy' where relationships of mirroring or simulation give rise to uncomfortable feelings of shame, envy or exclusion, which may be prompted by a sense of unfavourable comparisons between self and other, and are often physically manifested. Kinesthetic empathy is clearly not the only aspect of difference but it is striking, in English at least, how physical and embodied the language of exclusion often is. We might think about how feelings of being 'out of step' or 'out of kilter' are metaphorical articulations of a kinesthetic sensation of exclusion. Experience of a lack of rhythmical connection, an inability to walk to a beat, a feeling of being looked down upon and many others continue this construction of a negative or excluding kinesthetic empathy.

Alternatively we might consider how kinesthetic empathy can be utilised as a force for seduction and manipulation. Chapters in this collection have again explored the possibilities here in a positive manner, such as Bolens' discussion of Charlie Chaplin's kinesthetic projection of humility or the exploration of participatory performances and environments by several authors. The embodied experiential force of kinesthetic empathy is of course one that carries us away, or carries us out of ourselves (another metaphor). Such manipulation of presence and persuasion and the forgetting of the rational, critical self are part of the performance of fascism and political extremism. The use of kinesthetic empathy interaction with an audience – the working of body language to communicate empathy with a crowd or an individual – is a key tool of the political operator and whatever one's political perspective, it is not always a force for good. Kinesthetic empathy practices are inseparable from networks of power, and as well as an ethics, we therefore also need to elaborate a politics of kinesthetic empathy.

These are just some of the avenues for further research in the areas of kinesthetic empathy and its creative and cultural practices that have come to our mind while preparing this book. We could continue to multiply examples and equally there is doubtless much exciting research already going on across different disciplines in these kinds of areas. This leads us to think that while kinesthetic empathy certainly does not describe all or everything about our everyday, cultural and creative interactions, it is certainly integral to our embodied and intersubjective experience. As the cultural turn, and its focus on the lived experience and processes of meaning making, collides with the corporeal turn, and its focus on the embodied experience, it seems to us that kinesthetic empathy provides some of the key tools we need for both living in and thinking about the world around us.

References

Damasio, A. (2003). *Looking for Spinoza: Joy, Sorrow and the Feeling Brain.* London: William Heinemann.

Norridge, Z. (2010). 'Dancing the Multicultural Conversation? Critical Responses to Akram Khan's Work in the Context of Pluralist Poetics'. *Forum for Modern Language Studies* (Special Issue on 'Evaluating Dance: Discursive Parameters', edited by Dee Reynolds) 46 (4), October: 415–430.

Notes on Contributors

Guillemette Bolens is Professor of English literature at the University of Geneva, Switzerland, where she teaches medieval literature with a focus on the history of the body and kinesics. Her essays have appeared in *Poetics Today, History and Philosophy of the Life Sciences, European Joyce Studies, Oral Tradition*, and she received the 2001 Latsis Award and the 2001 Hélène and Victor Barbour Award for her book *La Logique du corps articulaire: Les articulations du corps humain dans la littérature occidentale*. Her book *Le Style des gestes: Corporéité et kinésie dans le récit littéraire* was published in 2008, and its English translation is forthcoming at the Johns Hopkins University Press.

Pamela Burnard works at the University of Cambridge, UK where she manages higher degree courses in Arts, Culture and Education and in Educational Research. She is co-editor of the *British Journal of Music Education*, associate editor of *Psychology of Music* and serves on numerous editorial boards. She is section editor in the *International Handbook of Research in Arts Education*, and in the forthcoming *Oxford Handbook of Music Education*. She has also co-edited several books, and has participated in numerous international research teams, contributing significantly to the field of creativity research in music education through her investigations. She is convenor of British Education Research Association Special-Interest-Group *Creativity in Education*, and has served on the Board of Directors for ISME.

Ian Cross is Director of the Centre for Music and Science in the Faculty of Music at the University of Cambridge where he is also a fellow of Wolfson College. Initially a guitarist, since 1986 he has taught in the Faculty of Music at Cambridge where he is now Reader in Music and Science. His research is guided by the aim of developing an integrated understanding of music as grounded in both biology and culture; he has published in the fields of music cognition, music theory, ethnomusicology, archaeological acoustics, psychoacoustics and music and language evolution.

Adriano D'Aloia is a postdoctoral researcher in the Department of Communication and Performing Arts of the Università Cattolica del Sacro Cuore of Milan. He received a Ph.D. in *Culture della Comunicazione* for his dissertation on 'Empathy in the Film Experience'. He is

curator of Rudolf Arnheim, *I baffi di Charlot. Scritti italiani sul cinema 1932–1938* (Torino: Kaplan 2009: English trans. forthcoming) and co-editor of the Italian translation of David Rodowick, *The Virtual Life of Film* (*Il film nell'era del virtuale*, Milano: Olivares 2008). His research focuses on intersubjectivity in the audiovisual experience and on the new forms of cinematic experience. His blog is accessible at http://anideaaday.wordpress.com.

Lucy Fife Donaldson completed her Ph.D. 'Engaging with Performance in Post-Studio Horror' in the Department of Film, Theatre & Television at the University of Reading in 2010. Her research focuses on the materiality of performance and its relationship to elements of film style.

Maiken Hillerup Fogtmann is an architect and designer from Aarhus, Denmark. For the last six years she has been working within the field of interaction design. The research activities carried out within the research centre, Interactive Spaces, are what initially sparked her interest in designing for and with the body. The work discussed in this chapter is a part of her Ph.D. project where she explores the concept of kinesthetic interaction with a focus on kinesthetic empathy. She is currently employed as a digital product designer at The LEGO Group, working on creating engaging new interactive play experiences.

Victoria Gray earned a BA (hons) Northern School of Contemporary Dance and an MA Performance from York St John University. She has worked as a choreographer and performer nationally and internationally. Her practice interrogates the intersection between contemporary European dance practices and Performance Art, with specific interest in performance practices that emerge out of the fine arts, particularly sculpture. She is co-director of O U I Performance (York) with Nathan Walker, curating Performance Art in the UK and a lecturer in Dance and Performance at York St John University.

Amy E. Hayes is a lecturer in the School of Sport, Health, and Exercise Sciences at Bangor University, UK. She completed her Ph.D. in Cognitive Psychology at the University of Oregon, USA. Her research interests include the role of attention in the perception of dynamic scenes; cognitive and motor performance in Parkinson's disease patients; and how motor actions influence emotional experience.

Brian Knoth is a digital media artist, musician and interactive systems designer. This work is realised in several contexts including interactive digital performance, multimedia installation and interactive systems for mind–body rehabilitation. He has collaborated on several award-winning projects and has presented/performed in numerous contexts including The Boston Cyberarts Festival, The International Computer Music Conference (Copenhagen, Denmark) and the Kinesthetic Empathy: Concepts and Contexts Conference (Manchester University, UK). Knoth has taught at the University of Rhode Island, Emerson College, Rhode Island College, and Brown University. He holds an MA in Media Arts from

Emerson College and a Ph.D. in Music (the Multimedia and Electronic Music Experiments programme) from Brown University.

Bonnie Meekums, Ph.D., is a lecturer in the University of Leeds School of Healthcare. Her first degree was in physiology and biochemistry; she later trained in dance, theatre and writing at Dartington College of Arts in Devon, UK and subsequently developed her approach to dance movement psychotherapy. Her research interests over the past 25 years have been centred in the arts in psychotherapy. Meekums is an honorary Fellow and senior practitioner of the Association for Dance Movement Psychotherapy UK, and teaches DMP in the UK, Poland, Latvia and Croatia. She has written many peer-reviewed journal articles and two books: *Creative Group Therapy for Women Survivors of Child Sexual Abuse* (JKP, 2000) and *Dance Movement Therapy* (Sage, 2002). She is also Symposium co-editor for the *British Journal of Guidance and Counselling*.

Joslin McKinney is Lecturer in Scenography at the University of Leeds. Building on ten years' experience as a professional designer, her practice-led PhD (2008) investigated the way audiences receive and respond to scenography. She has been a co-convenor of the Theatre and Performance Research Association's Scenography working group and a regular contributor to the International Federation for Theatre Research (Scenography Working Group). She is the lead author of the *Cambridge Introduction to Scenography* (2009).

Chris Nash is a London-based photographer who has been described as 'Our most imaginative interpreter of Dance' (The Guardian) and is the recipient of a Dance Umbrella/ Time Out Award, the inscription of which reads; 'For helping to make the face of dance more recognisable'. More recently he was awarded a prestigious NESTA Dreamtime grant and has had a major exhibition at the Victoria and Albert Museum in 2011. Aside from his dance photography, Chris Nash pictures can be found on advertising billboards, in fashion catalogues and on album and book covers.

Rose Parekh-Gaihede holds an MA in cultural studies (Moderne Kultur og Kulturformidling) from the University of Copenhagen. Her artistic education is within physical theatre attained through apprenticeship with ensembles such as at Periplo Compañía Teatral in Buenos Aires. In 2007 she founded the non-profit organization Seismograf for artistic, interdisciplinary research. She is currently working as an independent performance artist with physical and sensorial theatre, and installation art.

Tal-Chen Rabinowitch studied psychology and musicology at the Hebrew University of Jerusalem, as well as performing arts (flute) at the Jerusalem Academy of Music and Dance. She has a master's degree in music cognition from the Hebrew University, which focused on the theoretical links between music and empathy. She is currently completing her Ph.D. at the Centre for Music and Science in the Faculty of Music, at the University of Cambridge.

This work explores experimentally the effects of musical group interaction on children's every-day capacity for empathy, and in particular, the emotional impact of synchronisation during musical interaction.

Matthew Reason is Reader in Theatre and Head of Programme for MA Studies in Creative Practice at York St John University. His work explores themes relating to performance documentation, reflective practice, audience research, theatre for young audiences, live art and contemporary performance and cultural policy. He has published two books: *Documentation, Disappearance and the Representation of Live Performance* (Palgrave 2006) and *The Young Audience: Exploring and Enhancing Children's Experiences of Theatre* (Trentham 2010). He is a member of the project team for 'Watching Dance: Kinesthetic Empathy' (www.watchingdance.org), an AHRC funded cross-disciplinary research project.

Dee Reynolds is Professor of French at the University of Manchester. She has written two books, *Rhythmic Subjects: Uses of Energy in the Dances of Mary Wigman, Martha Graham and Merce Cunningham* (Dance Books, 2007) and *Symbolist Aesthetics and Early Abstract Art: Sites of Imaginary Space* (CUP, 1995). She also co-edited, with Penny Florence, *Feminist Methodologies: Multi-Media* (Manchester University Press, 1995) and has edited several special issues of journals, including *Dance Research Electronic* on Dance and Neuroscience (2012). Her work has appeared in numerous edited collections and journals, including *Body and Society, Body, Space and Technology Journal, Dance Research*, and *Dance Research Journal*. From 2008 to 2011 she directed the research project 'Watching Dance: Kinesthetic Empathy' (www.watchingdance.org), funded by the AHRC.

Nicola Shaughnessy is Senior Lecturer in Drama and Deputy Head of the School of Arts at the University of Kent. Her research and teaching interests are in the areas of applied theatre, contemporary performance, dramatic auto/biography and cognition and performance. She is Director of the Research Centre for Cognition, Kinesthetics and Performance. Her publications include articles on gender and theatre, auto/biography and applied theatre. She is the author of *Gertrude Stein* for the Writers and their Work series (Northcote House, 2007) and co-editor of *Peg Woffington: in the Lives of Shakespearean Actors* series (Pickering & Chatto, 2008). Her current book project is entitled *Applying Performance (Palgrave).*

Steven P. Tipper is Professor of Cognitive Psychology at Bangor University, UK. His research interests include attention, embodiment, mirror systems, motor control and social cognition. His work on attention has emphasised the importance of inhibitory mechanisms in attentional control, and the role that the demands of action play in guiding attention. In recent work he has investigated how perceptual-motor processes contribute to emotion and social cognition.

Sarah Whatley is Professor of Dance at Coventry University. As a researcher and dance artist, her research specialises in the interface between dance and new technologies, dance analysis, somatic dance practice and pedagogy, and inclusive dance. She led the AHRC-funded Siobhan Davies archive project (www.siobhandaviesreplay.com) and is now working on the AHRC-funded Digital Dance Archives project with the University of Surrey. She led the JISC-funded D-TRACES project, is part of the AHRC-funded Screendance network and is a member of the International Education Workgroup for The Forsythe Company's Motion Bank project. She edits the *Journal of Dance and Somatic Practices* and is on the editorial board of the *International Journal of Screendance*.

Index

Proper Names